COLLINS
COMPLETE GUIDE TO
BRITISH
BIRDS

D1423617

Paul Sterry

Collins

HarperCollins Publishers Ltd.
77-85 Fulham Palace Road
London W6 8JB

www.collins.co.uk

Collins is a registered trademark of HarperCollins Publishers Ltd.

First published in 2004

14 13 12
10 9 8 7

A catalogue record for this book is available from the British Library.

ISBN: 978-0-00-723686-2

Collins uses papers that are natural, renewable and recyclable products made from
wood grown in sustainable forests. The manufacturing processes conform to the
environmental regulations of the country of origin.

Colour reproduction by Nature Photographers Ltd.
Edited and designed by D & N Publishing, Hungerford, Berkshire
Printed and bound in China by South China Printing Co., Ltd.

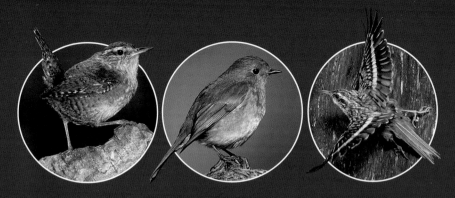

CONTENTS

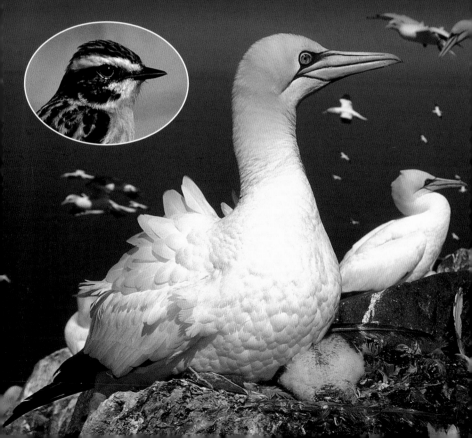

INTRODUCTION TO BRITISH BIRDS

For such a comparatively small – and in parts overcrowded – region, Britain and Ireland boast an amazing diversity of birdlife. The topography, geology and history of land use of these islands has encouraged a rich array of habitats to develop, all of which contribute to the diversity of our wildlife and to that of our birds in particular. And our geographical location is significant, too: situated on Europe's Atlantic coast, the British Isles are circled by seas that allow seabirds galore to colonise our shores. Furthermore, good fortune, in the form of the Gulf Stream, dictates a mild and comparatively equitable climate for much of the time. Little wonder then that, compared to a land-locked area of mainland Europe of similar size, our islands boast a disproportionately generous diversity of bird species.

Given the rewards on offer, it is little wonder then that birdwatching is so popular as a hobby. The enthusiastic passion for birds we see today is founded on a heritage of detailed and dedicated ornithological study dating back two centuries or more. *Complete British Birds* builds on this cumulative wealth of knowledge, providing an instructive tool for the identification of almost any bird you are likely to encounter in our region. Furthermore, the inclusion of pertinent background information helps the reader to put each species in ornithological perspective and to understand the factors influencing the status – and, in many cases, the plight – of birds in Britain and Ireland today.

THE REGION COVERED BY THIS BOOK

The region covered by this book comprises the whole of mainland England, Wales, Scotland and Ireland, as well as offshore islands including the Shetlands, Orkneys, Hebrides, Isle of Man and the Scilly Isles. In addition, I have also included the Channel Islands in this book because their proximity to, and ecological affinities with, northern France make a valuable contribution to our wildlife. Lastly, the seas surrounding our islands are also included in the geographical extent of this book because of their obvious significance to many of our seabirds, some of which favour offshore waters and spend much of their lives out of sight of land. They are just as much a part of our ornithological heritage as terrestrial species and, with the rise in popularity of pelagic birdwatching trips, they are becoming increasingly accessible to birdwatchers.

THE CHOICE OF SPECIES

This book is intended to cater for the needs of the keen birdwatcher – the sort of person whose enthusiasm is built on several years of experience – while not neglecting the needs of the beginner. All our resident species are included here, as are seasonal visitors to the region – those that are with us in spring and summer, as well as birds that visit us during the winter months. In addition, I have also included all those species that occur regularly as passage migrants – birds that pass through our islands on migration in spring and autumn. As a reflection of their importance to birdwatching in our region, the bulk of the book is devoted to all these common, or relatively frequently occurring, species.

Accompanying the rise in popularity of birdwatching in general, there has been an increased interest in, and knowledge of, vagrants to the region. To cater for this, I have also included a generous selection of rarities in the book; these are featured at the back, to reflect their lesser importance in the overall scheme of things, and to reduce the likelihood of optimistic misidentification of common species. Given the fickle nature of vagrancy, it is difficult to be precise about such things – numbers vary from year to year – but almost every bird species that occurs here, say, at least five times in a good year is included.

HOW TO USE THIS BOOK

This book has been designed so that the text and photographs for each species are on facing pages. A system of labelling clearly states the identity and, if appropriate, the plumage and sex of each photograph to avoid ambiguity. The text complements the information conveyed by the photograph.

By and large, the order in which the species appear in the main section of the book roughly follows the standard systematic classification of birds – the one that is adopted by most other field guides. However, in a few instances I have tinkered with the standard running order to allow, for example, confusingly similar species to appear on the same page, and so that, where possible, members of the same group of birds can appear side by side on the same page.

SPECIES DESCRIPTIONS

At the start of each species description, the most commonly used and current English name is given. This is followed by the scientific name of the bird in question, which comprises the species' genus name first, followed by its specific name. In a few instances, reference is made, either in the species heading or in the main body of the text, to a further subdivision – subspecies – where this is pertinent. There then follows some measure of the species' size. In most instances, the length is given, but for birds that are more commonly seen in flight, such as birds of prey, wingspan is given instead.

The text has been written in as concise a manner as possible. To avoid potential ambiguities in species description the plumage in question appears in bold at the start of the relevant passage of text. The bird's voice is then described; in most cases this involves a phonetic description of the call, but with the majority of songbirds the song itself is also portrayed.

HABITAT AND STATUS

Most birds are extremely habitat specific, and so information is provided about their preferences and predilections. This helps narrow down the field when trying to identify a mystery bird, and it can also be used as a pointer if you want to seek out a particular species. Some details about the status of each species in the region is also provided. First, information about whether a bird is a year-round resident, seasonal visitor or passage migrant is given. Secondly, a rough indication of population numbers or annual occurrence is given; this will serve as a guide to the likelihood of seeing particular species, and how much effort might be needed to achieve this goal. The figures provided are necessarily rough estimates – many birds are difficult to survey and populations fluctuate from year to year. When compiling the information about bird numbers, reference to a number of sources was made, including surveys by the Royal Society for the Protection of Birds (RSPB) and the British Trust for Ornithology (BTO) amongst others. All self-respecting birdwatchers should become members of one or other of these organisations, and preferably both; the BTO's publications form the backbone of most ornithologists' libraries (*see* Further Reading, page 282).

OBSERVATION TIPS

For each species I have provided information that should help the birdwatcher pinpoint the bird in question, or at least improve the chances of discovery or observation. In some cases, tips are provided that will help distinguish the species from any superficially similar cousins.

MAPS

The maps provide information about the distribution and occurrence of each species. They represent the current ranges of birds in the region in general terms. Bear in mind that, given the size of the maps, small and isolated populations may not be featured. Furthermore, the ranges of some species change from year to year; this is particularly true of certain winter visitors and passage migrants.

Key to maps

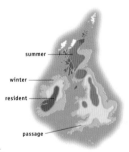

■ on land and ■ at sea = year-round resident;
■ on land and ■ at sea = summer breeding visitor;
■ on land and ■ at sea = winter visitor;
■ on land and ■ at sea = likely occurrence as a passage migrant.
Paler shades of each of these colours give a very rough impression of where a species is less common.

CALENDAR BAR

The calendar bar offers a quick reference to a species' presence or absence throughout the year. Colours are used to indicate presence and reflect those used on the maps; white denotes absence. Year-round presence across much of the region is indicated by purple, even where there may be subtle, local changes in range between seasons. Where there are more profound differences through the year, in terms of breeding and non-breeding distribution, or habitat, then seasonal colours (red for breeding season, blue for non-breeding) are used. Yellow indicates months in which a species can be seen on passage. Two shades of each colour are used: a darker shade indicates there is a good chance of seeing a particular species in its favoured habitat; a paler shade denotes it may only sometimes be found.

PHOTOGRAPHS

Great care has gone into the selection of photographs for this book and in many cases the images have been taken specifically for the project. Preference was given to photographs that serve both to illustrate key identification features and to emphasise the beauty of the bird in question. Wherever possible, I have tried to avoid the rigid constraints of most previous photographic guides to birds, adopting instead contemporary approaches to design that make full use of computer software.

For each species, photographic emphasis has been given to the plumage, or plumages, most likely to be encountered in the region. However, by using insets as comprehensive a range of additional plumages and poses has been included as well.

The way in which many of our smaller songbirds are photographed – long lenses with a limited depth of field – necessarily means that they tend to become, to a degree, isolated from their backgrounds. In order to provide additional information about their habitat preferences, many of the illustrations of these birds are set against a backdrop of an appropriate habitat.

Wherever I feel there is potential for confusion with another bird not featured on the same page, I alert the reader to the possibilities with cross-referencing 'Confusion Species' boxes.

GLOSSARY

Axillaries – feathers on the part of the underwing that corresponds roughly to what we might call the armpit.

Carpal – the part of the wing that corresponds to the wrist; this area of feathering is contrastingly dark in several raptor species.

Cere – bare skin at the base of the bill and around the nostrils.

Eclipse – the female-like plumage acquired by many male ducks during their summer moult.

Eye-stripe – a stripe through the eye, from the base of the bill to the ear coverts.

First autumn – a bird in its first autumn, whose plumage may be juvenile or first winter depending on when moult occurs.

First winter – the plumage acquired after a bird's juvenile feathers have been moulted.

Flight feathers – the long feathers (primaries, secondaries and tertials) on the trailing half of the wing.

Immature – a young bird whose plumage is not adult. Depending on the species, this stage may last months or years.

Juvenile – a newly fledged bird in its first set of feathers.

Length – the distance from the tip of the bill to the tip of the centre of the tail.

Leucistic – atypically pale appearance of the plumage, or parts of the plumage, due to a lack of feather pigmentation.

Lore – area of feathering between the eye and the base of the upper mandible.

Malar stripe – narrow stripe of feathers that borders the throat.

Mantle – area of feathers on the upper back.

Moult – the process of feather replacement in the cycle of plumage renewal.

Moustachial stripe – a line of feathers running from the base of the lower mandible to the cheeks.

Orbital ring – ring of bare skin around the eye.

Pelagic – favouring the open sea.

Primaries – the outermost flight feathers.

Secondaries – the middle flight feathers.

Species – a group of genetically similar individuals, members of which can reproduce with one another and produce viable offspring; fertile offspring cannot be produced when members of two separate species interbreed.

Speculum – a glossy patch seen on the upper secondaries of some duck species.

Submoustachial stripe – the line of feathers (typically contrastingly pale) between the malar and moustachial stripes.

Subspecies – a geographically isolated population of individuals of a given species that possess distinct plumage differences from populations elsewhere in the species' range.

Supercilium – a typically pale stripe of feathers that runs much of the length of the head above the eye.

Tarsus – what most people refer to as a bird's leg, although strictly speaking it is anatomically part of the foot.

Tertials – the innermost flight feathers

Tibia – the visible upper part of a bird's leg.

Vagrant – a bird that appears accidentally outside the species' typical range, be it breeding, non-breeding or migratory.

Wing coverts – the feathers that cloak the leading half (as seen in flight) of both surfaces of the wings.

Wingbar – a striking bar on the wings (typically either white or dark) formed by pale or dark margins to the wing covert feathers.

Wingspan – the distance from one wingtip to the other.

BIRD TOPOGRAPHY

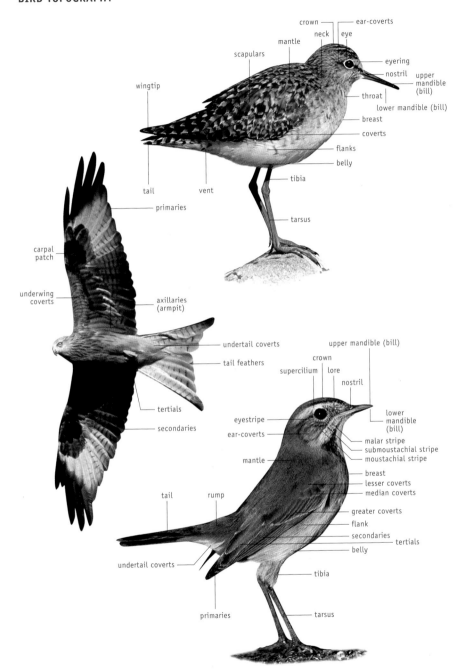

crown
ear-coverts
neck
eye
mantle
scapulars
eyering
nostril
upper mandible (bill)
throat
lower mandible (bill)
breast
coverts
flanks
belly
tibia
tarsus
wingtip
primaries
tail
vent

carpal patch
underwing coverts
axillaries (armpit)
undertail coverts
tail feathers
tertials
secondaries
tail
rump
undertail coverts
primaries

upper mandible (bill)
crown
supercilium
lore
nostril
lower mandible (bill)
eyestripe
ear-coverts
malar stripe
submoustachial stripe
moustachial stripe
mantle
breast
lesser coverts
median coverts
greater coverts
flank
secondaries
tertials
belly
tibia
tarsus

HABITATS FOR BIRDS

A combination of geology, geography and historical land use has conspired to create a wealth of different habitats in Britain and Ireland, and we are indeed fortunate to live in an area that boasts such a diverse array. By and large, British and Irish habitats are fragmented. However, the mosaic effect created by the juxtaposition of several different habitats does mean that an amazing diversity of birdlife can sometimes be found in a comparatively small area.

Although a few bird species are rather catholic in their choice of habitat, birdwatchers soon come to realise that the majority have much more specific needs. Their behaviour, feeding and nesting requirements, and indeed structure, have evolved to suit special niches in particular habitats. However, although a species may be habitat specific, it does not follow that it will be found in all examples of this habitat throughout the region. Climatic factors can have a profound effect on a species' range, influencing, for example, the ability of a bird to feed or, more profoundly, to survive extreme weather.

Fundamentally, the character of any given habitat is influenced by, and in some cases determined by, the geography, geology and botany of the area, although arguably the single most significant factor affecting the majority of sites today is the influence of man. Only certain coastal habitats and remote areas of the highest mountain tops can truly be said to have escaped human interference.

Man's influence has not always been to the detriment of wildlife diversity, and indeed some habitats, such as heathland, owe their very existence to clearance of trees from the land. As an example of man's contemporary role, woodland management carried out in a traditional manner can exert a positive influence on plant and animal diversity. Indeed, positive land management is an integral part of the day-to-day work undertaken on almost all nature reserves.

For some birdwatchers, studying the distinctions between our different habitats may seem like a rather esoteric pursuit, and one that lacks relevance to their everyday activities. However, it really is worth spending time familiarising yourself with their basic characters and differences for more practical reasons. Developing an understanding of the habitat in which a bird lives helps us to appreciate more fully the life of the bird in question in the context of the environment as a whole. From a more practical point of view, being able to recognise a habitat at a glance means you will save yourself a lot of time and effort when it comes to pinning down localised species. Habitat preferences aid bird identification.

The following pages detail all of our most characteristic and distinctive habitats. Contained within each habitat section is information about each one's character and vegetation, along with their significance to birds and the key species for which they are best known.

THE COAST

In habitat terms, the coastline is arguably the British Isles' crowning glory. Although development has marred considerable stretches of the coast, particularly in southern England, those that remain unspoilt there, and elsewhere in Britain and Ireland, are truly wonderful and harbour some of our most charismatic birds. The rich intertidal zone, bathed twice daily by an advancing and retreating tide, and the offshore waters too, are fundamental to the diversity and abundance of birdlife around our coasts. Our coastline is extremely varied, but in all its forms, whether dramatic cliffs or expansive estuaries and saltmarshes, it harbours a wonderful selection of birds.

Cliffs

For breathtaking scenery and a sense of untamed nature, coastal cliffs offer unrivalled opportunities for the birdwatcher. Man has had minimal impact on these areas and during the spring and summer months a few select locations throng with breeding seabirds. The British Isles have some of the finest seabird cliffs in Europe, with populations of species such as Razorbill and Gannet that are of global importance. The best time to visit a colony is between April and July, when the sight, sound and smell

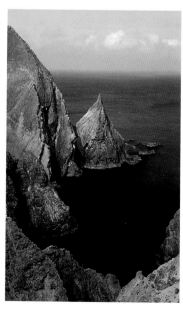

of the birds will be at its height. Because each species has unique nesting requirements, not every seabird species will be found on every cliff. Where stable ledges occur, Guillemots and Kittiwakes can be abundant, while Puffins favour grassy slopes in which they can excavate burrows. Some seabirds are solitary nesters but many, such as Cormorants and gulls, form loose colonies, their concentration due as much to the limited availability of nesting sites as to anything else. A fundamental requirement for any seabird colony is the close proximity of good feeding grounds.

Classic seabird colonies can be found on Skomer Island in Pembrokeshire, the Farne Islands in Northumberland, Hermaness on Unst and Noss, both in the Shetland Isles, and Great Saltee Island, off the coast of Wexford in Ireland.

Estuaries and Saltmarshes

To the unenlightened eye, an estuary may seem like a vast expanse of mudflats, studded with a mosaic of bedraggled-looking vegetation and very little else. For the birdwatcher, however, this is one of the most exhilarating of all habitats to visit. Incredible numbers of marine worms and tiny molluscs thrive in the oozing mud, their numbers supported by the vast amount of organic matter deposited when river meets sea. Benefiting from all this biological richness are the waders and wildfowl that feed on our estuaries in huge numbers from autumn to spring.

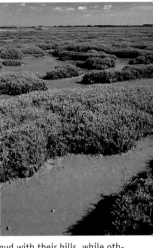

Evidence for the wealth of marine life found in mudflats and estuaries is not always easy to detect, although the casts of lugworms and the carpet of small marine molluscs on the surface hint at the productivity in the mud itself. Waders are perhaps the most characteristic group to exploit this resource, each species having a bill length and feeding strategy adapted to suit a particular food source (this also helps avoid undue competition between different species). Dunlin, for example, tend to feed on small surface-living animals, while Curlew and godwits use their long bills to probe deep for more substantial prey. Wildfowl, too, occur in huge numbers on many estuaries. Some, such as Shelduck, feed on minute animals filtered from the mud with their bills, while others, such as Brent Geese and Wigeon, favour plant material. With the exception of a few bird species, such as the Shelduck, most of the birds that visit our estuaries nest in more northerly parts of Europe and further afield, and are present in our region outside the breeding season, from September to March. The estuaries of the British Isles are globally important refuges for many bird species.

One of the advantages of living, as we do, on comparatively small islands that are well endowed with rivers is that most people do not have to travel far to visit a coastal estuary. All have something to offer the birdwatcher, but particularly rewarding locations include the Exe Estuary in Devon, Pagham Harbour in Sussex, Blakeney Harbour in Norfolk, Morecambe Bay and the Solway Firth in the northwest of England, and the Shannon Estuary and Strangford Lough in Ireland.

Rocky Shores

The intertidal zone on a rocky shore is an unbelievably rewarding place to visit. However, although rock pools and gullies team with invertebrates, the variety of birdlife is comparatively limited. During spring and summer, Oystercatchers are found nesting above the high-tide line; human disturbance excludes them from many popular stretches of coastline. Outside the breeding season, Turnstones and Purple Sandpipers (*right*) join them, but the distribution of both species does tend to be rather patchy and local. Almost any safe, sheltered stretch of rocky shore on the west coasts of Britain and Ireland will be worth exploring.

Sandy Shores and Dunes

Beloved of holidaymakers, sandy shores are also of interest to the birdwatcher. Beneath the surface of the sand lives an abundance of marine worms and molluscs whose presence would go largely undetected were it not for the feeding activities of birds and the profusion of dead shells found along the strandline. Outside the breeding season, look for Sanderlings as they follow the line of breaking waves in search of small invertebrates; Black-headed Gulls are seldom far away.

Offshore, fish and crustaceans provide a rich supply of food for those bird species that are sufficiently well adapted to catch them. During the summer months, terns can be seen plunge-diving here, while during the winter months grebes, Red-throated Divers and seaducks may exploit this resource.

On the landward side of the beach, colonising plants establish stable dune systems where birds such as Ringed Plovers and terns may nest. Sadly, however, human disturbance effectively excludes these species from almost all suitable areas in southern England.

Fine examples of dunes and sandy shores can be found by visiting Dawlish Warren in Devon, Kenfig and Newborough Warren, both in Wales, Holy Island in Northumberland, and Ballyteige in Wexford, Ireland.

FRESHWATER HABITATS

For the birdwatcher, freshwater habitats have the same magnetic appeal as do coastal habitats. In Britain and Ireland, we are indeed fortunate in having a wealth of examples, from small ponds and streams to large lakes and river systems; few people have to travel excessive distances to visit one or more of these habitats.

Rivers and Streams

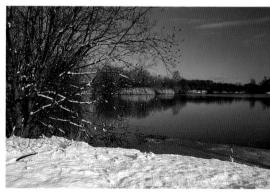

Flowing water has a charm all of its own, and a trip to one of our rivers and streams will invariably yield sightings of interesting birds. If the margins are cloaked with vegetation, a rich variety of invertebrate life will be found there, matched, beneath the surface of the water (assuming it is clean and unpolluted), by a wealth of invertebrate and fish life, sheltering among the drifts of submerged aquatic plants. In turn, this abundance of freshwater life supports a splendid array of birds, some species of which are found nowhere else.

Many larger rivers and streams support populations of Mute Swans, Mallards and Grey Herons. Small lowland streams are favoured by Kingfishers (*right*) and Little Grebes, while, in the north and west of the region in particular, Dipper and Grey Wagtail are characteristic species. In a few parts of southern England, chalk streams are managed as watercress beds. These come into their own during the winter months, when Green Sandpipers, Water Rails and the occasional Water Pipit join forces with the resident Grey Wagtails.

Almost any unpolluted stream is likely to be worth visiting, and even rivers, where their course is not influenced by large towns or cities, will hold some interest.

Lakes and Ponds

Bodies of standing water often harbour a strikingly different range of plants and animals from those found in flowing water. Many seemingly natural lakes are man-made, or at least man-influenced, and within this category fall flooded gravel pits and, more obviously, reservoirs and canals. By midsummer, a rich growth of aquatic plants dominates many of our smaller ponds as well as the margins of lakes. Evidence of the abundance of invertebrate life beneath the surface is provided by the emergence, from aquatic immature stages, of adult dragonflies and caddis flies. Where they are left to their own devices, the margins are soon encroached by stands of emergent plants, and species such as the Common Reed sometimes form extensive beds around larger lakes; indeed this species is often encouraged to flourish on account of its key importance, in economic terms, and to certain specialised animals.

Coots and Moorhens are almost ubiquitous residents of lowland lakes and ponds, and if the water body in question is large enough to support a significant fish population then Great Crested Grebes are also likely to be present; they build their floating nests around the margins in the spring. In remote parts of

Scotland, often surprisingly small pools are occasionally graced by Red-throated Divers (*right*) and Slavonian Grebes, while larger ones are the haunt of Black-throated Divers. Sedge Warblers and Reed Buntings nest in emergent vegetation of all types, but restricted to extensive reedbeds – especially those in eastern England – are unique bird communities comprising Bittern, Marsh Harrier and Bearded Tit, along with more widespread species such as Reed Warbler.

During autumn and winter, areas of open water become refuges for large flocks of waterbirds such as Tufted Duck, Pochard, Gadwall and Coot. For many species, reservoirs and flooded gravel pits fulfil the same role as natural and semi-natural lakes, with the added advantage to the birdwatcher that they are often with striking distance of urban areas.

Excellent areas of open water include Bosherston Pools in Pembrokeshire and Loch Garten in Scotland. Man-made water bodies include Chew Valley Reservoir in Somerset and Rutland Water; even relatively small flooded gravel pits can be productive so long as they are not subject to disturbance by watersports or polluted by the excesses of carp fishing. Extensive reedbeds can be found at Stodmarsh NNR in Kent, Minsmere RSPB Reserve in Suffolk and Leighton Moss RSPB Reserve in Lancashire.

Mires, Fens and Bogs

The encroachment of vegetation into areas of open water leads to the creation of habitats know as mires, which are more popularly referred to in a general context as marshes. Marshes often form on neutral soils, but where the ground is rich in bases the resultant habitat is called a fen. Conversely, acidic soils encourage the formation of bogs. The nature of the underlying soil has a profound influence on the plant species that grow there and consequently the appearance of the mire in question. Thus, for example, we find that certain plants, such as cotton-grasses, *Sphagnum* mosses, sundews and butterworts, are essentially restricted to acid soils.

Nesting birds such as Snipe, Sedge Warbler and Reed Bunting make use of these wetlands for nesting and, when insect life is at its most abundant in spring and summer, Hobbies are sometimes attracted to feed on the dragonflies that are associated with these habitats. Snipe numbers build up outside the breeding season, and, although difficult to observe, Jack Snipe and Woodcock will also be found here during the winter months.

Perhaps the most accessible fenland area is Wicken Fen in Cambridgeshire, but Hickling Broad in Norfolk is also well worth visiting for its mosaic of wetland habitats. Almost every country has examples large and small of marshland habitat, but wet bogs abound in the New Forest in Hampshire, on Dartmoor in Devon, and across large tracts of upland Wales, Scotland and central Ireland.

WOODLAND

The vast tracts of forest that once cloaked much of Britain and Ireland have long since gone, felled and cleared by man over the centuries. Fortunately for the birdwatcher, many parts of England, Wales and Scotland still harbour pockets of woodland, some of which are large enough to retain a wilderness feel and a characteristic array of forest plants and animals. Ireland fares less well in terms of woodland and consequently its tally of forest birds is less impressive.

Deciduous Woodland

Woodlands of deciduous trees are found throughout most of the region. They are (or would be if they were allowed to flourish) the dominant natural forest type in all regions except in parts of Scotland, where evergreen conifers predominate in many parts. As their name suggests, deciduous trees shed their leaves in winter and grow a new set the following spring. The seasonality seen in deciduous woodland is among the most marked and easily observed of any habitat in the region and is reflected in the seasonal occurrence and abundance in the birdlife harboured there.

Almost all woodland in the region has been, and still is, influenced in some way by man. This might take the form of simple disturbance by walkers at one end of the spectrum or

clear felling at the other. Man's influence is not always to the detriment of wildlife, however, and sympathetic coppicing of hazel and ash, for example, can encourage a profusion of wildflowers and insects, along with as diverse an array of birds as you could hope for in a northern European woodland.

The majority of our deciduous woodlands are home to thriving populations of birds, with both residents and summer visitors breeding there. Most of our migrant visitors include insects and other invertebrates in their diet, and the fact that this resource is in short supply in winter may be one reason why these species are with us only during the summer months. Many residents also include insects in their diet during the breeding season, but turn to seeds and nuts during the winter months; a few specialised birds manage to find enough invertebrates to keep them going throughout the year.

The tit family is well represented in deciduous woodland, most members of which are beloved of birdwatchers. The Chaffinch, too, is widespread and common, but its relative the Hawfinch is a much scarcer bird with a distinctly patchy distribution. Nuthatch, Treecreeper and three species of woodpecker (Great Spotted, *left*) add to the variety of our resident woodland birds, with Sparrowhawk and Tawny Owl the most typical predators across the region; Buzzards are widespread and common only in the west and north.

Spring sees the arrival of migrants such as Chiffchaff, Willow Warbler and Blackcap, whose songs boost the dawn chorus across much of the region. Redstart, Pied Flycatcher and Nightingale are also welcome arrivals, the first two showing a marked preference for western woodlands, while the latter is confined mainly to the south and southeast of England.

Outside the breeding season, numbers of several of our resident bird species are boosted by influxes of migrants from northern mainland Europe. With them come arrivals of species that are essentially winter visitors to our region, notably Brambling, Fieldfare and Redwing, although the latter two are not restricted to wooded habitats by any means.

Almost any small pocket of deciduous woodland is likely to harbour an interesting collection of birds, but among the larger, more rewarding sites are the New Forest in Hampshire and the Forest of Dean in Gloucestershire.

Coniferous Woodland

Unlike our deciduous trees, conifers are, with the exception of a few species, evergreen and keep their leaves throughout the year. Instead of having broad, often rounded leaves, they have narrow ones that are called needles. Their flowers and seeds are borne in structures known as cones, and the shape of the trees themselves is often conical in outline.

Areas of native conifer woodland are restricted to a few relict pockets of Caledonian pine forest in the Highlands of Scotland. Conifers that are seen almost everywhere else in Britain and Ireland have either been planted or have seeded themselves from mature plantations. While our native conifer forests harbour an intriguing selection of birds, some of which are unique or nearly so to this habitat, plantation conifers are usually species poor. This is a reflection of the fact that the biodiversity as a whole is extremely limited here: few plants can flourish on the deeply shaded woodland floor of a mature plantation and the trees themselves support an extremely limited invertebrate community. Poor pickings indeed for insect-eating birds.

Caledonian pine forests harbour the only bird species unique to these islands: the Scottish Crossbill. In addition, although widespread in Europe generally, the Crested Tit and Capercaillie are also restricted to this habitat in the British Isles. Clearings and widely spaced trees also encourage birds such as Tree Pipit and Redstart, making a trip to central Scotland an extremely rewarding one.

Despite their bad name, plantation forests elsewhere in the region still merit some attention from the birdwatcher. In particular, mature plantations of larch and spruces are the only locations where you stand any reasonable chance of finding Crossbills, although their numbers and precise distribution do vary markedly from year to year. In addition, a modest selection of more general woodland birds can be found

in most plantations, including the likes of Chaffinch, Coal Tit and Great Spotted Woodpecker. In recent years, the elusive Goshawk has staged something of a comeback and now nests in a few select areas.

For the best areas of Caledonian pine forest, visit the Abernethy and Rothimurchus forests, near Aviemore in Scotland. The areas comprise both tracts of native forest and mature plantations, the latter easily recognised by the uniformity in size of the trees and their regimented appearance. Mature pine plantations are widely scattered elsewhere in the region but most evident in the north and west.

HEDGEROWS AND SCRUB

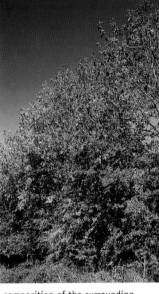

Once so much a feature of the British countryside, hedgerows have suffered a dramatic decline in recent decades, grubbed up by farmers keen to expand arable field sizes, or, more insidiously, wrecked – both in terms of appearance and in their value to wildlife – by inappropriate cutting regimes. While many landowners – certainly in the part of north Hampshire where I live – remain indifferent to the plight of this valuable wildlife resource, there does appear to be something of a resurgence of interest in hedgerows in the countryside at large: their value, both in wildlife terms, and as stock-proof barriers and windbreaks, is again appreciated by many.

The extent of scrub in the landscape has also diminished in recent times. Although difficult to define in strict habitat terms, most would understand the word to mean a loose assemblage of tangled, medium-sized shrubs and bushes interspersed with patches of spreading plants such as bramble and areas of grassland. Scrub is frequently despised by landowners – sometimes even by naturalists, too – but its value to many species formerly considered so common and widespread as not to merit conservation attention should not be underestimated.

Hedgerows usually comprise the species, and acquire the character, of any woodland edge in the vicinity. For many birds, the margins of woodlands are more important than adjacent interiors, and so a good network of hedgerows can dramatically increase the availability of this habitat in a region. Scrub, too, reflects the botanical composition of the surrounding area. However, because it is essentially a colonising habitat and not an established one, the bushes and shrubs that comprise the habitat tend to be those that are fastest growing.

Most areas of hedgerow and scrub are good for songbirds, although the exact species present depends on geographical location. The numbers of resident species such as Robin, Dunnock, Wren, Long-tailed Tit, Bullfinch and Yellowhammer are boosted by summer migrants, including Whitethroat, Lesser Whitethroat and Blackcap. All of these species find the tangled undergrowth ideal for nesting, and the foliage and flowers of the component plants are a rich source of insects and other invertebrate food.

Where insensitive cutting does not ruin mature hedgerows, autumn sees the appearance of fruits, berries and nuts. Large numbers are taken by resident thrush species, including Blackbird and Mistle Thrush, but their ripening often coincides with the first arrivals of Fieldfares and Redwings, winter visitors from mainland Europe.

GRASSLAND AND FARMLAND

A good grassy meadow, full of wildflowers and native grass species, is a delight to anyone with an eye for colour and an interest in natural history. Unfortunately, prime sites are comparatively few and far between these days, either lost to the plough or having been 'improved' by farmers for grazing, by seeding with fast-growing, often non-native grass species and by the use of selective herbicides. When this happens, the grassland loses its value to wildlife, and such intensively farmed fields are almost devoid of significant bird interest, apart from the inevitable generalists such as Jackdaw and Woodpigeon.

It should not be forgotten that, in the context of the British Isles, grassland is a man-made habitat, having arisen as a result of woodland clearance for grazing in centuries past. If a site is to be maintained as grassland, continued grazing or cutting is needed to ensure that scrub regeneration does not occur. In the past, the way in which grassland was managed had the beneficial side effect – from a naturalists' perspective – of increasing wildlife diversity. Under modern 'efficient' farming regimes the opposite is the case.

Although arable fields may fall loosely under the category of grasslands (crop species such as wheat, barley and oats are grasses, after all), their interest to the birdwatcher tends to be minimal in many areas. Formerly, populations of insects and other invertebrates would have fed hungry broods in spring and summer while weed seeds and spilt grain would have supported huge flocks of buntings and finches in autumn and winter. Nowadays, however, the use of ever more efficient insecticides and molluscides ensures that there are precious few invertebrates for birds to feed on during the summer months. Modern herbicides ensure that 'weeds' are kept to a minimum and decades of chemical use have resulted in the soil's seed bank being depleted dramatically. And arable crops themselves are harvested extremely efficiently these days, with little left to waste. As if this were not enough, autumn ploughing has resulted in winter stubble fields all but disappearing in many areas, so what little spilt grain and surface weed seeds that are present are for the most part buried out of reach of small-billed birds such as buntings and finches.

So what is left for the birds to feed on? The answer is not a lot. Little wonder then that previously common and widespread birds such as the Corn Bunting and Tree Sparrow are in catastrophic decline. A few opportunists thrive on modern farms – Woodpigeons, for example, have benefited greatly from the spread of oilseed rape as a crop. Stone-curlews still grace areas of arable prairies in southern England and East Anglia, it has to be said, often with the encouragement of the farmers on whose lands they nest. And, of course, there is the Pheasant; actively encouraged for hunting, this alien species is little short of abundant at the start of the shooting season. For most other 'farmland' birds, however, modern farming is little short of a disaster.

HEATHLAND

Home to a number of specialised birds, some of which are rare and almost unique to this habitat, heathlands are under considerable threat today and are the subject of much attention from conservation bodies. The habitat is essentially restricted to southern England, with the majority of sites concentrated in Surrey, Hampshire and Dorset. However, additional isolated examples of heathland can be found further afield, in south Devon and Suffolk, for example, and in coastal districts of Cornwall and Pembrokeshire. This fragmented distribution adds to the problems that beset the habitat: 'island' populations of plants and animals have little chance of receiving genetic input from other sites.

Heathland owes it existence to man and came about following forest clearance on acid, sandy soils. Regimes of grazing, cutting and periodic burning in the past have helped maintain the habitat, and continued management is needed to ensure an appropriate balance between scrub encroachment and the maintenance of an open habitat. Ironically, man is also the biggest threat to the habitat: uncontrolled burns cause damage that takes decades or more to repair, while the destruction of heathland for housing developments obviously means the loss of this unique habitat for good.

The habitat's name is clearly derived from the presence, and often dominance, of members of the heath family of plants, all of which flourish on acid soils. For the ultimate visual display, visit an area of heathland in July, August and September, when the plants are in full bloom. However, in order to get the best views of the habitat's birds, April and May are probably the best months. Specialities such as Dartford Warbler and Hobby can be seen then, and, although not entirely restricted to this habitat, Nightjar and Woodlark are often present in good numbers too. Resident Stonechats and Linnets

are also typical heathland species, and a visit during the winter months may provide lucky observers with sightings of Great Grey Shrike, Hen Harrier or Short-eared Owl.

UPLANDS

Together with more remote stretches of coastline, upland areas are perhaps the only parts of the British Isles to retain a sense of isolation for the visitor. Many of these areas appear wild and untamed, although in reality this is often just an illusion and few areas can be said to be truly pristine.

In centuries gone by, all but the highest peaks would have been wooded. Clearance of trees and subsequent, often excessive, grazing by sheep has ensured that the natural woodland has disappeared and cannot regenerate. In general terms, moorland is the dominant habitat in upland areas, although the characteristic plants and appearance vary considerably from region to region and are profoundly influenced by soil-type and climate. In a few areas, mountains dominate the landscape, sometimes rising to altitudes above the level at which trees would grow if they were allowed to do so; these areas harbour unique communities of plants and animals.

Surely the most evocative sound of upland areas in the British Isles is the somewhat mournful call of the Golden Plover displaying on its breeding territory. As a nesting bird, it is restricted to moorland habitats and is often found in close proximity to other breeding waders such as Dunlin, Redshank, Curlew and Snipe. Songbirds are comparatively thin on the ground in this habitat, although the Twite does breed sparingly in the north, alongside the ubiquitous Meadow Pipit. This latter species is essential to the diet of many predators, notably the Merlin. Hen Harriers occur sparingly across the region, while Short-eared Owls are more widespread nesters on grassy moors, their diet including small mammals as well as birds.

Heather moors are perfect for Red Grouse, and this species is widespread and often encouraged by those with shooting interests in many parts of northern Britain. Its cousin, the Black Grouse, also favours moorland habitat but usually occurs where grassland and small conifer plantations are sited side by side.

Keen birdwatchers make regular pilgrimages to our higher mountains in search of more specialised birds. With the exception of a few remote spots, human disturbance largely excludes shyer species from most mountains in England and Wales, although many Scottish mountain regions still have good populations of Golden Eagles and Peregrines. Ptarmigan live unobtrusive lives on the higher peaks in Scotland and even the confiding Dotterel still breeds there.

The North York Moors, Lake District and southern uplands of Scotland harbour some extensive tracts of moorland habitat, while the Cairngorm Mountains are probably the best, and most accessible, location for high-altitude specialities.

THE URBAN ENVIRONMENT

For the majority of people in the British Isles, who live in towns and cities, the urban environment is the one with which they are most familiar. It is encountered on a day-to-day basis, with trips to the countryside relegated to weekend visits or holiday excursions. It would be a mistake, however, to assume that the urban environment is without its wildlife interest. Many of our birds are extremely adaptable and have successfully colonised this seemingly unpromising 'habitat'. In part, this is because many features associated with our buildings and gardens mimic special niches in natural habitats. Mature gardens with hedgerows and shrubs, for example, recall woodland margins, while buildings resemble man-made cliffs, their roof spaces doubling as artificial caves.

Visit any mature city park, such as Hyde Park or Richmond Park in London, and you will find an array of birds more usually associated with woodland or farmland. These include Woodpigeon, Jay, Great Spotted Woodpecker, Blue Tit, Great Tit, Blackbird and Robin. A number of these also find town gardens much to their liking, although the more informal the garden the more species it is likely to attract. As a reflection of the comparatively healthy numbers of songbirds in urban and suburban districts, the Sparrowhawk population is also thriving in many towns.

A select number of birds, however, seem inextricably linked to the urban environment, in our region at least. House Sparrows, Collared Doves and Feral Pigeons, for example, are seldom found far from human

habitation and Swifts rarely nest anywhere other than in the roofs of buildings. Starlings often feed in gardens and roost during the winter months in towns, sometimes in phenomenal numbers. The winter can also herald the arrival of more unusual visitors from the Continent. Redwings and Fieldfares, for example, will move into suburban areas when driven by severe weather and depletion of natural berry supplies in the countryside. One winter visitor in particular, however, is more associated with the urban setting than any other and this is the Waxwing. This delightful and often confiding bird invariably turns up in suburban gardens and industrial estates where berries of planted Rowans and Whitebeams satisfy its hunger.

Despite its peculiar leucistic appearance, this really is an Oystercatcher.

PLUMAGE

Birds are unique in many respects, but perhaps their most visible characteristic is the layer of feathers that covers their bodies. This serves a variety of functions in the day-to-day lives of birds, and feathers on different parts of the body have evolved for a range of purposes. Those that cover the bulk of the body provide superb insulation against the cold and, to varying degrees, waterproofing too. And, of course, there are the feathers on the wing that enable flight in all its forms to take place. From the birdwatcher's point of view, feathers are there to be marvelled at but, when interpreted correctly, they can also provide a wealth of information about the bird in question. The sex of an individual can often be told at a glance and, in addition, its age and whether or not it is in breeding or non-breeding plumage can also be discerned in many cases. Such information is interesting in its own right, but more fundamentally it offers clues to birdwatchers with regards to identification. Furthermore, by distinguishing males from females, adults from juveniles and so on, we can gain a fuller understanding of the complex social lives that many birds lead.

From the bird's point of view, the colours and plumage patterns have a more fundamental importance: during the breeding season, social responses are often dictated by appearance, while at the other extreme, for birds with camouflaged plumage, the ability to blend in with the surroundings can mean the difference between life and death.

Feathers do not grow continually like mammalian hair, and once they are fully formed they are essentially dead. As a result of the wear and tear of everyday life, the feathers become abraded and over a period of time the patterns and colours fade. And it is not just a bird's appearance that can change due to wear: flight feathers can become worn and damaged to the point that the ability to fly is impaired. To combat this gradual deterioration, birds moult and replace their feathers on a regular basis.

In most cases, moulting occurs at specific times of the year and takes place over a comparatively brief space of time. For the majority of birds, the main moult occurs in late summer after the breeding season has finished; many migratory birds that breed in the region moult before they embark on their autumn journeys. Some birds, notably many passerines, have very distinct breeding and non-breeding (or summer and winter) plumages. For some, the transformation is achieved by having a second, partial moult in the spring, but with certain groups, such as buntings and finches, comparatively dowdy plumage seen in autumn and winter gives way to the bright colours of spring and early summer by abrasion of the pale tips to the feathers on many parts of the body.

The ability to fly is obviously a function that all British and Irish birds need to retain at all costs. And so the replacement of flight feathers presents a challenge that is addressed in a variety ways by different groups of birds. Wildfowl, for example, moult all their flight feathers in one go, typically in summer. Being completely flightless for a month or more makes them vulnerable, and most species therefore undertake the process in the comparatively safe havens of inaccessible marshes or the open sea. Raptors on the other hand, which spend a far greater proportion of the lives in the air, replace their flight feathers one by one, over an extended period. As a result, they retain the ability to fly, regardless of the time of year.

Black-headed Gulls have five recognisable age- and seasonal-related plumages; this one is a summer adult.

IDENTIFYING BIRDS

Some birds are so unique in appearance that, even if you have never seen one before, you will have no difficulty in identifying it correctly. In this respect, think of species like the Puffin or Kingfisher. However, what about a nondescript wader in winter plumage, or a silent *Phylloscopus* warbler, or a pipit? How should you go about making a correct identification in these cases, where plenty of alternative choices are available?

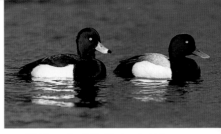

Which one is a Tufted Duck and which one a Scaup? Use this book to decide!

The fundamental point to make is that, wherever possible, you should take down contemporaneous notes about your observations; it is amazing what tricks the memory can play if you write things down later. Then you can refer to this book at your leisure. All the key information you need for a correct identification is contained within the species descriptions in the *Complete British Birds*.

First, try to gauge the size of the bird in question, bearing in mind that, at a distance, absolute size is always difficult to determine: better to try to assess the size relative to a nearby species whose identity is known with certainty. Second, look at the shape of the bird and its proportions. For example, does it have rounded or pointed wings in flight? Are its legs long and wader-like? What shape is the bill, and is the tail long or short?

If time permits, try to study and describe accurately the colours and patterns on the body of the bird. Bear in mind though that appearances can be deceptive: the angle of the light, for example, can have a profound influence on a bird's appearance and it is worth remembering that variations in plumage do occur, even in birds of the same species, age and sex. You may only get a frustratingly brief, or a partial, view of a bird and consequently it can be difficult to assess all the potential characters that might be needed for identification. However, with each group of birds, there tends to one part of the body where sufficient key identification features are present to enable distinction between similar species. It might be the pattern of stripes on the head of a bunting, for example, the presence or absence of wingbars on a warbler, or the shape and extent of white on the rump of a flying wader. If you can determine which are the key areas to concentrate on for a particular bird (assuming you see it well enough to decide, for example, that it is a finch and not a bunting), you will improve greatly your chances of making a correct identification.

Most birds found in Britain and Ireland are extremely habitat specific and consequently where you see a mystery bird can have a profound bearing on your ability to identify it. The same is true for resident species, for migrants and for displaced vagrants. Recognise the habitat and this will help you narrow down the alternatives.

Many birds are vocal enough for their calls and songs to be used accurately in identification. Learning them with any degree of confidence is a matter of experience, but with time you should be able to detect, for example, migrating flocks of Redwings flying overhead at night and to determine that Grey Plovers are present on an estuary simply by hearing their calls.

Aspects of the behaviour of many bird species can provide vital clues in the process of identification. Again, experience is the key with more subtle behavioural traits – the way in which a diving bird dives, for example – but in many cases it is much more obvious, as in the aerial sorties performed by Spotted Flycatchers or the drumming action of a Great Spotted Woodpecker.

Finally, although it is always a thrill to discover something unusual, most mystery birds turn out to be the most common and widespread candidate, given that they are within range and in the correct habitat. So when embarking on a process of identification by elimination, bear in mind that any unusual bird you come across is more likely to be a common species in a plumage, or at an angle, with which you are not familiar, rather than something more rare.

MIGRATION AND MOVEMENTS

In common with other parts of the temperate northern hemisphere, Britain and Ireland experience a climate that is extremely changeable throughout the year. Broadly speaking, we can recognise four fairly distinct seasons and these have a profound influence on almost all of our birds. The seasonal responses by birds are subtle: the diet of some species varies according to season, and hardy mountain species

⊘ Red-backed Shrike – a classic passage migrant.
⊙ Bad weather can have a devastating effect upon migrants such as these House Martins.

may be forced to descend to lower altitudes in response to bad weather. Other birds make more widespread movements – for example, birds that disperse outside the breeding season and wander nomadically in search of food within the same overall general area. Others may switch habitat altogether between the breeding and non-breeding seasons – for example, Dunlins, which nest on inland moors but spend the rest of their lives on the coast. To complicate matters further, although some of the Dunlins around our coast in winter are bound to be British breeders, by far the majority are birds that have come here from breeding grounds thousands of miles away in northern Europe and Arctic Asia. Such large-scale and directional movements are referred to as migrations.

In migration terms, the most conspicuous exponents of this survival strategy are those species that visit us during the summer months for the purposes of nesting. Many of our most familiar songbirds fall into this category, and the majority of warbler species, for example, are only with us for a few brief months in spring and early summer. As a general rule, summer migrant visitors that breed in our region head south in autumn, many wintering in sub-Saharan Africa.

Although many small birds migrate at night, and hence their migration cannot actually be witnessed, these birds have to stop off to feed during the daytime. Many concentrate along the coast – either the point of departure or the first point of arrival, depending on the direction of migration – especially if bad weather halts their progress; nocturnal migrants favour clear nights and are presumed to use the stars as navigation aids. Migration can also add a bit of spice to the life of a birdwatcher because, being influenced by the weather and hence somewhat unpredictable, you never really know what might turn up where at migration times. Consequently, during periods of easterly and southeasterly winds, migrants from Continental Europe are more likely to get blown off course and arrive on the east coast. In contrast, strong westerly airflows in early autumn are almost guaranteed to produce a scattering of records of North American waders in the west.

BIRDWATCHER'S CALENDAR

One of the great things about birdwatching in Britain and Ireland is that the species you will encounter in any given area vary considerably throughout the year. Although such seasonal changes are evident in almost all parts of the region, and in most habitats, some areas may have more to offer the visiting birdwatcher in the dead of winter, say, while the peak time in terms of variety and numbers for another location could be May or June. To help readers get the most from the region, the following pages contain location and habitat highlights to visit in the form of a birdwatcher's calendar.

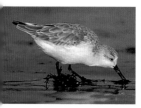

JANUARY ⊙ A foraging Sanderling
Early January, in the dead of winter, is often the best time of year to observe birds that form flocks outside the breeding season. On farmland, look for Lapwings and Golden Plovers, which sometimes mingle together, and roaming and nomadic parties of Redwings and Fieldfares. Around the coast, wildfowl numbers often peak at this time of year and, along the south coast of England in particular, Brent Geese begin to spend more time feeding on coastal grassland than on estuarine vegetation, often becoming more toler-

ant of people at the same time. If you are fond of walking the Downs or undertaking long hikes across coastal grassland, you stand a good chance of coming across a day-flying Short-eared Owl, or perhaps even a Hen Harrier or Merlin. For the privileged few, a trip to an area of lowland heath may result in the discovery of a Great Grey Shrike, while a journey into the Highlands of Scotland should yield sightings of Ptarmigan in pure white winter plumage and perhaps small parties of Snow Buntings too.

FEBRUARY ⊙ Wigeon on the north Norfolk coast

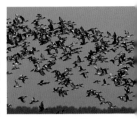

By the time February arrives, the days have begun to lengthen appreciably, although, in line with the old country saying, the cold often strengthens too. To make use of the increasing day-length, consider journeying to the north of the region. The Solway Firth, for example, will still host thousands of geese and swans, while a trip to Caithness or Orkney will yield fantastic collections of seaducks – Long-tailed Ducks, Scaup and scoters in particular – along with sightings of Great Northern Divers and, possibly, even a Little Auk or two. Further south, a visit to north Norfolk (the Wells area in particular) will result in some amazing views of White-fronted and Brent Geese and Wigeon, while the Wexford Slobs in Ireland has an equally well-deserved reputation for wildfowl. Wherever you live, monitor the weather forecasts at this time of year because severe weather elsewhere in the region, or further afield in mainland Europe, can result in some significant movements of birds. It is worth checking the coast at such times for scarce northern gulls and inland reservoirs for displaced divers and seaducks. Closer to home, Siskin numbers typically build up on garden feeders and February is also a prime month to look for Waxwings, which move into towns in search of berries once supplies in the countryside at large have been depleted.

MARCH ⊙ A singing Dunnock

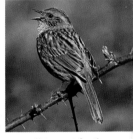

Although there is usually still a raw edge to the weather, sunny days in March can often be pleasantly warm and this is the time to look for displaying raptors. Sparrowhawks are comparatively widespread across the region, while Buzzards are more confined to western and northern districts of Britain. In the run-up to the breeding season, most other residents are beginning to display. Look for pairs of Great Crested Grebes on lakes and for the aerial displays performed by territorial Lapwings in areas of grassy open country. Hedgerows and mature gardens ring to the sound of singing Dunnocks, and other resident songsters such as Song Thrushes and Robins are also in good voice at this time of year. Great Spotted Woodpeckers can often be heard drumming – a territorial display – on woodland walks, and you can listen out for the shrill, raptor-like calls of the Lesser Spotted Woodpecker too; March is probably the best month to look for this elusive species. As a sign of things to come, the first migrant Wheatears are usually spotted on the south coast towards the end of the month.

APRIL ⊙ Summer plumage Mediterranean Gull

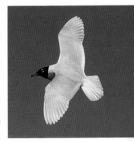

For many of our resident songbirds, the breeding season is well under way by April, and species such as Robins and Blackbirds will probably be sitting on eggs by now. On the coast, look for flocks of terns feeding offshore or displaying near nest sites. They will often be in the company of Black-headed Gulls, and a careful scrutiny of their numbers at this time of year may reveal the occasional Mediterranean Gull in full breeding plumage. April is also the month when the main arrivals occur of most of our common migrant visitors. Chiffchaffs, Willow Warblers and Blackcaps are among the first to appear, followed by the first Cuckoos and Garganey towards the middle of the April. The remaining migrant warblers, along with visitors such as Nightingales, Turtle Doves and Hobbies, appear only in numbers towards the end of the month. For the chance of seeing something a bit more exotic, you could try visiting the Scilly Isles in April; Hoopoes and Golden Orioles are regular there at this time of year, and who knows what else might turn up?

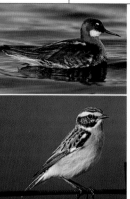

MAY © Red-necked Phalarope (*top*) and Whinchat (*below*)

The dawn chorus is often most impressive in early May. If you have used the previous month or so to become familiar with the songs of our common resident birds, now is the time to start getting to know those of our less familiar summer visitors. Distinguishing and identifying the different warblers is a particular challenge at this time of year. If there has been a good hatch of dragonflies, it can be worth visiting your local lake or flooded gravel pit, because Hobbys are often at their most conspicuous when feeding on these insects. As dusk approaches, it can also be worthwhile visiting areas of heathland and woodland for displaying Nightjars and Woodcocks, respectively. Migration has not finished by any means come May, so look out for newly arrived Honey-buzzards displaying at well-known raptor watch points. At reedbed reserves on the East Anglian coast, Bitterns can often be heard and Marsh Harriers seen. Meanwhile, Corncrakes are the highlight of a trip to the Outer Hebrides, while Red-necked Phalaropes are among the prizes offered by a visit to the Shetland Isles.

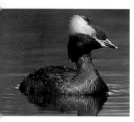

JUNE © Slavonian Grebe

In June, the breeding season is in full swing for most birds and, indeed, some species may even be contemplating embarking on a second brood. In lowland woodlands, first broods of common species such as Blue Tits and Great Tits are often fledged by now, and the fledging of juvenile Sparrowhawks is often conveniently timed to coincide with the rich pickings afforded by these inexperienced (and hence easy-to-catch) songbirds. June is a great time to visit the Highlands of Scotland in search of the region's specialities. The mountain tops are usually free of snow by this time of year and you stand a good chance of seeing Ptarmigan, with an outside possibility of encountering Golden Eagle and Dotterel. Search the region's pine forests for Crested Tits, Scottish Crossbills and Capercaillies; Ospreys fish on some of the larger Scottish lochs and Slavonian Grebes are another colourful highlight.

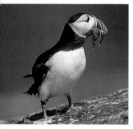

JULY © Puffin with fish

By midsummer the breeding season is drawing to a close for many birds, and you may be lucky enough to come across the occasional family group of fledged youngsters with parents in attendance. Particularly noticeable in the west of Britain will be family parties of Buzzards, which wheel and circle overhead: they announce their presence with their characteristic calls. July is a classic month to visit a seabird colony. Here, too, the young of the season may be on the point of fledging and so, with species such as terns and Puffins, you should be rewarded by the sight of adult birds returning to the nest, their bills full of fish. Accessible seabird colonies can be found on the Farne Islands in Northumberland, Blakeney Point in Norfolk and Skomer Island in Pembrokeshire. Boat trips from the Scilly Isles also yield excellent views of seabirds, but for the ultimate land-based experience try to visit the Gannet colony on the Bass Rock in the Firth of Forth. And in your local area, take a last look at any Swifts that are nesting; their brief stay in our region often ends in July, and typically by the beginning of August most adults have abandoned their breeding haunts.

AUGUST © Manx Shearwater

Traditionally, August has always been thought of as a quiet month in the birdwatcher's calendar. It is certainly true that many songbirds keep a low profile at this time – the breeding season is essentially over and many moulting birds prefer to remain unobtrusive. However, there is still plenty to see if you travel to the right habitats and visit the right parts of the region. The breeding season for many Arctic-nesting waders is amazingly brief, and by mid-August returning migrants have begun to appear on the coast in good numbers, some still retaining elements of their breeding plumage. Coastlines

are generally good places to visit at this time of year: a trickle of migrating terns can be seen in many places and, on the land, migrant Wheatears sometimes linger on areas of short grassland.

For birdwatching highlights in August, you need to travel to the far-flung extremities of the region. If you head north to the Shetland Isles, you will catch the tail end of the seabird season (as the islands are that much further north, the season is late) and there is always a possibility of seeing a few early migrant passerines: Barred Warblers are occasionally recorded in August here. At the other end of the region, pelagic trips from the Scilly Isles come into their own now, and specialities such as Cory's Shearwaters and Storm-petrels are regularly encountered. For a more unearthly experience, how about staying overnight on an island known to harbour breeding Manx Shearwaters, such as Bardsey or Skomer, both in Wales? The breeding season will still be in full swing for this species and the sound of their weird, demented calls will stay with you for the rest of your life. Closer to home, as a sign of impending migration, Swallows and House Martins often gather in large numbers on overhead wires.

SEPTEMBER ☉ Wryneck (*top*) and Spotted Crake (*below*)

For many birdwatchers, September is the highlight of the year. Although changeable, the weather is often surprisingly good and a wide selection of migrants pass through the region. Many of the returning waders and wildfowl – particularly those that winter here – turn up in good numbers irrespective of the weather. However, the appearance of most passage migrants – or more precisely, their numbers and distribution – is strongly influenced by the weather. So to be sure of getting the most from the month, the birdwatcher needs to take the prevailing weather conditions into consideration too.

Westerly gales are often a feature of the month, their effect and significance in birdwatching terms being felt most along west-facing coasts in the region. Prolonged strong winds often force migrating seabirds – southbound in autumn – to pass far closer to land than they would otherwise choose to do, and observers can get astonishingly good views of otherwise pelagic species such as Sabine's Gulls, Sooty Shearwaters and Leach's Storm-petrels. Precise wind direction often has a profound bearing on the number of birds seen and their proximity to land. Most classic sea-watching sites have an almost folkloric tradition associated with the optimum conditions that dictate a classic sea-watch day, so you will need to do your homework to discover the recommendations for any given site. Arguably the best-known locations are St Ives, Porthgwarra and Pendeen, all in Cornwall.

If the prevailing winds are coming from an easterly direction, a different set of rules apply. At such times, southbound migrants from mainland Europe tend to get blown across the North Sea and, unsurprisingly, east coasts from Kent and East Anglia to St Abb's Head and Fair Isle in Scotland get the lion's share of any arrivals.

OCTOBER ☉ Pink-footed Geese (*right*) and Snow Bunting (*below*)

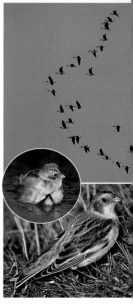

By October, there is usually a distinct chill in the air and many regions will have experienced their first frosty nights. Britain and Ireland begin to receive the first significant influxes of winter visitors, and migrant thrushes – notably Redwings and Fieldfares – make a noisy arrival to northern and eastern coasts. The majority of Pink-footed and Brent geese that winter in our region have also arrived by October and, also from the north, parties of Snow Buntings begin to appear around the coast. The majority of our wintering wildfowl and waders have arrived by now, and one of the most spectacular birdwatching sights October has to offer is that of massed Knot flocks in flight over The Wash.

October is traditionally regarded by many as the 'Scilly season', a time when vagrants of Asian, Arctic and North American origins turn up not infrequently on this group of islands. Watching rarities on the Scillies is seldom a solitary pursuit and many people find the crowd mentality of such gatherings off-put-

ting to say the least. However, do not dismiss the idea of visiting the Scillies at this time of year, even if group birdwatching is not your idea of fun. The islands are large enough, and there really are enough birds, for visitors to go birdwatching in comparative isolation if they choose to do so. Of course, there are plenty of other sites where migrants, common and scarce, turn up in October, although it has to be said that the majority are concentrated around the coast.

NOVEMBER ⊚ Wintery lakes are good for wildfowl

The main influxes of winter visitors come in November, and restless flocks of Fieldfares and Redwings turn up almost anywhere at this time of year. Generally speaking, if it is going to be a good winter for Waxwings, this will have become apparent by now – small parties will begin to turn up on the east coast, with East Anglia being a prime location. As an added bonus if you happen to live near eastern or northern coasts in the region, northerly gales at this time of year can sometimes drive groups of Little Auks surprisingly close to land. Although our weather is rather unpredictable, it is not unusual for many parts to experience a brief cold snap in November. If extreme weather is affecting mainland Europe then small numbers of Smew sometimes appear on ice-free lakes and reservoirs in our region. During freezing conditions here, wintering Water Rails are more likely to venture out into the open in their favoured wetland habitats. For a more predictable birdwatching spectacle, pay a visit to the Scottish island of Islay to see the large flocks of Barnacle Geese.

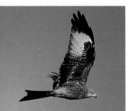

DECEMBER ⊚ Red Kite

Although December is generally a quiet month in the birdwatching year, it is not without interest. Waterbird numbers on inland lakes and reservoirs often peak at this time and wintering thrushes are extremely widespread. It is also a good month in which to look for flocks of Bramblings and Hawfinches; the former species favours mature beech woods, while the latter is typically discovered in the vicinity of mature hornbeam trees. Visit the coast and, depending on your destination, you stand a chance of discovering a wintering Black Redstart on a beach, or perhaps a Shorelark on a saltmarsh in the east. It is also worth scrutinising flocks of Black-headed Gulls, because among their numbers you may be lucky enough to discover a Mediterranean Gull. In seas around Ireland and Scotland, and off the west coasts of England and Wales, the highlight of a Christmas birdwatch will be the discovery of a Great Northern Diver riding the waves. By contrast, if you live in central and southern Britain, a trip to a Red Kite stronghold should not be missed; feeding stations in central Wales sometimes attract dozens of birds in mid-winter.

CONSERVATION

Although *Complete British Birds* is primarily a field guide, some of the problems faced by the region's birds in particular, and its wildlife in general, must be addressed if the book is to live up to the implications of its title. The British Isles still harbour a wealth of natural history and retain large tracts of land full of wildlife interest. But apart from a small number of determined optimists, few people would deny that many of our species and habitats are under serious threat. The region may still look green and pleasant to the eye, but scratch the surface and, in many cases, the reality is depressingly different.

As elsewhere in the world, at the root of the problems faced by our environment is the scale of the human population, its quest for economic improvement in its many guises and recent technological advances that have made many of these aspirations more achievable. The problems manifest themselves in issues such as pollution, the swallowing of land for housing, industrial and road projects, and, last but certainly not least, modern farming and fishery practices. Whatever the causes, the result has been fragmentation and degradation of wildlife-rich habitats, an overall decline in biodiversity and local extinctions of certain species.

Taken as a group, birds are generally the most conspicuous of our larger animals, and many are located high in the food chain. As a result, the plight of many species is indicative of the problems that

beset the habitats in which they live; as such, they can be seen as conservation indicators. However, it is a mistake to view birds in isolation and outside the context of the environment as a whole. Consequently, even though your own fundamental interest in wildlife may be ornithological, as a responsible birdwatcher you should concern yourself with environmental matters generally.

WHO IS TO BLAME?

Ultimately, of course, as voters and consumers in society, we all share some of the responsibility. But this does not alter the fact that the causal agents of environmental damage often act outside the sphere of influence of the individual, and certainly not on their behalf.

Because of its economic power, one of the most immediate threats to our wildlife comes from commerce. A few businesses do genuinely have an interest in nature conservation, but it is probably fair to say that, for most, environmental issues are very much secondary to their primary economic goals. Although the ways in which commercial interests affect our wildlife and habitats are sometimes blindingly obvious – think of oil spills – the effects are not always immediately apparent. Take forestry, for example. In principle it sounds like a good idea, and indeed in many circumstances planting trees is a beneficial thing. But consider the consequences of the large-scale

We all want to use petrol, but should we accept oil spills as an inevitable consequence?

commercial afforestation, and the accompanying drainage, that has blighted the Flow Country of Caithness and Sutherland. Were it not for the actions of conservation organisations such as the RSPB, the ruination of the UK's last great wetland wilderness – breeding haunt of Red-throated Divers and vast numbers of waders and ducks – would undoubtedly be continuing apace today.

And then there is farming. Without doubt, the greatest impact on our terrestrial wildlife – birds in particular – in the last 50 years has come as a result of changes in agricultural land use and the modernisation of farming practices. In this respect, it is perhaps useful to make the distinction between *farmers* and *farming*: although the individuals concerned may regard it as a way of life, taken as whole, the scale of farming today – and its impact on the environment – is truly industrial.

Since the arrival of man in the region, agriculture has always been an agent of change in the landscape and has helped shape it. In part, it is as a consequence of the resulting mosaic of man-influenced habitats that our region has such potential for biodiversity. Until as recently as the 1930s, say, the way in which the land was farmed, and the slow pace of change, ensured that even land in production accommodated a surprising diversity of wildlife. Furthermore, farming practices generally did not impinge to the same degree as they do now on land not directly in production.

Today, however, this is no longer the case where farms adopt modern practices of 'efficient' farming methods, including the profligate use of chemicals. The specific environmental problems associated with modern farming are well documented and are discussed earlier under the heading 'Grassland and Farmland' (*see* page 13). While it is a mistake to view farming *per se* as bad, many modern agricultural practices, while good for the farm budget, are frequently a disaster for wildlife biodiversity and abundance.

Thankfully, there are still parts of Britain and Ireland where the pace of agricultural change has been slow. In many northern and upland districts, for example, traditional hay meadows are still a feature of the landscape and, even where the land is farmed more intensively, there are margins where wildlife can co-exist. Even in lowland southern England there are a few farmers for whom encouraging wildlife matters as much as farming the land. Sadly, however, landowners who are at best indifferent or at worst gleefully antagonistic towards conservation appear to predominate; any interest in wildlife in the broadest sense is seemingly restricted to species that can be exploited, or which are perceived to impinge on profit margins.

What can be done about farming in the British Isles today, given that we all want to eat and food has to come from somewhere? Surely farmland does not necessarily have to be a wildlife desert and there is scope for farming and conservation to work side by side? After all, in many ways the two do have broad similarities: both often use rather similar approaches – the selective cutting and clearing of vegetation, for example, and removal or destruction of certain animals. However, the distinction, and the fundamental incompatibility, between the two lies in their respective goals with regards to the area of

Where are the margins for wildlife in this area of farmland?

land being managed. In a broad sense, the aim of much modern farming is to *minimise* biodiversity – single-species crops are grown to the exclusion of other plants, for example – whereas the intention of conservation management is to *maximise* biodiversity.

Much stricter, environmentally targeted farming regulations would certainly benefit wildlife, as would a system of rewarding environmentally friendly farmers while penalising those who fail to meet targets. That is easy to say, but much harder to put into practice. How, for example, do you set the targets and how would success be monitored, bearing in mind that managing farmland with conservation in mind is not simply a matter of leaving hedgerows intact? Worthwhile management requires a comprehensive knowledge of all the plants and animals present on the land in question; that is why conservation organisations place so much emphasis on conducting thorough surveys. Otherwise, how could an assessment be made of which plants and animals were vulnerable, and hence the best way to manage the land with conservation in mind? No farmer could be expected to recognise every single plant and animal species on his or her land, so advice on such matters could come only from independent experts. Such changes would come at a cost: for consumers, it could only mean higher food prices. Will any of this ever happen? Probably not, because as the system stands it is not in the interests of the agricultural and agri-chemical sectors to change, and their combined lobbying voices are so influential. Besides, a significant proportion of the population will probably always place more importance on the price of food, rather than on its quality or the way in which it is produced.

Problems affecting our environment are not restricted to the land. The chronic low-level pollution and

No matter what the environmental cost, sooner or later even the most controversial of road improvement schemes seems to get the green light

catastrophic oil spills that blight our seas, not to mention the industrial-scale exploitation of offshore fish stocks, are no less disastrous just because we cannot observe the effects with our own eyes. In the marine environment, birds more than any other group act as visible indicators of the predicament beneath the waves. Unsurprisingly, for almost every species the story is one of decline, and facts and figures abound to substantiate the trends. But in an interesting twist to the tale, numbers of Fulmars and Gannets have actually risen while commercial exploitation of the sea has increased. In a curious parallel to the rise of Woodpigeon on land (this species has benefited from the modern trend of growing oilseed rape), these seabirds are thought to have profited from the so-called by-catch associated with industrial fishing: they will eat dead and injured fish that escape from the nets, as well as discarded fish that are thrown back. But with fish stocks declining everywhere, they too will surely suffer in the end. As a sad indictment of the times, the saying 'there's plenty more fish in the sea' is now best used in an ironic context.

Can we rely on government to safeguard the environment? Whatever party is in power, economic matters, be they housing, farming, fishing or industry related, ultimately always seem to be given priority over environmental issues, and it is probably naive to expect otherwise. If you are in any doubt, just think of the number of times in recent years when roads and railway lines have been allowed to destroy Sites of Special Scientific Interest. Generally speaking, our legislation reflects the priorities of government and society as a whole, and, despite their good intentions, statutory conservation bodies are always going to be constrained by the law.

WHAT IS CONSERVATION?

Broadly speaking, the fundamental aim of conservation is to preserve, or in some cases to restore, the maximum naturally occurring biodiversity that any given area can support in terms of native species. However, conservation measures have to be tailored to suit a particular habitat or landscape and cannot be made without an appreciation of ecology. It is, thus, worth considering an important ecological principle.

In nature, any given area of virgin land will be colonised by a progression of increasingly stable plant communities. For example, with time, the upper reaches of a sandy beach will become stabilised by Marram Grass, then colonised by dune specialists, leading eventually to the formation of woodland. Ecologists refer to this process as habitat succession, the final stage in the process being a climax community. So, in the context of a pristine Brazilian rainforest, say, where the intention would be to conserve the existing climax vegetation, it might be sufficient to leave the land and the forest untouched. However, in the context of Britain and Ireland, many of the habitats we value so highly in wildlife terms are intermediates in the chain of succession; unless land management is carried out they lose their character, and

with it often the key species for which they are important. In addition, active measures sometimes have to be taken to redress the consequences of man's previous actions. So, for example, attempts are often made to exterminate rats, and occasionally feral cats, from seabird colonies where they have been introduced. In Britain and Ireland, conservation seldom means setting the land aside and doing nothing.

WHAT CAN YOU DO FOR CONSERVATION?

Unless you happen to be a large landowner, then the answer is probably not a great deal on your own. Real influence can only be exerted by becoming a member of a group that is able to speak with a louder voice. So, join organisations that are devoted to the study and promotion of conservation issues. In the context of birds, the BTO and RSPB are the main candidates, but in the wider arena Greenpeace and the Worldwide Fund for Nature are active campaigners.

Probably the most effective step that can be taken to safeguard the terrestrial environment is to remove as much land as possible from the threat of development or intensive agriculture by ownership. Buying land on a piecemeal basis and establishing small nature reserves is one way, but a far more effective option is to donate money to the likes of the RSPB or one of the county wildlife trusts, specifically for the purchase of land. But the job does not stop there. Nature reserves invariably need managing and, again, this is where you can help: join the ranks of conservation volunteers in helping the likes of your local county wildlife trust.

There *are* positive steps that individuals can take to improve things on a smaller scale and to minimise their own impact on the environment. For example, wherever possible you can buy organically grown food, ideally obtaining as much as you can from local sources where you can see what is going on at the farm in question. Away from the food front, you can oppose all large-scale developments in the countryside on principle, be they road developments or proposed housing schemes; once land has been built upon it is lost for ever and can never be replaced. Closer to home, and with birds in mind, the provision of nest boxes, nest sites and feeding stations in the garden can make a useful contribution. It is probably no exaggeration to say that hundreds of thousands of households feed birds on a regular basis and this can only be a positive thing. However, arguably the single most significant thing anyone can do for birds in the context of the garden is to discourage domestic cats.

It has to be said that certain elements of the conservation movement do not serve the cause well. At the extremes, we find ill-informed opinion and cynical misinformation being portrayed as fact, and many issues that are beset by sentimentality. An excellent illustration of this is the misunderstandings surrounding Sparrowhawks with regards to songbird numbers. It is unproductive to try and correct the reasoning of anyone unable or unwilling to grasp the basics of ecology. Those that can, appreciate that where the balance has not been altered by man, predators are an essential element in the natural order of things, part of the system of checks and balances in nature that drives evolution and helps maintain healthy populations. Selective resentment of one predator on purely subjective grounds, and without scientific basis, is dangerous and ridiculous. Taking the argument to its logical extreme, objecting to Sparrowhawks because they kill songbirds could lead, for example, to moth enthusiasts calling for the extermination of bats and fish enthusiasts calling for grebes and Kingfishers to be wiped out. If all this sounds far-fetched, bear in mind that some fishermen are calling for the local extermination of Cormorants because they assert that the birds are catching 'their' fish, and pigeon-fanciers regularly call for Peregrines to be shot.

So, it is important to put things in an ecological perspective before any emotional conclusions are formed. Ponder the subject of life and death, and bear in mind that, apart from a few strict vegetarian species and specialist scavengers, all birds kill and eat other animals – some seasonally, some year round – in order to survive. Furthermore, in nature, birds like other animals are highly unlikely to die peacefully in their sleep, as some people might like to believe. Death comes in many forms: disease, injury, starvation and cold to name but four. By comparison with these causes of death, the swift dispatch of a weak or injured individual at the talons or bill of a predator seems like a wholesome alternative.

Despite the legitimate concerns about conservation in Britain and Ireland, and the well-being of the region's birdlife, all is not doom and gloom. An increasing number of people appreciate the need for active conservation measures and a small army of motivated and informed naturalists and conservationists has evolved in recent decades. An excellent network of nature reserves exists and birdwatching has never been more popular; this is reflected in membership numbers of organisations such as the RSPB that fight the corner for bird conservation. Long may all of these interested parties continue in their good work and help to preserve the rich birdlife still present in our wonderfully diverse islands.

RED-THROATED DIVER *Gavia stellata* LENGTH 55–65cm

An elegant water bird. Swims low in the water, holding its head and dagger-like bill tilted upwards. Dives frequently. In flight, the head and neck are held outstretched while the feet and legs trail behind. The sexes are similar. **SUMMER ADULT** has blue-grey on the face and sides of the neck. Note also the red throat (looks dark at certain angles) and black and white lines on the back of the neck,

!CONFUSION SPECIES!

and, lower down, on the sides of the neck, too. The upperparts are otherwise brownish-grey, while the underparts are whitish. **WINTER ADULT** has grey upperparts, delicately spangled with small white spots. The underparts, including the sides to the neck and face, are white. **JUVENILE** is similar to the winter adult but the

In WINTER PLUMAGE may be confused with GREAT CRESTED GREBE *Page 28*

upperparts are browner and the underparts appear grubby white. **VOICE** – utters a goose-like *kaa-kaa-kaa* in flight. Silent in winter. HABITAT AND STATUS Nests beside small pools but usually feeds at sea. Outside the breeding season, it is found in shallow coastal seas; individuals occasionally turn up inland on reservoirs etc. A scarce breeding species: around 1,000 pairs probably nest in the region each year. More widespread, and locally common, in winter due to an influx of birds from northern Europe. At this time as many as 10,000 birds may be present; it is most numerous on the east coasts of England and Scotland. OBSERVATION TIPS It occurs in the breeding season on Shetland and Orkney; to avoid disturbance, watch birds from a car. In winter, scan sheltered coastal seas.

BLACK-THROATED DIVER *Gavia arctica* LENGTH 60–70cm

A robust water bird that swims buoyantly, typically holding its bill horizontally. Dives frequently. In flight, the head and neck are held outstretched while the feet and legs trail behind. The sexes are similar. **SUMMER ADULT** is stunning, with a blue-grey nape and head and black throat; the sides of the neck are adorned with black and white lines. The blackish back is marked with a chequerboard of white spots while the underparts are white. **WINTER ADULT** has mainly grey-black upperparts and whitish underparts; a striking white patch is often visible on the flanks at water level in swimming birds. **JUVENILE** is similar to the winter adult but the upperparts are browner while the underparts appear slightly grubby. **VOICE** – on breeding territory, utters croaking and wailing calls. Silent in winter. HABITAT AND STATUS A rare and protected breeding species that nests beside large lochs, where it feeds; perhaps 100 or more pairs breed each year. More widespread in winter thanks to an influx of birds from Scandinavia, when around 1,000 birds are probably present. Outside the breeding season, it is mainly coastal although stray individuals occasionally occur inland on reservoirs etc. OBSERVATION TIPS To avoid disturbance, restrict observations during the breeding season to lochside roads. In winter, it is most commonly seen off Scottish coasts and off the east and south coasts of England. Scan calm seas for swimming birds; during onshore gales look for displaced birds in flight.

GREAT NORTHERN DIVER *Gavia immer* LENGTH 75–85cm

A large and robust water bird. Swims buoyantly, with its massive bill held horizontally or very slightly elevated. In flight, the head and neck are held outstretched while the feet and legs trail behind. The sexes are similar. **SUMMER ADULT** has a black neck (a sheen is visible in good light) marked with two rows of white stripes. The upperparts are blackish, with a chequerboard of white spots on the mantle and smaller white spots elsewhere. The underparts are gleaming white. The bill is dark. **WINTER ADULT** has dark grey upperparts and whitish underparts, including the throat and front of the neck; note the dark half-collar on the neck. The bill is greyish with a dark culmen. **JUVENILE** is similar to the winter adult but the upperparts are brownish-grey while the underparts are grubby white. **VOICE** – the wailing, evocative 'song' is seldom heard in Britain. Silent in winter. HABITAT AND STATUS Essentially a non-breeding visitor to Britain, with perhaps a few thousand birds being present. It favours coastal seas, often off rocky headlands; tolerates rough conditions. Widespread off the coasts of Scotland, Ireland and southwest England. Occasionally lingers in northern waters into summer, creating the suspicion of nesting. OBSERVATION TIPS Easiest to observe off rocky shores around Scottish and Irish coasts, November–March. Dives frequently, making prolonged observation difficult.

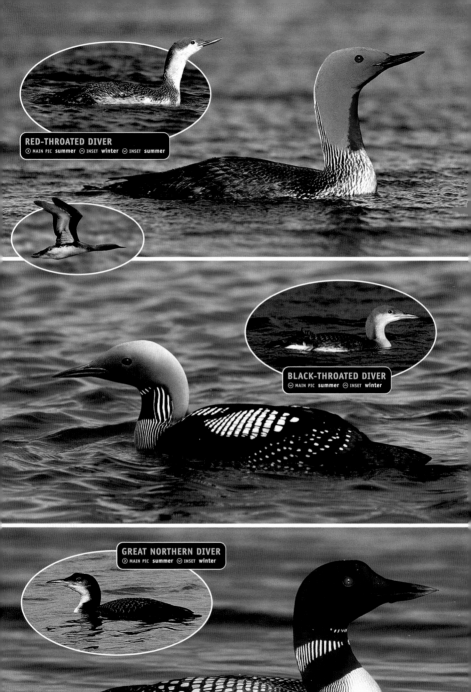

RED-THROATED DIVER
⊙ MAIN PIC summer ⊙ INSET winter ⊙ INSET summer

BLACK-THROATED DIVER
⊙ MAIN PIC summer ⊙ INSET winter

GREAT NORTHERN DIVER
⊙ MAIN PIC summer ⊙ INSET winter

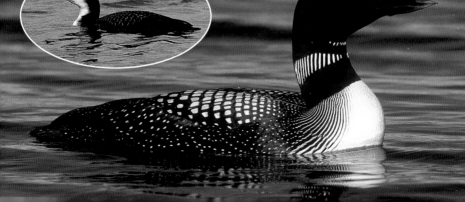

GREAT CRESTED GREBE *Podiceps cristatus* LENGTH 46–51cm

An elegant and graceful water bird with a slender neck and dagger-like bill. Flies with head and neck outstretched and legs trailing; note the striking white panels on the wings. Swims buoyantly and dives frequently, and for extended periods, in search of fish. Builds a floating nest of compacted water plants among emergent vegetation on bodies of fresh water. In early spring, pairs perform

!CONFUSION SPECIES!

WINTER PLUMAGE RED-THROATED DIVER
Page 26

JUVENILE COOT
Page 102

elaborate ritual displays. The sexes are similar, but summer and winter plumages are noticeably different. **SUMMER ADULT** has grey-brown upperparts, including the nape. The underparts, including the front of the neck, are whitish, flushed buffish-orange on the flanks. The head is adorned with a black cap and crest, with a striking orange-buff ruff bordering the paler cheeks. The bill is pink and the eye is red. **WINTER ADULT** has rather drab grey-brown and white plumage by comparison; it loses the colourful ruff but retains the dark cap and a suggestion of a crest. The bill is dull pink. **JUVENILE** recalls the adult in winter but has striking dark stripes on the cheeks. **VOICE** – vocal during the breeding season, when it utters a range of wailing and croaking calls. HABITAT AND STATUS A widespread and locally common breeding species in England, Wales and Ireland with a population of several thousand pairs; less numerous in southern Scotland and scarce or absent further north. Favours large, fish-rich lakes, reservoirs and flooded gravel pits. In winter, birds from mainland Europe boost numbers here (up to 10,000 birds may be present), especially in harsh weather; also occurs on inshore coasts at this time of year. OBSERVATION TIPS Easiest to see during the breeding season, when pairs are conspicuous and active. Sometimes nests in surprisingly urban areas (including park lakes in central London), where they are often indifferent to human observers.

RED-NECKED GREBE *Podiceps grisegena* LENGTH 40–45cm

An elegant water bird that recalls a Great Crested Grebe, but that is smaller and more stocky in appearance. Swims buoyantly but low in the water and dives frequently for fish. The diagnostic yellow-based bill can be seen at all times. Flies with the head and neck outstretched and legs trailing; note the white panels on the wings. The sexes are similar, but summer and winter plumages

!CONFUSION SPECIES!

WINTER PLUMAGE RED-THROATED DIVER
Page 26

JUVENILE COOT
Page 102

are noticeably different. **SUMMER ADULT** has greyish-brown upperparts, including the nape. The underparts are whitish, with grey streaking on the flanks. The most striking feature is the brick-red neck and upper breast. The head is adorned with white-bordered pale grey cheeks and crowned with a black cap that has a hint of a crest. **WINTER ADULT** loses the neck colours but often retains a hint of a reddish collar. The cheek pattern is less well defined and the ear coverts are grubby-looking. **JUVENILE** recalls the winter adult but shows more extensive red on the neck; note the striking dark stripes on the cheeks. HABITAT AND STATUS Best known as a scarce winter visitor, with perhaps 100 or so birds present between October and March. At this time, it typically favours sheltered inshore seas and the mouths of estuaries. However, it occasionally turns up on inland lakes and reservoirs, especially during cold spells. A few pairs sometimes linger on large, well-vegetated lakes during the summer months, especially in northern Britain, giving rise to speculation about possible breeding. OBSERVATION TIPS Easiest to observe on calm winter days by scanning likely coastal seas, particularly on the southern and eastern coasts of Britain. The length of time spent diving means that prolonged observation of the species is often difficult. Birds that turn up on inland lakes often stay for a week or so if the feeding is good, thus increasing the prospect of getting good views.

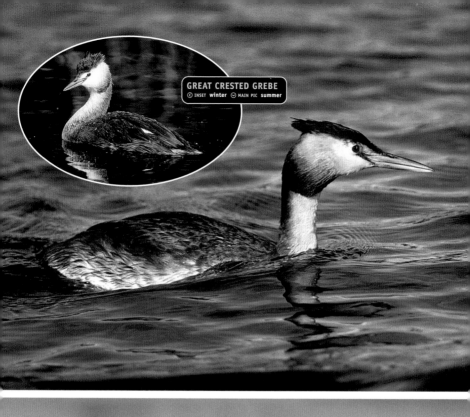

GREAT CRESTED GREBE
◁ INSET winter ◁ MAIN PIC summer

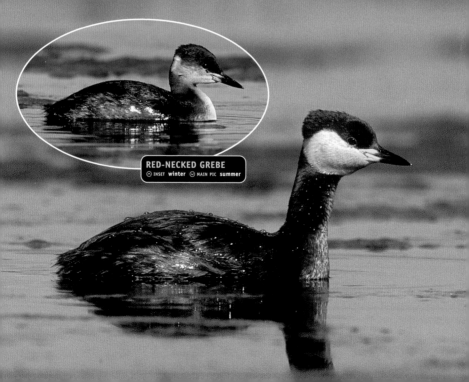

RED-NECKED GREBE
◁ INSET winter ◁ MAIN PIC summer

LITTLE GREBE *Tachybaptus ruficollis* LENGTH 25–29cm

This small, dumpy and buoyant bird is Britain's smallest grebe. Note the whitish powderpuff of feathers at the rear end. Dives frequently for fish and aquatic invertebrates. In flight (seldom seen), the head and neck are held extended with legs trailing; wings are rounded and uniform grey-brown. The sexes are similar, although summer and winter plumages differ. **SUMMER ADULT** has mainly brownish plumage, but the neck and cheeks are a striking chestnut. Note also the white-tipped dark bill that sports a lime-green spot at the base. **WINTER ADULT** has mainly brown upperparts and buffish underparts. **JUVENILE** recalls the winter adult, but note the pale throat and black stripes on face. **VOICE** – utters a characteristic whinnying call. HABITAT AND STATUS A widespread and fairly common resident of freshwater habitats, from ponds to lakes and slow-flowing rivers; several thousand pairs occur in the region. Some dispersal takes place in winter, when the species turns up on sheltered coasts and estuaries. OBSERVATION TIPS Its presence is easiest to detect by listening for its distinctive call; patient observation of marginal vegetation then usually yields sightings. However, birds spend comparatively little time at the surface between dives.

!CONFUSION SPECIES!

JUVENILE COOT
Page 102

BLACK-NECKED GREBE *Podiceps nigricollis* LENGTH 28–34cm

A small and distinctive water bird. Swims buoyantly and dives frequently. Recognised at all times by its uptilted bill and steep forehead. Note also the beady red eye. In flight, note the white patch on the trailing edge of the wing. The sexes are similar, but summer and winter plumages are distinctly different. **SUMMER ADULT** has blackish head, neck and back, the face adorned with golden-yellow tufts. The flanks are chestnut. **WINTER ADULT** has mainly blackish upperparts and white underparts. At this time, it is distinguished from the similar Slavonian Grebe by head shape and by the greater extent of black on its cheeks. **JUVENILE** is similar to winter adult but with white elements of the plumage buffish instead. **VOICE** – calls include various whistles and squeaks; silent in winter. HABITAT AND STATUS Known mainly as a scarce winter visitor to sheltered coasts, with perhaps 100 or so records each year; occasionally turns up on inland freshwater lakes and reservoirs. A handful of pairs remain to breed in the region, favouring shallow, well-vegetated lakes. OBSERVATION TIPS Easiest to observe in winter on calm days along sheltered coasts, bays and estuaries. Birds are often faithful to the same general area during their stay. Some birds linger long enough to acquire breeding plumage.

!CONFUSION SPECIES!

JUVENILE COOT
Page 102

SLAVONIAN GREBE *Podiceps auritus* LENGTH 31–38cm

An elegant water bird that swims buoyantly and dives frequently in search of small fish and aquatic invertebrates. Note the beady red eye, seen at all times. Its flattish crown and bill shape (both mandibles are curved) allow separation from the similar Black-necked Grebe at all times; note also the white tip to the bill. In flight, wings show white patches on both leading and trailing edges. The sexes are similar, but summer and winter plumages are distinctly different. **SUMMER ADULT** has reddish-orange neck and flanks. The back is black and the black head is adorned with golden-yellow plumes. **WINTER ADULT** has mainly black upperparts and white underparts. Note the clear demarcation between the black cap and white cheeks. **JUVENILE** is similar to winter adult. **VOICE** – territorial calls include various rattling trills and squeals. HABITAT AND STATUS Most numerous in the region in winter, when several hundred birds can be found in sheltered coastal waters. Fifty or so pairs breed in Scotland each year, favouring shallow lochs with abundant sedges. OBSERVATION TIPS In winter, search for the species on calm days along sheltered stretches of coast. Observation in summer is more problematic, since this protected species should never be disturbed when nesting – try visiting one of the RSPB's Scottish reserves where the species breeds.

!CONFUSION SPECIES!

JUVENILE COOT
Page 102

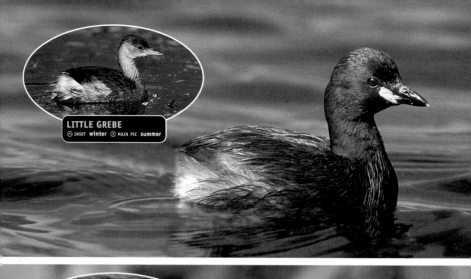

LITTLE GREBE
◈ INSET **winter** ❱ MAIN PIC **summer**

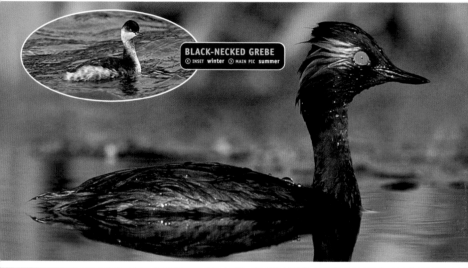

BLACK-NECKED GREBE
◈ INSET **winter** ❱ MAIN PIC **summer**

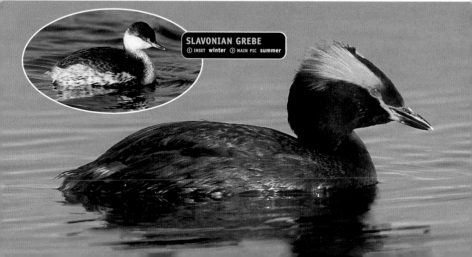

SLAVONIAN GREBE
◈ INSET **winter** ❱ MAIN PIC **summer**

STORM-PETREL *Hydrobates pelagicus* LENGTH 14–16cm

Britain's smallest seabird; looks improbably tiny when dwarfed by waves in a rough sea. Its dark plumage and white rump give it a passing resemblance to a House Martin, which is occasionally seen migrating over sea. Storm-petrels are, however, seemingly unaffected by even gale-force winds and have a strong, direct flight. When feeding, a Storm-petrel flutters low over the water with dangling feet. The sexes are similar throughout the year. **ADULT** appears all dark at a distance except for the white rump. At

!CONFUSION SPECIES!

HOUSE MARTIN IN FLIGHT
Page 174

close range (for example, in the hand) the plumage is seen to be dark sooty-brown. In flight, note the square-ended tail and the white bar on the underwing. **JUVENILE** is similar to the adult but in its first autumn it typically shows a pale wingbar on the upperwing. **VOICE** – silent at sea, but at breeding colonies utters strange gurgling and purring calls from nesting burrows. **HABITAT AND STATUS** A true seabird that seldom comes close to land except during the breeding season, and then only at night. Colonies are found on remote, offshore islands, typically where mammalian ground predators are absent. Nests in burrows, rock crevices and cavities on old stone walls. Upward of 100,000 pairs probably breed in the region, but you could be forgiven for doubting this if the effort needed to see the species is anything to go by. OBSERVATION TIPS From April to August, Storm-petrels can be seen from ferries, particularly those that cross the Irish Sea and from mainland Scotland to Shetland and the Outer Hebrides. Observers not familiar with the species often fail to appreciate just how tiny it appears at sea until their first sighting. During the summer months, pelagic trips (particularly from the Scilly Isles) typically attract the species with fish offal. In August and September, northwesterly gales often force migrating Storm-petrels to pass close to headlands on west-facing coasts in the region, so monitor weather forecasts at this time of year. If you want to get really close-up views of the species you have two options: either stay overnight on one of the known accessible breeding islands and search for birds with a torch, or tag along with a coastal ringing group (Storm-petrels are routinely mist-netted, having been lured by taped recordings of their calls).

LEACH'S STORM-PETREL

Oceanodroma leucorhoa LENGTH 18–20cm

Although it is still tiny by seabird standards, this cousin of the Storm-petrel is a more robust-looking bird with appreciably longer wings. Its flight pattern is also distinctly different from Storm-petrel's: rather than being direct and fluttering (almost bat-like), that of Leach's appears ever-changing in terms of direction, with powerful wingbeats and glides. The sexes are similar throughout the year. **ADULT** plumage is sooty-grey but often looks all dark at a distance, except for the pale panel on the upperwing coverts. The fact that the tail is forked is not always easy to discern, and the pale grey line that divides the rump is seen only at extremely close range. Unlike Storm-petrel, the underwings are all-dark. **JUVENILE** is similar to the adult. **VOICE** – silent at sea, but at breeding colonies birds utter a bizarre-sounding gurgling rattle; this has been likened to an insane-sounding pixie chuckling and being sick! HABITAT AND STATUS A truly oceanic species that seldom comes close to land except during the breeding season, and then only at night. Many tens of thousands of pairs nest in the region but all are found on remote and inaccessible islands. OBSERVATION TIPS This is one of the trickiest British species to observe, let alone see well. A visit to a breeding colony is out of the question for most people: probably the least inaccessible are on St Kilda and North Rona, and a visit to other sites would require a full-blown expedition. The species is seldom seen from ferries and typically does not follow boats. The best chances of observation come in September and October, when severe onshore gales sometimes force birds close to the shore; Cornwall, north Wales, Cheshire and the west coast of Ireland offer the best chances. In particularly bad weather, storm-driven birds occasionally turn up on inland reservoirs.

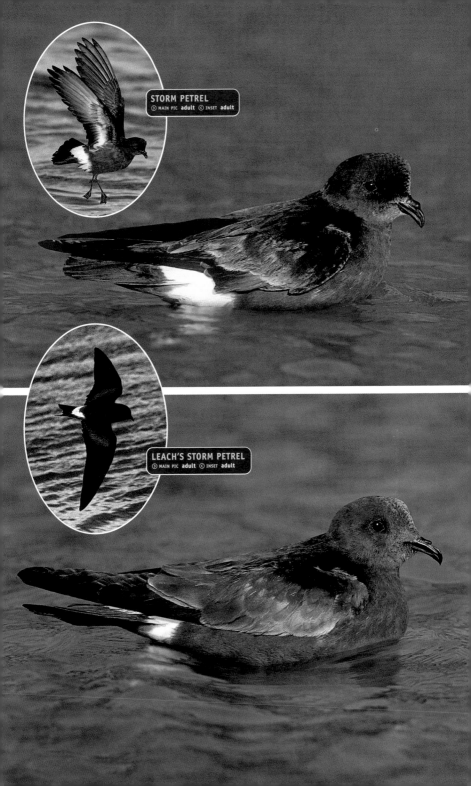

STORM PETREL
⊙ MAIN PIC **adult** ◐ INSET **adult**

LEACH'S STORM PETREL
⊙ MAIN PIC **adult** ◐ INSET **adult**

MANX SHEARWATER *Puffinus puffinus* WINGSPAN 75–85cm

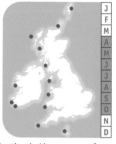

The commonest shearwater in the region. Flies low over the water on stiffly held wings. Contrasting dark upperparts and mainly white underparts are revealed as it banks and glides. The sexes are similar. **ADULT** has blackish upperparts and mainly white underparts, although the wing margins are dark. **JUVENILE** is similar to adult. **VOICE** – silent at sea, but at breeding colonies weird, strangled coughing calls are uttered after dark by nesting birds. HABITAT AND STATUS A summer visitor to the region, present May–September. Spends most of its life at sea and only visits land to breed, and then only after dark. Nests in burrows on offshore islands. Several hundred thousand pairs breed in the region. OBSERVATION TIPS Seen off headlands on the west coasts of England and Wales, around most of Ireland and west and north Scotland. Also seen on ferry crossings. For close-up views, stay overnight on an island known to harbour nesting birds, such as Bardsey Island or Skomer.

MEDITERRANEAN SHEARWATER *Puffinus yelkouan* WINGSPAN 80–90cm

Similar to Manx Shearwater (formerly treated as a subspecies) but separable with care. Flies on stiffly held wings, banking and gliding low over the water. The sexes are similar. **ADULT** has brown upperparts and grubby white underparts; undertail coverts are brown (white in Manx) and the underwings show a comparatively limited amount of white. The feet project slightly beyond the tail. **JUVENILE** is similar to adult. **VOICE** – silent in the region. HABITAT AND STATUS A scarce visitor, typically observed in late summer and autumn. Only seen at sea. OBSERVATION TIPS The southwest approaches are the hotspot for this species, and most sightings come from well-known sea-watching locations from Dorset to Cornwall, and in southern Ireland and west Wales. Ferry crossings to the Scilly Isles can also be productive.

CORY'S SHEARWATER *Calonectris diomedea* WINGSPAN 105–125cm

A large and impressive seabird. Its flight is effortless, and it banks and glides on wings that are either held stiffly or bowed. Only ever seen at sea, and views are typically distant. The sexes are similar. **ADULT** has mainly buffish-brown upperparts with darker wingtips and a dark tip to the tail (sometimes shows a limited amount of white at the base of the tail). Underparts are white, the wings having dark margins. The dark-tipped yellow bill pattern is only discernible at close range. **JUVENILE** is similar to the adult. **VOICE** – silent in the region. HABITAT AND STATUS A scarce summer visitor from its Mediterranean breeding grounds. Numbers vary from year to year. At the right time and place, double figures are seen in a day, although the most sea-watches yield no sightings. OBSERVATION TIPS Ferry crossings between Cornwall and the Scilly Isles in late August and September are usually good, as are pelagic trips. Occasionally seen off headlands in Cornwall, the Scilly Isles, west Wales and southern Ireland; elsewhere, sightings are a hit-and-miss affair.

GREAT SHEARWATER *Puffinus gravis* WINGSPAN 105–120cm

Similar to Cory's but separated using plumage details, and because generally it flies on stiffer wings. The sexes are similar. **ADULT** has brown upperwing coverts and mantle, contrasting with darker wingtips. Note the dark tail and contrasting white uppertail coverts. Also sports a dark cap that is separated from the mantle by a white collar. The underparts are mainly white with dark markings. **JUVENILE** is similar to the adult. **VOICE** – silent in the region. HABITAT AND STATUS A summer visitor, passing through the region on its circum-Atlantic non-breeding wanderings; nests in the south Atlantic in our winter. Numbers vary from year to year, but in good seasons an observer in the right place might notch up double figures. OBSERVATION TIPS For the best chances of seeing the species, take a pelagic trip from Cornwall or the Scilly Isles in August or early September.

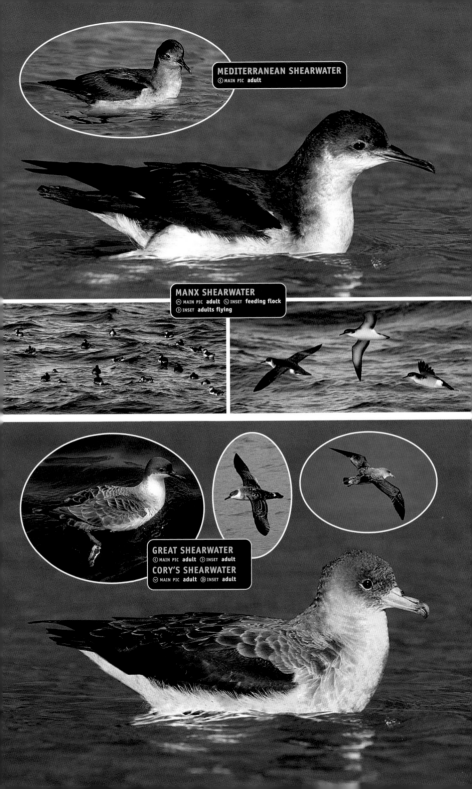

MEDITERRANEAN SHEARWATER
◎ MAIN PIC **adult**

MANX SHEARWATER
◎ MAIN PIC **adult** ◎ INSET **feeding flock**
◎ INSET **adults flying**

GREAT SHEARWATER
◎ MAIN PIC **adult** ◎ INSET **adult**
CORY'S SHEARWATER
◎ MAIN PIC **adult** ◎ INSET **adult**

FULMAR *Fulmarus glacialis* WINGSPAN 105–110cm

A superficially gull-like relative of the shearwaters and petrels. Easily distinguished from gulls at close range by its tube nostrils and, in flight, by its stiffly held wings and effortless gliding action. Swims buoyantly and often gathers in groups where feeding is good, for example around fishing boats. Generally sociable and nests in colonies on sea cliffs. Typically indifferent to the presence of human observers, although capable of regurgitating its oily and smelly crop contents in projectile fashion over an intruder if alarmed. The sexes are similar. **ADULT** typically has blue-grey upperwings and back. The head, underparts and tail are white. Note the dark smudge around the eye. The so-called 'Blue Fulmar' is occasionally seen in the region as a visitor from Arctic latitudes; the white elements of its plumage are blue-grey. **JUVENILE** is similar to the adult, once the chick's fluffy white down has been lost. **VOICE** – various gurgling cackles and grunts are uttered at colonies. HABITAT AND STATUS Typically nests on ledges on sea cliffs and forms sizeable colonies. Otherwise, seen gliding over the sea. As recently as the end of the 19th century, Fulmars were restricted as a breeding species to St Kilda. Now they can be found in suitable habitats around the entire coastline of the British Isles, although the largest colonies are still in the north of the region. Several hundred thousand pairs nest in Britain and Ireland. OBSERVATION TIPS This is one of the easiest seabirds to observe. Although not tied to the land, birds often linger in the vicinity of the nesting colonies throughout the year, even though breeding occurs only between May and August. Can be seen almost anywhere around the British and Irish coast, except the most sheltered of inshore waters. To see the species in numbers, visit Shetland and Orkney, where Fulmars are common both on sea cliffs and in fishing harbours.

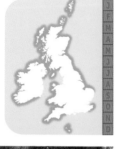

nesting

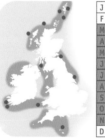
dark phase

GANNET *Morus bassanus*
WINGSPAN 165–180cm

A distinctive bird, and the largest seabird in the region. Recognised in flight by its cigar-shaped body and long, narrow wings. Flies with deep, powerful wingbeats, but in strong winds it glides effortlessly on stiffly held wings. The bill is large and dagger-like. When a shoal of fish is discovered, groups of birds plunge-dive from a considerable height, providing an extraordinary spectacle. The sexes are similar, but adult plumage is acquired through successive moults over a five-year period. **ADULT** has essentially white body plumage with black wingtips. Note the buffish-yellow wash to the head. **JUVENILE** has dark brown plumage, speckled with white dots. **SECOND WINTER** is similar to juvenile but underparts are mainly white; typically, the head and neck are white except for a dark cap. **THIRD WINTER** recalls adult but shows extensive dark feathering on the back and inner wings. **FOURTH WINTER** is similar to the adult but some of the secondaries on the inner wing are dark. **VOICE** – silent at sea, but nesting birds utter harsh, grating calls. HABITAT AND STATUS Apart from when it is nesting, the species is found exclusively at sea. Shows no affiliation for inshore waters but often passes close to headlands, especially during strong onshore winds. Nests on steep and inaccessible sea cliffs. Although there are only a dozen or so important British and Irish colonies, they contain around 200,000 pairs, representing nearly three-quarters of the world population for the species. During the winter months, most immature Gannets, and many adults too, move south to warmer waters off the west coast of Africa. However, smaller numbers remain in the region throughout the year. OBSERVATION TIPS Although a sea watch from almost any headland around the coast is likely to yield sightings at any time of year, the period between April and September is best for seeing the species at sea. However, do try to visit a Gannet breeding colony as well. Flamborough Head in Yorkshire, and Noss and Hermaness in Shetland, provide superb opportunities, but nothing can rival the close-up encounters offered by a trip to the famous colony on Bass Rock.

juvenile

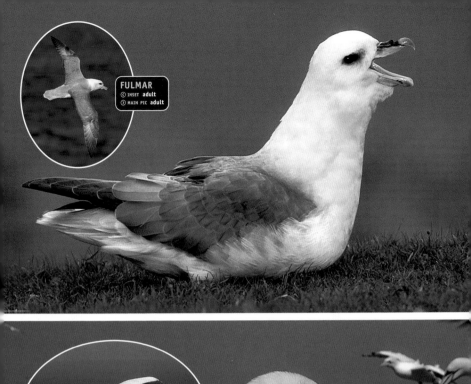

FULMAR
◁ INSET **adult**
▷ MAIN PIC **adult**

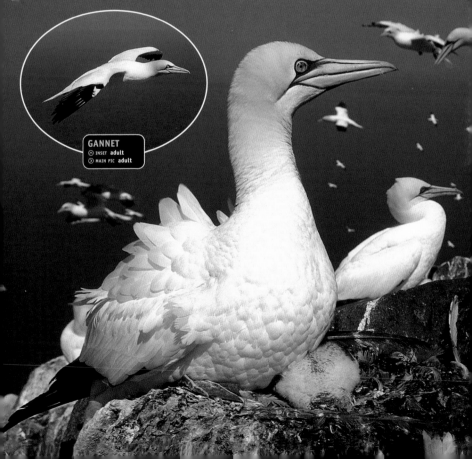

GANNET
◁ INSET **adult**
▷ MAIN PIC **adult**

SHAG *Phalacrocorax aristotelis* LENGTH 65–80cm

Superficially similar to the Cormorant, but appreciably smaller and easily separable. Swims low in the water and dives frequently for fish, using its large webbed feet for propulsion; typically employs a leap in order to submerge. Bill is hook-tipped but distinctly more slender than that of Cormorant. Flies with head and neck outstretched, and often seen perching on rocks with wings held outstretched to dry. The sexes are similar. **SUMMER ADULT** looks all dark at a distance but, at close range and in good light, note the oily green sheen to the plumage. Shows a striking yellow patch at the base of the bill and sports a prominent crest. **WINTER ADULT** loses the crest and the colours at the base of the bill are more subdued. **JUVENILE** has dark brown upperparts and buffish-brown underparts, but with a noticeable pale throat. The crown peaks on the forehead, whereas with juvenile Cormorant the peak is at the rear of the crown. **VOICE** – utters various harsh grunting calls at breeding colonies, but otherwise silent. HABITAT AND STATUS A resident species and an exclusively marine bird that favours rocky shores and tolerates – even delights in – the roughest

of seas. Nests colonially on sea-cliff ledges and commonest on western and northern coasts, with several tens of thousands of pairs breeding in the region. In winter, most Shags remain at sea close to their nesting colonies. Some dispersal of immature birds occurs, however, and storm-driven birds do occasionally turn up inland at such times. OBSERVATION TIPS Easy to see at most large and accessible seabird colonies. For really close-up views, visit the Farne Islands in Northumberland.

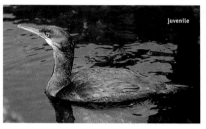
juvenile

CORMORANT *Phalacrocorax carbo* LENGTH 80–100cm

A large, dark water bird with a heavy, hook-tipped bill. Associated mainly with coastal waters. Swims low in the water and dives (typically with a noticeable leap) frequently for fish; uses its large webbed feet to propel itself through the water. Flies with the head and neck held forward, and often perches on rocks or posts with the wings outstretched to dry. The sexes are similar. **SUMMER ADULT** appears mainly dark but, in good light and at close range, note the plumage's oily sheen and the black-bordered brownish feathers on the wings. The eye is green and the skin at the base of the bill is yellow, grading to white. In full breeding plumage, shows a white thigh patch and white on the head and neck. **WINTER ADULT** loses the white feathering on the thigh, head and neck. **JUVENILE** has brown upperparts and whitish underparts; acquires adult plumage over a period of two years. **VOICE** – utters nasal and guttural calls at breeding colonies, but otherwise silent. HABITAT AND

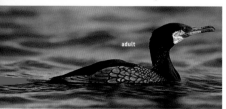
!CONFUSION SPECIES!
GREAT NORTHERN DIVER
Page 26

STATUS Resident and found mainly around the coast; typically a bird of sheltered inshore waters. Breeds colonially, the large twig and seaweed nests being constructed usually on sea-cliff ledges but occasionally in trees (the site of choice for most mainland European birds). Consequently, most colonies in the region are concentrated around western and northern coasts, and several thousand breeding pairs are found in the region. Outside the breeding season, Cormorants are

adult

more widespread and can be found on estuaries and along sheltered coasts throughout the region. Particularly in winter, they also visit fish-rich inland freshwater sites, including rivers, flooded gravel pits and reservoirs. Small numbers have also begun nesting at suitable inland sites. OBSERVATION TIPS This is an easy bird to see and to identify, although there is scope for confusion with the Shag. Poor views could lead to a juvenile in particular being mistaken for a diver, although the Cormorant's proportions, bill shape and diving pattern should soon dispel any doubts.

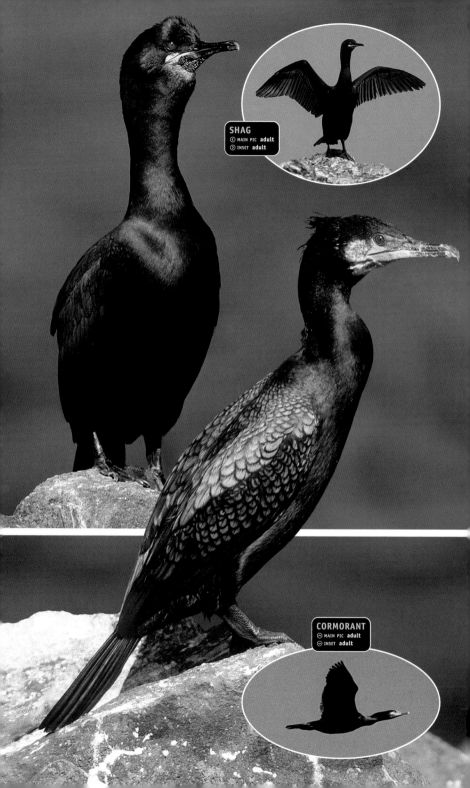

SHAG
- < MAIN PIC **adult**
- > INSET **adult**

CORMORANT
- ⌃ MAIN PIC **adult**
- ⌄ INSET **adult**

SPOONBILL *Platalea leucorodia* LENGTH 80–90cm

An unmistakable wetland bird with a long, flattened bill that has a spoon-shaped tip. Feeds by wading through shallow water, sweeping the bill from side to side to catch small fish and crustaceans. Often stands with the bill tucked under the wings, leading to confusion with a sleeping Little Egret, or even a Mute Swan if the long black legs are not visible. In flight, the head and neck are held extended with legs trailing. The sexes are similar. **BREEDING ADULT**

!CONFUSION SPECIES!

LITTLE EGRET
Page 42

has mainly white plumage, although the base of the bill and breast are flushed yellow. There is a crest of bushy feathers on the nape. The bill is black with a yellow tip. **NON-BREEDING ADULT** is similar, but the yellow flush and the crest are absent. **JUVENILE** is similar to the non-breeding adult, but the legs and bill are dull pinkish. **VOICE** – generally silent. HABITAT AND STATUS Typically known as a scarce non-breeding visitor to Britain, often in spring. Most records (up to 100 per year) occur in south and east England, which is not surprising given the proximity of breeding colonies in the Netherlands. A few pairs have also nested in England in recent years and, hopefully, will continue to do so. Favours extensive areas of shallow water (both fresh and brackish) for feeding, and most records are coastal. OBSERVATION TIPS A visit to the coastal wetland reserves of Suffolk and north Norfolk in spring often yields sightings. Elsewhere, the species is more unpredictable in occurrence, although the Exe estuary in Devon and Titchfield Haven in Hampshire host Spoonbills on a fairly regular basis.

BITTERN *Botaurus stellaris* LENGTH 70–80cm

Despite its size, this species is hard to see on account of its retiring nature and the superb camouflage afforded by its streaked brown plumage in its favoured reedbed habitat. Its typical posture is hunched and dumpy but, if alarmed, the head and neck are held outstretched, pointing skywards. The bill is dagger-like and the legs and feet are long and powerful. Superficially owl-like in flight, but note the outstretched head and neck and trailing legs. The sexes are similar. **ADULT** has essentially brown plumage, with intricate and fine streaks and barring that create excellent camouflage. Shows a dark moustache and cap. **JUVENILE** is similar to the adult but the crown and moustache are brown. **VOICE** – territorial males utter deep booming calls in spring, mostly at night. HABITAT AND STATUS Favours extensive reedbeds with areas of shallow water for feeding. Outside the breeding season, wandering birds occasionally turn up in more open wetland areas. Only a handful of pairs breed in the region, being restricted to coastal wetland reserves, mainly in East Anglia. Numbers are boosted slightly in winter owing to an influx of birds from mainland Europe. OBSERVATION TIPS Seldom leaves the cover of reedbeds, so typical views are brief and relate to birds in flight. Reedbed reserves at Cley and Titchwell in Norfolk, Minsmere in Suffolk and Leighton Moss in Lancashire offer the best chances of glimpsing or hearing a Bittern in the breeding season. For more prolonged and reliable views, visit the Lea Valley Country Park in Hertfordshire in winter.

WHITE STORK *Ciconia ciconia* LENGTH 100–115cm

A large and unmistakable black and white bird, both on the ground and in flight. Soars effortlessly on broad wings with the head and neck outstretched, and with trailing legs. The sexes are similar. **ADULT** has mainly grubby white plumage except for the black flight feathers. The bill is long, dagger-like and red, while the long legs are pinkish-red. **JUVENILE** is similar to the adult but the leg and bill colours are duller. **VOICE** – silent in the region. HABITAT AND STATUS A scarce visitor to the region (mainly south and east England), migrants having drifted west from their passage between breeding grounds in mainland Europe and wintering grounds in Africa. Most records (fewer than 20 per year) occur in spring and summer, and birds occasionally linger for a few days to feed. Some records may relate to escapees from captivity. OBSERVATION TIPS So large and distinctive that confusion is unlikely. Typically, it feeds out in the open and so observation is usually straightforward.

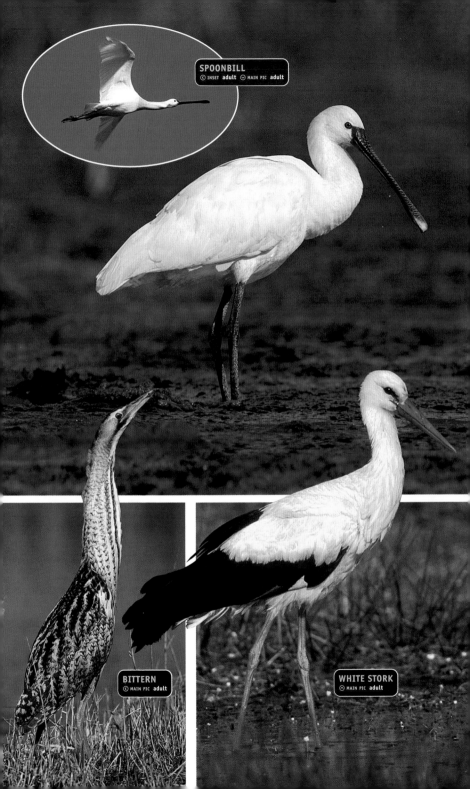

SPOONBILL
ⓒ INSET adult ⊙ MAIN PIC adult

BITTERN
ⓒ MAIN PIC adult

WHITE STORK
⊙ MAIN PIC adult

LITTLE EGRET *Egretta garzetta* LENGTH 55–65cm

An elegant and unmistakable pure white, heron-like bird with a black, dagger-like bill and a long neck. The legs, which are long and black, contrast with the bright yellow toes, although these latter features are not always visible in wading birds. Feeds actively in water, often chasing small fish and stabbing at them with vigour and accuracy. When resting, adopts a hunched posture, with the bill often hidden from view. In flight, note the trailing legs, and the neck, which

!CONFUSION SPECIES!

SPOONBILL
Page 40

is held in a curved 'S' shape. The sexes are similar. **ADULT** has essentially pure white plumage. Note the yellow eye. In breed-ing plumage, sports elongated nape plumes. **JUVENILE** is similar to the adult. **VOICE** – generally silent. HABITAT AND STATUS Not so long ago, the Little Egret was classed as a rarity in Britain. Nowadays, it is a common sight on estuaries and coastal rivers in southern England, East Anglia and south Wales, where it can be found throughout the year. The species has also started to breed in the region and there seems no reason to suppose that it will not continue to do so. As Little Egrets become more com-mon, so occasional sightings are had almost anywhere in the region in suitable habitats. Typically, coastal waters are favoured, but it is now not unusual for individuals to pay brief visits to inland wet-lands. OBSERVATION TIPS This species presents few identification problems. Given its size, and the fact that it generally feeds out in the open, it is easy to see on estuaries and coastal marshes from Nor-folk to Cornwall. Roosts, such as those at the Little Sea on Studland Heath in Dorset, are worth visit-ing to witness the spectacle of flying birds in numbers.

GREY HERON *Ardea cinerea* LENGTH 90–98cm

A large and familiar wetland bird. Often stands motionless for minutes – sometimes hours – on end, waiting for prey to pass within striking range of its bill. However, sometimes it will engage in active pursuit, too. Fish and amphibians are its main prey, but occasionally small mammals may be taken. Often rests on one leg. In flight, note the broad wings and slow, flapping wingbeats; the neck is held in a hunched 'S' shape and the legs and feet trail behind. The sexes are similar,

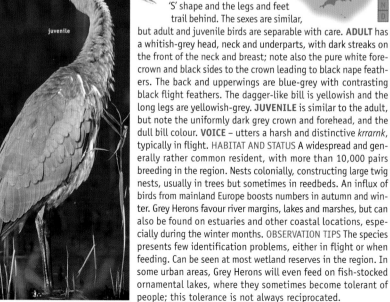

juvenile

but adult and juvenile birds are separable with care. **ADULT** has a whitish-grey head, neck and underparts, with dark streaks on the front of the neck and breast; note also the pure white fore-crown and black sides to the crown leading to black nape feath-ers. The back and upperwings are blue-grey with contrasting black flight feathers. The dagger-like bill is yellowish and the long legs are yellowish-grey. **JUVENILE** is similar to the adult, but note the uniformly dark grey crown and forehead, and the dull bill colour. **VOICE** – utters a harsh and distinctive *krrarnk*, typically in flight. HABITAT AND STATUS A widespread and gen-erally rather common resident, with more than 10,000 pairs breeding in the region. Nests colonially, constructing large twig nests, usually in trees but sometimes in reedbeds. An influx of birds from mainland Europe boosts numbers in autumn and win-ter. Grey Herons favour river margins, lakes and marshes, but can also be found on estuaries and other coastal locations, espe-cially during the winter months. OBSERVATION TIPS The species presents few identification problems, either in flight or when feeding. Can be seen at most wetland reserves in the region. In some urban areas, Grey Herons will even feed on fish-stocked ornamental lakes, where they sometimes become tolerant of people; this tolerance is not always reciprocated.

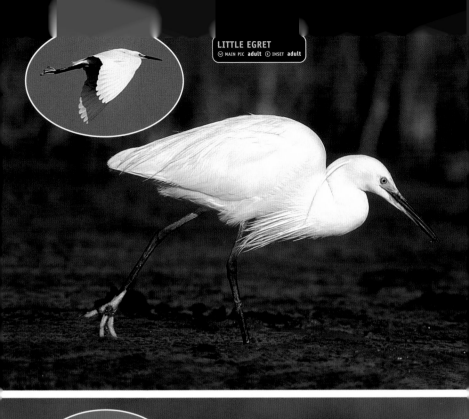

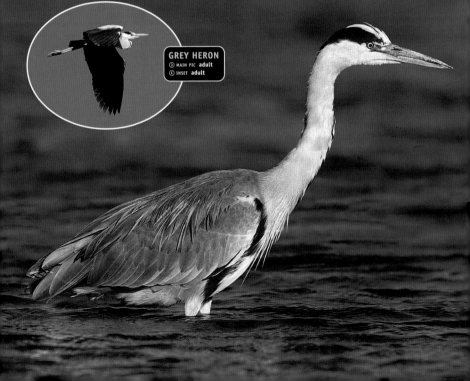

GREY HERON
MAIN PIC **adult**
INSET **adult**

MUTE SWAN *Cygnus olor* LENGTH 150–160cm

A distinctive water bird and the largest bird in the region. When swimming, the neck is held in an elegant curve. Family groups, with parents accompanied by young cygnets, are a feature of many lowland lakes in spring. Mute swans are generally tolerant of human observers. In flight, note the broad wings and shallow but powerful wingbeats, which produce a characteristic, throbbing whine. The sexes are rather similar, but the bill's basal knob is largest in males. **ADULT** has essentially pure white plumage, although the crown is sometimes suffused with orange-buff. The bill is orange-red (the colour is more intense in males than females) and the base of the bill is black. **JUVENILE** has grubby grey-brown plumage and a dull pinkish-grey bill. **VOICE** – generally silent, although it does utter a variety of grunting calls on occasions. HABITAT AND STATUS Our commonest and most widespread swan (several tens of thousands of pairs) and the only one that is resident. Found on all sorts of freshwater bodies, besides which it nests; in winter, it also occurs on sheltered coasts. OBSERVATION TIPS Easy to observe and identify. Breeding birds at Abbotsbury Swannery in Dorset are spectacular.

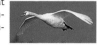

WHOOPER SWAN *Cygnus cygnus* LENGTH 150–160cm

A large and impressive water bird. Similar in size to Mute Swan but easily separable by bill shape and colour. Typically holds the neck straight, not curved. Usually seen in medium-sized flocks, among which family groups are readily discernible. In flight, the head and neck are held outstretched in the manner of other swans. The sexes are similar, but adults and juveniles are easily separable. **ADULT** has essentially pure white plumage, although in spring and summer some individuals have the head and upper neck stained orange. The bill is triangular and rather long; it is adorned with a striking yellow patch that extends beyond the nostril. **JUVENILE** has grubby buffish-grey plumage and a dark-tipped pale pink bill. **VOICE** – utters loud, bugling calls. HABITAT AND STATUS Although a handful of pairs breed in the region each year, the species is best known as a winter visitor (October–March), involving several thousand birds, most of which come from breeding grounds in Iceland. Whooper Swans favour a range of habitats when they are in Britain, from arable farmland to wet meadows and lakeside marshes. Many birds return to traditional sites each autumn, although some dispersal does occur in severe weather. OBSERVATION TIPS Whooper Swans sometimes associate loosely with other swan species, so do not assume that any winter flock you come across contains just one species. For good views, visit Welney in Cambridgeshire or Caerlaverock on the Solway Firth.

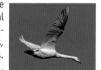

BEWICK'S SWAN *Cygnus columbianus* LENGTH 115–125cm

The smallest of our three swan species. Typically seen in medium-sized flocks comprising family groups that remain intact during their winter stay. Superficially similar to the larger Whooper Swan, but separable with care. The sexes are similar, but adults and juveniles are distinguishable. **ADULT** has essentially pure white plumage. The bill is wedge-shaped but proportionately shorter than in Whooper Swan; the yellow colour is less extensive (typically not extending beyond the start of the nostrils) and the patch of colour is usually rounded, not triangular. **JUVENILE** has grubby buffish-grey plumage and a bill that is usually dark at the tip, pink along much of its length and whitish at the base. **VOICE** – utters various honking and bugling calls. HABITAT AND STATUS A winter visitor, mostly to traditional sites and involving several thousand birds. In severe winters, some dispersal occurs and weather-related influxes occur from mainland Europe. Flocks favour seasonally flooded grassland, marshy meadows and occasionally arable farmland. OBSERVATION TIPS For the most spectacular views, visit the Ouse Washes (particularly Welney) and Slimbridge in Gloucestershire.

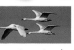

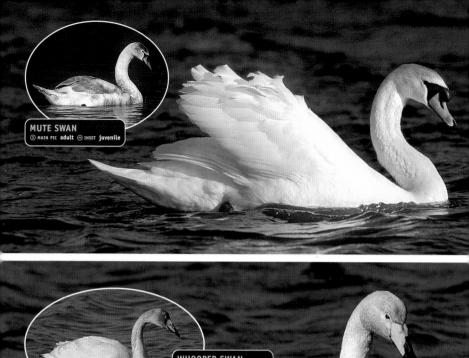

MUTE SWAN
⊘ MAIN PIC **adult** ⊘ INSET **juvenile**

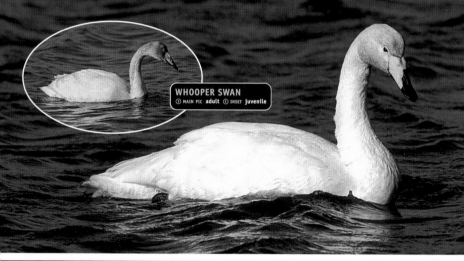

WHOOPER SWAN
⊘ MAIN PIC **adult** ⊘ INSET **juvenile**

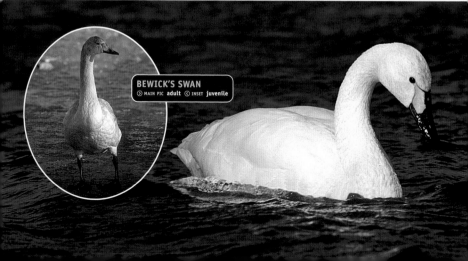

BEWICK'S SWAN
⊘ MAIN PIC **adult** ⊘ INSET **juvenile**

BEAN GOOSE *Anser fabalis* LENGTH 65–85cm

A robust and heavy-looking 'grey' goose with a bulky bill and orange legs. The neck is proportionally long when compared to its most similar cousin, the Pink-footed Goose. In flight, both the upperwing and underwing look rather uniformly dark, but at close range note the pale bars on the upper surface. The dark rump and tail contrast with a narrow white band that defines the tail-base. Bean Geese typically form single-species flocks. The sexes are similar, but adults and juveniles are separable. Two distinct subspecies occur in the region. **ADULT** is dark chocolate-brown on the head and neck, grading to paler brown on the breast and belly. The stern is white and the back is dark brown, the feathers having pale margins. The subspecies *fabalis* (which breeds in northern Europe) is rather large and particularly long-necked, with a large bill usually marked with a considerable amount of orange. The subspecies *rossicus* (which breeds in northern Siberia) is smaller, with a shorter neck and a smaller bill showing a reduced amount of orange. Individuals of both sub-species sometimes show a limited amount of white at the base of the bill. **JUVENILE** is similar to its respective subspecies adult, but the colours on the bill and legs are subdued. **VOICE** – utters a nasal, trumpeting cackle. HABITAT AND STATUS Exclusively a winter visitor to the region with, at best, a couple of hundred individuals occurring in most years. Severe winter weather sometimes produces a small additional influx of birds from mainland Europe. Flocks are scattered thinly, and often rather unpredictably, across England and Scotland, with the species being recorded far less frequently in Wales and Ireland. Bean Geese typically favour wet grassland, marshes and arable fields. OBSERVATION TIPS In most winters, this tends to be a difficult species to pin down. The most reliable group is a flock that winters regularly in northeast Norfolk, on the flood-plain of the River Yare.

!CONFUSION SPECIES!
Head may be confused with those of GREYLAG GOOSE (*left*) and IMMATURE WHITE-FRONTED GOOSE (*right*)
Page 48

adult *rossicus*

PINK-FOOTED GOOSE *Anser brachyrhynchus* LENGTH 60–75cm

Superficially similar to its cousin, the Bean Goose, but smaller and more compact; the proportionally smaller bill is marked with pink, not orange. The pink colour of the legs is diagnostic. In flight, note the pale blue-grey back, rump and upperwing coverts; the tail shows a considerable amount of white. Typically forms single-species flocks. The sexes are similar, but adults and juveniles are separable with care. **ADULT** has a dark chocolate-brown head and upper neck, grading to buffish-brown on the breast and belly. The back is blue-grey, the feathers having pale margins. **JUVENILE** is similar to the adult but the back is buffish (not grey) and the feathers are not so clearly defined by pale margins; the colours on the legs and bill are subdued. **VOICE** – utters nasal, trumpeting cackles, similar to, but higher pitched than, Bean Goose. HABITAT AND STATUS A locally common winter visitor, mainly from breeding grounds in Iceland, with smaller numbers from Greenland. The majority of birds are found from East Anglia and Lancashire north to eastern Scotland. More than 100,000 birds visit the region each winter, representing some three-quarters of the world population. Pink-footed Geese favour arable and stubble fields and permanent grassland, typically roosting on estuaries or large bodies of fresh water. OBSERVATION TIPS The species is easy to observe at traditional wintering grounds such as the north Norfolk coast (particularly around Holkham), the Lancashire coast, the Solway Firth and much of southeast Scotland. The sight and sound of skeins of Pink-footed Geese flying between roosting and feeding grounds at dawn and dusk is one of the great spectacles in British birdwatching and should not be missed.

!CONFUSION SPECIES!
Head may be confused with those of GREYLAG GOOSE (*left*) and IMMATURE WHITE-FRONTED GOOSE (*right*)
Page 48

adult

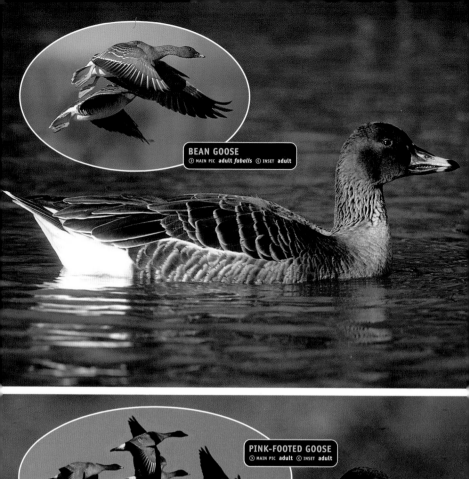

BEAN GOOSE
⊙ MAIN PIC **adult** *fabalis* ⊙ INSET **adult**

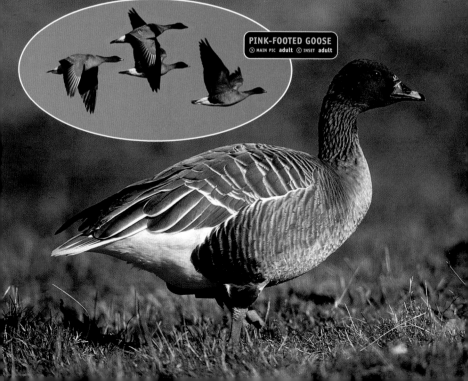

PINK-FOOTED GOOSE
⊙ MAIN PIC **adult** ⊙ INSET **adult**

WHITE-FRONTED GOOSE *Anser albifrons* LENGTH 65–75cm

A distinctive 'grey' goose, the adults of which have a striking white patch on the forehead. Two distinct subspecies occur in the region, wintering in geographically distinct areas with little overlap. The Greenland White-fronted Goose *A. a. flavirostris* typically has overall darker plumage than the slightly smaller European White-fronted Goose *A. a. albifrons*. The Greenland has an orange bill whereas in the European it is pink; however, it can be surprisingly difficult to ascribe a colour in the field. The legs are orange in both subspecies and at all ages. In flight, all birds have rather uniformly dark wings; the faint pale wingbars are less conspicuous than with the Bean Goose. The sexes are similar (given subspecies differences), but adults and juveniles can be separated. **ADULT GREENLAND** has a dark brown head grading to slightly paler brown on the neck and underparts; it has bold black patches on the belly and a large white forehead blaze. The back is dark grey-brown and the stern is white. The tip of the orange bill is white. **ADULT EUROPEAN** is appreciably shorter-necked than the Greenland and paler, too, especially on the head, belly and back. The tip of the pink bill is white. **JUVENILES** are similar to their respective adults but lack the white forehead blaze and black belly markings; the tip of the bill is dark. **VOICE** – in flight, utters barking, rather musical calls. HABITAT AND STATUS A winter visitor to the region that typically is faithful to traditional haunts. In such places it is locally common and favours damp grassland for feeding. In severe winters, it occasionally turns up away from known sites. Greenland White-fronted Geese (the entire population of which winter in the region) are found mainly in Ireland and north and west Scotland, whereas European White-fronts favour southern England and south Wales. In good years, the combined numbers of both subspecies wintering in Britain can exceed 20,000, and so it is not unusual to encounter flocks numbering hundreds – sometimes thousands – of birds. OBSERVATION TIPS Some of the best areas to observe the species include Slimbridge, north Norfolk, Islay and the Wexford Slobs in Ireland. In parts of Norfolk – notably the Holkham area – the birds are almost oblivious to human observers and so superb close-up views can be obtained.

!CONFUSION SPECIES!

Head of IMMATURE WHITE-FRONTED may be confused with that of PINK-FOOTED Page 46

adult

immature

GREYLAG GOOSE *Anser anser* LENGTH 75–90cm

The largest of the so-called 'grey' geese and the only one that breeds in Britain. The species is the ancestor of domesticated 'farmyard' geese. As a consequence, it is hardly surprising that the precise natural range of the Greylag Goose is confused by the presence of numerous feral populations. Compared to other 'grey' geese, the Greylag appears bulky and more uniformly grey-brown. The pink legs and the heavy, pinkish-orange bill help with identification. In flight, the pale forewings, rump and tail contrast markedly with the darker flight feathers. The sexes are similar. **ADULT** has essentially rather uniform grey-brown plumage, but with dark lines on the side of the neck, barring on the flanks and pale margins to the feathers on the back. The pinkish-orange bill is pale-tipped. **JUVENILE** is similar to the adult but even more uniformly grey-brown in appearance; the bill lacks the adult's pale tip. **VOICE** – utters loud, honking calls, exactly like the familiar calls of farmyard geese. HABITAT AND STATUS In lowland England the species is widespread but patchily distributed, with an easterly bias. In northern England and southern Scotland, it is more widespread and common. Numbers of residents are boosted between October and March by an influx of birds from Iceland – several tens of thousands of birds are present at this time. Favoured feeding habitats include damp grassland, lake margins and farmland. Most Scottish Greylags are probably genuinely wild, while those elsewhere may well be feral birds. OBSERVATION TIPS Many flooded gravel pits in lowland Britain now have established populations of Greylags. To see the greatest numbers, however, visit southern Scotland in winter where wild and feral populations coexist.

!CONFUSION SPECIES!

Head may be confused with that of PINK-FOOTED Page 46

'farmyard' goose

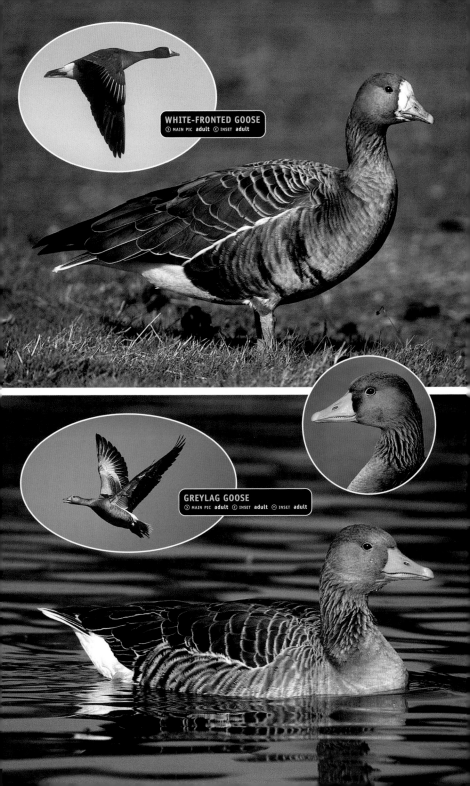

WHITE-FRONTED GOOSE
MAIN PIC **adult** INSET **adult**

GREYLAG GOOSE
MAIN PIC **adult** INSET **adult** INSET **adult**

BRENT GOOSE *Branta bernicla* LENGTH 56–61cm

The smallest goose in the region, and about the same size as a Shelduck. Overall it appears rather dark, but good light reveals subtle plumage patterns. Careful scrutiny of these patterns allows separation of the two subspecies that winter in the region: the so-called Pale-bellied Brent *B. b. hrota* (which breeds on Svalbard and Greenland) and the so-called Dark-bellied Brent *B. b. bernicla* (which breeds in Russia). Invariably seen in sizeable and noisy flocks. In flight, looks mainly dark except for the white rear end. All birds have a black bill and black legs. The sexes are similar, but adults and juveniles are separable. **ADULT PALE-BELLIED BRENT** has a blackish head, neck and breast, the side of the neck adorned with a narrow band of white feathers. There is a neat division between the dark breast and the pale grey-buff belly. The back is a uniform dark brownish-grey. **ADULT DARK-BELLIED BRENT** is similar but the colour of the belly is darker (almost the same colour as the back); note, however, the paler flanks. **JUVENILES** are similar to their respective adults, but note the pale barring (feather margins) on the back and the absence of white markings on the side of the neck. **FIRST WINTER** is similar to its respective juvenile, but acquires white on the sides of its neck in the New Year. **VOICE** – an extremely vocal species, uttering a nasal *krrrut*. HABITAT AND STATUS This winter visitor to the region has an almost exclusively coastal distribution, the main concentrations being on sizeable estuaries in south and east England, and around much of the Irish coast. Birds favour estuarine habitats, often grazing on eel-grass and other saltmarsh plants, plus various seaweeds, after their arrival in autumn. Typically, the importance of grassland and even farmland habitats increases during their stay. Pale-bellied Brent Geese from Greenland winter mainly in Ireland, while birds from Svalbard can be found around Lindisfarne in Northumberland. Elsewhere in southern Britain, the visitors are Dark-bellied Brents, with the main concentration being found between north Norfolk and the Solent. In a typical year, as many as 100,000 birds may be present in the region as a whole. OBSERVATION TIPS Brent Geese are conspicuous and vocal winter visitors to many of our estuaries and, consequently, are hard to miss. In recent years, they have become tolerant of human observers and tend to become increasingly so as the winter progresses. Astonishingly close views can often be obtained along the north Norfolk coast and on the Solent, especially at Farlington Marshes in Hampshire.

adult
Pale-bellied
Brent

BARNACLE GOOSE *Branta leucopsis* LENGTH 58–69cm

A small and particularly well-marked goose. Invariably seen in large, noisy flocks. The vast majority of this winter-visiting species return to traditional sites. All birds have black legs and bill. In flight, it looks strikingly black and white. The sexes are similar. **ADULT** has a mainly white face. Note the black line from the bill to the eye, and the black crown and nape that merge with the black neck and breast. The belly is whitish-grey with faint dark barring on the flanks, and the back is grey with well-defined black and white barring. The stern is white, while the tail is black. **JUVENILE** is similar to the adult but the white elements of the plumage are often tinged yellow and the barring on the back is typically less well defined. **VOICE** – flocks utter loud, barking calls. HABITAT AND STATUS This winter visitor has a mainly coastal distribution, favouring a range of habitats from grazing pastures and arable fields to saltmarshes; it often roosts on mudflats. Birds from Greenland winter mainly on islands off the northwest coast of Scotland (notably Islay) and also on islands off the northwest coast of Ireland. Birds from Svalbard visit the Solway Firth. The species occasionally turns up elsewhere in the region, particularly in severe winters; such records probably relate to birds displaced from mainland Europe. However, Barnacle Geese are also kept in captivity, so beware of the possibility of escapees. OBSERVATION TIPS This is an easy species to identify and to observe if you visit known wintering grounds at the right time of year. The Solway Firth (particularly Caerlaverock National Nature Reserve) offers excellent opportunities for seeing Barnacle Geese in numbers, but for the ultimate spectacle, visit the island of Islay off Scotland's west coast.

adult

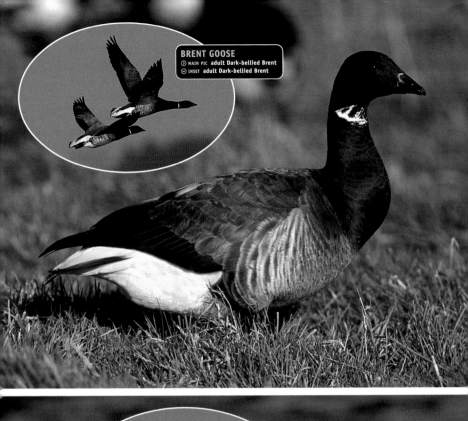

BRENT GOOSE
⟩ MAIN PIC **adult Dark-bellied Brent**
⟨ INSET **adult Dark-bellied Brent**

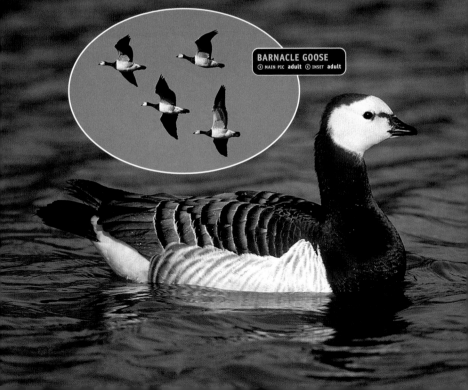

BARNACLE GOOSE
⟩ MAIN PIC **adult** ⟨ INSET **adult**

SHELDUCK *Tadorna tadorna* LENGTH 55–65cm

A large, goose-sized duck with bold and distinctive markings. In poor light, it can look distinctly black and white. However, colourful elements of plumage become apparent in good light. In flight, the wings show contrasting white coverts and black flight feathers. The sexes can be separated with care. **ADULT MALE** is largely white but with a dark green head and upper neck (looks black in poor

juvenile

light), a chestnut breast band, a black belly stripe and a flush of orange-buff under the tail. The legs are pink and the bill is bright red with a conspicuous knob at the base. **ADULT FEMALE** is similar, but the bill's basal knob is much smaller. **JUVENILE** has mainly buffish-grey upperparts and white underparts. **VOICE** – courting males utter a whistling call, while the female's call is a cackling *gagaga*.... HABITAT AND STATUS A familiar sight on most estuaries in the region, where it sifts the mud for small invertebrates. It also occurs in smaller numbers at inland freshwater sites. Shelducks are hole-nesters. In the summer months, many adults migrate to the Netherlands' Waddenzee to moult; smaller numbers congregate at sites like Bridgwater Bay in Somerset for the same purpose. The birds disperse and return to our estuaries in early autumn, when many tens of thousands are present in the region. OBSERVATION TIPS An easy species to see on most estuaries around the coasts of Britain and Ireland, except of course in July and August.

CANADA GOOSE *Branta canadensis* LENGTH 95–105cm

A large and familiar goose. The Canada Goose was introduced from North America 300 or so years ago and it is now our most widespread and familiar goose. Its long neck and upright stance give it a swan-like silhouette. All birds have a blackish bill and dark legs. In flight, the wings appear uniformly grey-brown, while the stern is white. The sexes are similar. **ADULT** has white cheeks on an otherwise black head and neck. The body is mainly grey-brown, darkest on the back (where pale feather margins create barring) and palest on the breast. The stern is

adult

white and the tail is dark. **JUVENILE** is similar to the adult but the barring on the back is less distinct. **VOICE** – utters loud, disyllabic trumpeting calls in flight. HABITAT AND STATUS The region's Canada Goose population numbers many tens of thousands of birds, the bulk of them concentrated in lowland England; the species is scarce in Wales and absent from much of Scotland and Ireland. It is usually found in the vicinity of water, but typically feeds on adjacent grassland, or even arable fields. Not only do Canada Geese favour natural and semi-natural habitats such as rivers, flooded gravel pits and reservoirs, but they seem quite at home in urban parks with ornamental lakes, where they can become remarkably tame. Most birds tend to be rather sedentary, although some dispersal does occur during the winter months. OBSERVATION TIPS Easy to find in most parts of lowland England and straightforward to identify.

EGYPTIAN GOOSE *Alopochen aegyptiacus* LENGTH 65–72cm

A striking and distinctive Shelduck-sized bird. The Egyptian Goose has become established as a breeding bird in the region following introductions dating back to the late 18th century. In flight, the bold white patch on the inner wing assists identification. The bill and legs are pink. The sexes are similar. **ADULT** has a grubby white head and neck, the pale eye surrounded by a dark patch. The orange-buff breast shows a clear division from the paler neck and the darker, grey-buff belly; note the small, dark patch on the centre of the breast. The back is dark grey-brown, and the white and chestnut colours on the wing can be seen in resting birds. **JUVENILE** is similar to the adult but the plumage colours are duller; the dark breast spot and patch around the eye are absent. **VOICE** – generally silent. HABITAT AND STATUS Seldom found far from water, but requires grassland for feeding and trees for breeding (typically nests in tree-holes). There are scattered records across lowland England, the bulk of the population (several hundred birds) is found in East Anglia. OBSERVATION TIPS The species' epicentre is still the Holkham area of north Norfolk, the site of introductions in the past.

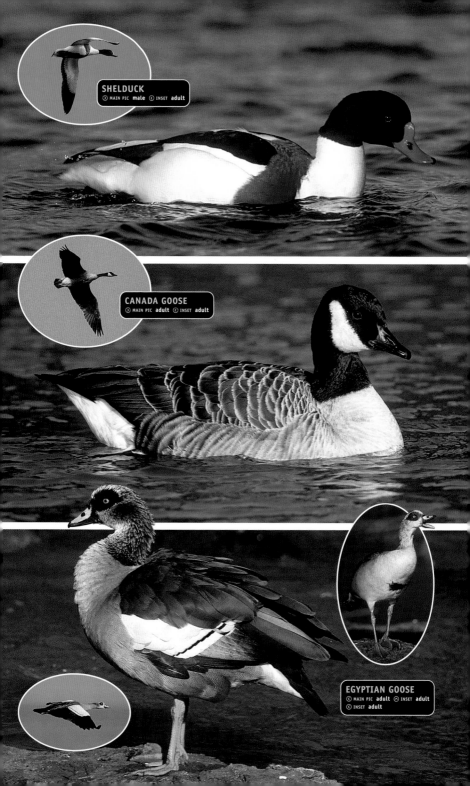

SHELDUCK
⊘ MAIN PIC **male** ⊙ INSET **adult**

CANADA GOOSE
⊘ MAIN PIC **adult** ⊙ INSET **adult**

EGYPTIAN GOOSE
⊙ MAIN PIC **adult** ⊙ INSET **adult**
⊙ INSET **adult**

MALLARD *Anas platyrhynchos* LENGTH 50–60cm

By far the most widespread and familiar duck in the region – there can be few water bodies of any size that do not have their quota of resident Mallards. In flight, both sexes show a white-bordered blue speculum. The sexes differ in appearance: the male has colourful elements to its plumage, while the female's subdued brown coloration affords it excellent camouflage when nesting. **ADULT MALE** has a yellow bill and a green, shiny head and upper neck that are separated from the chestnut breast by a striking white collar. The underparts are grey-brown except for the black stern and white tail. The back is grey-brown, grading to reddish-brown. The legs and feet are orange. In eclipse, the male resembles an adult female, but note the yellow bill colour and well-defined reddish-brown breast. **ADULT FEMALE** has an orange-brown bill and mottled brown plumage. The legs and feet are dull orange-yellow. **JUVENILE** is similar to the adult female. **VOICE** – the male utters a range of whistles and nasal calls. The female utters familiar quacking calls. HABITAT AND STATUS Found virtually throughout the region, favouring almost every habitat where water is present, with the exception of the highest mountains. Commonest on lowland lakes, rivers and flooded gravel pits, but will also thrive on ornamental lakes in urban areas, where it often becomes tame. It is likely that more than 100,000 pairs breed in the region, these birds tending to be resident and rather sedentary. In winter, however, the number of Mallards probably doubles thanks to an influx of birds from northern Europe. OBSERVATION TIPS Easy to find throughout the region. Identification of the male is straightforward, except when it is in eclipse plumage, when it resembles a female. The female could be confused with females of other larger dabbling ducks.

domesticated
Mallard

male

female

WIGEON *Anas penelope* LENGTH 45–50cm

A distinctive dabbling duck, the males in particular of which are colourful and attractive. Outside the breeding season, it is gregarious and the sizeable flocks that form are a familiar sight on many estuaries in the region. The male's whistling call is also one of the most evocative sounds of our coast in winter. The sexes are dissimilar: only the males have colourful and distinctive markings. **ADULT MALE** has an orange-red head with a yellow forehead. The breast is pinkish while the rest of the plumage is mainly grey and finely marked, except for the white belly and characteristic black and white stern. In flight, note the striking white patch on the wing. The bill is pale grey and dark-tipped. In eclipse plumage, it resembles an adult female, although the white wing patch is still evident. **ADULT FEMALE** is mainly reddish-brown, darkest on the head and back. Note, however, the white belly and stern. In flight, it lacks the male's white wing patch. The bill is grey and dark-tipped. **JUVENILE** resembles adult female. **VOICE** – the male utters a distinctive *wheeeoo* whistling call. HABITAT AND STATUS Although Wigeon do breed in the region in small numbers (a few hundred pairs), the species is best known as a locally common winter visitor: several hundred thousand are probably present between November and March. Estuaries, mudflats and coastal grazing pastures are the classic habitats for the species. However, significant numbers are also found on inland wetlands, and flocks even feed on agricultural land in some areas. OBSERVATION TIPS Often detected by its call before the bird itself is actually seen. Males are easy to identify, but solitary females (an unusual sight) can be a bit problematic; the rather bulky proportions, reddish overall coloration, 'gentle' expression and rounded head all help.

male

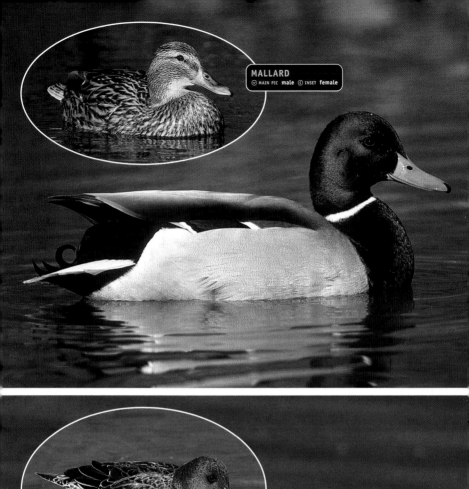

MALLARD
MAIN PIC **male** · INSET **female**

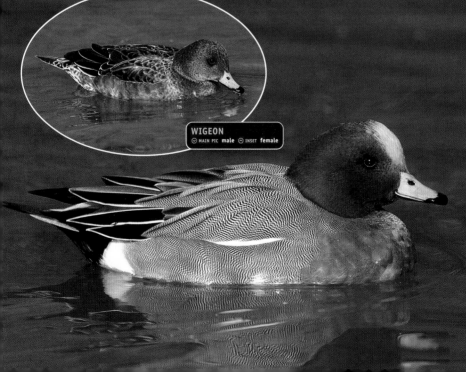

WIGEON
MAIN PIC **male** · INSET **female**

SHOVELER *Anas clypeata* LENGTH 46–52cm

With its distinctive, long and flattened bill, the Shoveler is unmistakable, even in silhouette. Compared to many other duck species, it is rather unobtrusive, typically favouring well-vegetated water margins. It moves quietly through the shallows, filtering food with its bizarrely shaped bill. In flight, the male shows a blue forewing panel and a white-bordered green speculum; the wing pattern in the female is similar but the blue is replaced with grey. The sexes are dissimilar in terms of the overall plumage. **ADULT MALE** has a shiny green head (this can look dark in poor light), a white breast and chestnut on the flanks and belly. The stern is black and white, and the back is mainly dark. Note the beady yellow eye and dark bill. In eclipse plumage, the male resembles an adult female, although the body is more rufous and the head is greyer. **ADULT FEMALE** has mottled buffish-brown plumage and a yellowish bill. **JUVENILE** is similar to the adult female. **VOICE** – the male utters a sharp *tuk-tuk* while the female utters a soft quack. HABITAT AND STATUS The species is seldom found far from water and birds usually feed in the shallows. Shovelers are occasionally seen on estuaries and mudflats in the winter, but are more usually associated with freshwater habitats, including lakes and marshes; they nest in rank vegetation not far from water. The species is best known as a winter visitor to the region. Numbers fluctuate throughout the year. Typically, the population peaks in late autumn and early winter, when there may be in excess of 10,000 birds present. However, by late winter the numbers have generally shrunk to around half that figure; 1,000 or so pairs remain to breed in Britain and Ireland. OBSERVATION TIPS Shovelers are relatively easy to see if you visit almost any wetland reserve during the winter months, although views of them tend to be rather distant. They are extremely unobtrusive during the breeding season.

GADWALL *Anas strepera* LENGTH 46–55cm

An increasingly familiar dabbling duck. It seems to have benefited from the spread of lowland flooded gravel pits and reservoirs, where sizeable flocks now gather during the winter months. At a distance, the plumage of the male simply looks grey and brown. However, at close range and in good light beautifully intricate, vermiculate patterns become apparent. In flight, both sexes show white in the speculum; the extent of this is greatest in males, which also show chestnut on the inner wing. The sexes are dissimilar in overall plumage. **ADULT MALE** has a buffish head and neck, with a clear separation from the grey, finely patterned breast and flanks. The centre of the belly is white and the stern is black, a useful identification feature even at a distance. Note the dark bill and yellow legs. In eclipse plumage, the male resembles an adult female. **ADULT FEMALE** has mottled brown plumage with a greyish head. Note the yellow bill. The white speculum can sometimes be glimpsed in feeding birds. **JUVENILE** resembles the adult female. **VOICE** – the male utters a croaking call while the female utters a mallard-like quack. HABITAT AND STATUS Gadwalls are almost invariably associated with freshwater habitats, favouring shallow water where they can dabble (and if necessary up-end) for water plants. Several hundred pairs breed in the region (using rank, waterside vegetation), while several thousand individuals can be present during the winter months. Lowland wetlands in central, southern and eastern England are the locations of choice for the species. OBSERVATION TIPS Visit almost any lake, reservoir or flooded gravel pit between November and March in lowland parts of the region and you stand a good chance of finding flocks of Gadwalls. The male's black stern is conspicuous at a distance, while the white on the speculum is equally distinctive in flight in both sexes (although more so in males than females).

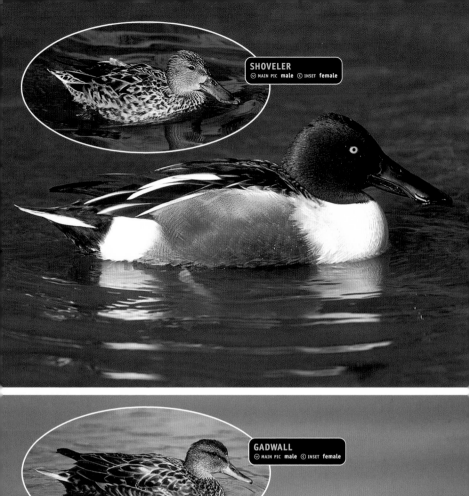

SHOVELER
⊙ MAIN PIC **male** ⓒ INSET **female**

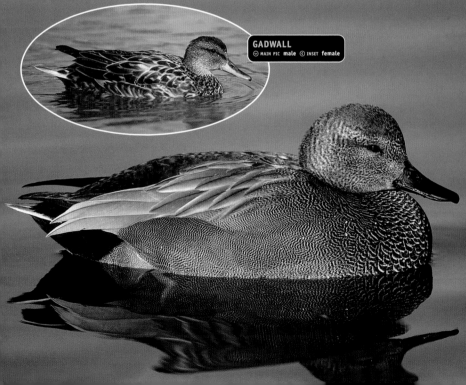

GADWALL
⊙ MAIN PIC **male** ⓒ INSET **female**

TEAL *Anas crecca* LENGTH 34–38cm

This is the smallest duck in Britain and also one of the most widespread. Flocks of Teals are a familiar sight in winter on estuaries, mudflats and inland wetlands, particularly those where they receive a degree of protection from hunting. Elsewhere, they tend to be nervous and flighty, taking to the wing – and rising almost vertically – at the slightest sign of danger. In flight, both sexes show a green speculum, defined by white borders. In other respects, the plumages of the sexes are dissimilar. **ADULT MALE** has a chestnut-orange head

male

with a yellow-bordered green patch through the eye. The plumage is otherwise grey and finely marked, except for the black-bordered yellow stern and the horizontal white line along the side of the body. The bill is dark grey. In eclipse, the male resembles an adult female. **ADULT FEMALE** has rather uniform mottled grey-brown plumage; the green speculum can sometimes be glimpsed in feeding birds. The bill is mainly grey but with a hint of yellow at the base. **JUVENILE** is similar to the adult female but the plumage is warmer buff; the base of the bill is yellowish. **VOICE** – male utters a ringing whistle while the female utters a soft quack. HABITAT AND STATUS Teals are seldom found far from water. Typically, they nest in dense waterside vegetation beside moorland pools and bogs, mostly in upland and northern parts of the region. At other times of year, they favour more open habitats in low-lying districts, and are found on freshwater marshes, estuaries and mudflats. On occasions, flocks will even feed on pastures and arable fields. Perhaps 2,000 pairs of Teals breed in the region, but their numbers are swollen in winter to in excess of 100,000 individuals by an influx of birds from northern Europe. OBSERVATION TIPS Easiest to observe outside the breeding season in coastal districts.

GARGANEY *Anas querquedula* LENGTH 37–41cm

Hardly any bigger than a Teal, this delightful little duck is the only wildfowl species that is exclusively a summer visitor to the region. Although not unduly shy on migration, birds do tend to be rather unobtrusive, since they prefer to feed amongst emergent vegetation. The male's rattling alarm call is often a useful indication that the species is present. In flight, the male reveals a pale blue-grey forewing and a white-bordered greenish speculum; the female lacks the pale forewing panel and the speculum is brown. The sexes are dissimilar in other plumage details. **ADULT MALE** has a reddish-brown head and a broad white stripe above and behind the eye. The breast is brown but otherwise the plumage is greyish, except for the mottled buffish-brown stern. In eclipse, the male resembles an adult female but retains the wing colours and patterns. **ADULT FEMALE** has mottled brown plumage, similar to a female Teal. However, note the uniform grey bill and the pale facial spot at the base of the bill. **JUVENILE** resembles an adult female. **VOICE** – the male utters a diagnostic rattling call while the female occasionally utters a very soft quack. HABITAT AND STATUS Between 50 and 100 pairs of Garganeys probably nest in the region each year, but the casual observer could be forgiven for assuming the species to be completely absent during the breeding season, such is its secretive nature at this time of year. The best chances of observing the species are during migration because birds are less wary then, and passage migrants occur in addition to those destined to nest here; March and April are perhaps the prime months. Even then, don't expect to see more than a handful of birds each spring, unless you make a determined effort. OBSERVATION TIPS For the best chances of seeing a Garganey, visit a wetland reserve in March or April and scan the shallow margins of open pools with emergent vegetation. Coastal reserves in East Anglia, and Stodmarsh National Nature Reserve in Kent, are reliable locations for migrant Garganeys.

female

male

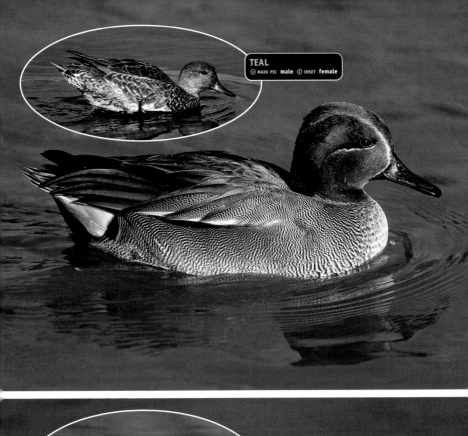

TEAL
⊙ MAIN PIC **male** ⊙ INSET **female**

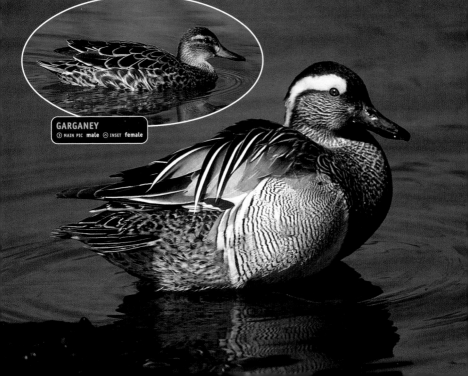

GARGANEY
⊙ MAIN PIC **male** ⊙ INSET **female**

PINTAIL *Anas acuta* LENGTH 51–66cm

An elegant dabbling duck. The male is easily recognised and even the comparatively drab female has a distinctive, elongated appearance with a pointed rear end. Pintails are unobtrusive during the breeding season, but at other times, when they feed in the open in flocks, they are easy to see. In flight, the male's grey wings and green speculum (with a white trailing edge) are striking; with the female, the white trailing edge on the inner wing is the most obvious feature. The sexes are dissimilar in other plumage details. **ADULT MALE** has a chocolate-brown head and nape, with the white breast extending as a stripe up the side of the head. The plumage is otherwise grey and finely marked, but note the cream and black stern, and the long, pointed tail that is often held at an angle. In eclipse plumage, the male resembles an adult female but retains the pattern and colours on the wings. **ADULT FEMALE** has mottled buffish-brown plumage. **JUVENILE** is similar to an adult female but the complex feather markings are less well developed. **VOICE** – the male utters a whistling call while the female's call is grating and harsh. HABITAT AND STATUS Pintails favour marshy waterside ground during the breeding season but are usually associated with estuaries in winter. Perhaps as few as 30 pairs breed in the region, but numbers are swollen to 20,000 or more during the winter months by visitors from northern Europe. OBSERVATION TIPS An easy species to observe and recognise during the winter months. Often up-ends in water to feed, when the striking stern colours and elongated tail are even more apparent.

J
F
M
A
M
J
J
A
S
O
N
D

RUDDY DUCK *Oxyura jamaicensis* LENGTH 35–43cm

A small, North American species that has established feral populations. Both sexes regularly cock their tails up. The male is unmistakable, but the female could be mistaken for a winter plumage Little Grebe if only a partial view is obtained.

!CONFUSION SPECIES!

LITTLE GREBE
Page 30

ADULT MALE has orange-chestnut body plumage, white cheeks, a black cap and nape and a bright blue bill; the colours are brightest in the spring. Note also the small, white stern. **ADULT FEMALE** has grey-brown plumage with paler cheeks that are broken by a dark line from the base of the bill; the bill is dull blue-grey, similar to that seen in a winter male. **VOICE** – mainly silent. HABITAT AND STATUS Favours lakes and flooded gravel pits with well-vegetated margins. Following its escape from captivity at Slimbridge several decades ago, the species is now a widespread resident in lowland Britain, the population amounting to several hundred pairs. However, the Ruddy Duck is now the subject of controversy, and justifiable plans are afoot to eradicate this alien species from Europe: as its range expands south and east, it threatens the genetic pool, and hence the very existence, of the closely related and highly endangered White-headed Duck. OBSERVATION TIPS Often rather unobtrusive. Easiest to see in the spring, when males engage in their strange 'bubbling', chest-beating courtship displays.

J
F
M
A
M
J
J
A
S
O
N
D

FERRUGINOUS DUCK *Aythya nyroca* LENGTH 38–42cm

An attractive and distinctive diving duck. Most records relate to single birds, which share similar habitats to, but usually keep apart from, other *Aythya* species. In flight, all birds show a striking white wingbar on the upperwing, white underwings and a white belly. In all birds, the cap is peaked and the bill is mainly grey, a pale band separating this colour from the dark tip.

!CONFUSION SPECIES!

FEMALE TUFTED DUCK
Page 62

The sexes are similar but separable with care. **ADULT MALE** has rich, reddish-brown plumage, which is darkest on the back, becoming almost black on the rump and tail. Note the white stern, white belly (not visible in swimming birds) and the beady white eye. **ADULT FEMALE** is similar to the adult male but the reddish coloration is duller and the eye is dark. **JUVENILE** is similar to the adult female but with even duller colours. **VOICE** – generally silent. HABITAT AND STATUS A scarce visitor to the region, with perhaps 20 or 30 records each year, most occurring from autumn to early spring. The exact status of the species is confused by the presence of undoubted escapes from captivity. Ferruginous Ducks favour lakes and flooded gravel pits with plenty of submerged and emergent vegetation. OBSERVATION TIPS Visit flooded gravel pits and reservoirs during the winter to stand a chance of finding this species.

J
F
M
A
M
J
J
A
S
O
N
D

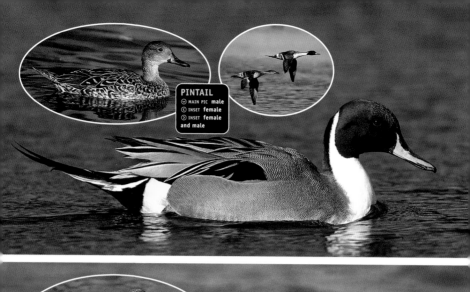

PINTAIL
⊙ MAIN PIC **male**
◐ INSET **female**
⊙ INSET **female and male**

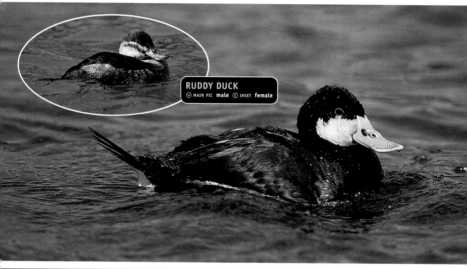

RUDDY DUCK
⊙ MAIN PIC **male** ◐ INSET **female**

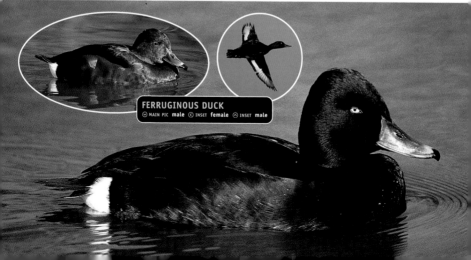

FERRUGINOUS DUCK
⊙ MAIN PIC **male** ◐ INSET **female** ⌃ INSET **male**

SCAUP *Aythya marila* LENGTH 42–51cm

A distinctive and comparatively bulky diving duck. Unlike the superficially simi-
lar Tufted Duck, Scaups of both sexes have rounded heads and lack that species'
tufted crown. Scaups form flocks outside the breeding season, when most
records in the region occur, and these are associated mainly with marine
waters. In flight, both sexes show a striking white wingbar. The sexes are
dissimilar in other plumage details. **ADULT MALE** has a green-glossed
head and dark breast, both of which can look almost black in certain
lights. The belly and flanks are white, the back is grey and the stern is
black. Note the yellow eye and dark-tipped

grey bill. In eclipse plumage, the male resem-
bles an adult male, but dark elements of the plumage are buffish-
brown. **ADULT FEMALE** has essentially brown plumage, palest and
greyest on the flanks and back. Note the conspicuous white facial
patch at the base of the bill. **JUVENILE** is similar to an adult female
but the white patch on the face is less striking. **VOICE** – generally
silent. HABITAT AND STATUS In most years, there are a few instances
where breeding is suspected, typically in the north of the region. However, it is as a winter visitor,
from breeding grounds in Iceland and Scandinavia, that the species is best known. Perhaps as many
as 10,000 birds are present at that time, most frequenting estuary mouths and the enclosed and rel-
atively sheltered waters of large bays and firths. Scaups occur less frequently at inland freshwater loca-
tions such as reservoirs, lochs and flooded gravel pits, and only linger if the supply of bottom-dwelling
invertebrate food is rich. OBSERVATION TIPS In the past, Scaup flocks could be found in the vicinity
of coastal sewage outfalls and at sites where other organic matter was dumped at sea, being attract-
ed by the marine invertebrates that flourished in the wake of this input. Nowadays, with anti-pollution
measures in place, the occurrence of this species is less predictable and less concentrated.

TUFTED DUCK *Aythya fuligula* LENGTH 40–47cm

A widespread and familiar diving duck in most parts of the region. Apart from the
male's distinctive plumage, both sexes can be recognised, even in silhouette,
by the tufted crown; this feature is longer and more distinctive in males than
females. The species forms large flocks in the winter, sometimes in the com-
pany of other diving duck species, as well as Coots. In flight, both sexes
show a striking white wingbar. The sexes are dissimilar in other plumage
details. **ADULT MALE** has essentially black and white plumage, although
a purplish sheen can be seen on the dark
head in good light. The white flanks look
particularly striking on swimming birds. Note

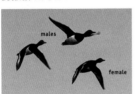

the beady yellow eye and the black-tipped blue-grey bill. In eclipse
plumage, white elements of plumage become buffish-brown. **ADULT
FEMALE** has essentially brown plumage that is palest on the flanks
and belly. Note the limited amount of white at the base of the bill
(cf. female Scaup), the yellow eye and the black-tipped blue-grey
bill. **JUVENILE** is similar to an adult female but with duller eye and plumage colours. **VOICE** – the
male utters a soft peeping call. HABITAT AND STATUS The Tufted Duck is a common year-round resi-
dent, with several thousand pairs breeding in the region; favoured habitats at this time of year include
lakes, reservoirs and flooded gravel pits with plenty of marginal vegetation. In winter, numbers are
boosted by an influx of birds from elsewhere in Europe and peak numbers are likely to exceed 50,000
individuals. At this time of year, Tufted Ducks can turn up on an even wider range of freshwater bodies.
OBSERVATION TIPS An easy species to see and to identify, the only real potential for confusion lying
with the Scaup. Tufted Ducks sometimes occur on urban lakes and can become surprisingly tame if fed
on a regular basis.

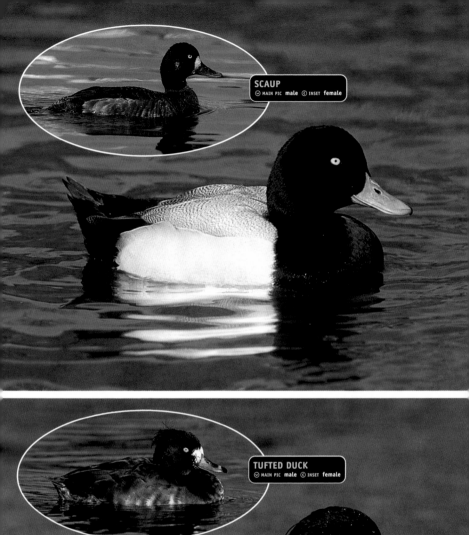

SCAUP
MAIN PIC **male** INSET **female**

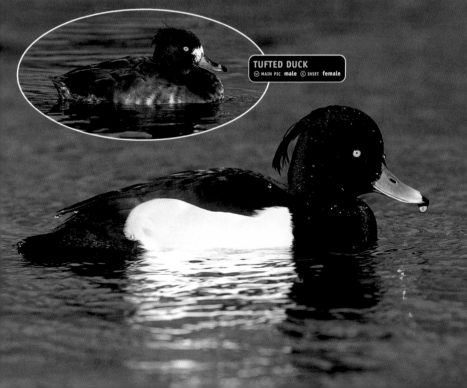

TUFTED DUCK
MAIN PIC **male** INSET **female**

POCHARD *Aythya ferina* LENGTH 42–49cm

A bulky and striking diving duck. Even in silhouette, the Pochard is distinctive, with its proportionately long bill, curving forehead and peaked crown. During the winter months, when the species is most numerous, it forms flocks, sometimes in loose association with Tufted Ducks and Coots. Both sexes have a dark bill marked with a pale grey transverse band. In flight, both sexes have rather grey, uniform wings with a dark trailing edge to the outer flight

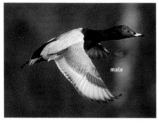

feathers. The sexes are dissimilar in other plumage details. **ADULT MALE** has a reddish-orange head, a black breast, finely marked grey on the flanks and back, and a black stern. In eclipse plumage, the black elements of the plumage are sooty-brown. **ADULT FEMALE** has a brown head and breast, and grey-brown on the back and flanks; typically, a pale 'spectacle' can be seen around the eye. **JUVENILE** resembles an adult female but the plumage is more uniformly brown. **VOICE** – mostly silent. HABITAT AND STATUS The breeding population of Pochards in the region is small, with perhaps just a few hundred pairs nesting each year. However, numbers are swollen considerably in autumn and winter by visitors from elsewhere in Europe, resulting in a non-breeding population that numbers several tens of thousands of birds. Pochards are often found alongside Tufted Ducks and are characteristic winter visitors to flooded gravel pits, reservoirs and larger lochs and lakes. Numbers appear to be on the increase. OBSERVATION TIPS Outside the breeding season, the species is both easy to observe and to recognise: visit almost any sizeable body of water between November and March and you should have little difficulty finding it. Pochards sometimes even occur on surprisingly urban water bodies in winter and can become quite tolerant of people in certain circumstances.

RED-CRESTED POCHARD *Netta rufina* LENGTH 54–57cm

A large and highly distinctive diving duck. Even the comparatively subdued plumage of the female is easily recognised, while the gaudy male is little short of unmistakable. Typically, sightings refer to solitary birds, and these frequently associate loosely with other diving ducks such as Pochards and Tufted Ducks. In flight, both sexes show striking white wingbars. In other plumage respects, the sexes are dissimilar. **ADULT MALE** has a bright orange head that is rounded in appearance. The neck, breast, belly and stern are black, while the flanks are white; this latter feature shows up well in swimming birds. The back is grey-buff and the long, comparatively narrow bill is bright red. In eclipse plumage, the male resembles an adult female but retains the red bill. **ADULT**

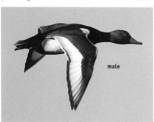

FEMALE has mainly grey-buff plumage that is darkest on the back and above the eye; note, however the conspicuous pale cheeks. The bill is mainly dark with a paler pink tip. **JUVENILE** resembles an adult female, but the bill is uniformly dark. **VOICE** – mostly silent. HABITAT AND STATUS Britain and Ireland are on the fringes of this species' natural range and so some records in the region may refer to genuine vagrants. However, the species is popular in captivity and the vast majority of sightings undoubtedly relate to escapees; feral breeding populations have even become established in a few places. Red-crested Pochards are usually found on large and well-vegetated water bodies such as flooded gravel pits, lowland lakes and long-established reservoirs. OBSERVATION TIPS The species presents few problems when it comes to identification. Of the 50–100 records each year, many are long staying, allowing plenty of opportunity for observation.

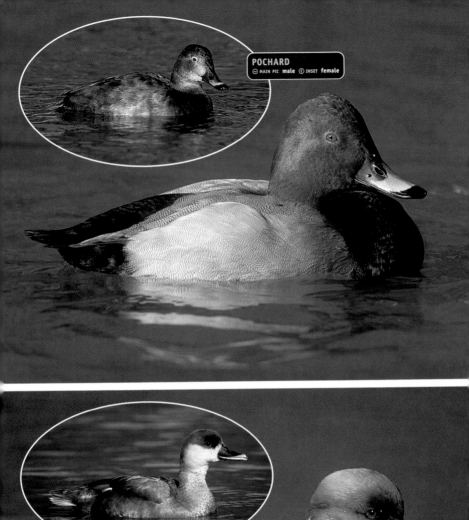

POCHARD
⊙ MAIN PIC **male** ⓒ INSET **female**

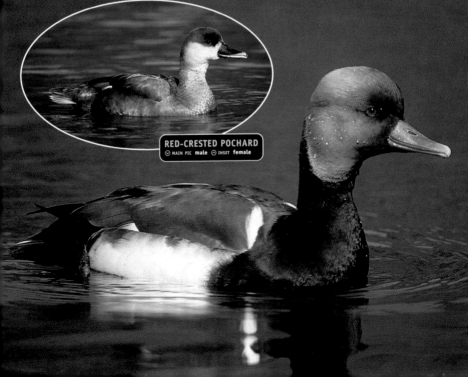

RED-CRESTED POCHARD
⊙ MAIN PIC **male** ⊙ INSET **female**

MANDARIN DUCK *Aix galericulata* LENGTH 41–49cm

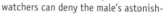

Together with its cousin, the Wood Duck, a male Mandarin Duck must rank as one of the most spectacular of all British birds. The plumage boasts a wide array of colours, many of which are displayed to full advantage on elaborate tufts and plumes. Although dowdy by comparison, even the female is well marked and distinctive. Despite its colourful appearance, British birdwatchers seldom give the species a second glance, many regarding it as 'plastic', to use popular jargon (a derisory term applied to species of captive origin, such as this one). Although it merits little attention in conservation terms as a consequence of its alien origins, few but the most diehard of purist bird-

female

watchers can deny the male's astonishing beauty. The sexes are strikingly dissimilar. **ADULT MALE** has a mane of orange, white, greenish and brown feathers, with white above the eye and elongated orange plumes arising from the cheek area. It also boasts orange sail-like feathers on the back, a dark breast with vertical white stripes, brown flanks and a white stern. The bill is bright red with a pale tip. **ADULT FEMALE** is grey-brown overall, darkest on the back and with pale buffish spots on the flanks. The belly is white, a white 'spectacle' (eye-ring and eye-stripe) surrounds the eye, and there is white at the base of the bill and on the throat. The bill is dull pink with a pale tip. **JUVENILE** resembles an adult female but the colours are duller and the patterns less striking. **VOICE** – mainly silent. HABITAT AND STATUS Originally from China and neighbouring parts of the Far East, this attractive species has long been popular in captivity. Escapes occurred over the years, and in some instances the species was deliberately released into the wild. As a result, a stable population has been established and this is expanding in some areas. There is a horrible irony to the fact that the feral population of Mandarin Ducks in Britain (several thousand individuals) is now probably greater than that across most of its range in the wild. The species favours large, well-vegetated lakes with wooded margins, the latter being important because tree-holes are the preferred nesting site. OBSERVATION TIPS Mandarin Ducks are present in most wildfowl collections and the species is often seen on village duck ponds, too. If you want to see it in more natural circumstances, visit Virginia Water in Windsor Great Park, a favoured haunt in its southeast England stronghold.

WOOD DUCK *Aix sponsa* LENGTH 43–50cm

A distinctive duck, males of which have gaudy and striking plumage. Females, although sombre by comparison, are well marked, although the potential for confusion with a female Mandarin Duck must be considered. The sexes are strikingly dissimilar. **ADULT MALE** has a shiny greenish-blue crown and mane, adorned with white lines. The chin and throat are white, extending onto the face as white lines. The breast is maroon, the flanks are buff and the back is greenish; these three areas are separated by white lines. **ADULT FEMALE** has mainly brown plumage, darkest on the back and head. The breast and flanks are marked with fine buffish streak-like spots. There is a white 'spectacle' around the eye and the white is more extensive than in a female Mandarin Duck. There is a small and well-defined amount of white on the throat and the bill is uniformly dark. **JUVENILE** resembles an adult female but the colours are duller and the patterns less striking. **VOICE** – mostly silent. HABITAT AND STATUS The Wood Duck is a North American native that has established itself to a limited degree, having escaped from wildfowl collections or been deliberately released. It favours well-vegetated lakes with wooded margins. The Wood Duck is a tree-hole-nester and perhaps 20 or 30 pairs breed in the region each year. OBSERVATION TIPS This species can be seen in the wild on mature lakes and gravel pits in central and southern England; Surrey and Berkshire are particular strongholds.

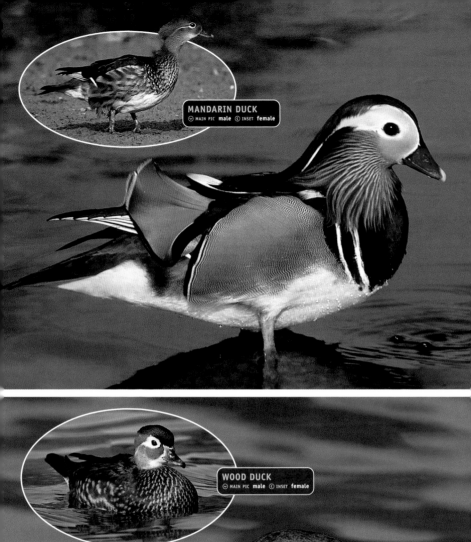

MANDARIN DUCK
⊙ MAIN PIC **male** ⊙ INSET **female**

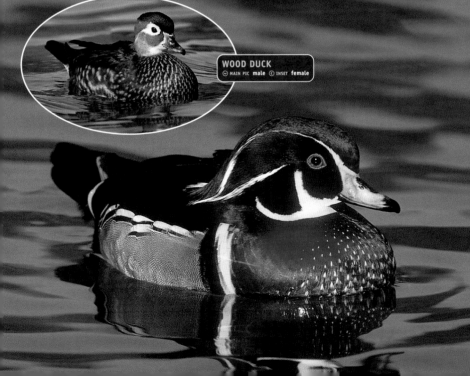

WOOD DUCK
⊙ MAIN PIC **male** ⊙ INSET **female**

LONG-TAILED DUCK *Clangula hyemalis* LENGTH 40–55cm

An elegant and attractive diving duck associated with open seas rather than shel-tered, inshore waters. Long-tailed Ducks are in their element among raging seas, and to watch them bobbing up and down on the swell, or flying along a line of breakers, is an evocative winter sight. The birds dive frequently, in search of bottom-dwelling invertebrates. In flight, note the dark wings and mainly white underparts. The sexes are dissimilar and the plumage of both varies considerably throughout the year. Only the male sports the long tail. **ADULT MALE IN WINTER AND SPRING** looks mainly black, grey and white, with a buffish patch around the eye and a pink band on the bill. **ADULT MALE IN SUM-MER** (seldom seen in the region) **AND IN ECLIPSE PLUMAGE** has mainly brown and black feathering, with white on the belly and flanks, and a pale buff patch around the eye; the bill is rather dark. **ADULT FEMALE IN WINTER** has mainly brown and white plumage; the face is white except for a dark cheek patch and crown. **ADULT FEMALE IN SUMMER** is similar, but the face is mainly brown, with a pale patch around the eye. **JUVENILE** is similar to an adult female in summer but more brown overall. **VOICE** – the male utters a characteristic nasal *ow-owlee*. HABITAT AND STATUS The Long-tailed Duck is essentially a winter visitor to the region, the greatest number (in excess of 10,000 birds) being present between December and early March. Those that visit us come from breeding grounds in Iceland and Norway. The species is usually found off gently shelving, often sandy, beaches and is commonest around Orkney, Shetland and off the northeast coast of Scotland. OBSERVATION TIPS Although Long-tailed Ducks often feed in relatively shal-low seas, the shelving nature of their favoured habitats means that, when viewed from the shore, the birds tend to be distant. Observation is further hindered by the fact that calm days in winter are rare. Cliff-top vantage points overlooking wide, sandy bays often offer the best chances of see-ing the species well, other than in flight. Once in a while, a stray Long-tailed Duck will turn up on a coastal pool, or further inland, affording the opportunity to get much closer, and prolonged, views.

EIDER *Somateria mollissima* LENGTH 50–70cm

A bulky seaduck that dives frequently and for long periods. The Eider is distinctive even in silhouette, on account of the wedge-shaped bill that forms a continuous line with the slope of the forehead. The species is gregarious for most of the year. In summer, several females may band together, accompanied by a 'creche' of youngsters. In flight, males look black and white, while females look mainly dark. Except during the summer moult, the sexes have strikingly dissimilar plumages. **ADULT MALE** has mainly black underparts and white upperparts, except for the black cap, lime green on the nape and a pinkish flush on the breast. In eclipse plumage, the male is mainly a mixture of brown and black, although some white feathering is always visible on the back, and there is a pale stripe above the eye. **ADULT FEMALE** is brown with darker barring, the plumage affording excellent cam-ouflage when the bird is nesting. **JUVENILE** is similar to an adult female, but typically shows a pale stripe above the eye. **VOICE** – the male utters a characteristic, and rather endearing, cooing *ah-whooo*. While doing so, the head is thrown back in a distinctive manner. HABITAT AND STATUS Eiders are almost exclu-sively coastal, nesting close to the seashore and feeding in inshore waters. They favour both estuaries and rocky shores, diving for invertebrate prey, particularly mussels and other molluscs. The species is common around the coasts of Scotland, northeast England and the northern coast of Ireland; several tens of thou-sands of pairs breed in the region. In winter, the Eider's range extends to southern England and a few birds linger year round at souther-ly outposts. OBSERVATION TIPS Since Eiders often feed close to the shore, and are seemingly indifferent to human observers, good views can be had in many parts of northern Britain. For real-ly exceptional encounters, visit the Farne Islands in Northumber-land, where nesting birds can be watched at distances down to 1m!

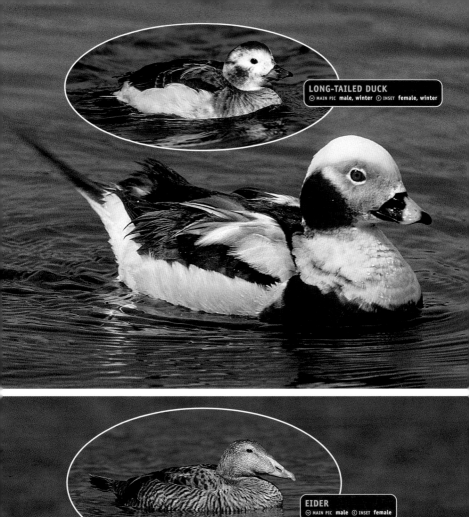

LONG-TAILED DUCK
MAIN PIC **male, winter** INSET **female, winter**

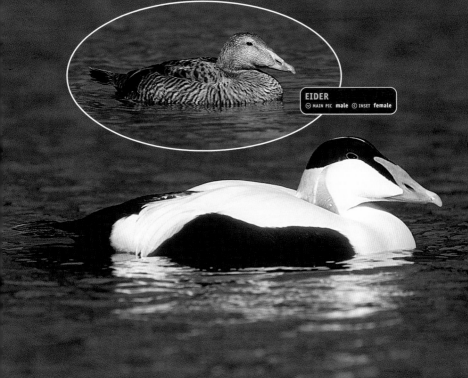

EIDER
MAIN PIC **male** INSET **female**

COMMON SCOTER *Melanitta nigra* LENGTH 44–54cm

A distinctive duck despite, or maybe partly because of, its comparative lack of striking features. In plumage terms, the male is the only all-black duck in the region, and the dark plumage of the female is relieved only by her contrasting pale cheeks. The relatively long tail, which is sometimes elevated when swimming, is a good clue to a bird's identity. Outside the breeding season, Common Scoters are gregarious and you are far more likely to encounter a flock than you are a solitary bird. In flight, they look mainly dark, although in good light the paler flight feathers can sometimes be discerned. **ADULT MALE** has uniformly black plumage. In good light, and at close range, a sheen is visible on the head. The otherwise dark bill has a striking yellow ridge (culmen) and is bulbous at the base. **FIRST-WINTER MALE** is similar to an adult male, although the plumage is browner and the bill is uniformly dark. **ADULT FEMALE** has mainly dark brown plumage but with well-defined pale buff cheeks. **JUVENILE** resembles an adult female. **VOICE** – displaying males utter piping calls. HABITAT AND STATUS During the breeding season, the few Common Scoters that remain in the region (perhaps 100 or so pairs may breed each year) grace northern lakes and lochs; nesting occurs among the waterside vegetation. At other times of the year, the Common Scoter is almost exclusively coastal in its distribution, favouring areas where the seabed is sandy. Sizeable flocks can be found in favoured locations, and several tens of thousands of individuals spend the winter with us. Common Scoters are also frequently seen on passage, presumably heading to and from breeding grounds in Scandinavia and wintering areas in the Bay of Biscay and further south. OBSERVATION TIPS On rough winter days, the only views you are likely to get of Common Scoters is of birds in flight; when sea-watching, they are typically seen in long, trailing lines that snake along the horizon. On calm days, and using a telescope, dense rafts of birds can sometimes be viewed from elevated vantage points overlooking sandy bays. The Moray Firth and Carmarthen Bay are home to sizeable flocks from November to March. Very occasionally, stray birds turn up on inland lakes and reservoirs.

VELVET SCOTER *Melanitta fusca* LENGTH 51–58cm

This bulky duck is similar to, but appreciably larger than, its cousin the Common Scoter. Both sexes show white in the wings (the inner flight feathers), the feature being striking and obvious in flight, but frequently visible, albeit partially, in swimming birds, too. White markings on the head of the male allow for the ready separation of drakes, while with females characteristic facial markings are good features to look for. Velvet Scoters often form a loose association with Common Scoter flocks, the two species favouring similar winter habitats. **ADULT MALE** has mainly black plumage, which serves to highlight the striking white patch seen below the pale eye and, when swimming, glimpsed areas of white on the closed wings. The bill is two-toned yellow and blackish. **FIRST-WINTER MALE** is similar to an adult male but lacks white under the eye. **ADULT FEMALE** has mainly dark sooty-brown plumage, with a pale cheek patch and a pale patch at the base of the bill; the bill is dark. **VOICE** – mainly silent in the region. HABITAT AND STATUS The Velvet Scoter is strictly a non-breeding visitor to the region from its Scandinavian nesting grounds; several thousand birds may be present, mainly between October and March. In common with its cousin, it favours coastal areas, although very occasionally a stray bird may turn up inland on a lake or reservoir. Sandy seabeds are favoured and the birds dive frequently in search of food. OBSERVATION TIPS This species is more tricky to find than its common cousin, but the distinctive white elements to its plumage mean that it can be identified with certainty at a distance, and even in flight. Search among Common Scoter flocks and you should find a few individuals, but for real numbers visit northeast Scotland (particularly the Moray Firth) in winter.

male

female

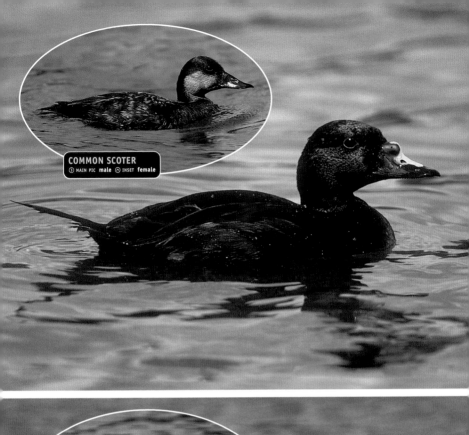

COMMON SCOTER
> MAIN PIC **male** > INSET **female**

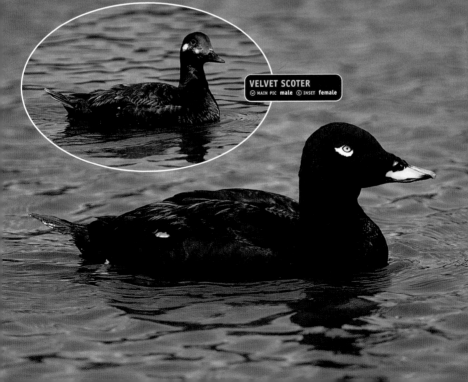

VELVET SCOTER
> MAIN PIC **male** > INSET **female**

GOLDENEYE *Bucephala clangula* LENGTH 42–50cm

A bulky and compact diving duck. Both sexes are striking and easy to recognise, but males have particularly attractive markings. Goldeneyes dive frequently, and for relatively long periods, mainly in search of invertebrate food. In flight, both sexes show white on the inner half of the wings; this feature is more extensive in males than females. In other plumage respects, the sexes are dissimilar. **ADULT MALE** has mainly black and white plumage. The rounded and peaked, green-glossed head is adorned with a beady yellow eye and a conspicuous white patch at the base of the bill. In eclipse plumage, a male resembles an adult female but retains his more striking white wing pattern. **ADULT FEMALE** has mainly grey-brown plumage on the body; this is separated from the dark brown head by a pale neck. Note the beady yellow eye. **JUVENILE** is similar to an adult female but has a dark eye. **VOICE** – displaying males utter squeaky calls and a Garganey-like rattle. HABITAT AND STATUS Thanks in part to the provision of nest boxes under a scheme initiated by the RSPB, perhaps up to 100 pairs of Goldeneyes now breed regularly each year in the region. They are associated with large lakes and lochs, the vast majority being found in the north. These figures are dwarfed during the winter months owing to an influx of birds from Scandinavia and further east. Several tens of thousands of birds can be present between November and March, and at this time of year they are found both on freshwater sites and on the coast, where estuaries and bays are favoured locations. OBSERVATION TIPS The Goldeneye is easiest to find during the winter months, when it is most numerous. A visit to almost any estuary, particularly on the east coasts of England and Scotland, is likely to yield sightings, as will most large lakes, lochs and well-established reservoirs, particularly in the north of the region. Goldeneyes seldom form large flocks and usually dive frequently, making prolonged observation difficult.

J F M A M J J A S O N D

male

SMEW *Mergus albellus* LENGTH 38–44cm

This elegant little diving duck is a so-called 'sawbill', related to mergansers and the Goosander. The male is surely one of the most stunning and striking of all our water birds, its black and white plumage making it almost unmistakable. It might just be possible to confuse the more sombre plumage of the female with that of a grebe in winter plumage. In flight, both sexes show a considerable amount of white on the innerwing, more extensive in males than females. In other respects, the sexes are strikingly dissimilar. **ADULT MALE** looks pure white

J F M A M J J A S O N D

male

at a distance, but a closer view reveals a black patch through the eye and black lines on the breast and back. In eclipse plumage (not seen in the region) the male resembles an adult female but retains the more extensive white on the wing. **ADULT FEMALE, JUVENILE** and **FIRST-WINTER** have an orange-red cap and nape that contrasts with white on the cheeks and throat; the body plumage is grey-brown. Collectively, they are known as 'Redhead' Smew. **VOICE** – silent in the region. HABITAT AND STATUS The Smew is an occasional and unpredictable winter visitor to the region, with perhaps around 100 records each year. Its appearance is usually related to the onset of severe weather at its nearest traditional wintering grounds in the Netherlands, which forces birds (predominantly Redheads) to move west. Unsurprisingly, the majority of records occur in southeast England, with birds turning up on fish-rich flooded gravel pits, reservoirs and lakes. OBSERVATION TIPS Watch the weather maps for mainland Europe during January and February. If the North Sea area, and the Netherlands in particular, experiences a cold snap, visit your local flooded gravel pit or reservoir to look for this species.

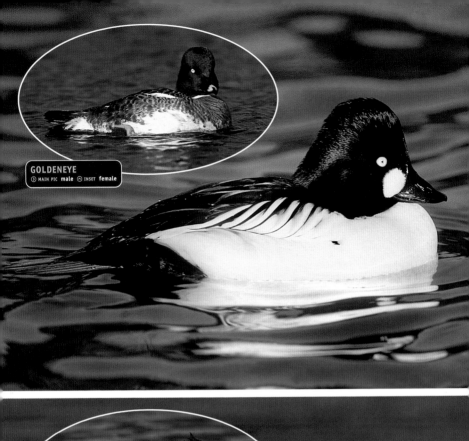

GOLDENEYE
⊙ MAIN PIC **male** ⊙ INSET **female**

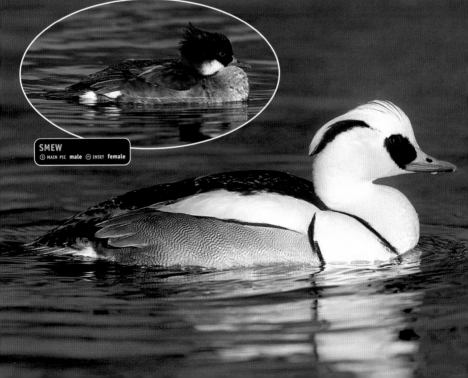

SMEW
⊙ MAIN PIC **male** ⊙ INSET **female**

GOOSANDER *Mergus merganser* LENGTH 58–66cm

A large and elegant diving duck, which swims buoyantly and with a stately posture. Goosanders have a long and relatively narrow bill, the mandibles of which have serrated edges – hence the term 'sawbill' is often applied to them. They dive frequently in search of fish. In flight, the entire upper surface of the male's inner wing is white, while in the female the white is restricted to the trailing edge. The sexes are dissimilar in other plumage details, too. **ADULT MALE** is unmistakable, with a bright red bill, a green-glossed head (which can look dark

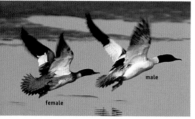

in poor light), a white body and a black back. A close view of the white elements of the plumage reveals them to be flushed with a delicate shade of pink. In eclipse plumage, the male resembles an adult female, although he retains the white wing pattern. **ADULT FEMALE** has a reddish bill, but the head is orange-red with a shaggy crest. The body plumage is greyish and palest on the breast; the chin is white. **JUVENILE** resembles an adult female but with duller plumage colours. **VOICE** – displaying males utter ringing calls. HABITAT AND STATUS Goosanders are associated almost exclusively with freshwater habitats. Typically, they breed beside wooded upland rivers and favour nest sites in tree-holes. A total of 1,000 or more pairs probably nest in the region each year, the majority being found in Scotland, northern England and central Wales. During the winter months there is an influx of birds from mainland Europe, when 5,000 or more individuals may be present. Fish-rich reservoirs, lochs and flooded gravel pits become the main haunts of this species at this time of year. OBSERVATION TIPS Take a spring walk a kilometre or two along almost any wooded, unspoilt upland river within the Goosander's breeding range and you are likely to discover it in small numbers. Understandably, the birds are likely to be nervous and flighty at this time of year, so for more prolonged views visit a reservoir or lake in winter and scan for this species. Don't expect to find large flocks, however, because Goosanders seldom gather in sizeable groups.

RED-BREASTED MERGANSER *Mergus serrator* LENGTH 52–58cm

A distinctive and rather slim diving duck. The Red-breasted Merganser is smaller than its cousin, the Goosander, and both sexes have a rather shaggy, or even spiky, crest on the back of the head. It dives frequently in search of fish. In flight, both sexes show white on the upper surface of the inner wing, the extent of which is greater in males than females. The sexes are strikingly dissimilar in other plumage details, too. **ADULT MALE** has a narrow red bill, a green head,

a white neck and an orange-red breast. The flanks are grey and the back is black. In eclipse plumage, the male is similar to an adult female but retains the extensive white on the wing. **ADULT FEMALE** has a red bill, a dirty orange head and nape, but a paler throat; the body plumage is otherwise greyish-buff. **JUVENILE** resembles an adult female. **VOICE** – mostly silent, although displaying males sometimes utter soft, grunting calls. HABITAT AND STATUS During the breeding season, when 2,000 or so pairs are probably present in the region, Red-breasted Mergansers favour fish-rich lakes and rivers. Their stronghold is Scotland, but the species is also found in northern England, north Wales and in parts of Ireland. Mergansers nest on the ground, in waterside vegetation, so unlike Goosanders they are less tied to wooded watercourses. Outside the breeding season, upwards of 10,000 birds are probably present in the region thanks to an influx from northern Europe. At that time of year the species is almost exclusively coastal, being particularly fond of estuaries. OBSERVATION TIPS In the spring, Red-breasted Mergansers can be found on many large Scottish rivers and lochs, as well as lakes in the Lake District and north Wales. Outside the breeding season, look for them on estuaries around the coast. The species is typically seen in ones and twos, although several may gather in one spot if the feeding is good.

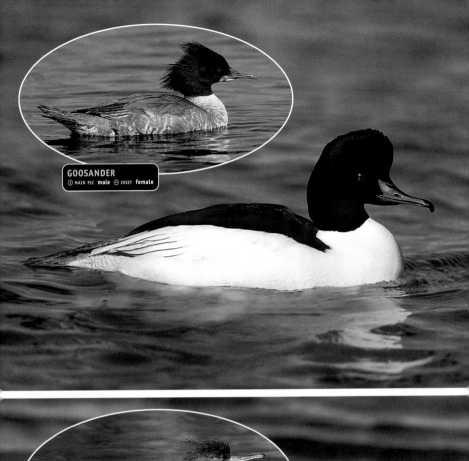

GOOSANDER
▷ MAIN PIC **male** ⌃ INSET **female**

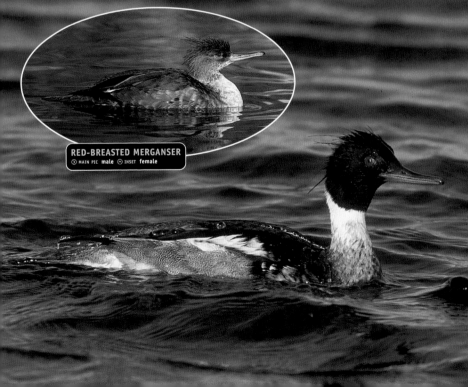

RED-BREASTED MERGANSER
▷ MAIN PIC **male** ⌃ INSET **female**

SPARROWHAWK *Accipiter nisus* WINGSPAN 60–75cm

A widespread and common raptor that catches small birds in flight in surprise, low-level attacks. In terms of abundance, it ranks second only to the Kestrel, although the Sparrowhawk is harder to observe than that species. All birds have relatively short, rounded wings, a proportionately long, barred tail, long legs and staring yellow eyes. The male is appreciably smaller than the female and is separable by plumage details as well as size. **ADULT MALE** has blue-grey upperparts and pale underparts that are strongly barred and reddish-brown on the body and wing coverts. **ADULT FEMALE** has grey-brown upperparts and pale underparts with fine, dark barring. **JUVENILE** has brownish upperparts and pale underparts, strongly marked with broad, brown barring. **VOICE** – utters a shrill *kew-kew-kew* in alarm. HABITAT AND STATUS Typically a bird associated with wooded habitats, both rural and suburban. The twig nest is constructed in a tree – conifers are favoured – and nesting areas tend to form the focal point for a nesting pair's territory. However, hunting may take place both within the woodland itself, or in adjacent farmland or open country. Established birds are typically resident, while juveniles tend to wander in autumn and winter. As many as 30,000 pairs breed in the region; in autumn, the young of that year more than double the total number present. OBSERVATION TIPS During the breeding season, Sparrowhawks are notoriously secretive. Often the only indication of their presence is the discovery of a pile of feathers at a regular 'plucking post' or the sound of alarm calls uttered by unseen birds at the discovery of a human intruder in their territory. In early spring, males are sometimes observed circling high above their territories. At other times of year, observation is really a matter of chance. Hunting birds are most active at dawn and dusk, and an experienced observer can sometimes detect specific Sparrowhawk-inspired alarm calls uttered by tits and other woodland birds.

!CONFUSION SPECIES!

CUCKOO IN FLIGHT
Page 160

adult

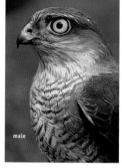

male

GOSHAWK *Accipiter gentilis* WINGSPAN 95–120cm

An impressive, buzzard-sized raptor. In flight, the broad, rounded wings and relatively long but thickset barred tail are noticeable. Circling and soaring birds typically fan their tails, which then appear rounded, and the white, fluffy, undertail coverts are often visible at such times. A close view of a perched bird (an unusual event) will reveal the orange eye, yellow legs and feet, and the striking pale supercilium. The sexes are similar, although males are appreciably smaller than females. **ADULT** has mainly grey-brown upperparts and pale underparts that are marked with fine dark barring. **JUVENILE** has brown upperparts and buffish underparts, the latter heavily marked with dark, teardrop-shaped spots. **VOICE** – utters a harsh *kie-kie-kie* during the breeding season; otherwise silent. HABITAT AND STATUS The Goshawk has staged something of a comeback in recent decades. At the start of the 20th century, the species was effectively extinct in the region, but almost certainly as a consequence of escape and release from captivity, a viable population of several hundred pairs is now present. Goshawk territories are typically centred on wooded habitats, the birds hunting along the margins as well as over adjoining open country for birds the size of Wood-pigeons. OBSERVATION TIPS A distinctly secretive bird, the observation of which is usually a matter of chance. Territorial birds often perform aerial displays on sunny days in late February and early March. For the best chances of observing the species, visit established raptor-watching points in the New Forest in Hampshire, the Forest of Dean and Haldon Forest near Exeter in Devon.

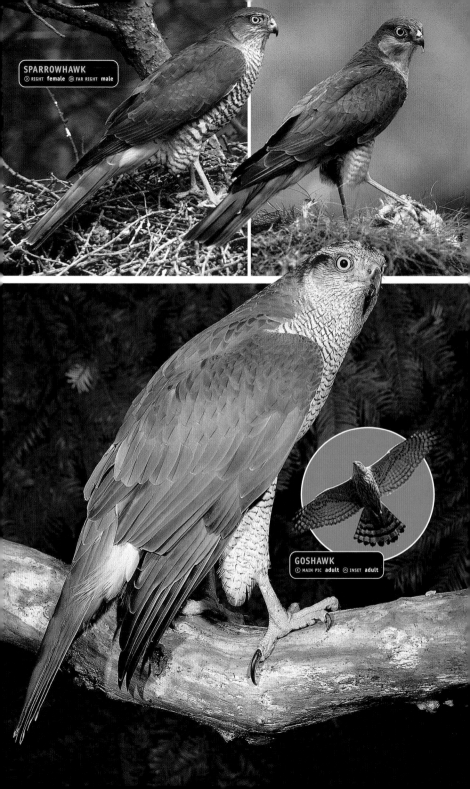

SPARROWHAWK
» RIGHT **female** » FAR RIGHT **male**

GOSHAWK
» MAIN PIC **adult** » INSET **adult**

RED KITE *Milvus milvus* WINGSPAN 145–165cm

An elegant and graceful raptor. It is readily identified on the wing by its deeply forked tail, which is constantly twisted as an aid to flight control, and by its long, bowed wings. The Red Kite seldom spends much time on the ground, except when hunting earthworms, but occasionally it will perch in trees for prolonged periods. The sexes are similar. **ADULT** has a pale grey head but otherwise it looks reddish-brown overall when perched. At close range, the yellow eye, base of the bill and legs can be discerned. When seen from below in flight, note the reddish-brown body and underwing coverts, the silvery-grey tail and patch on the primaries, and the otherwise dark wings. From above, the tail appears red, while the reddish-brown back and wing coverts contrast with the dark flight feathers. **JUVENILE** resembles an adult but has rather subdued colours and pale tips to the wing coverts. **VOICE** – utters shrill calls in flight, not unlike somebody whistling for their dog. HABITAT AND STATUS Until as recently as the late 1980s, the status of the Red Kite in Britain was essentially that of a relict population confined to moors and neighbouring wooded valleys in central Wales. However, a series of reintroduction programmes in England and Scotland has changed all that and viable populations now exist at several sites across the region. Information about numbers and breeding success is guarded and necessarily sketchy at best, but it is likely that several hundred pairs now nest in the region as a whole. Red Kites favour areas where a mosaic exists of open country, including farmland, and scattered patches of woodland for nesting and roosting. OBSERVATION TIPS If you visit one of a handful of honeypot sites for the species, then seeing a Red Kite should not present a problem. Winter feeding stations near Tregaron and Rhayader in central Wales typically attract 50 or more birds at once, and significant numbers are also present in the Chilterns, particularly along the M40 corridor in the vicinity of Christmas Common. Elsewhere in the region, encountering a Red Kite is more a matter of luck. Birds, and particularly young of the year, often wander in autumn and winter, turning up in some unlikely places.

MARSH HARRIER *Circus aeruginosus* WINGSPAN 110–125cm

A graceful raptor, typically associated with wetland habitats. It is easiest to observe in flight, and is typically seen quartering the ground at a slow pace, occasionally stalling and dropping into the vegetation to catch prey. The sexes are dissimilar. **ADULT MALE** is reddish-brown except for the blue-grey head and the grey, unbarred tail. In flight, note the grey and reddish-brown areas on the wings and the black wingtips. **ADULT FEMALE** is mainly dark brown, except for the pale leading edge to the wings and the pale cap and chin. A good view reveals the tail to be reddish-brown. **JUVENILE** is similar to an adult female but the tail is dark brown. **VOICE** – mainly silent, but displaying birds sometimes utter a whining call. HABITAT AND STATUS In Britain, Marsh Harriers are rightfully thought of as classic wetland birds, invariably associated with extensive reedbeds and marshes during the breeding season. On migration, of course, they can be seen in other open country habitats. Perhaps 100 or so pairs of Marsh Harriers attempt to breed each year, the majority in East Anglia and many in sites protected by reserve status. Most birds migrate to the Mediterranean region and further south in autumn, although a handful remain in Britain throughout the year. OBSERVATION TIPS For the best opportunities to observe this species, visit one of the East Anglian wetland and reedbed reserves in spring. Titchwell and Minsmere, both RSPB reserves, are classic locations for Marsh Harriers.

!CONFUSION SPECIES!

BUZZARD
IN FLIGHT
Page 82

MONTAGU'S
HARRIER
Page 80

juvenile

juvenile

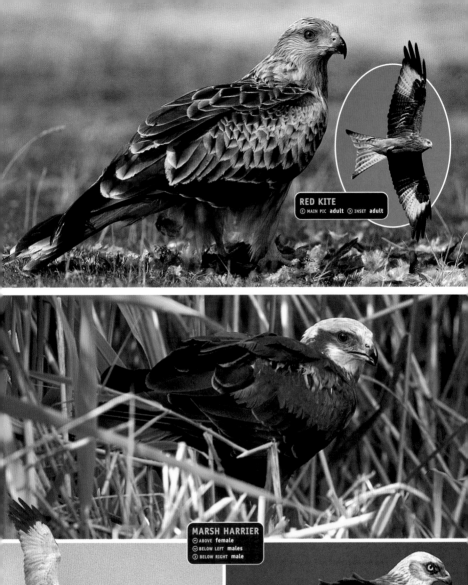

RED KITE
◁ MAIN PIC **adult** ▷ INSET **adult**

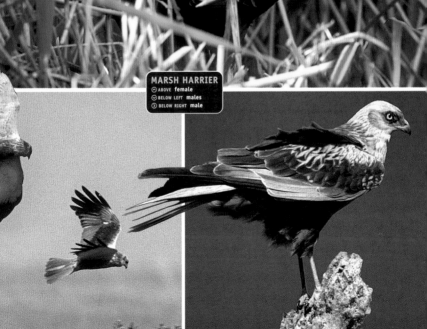

MARSH HARRIER
⌃ ABOVE **female**
⌄ BELOW LEFT **males**
▷ BELOW RIGHT **male**

MONTAGU'S HARRIER *Circus pygargus* WINGSPAN 100–115cm

A graceful raptor that is capable of slow, buoyant flight. Typically, the species quarters the ground, occasionally plunging into cover after prey. The sexes are dissimilar. When seen well, males are relatively easy to identify, but females

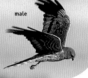

!CONFUSION SPECIES!

MARSH HARRIER
IN FLIGHT
Page 78

and juveniles are a challenge to separate from corresponding plumages of Hen Harrier. The proportionately narrower and longer wings of Montagu's Harrier are useful aids to identification. **ADULT MALE** has mainly blue-grey plumage with a smaller extent of white on the rump than in a male Hen Harrier. Note the black wingtips, the single dark bar on the upperwing and the two dark bars on the underwings; at close range, chestnut barring on the underwing coverts and streaking on the belly are visible. **ADULT FEMALE** has pale brown plumage with darker barring on the wings and tail, and streaking on the body underparts. Note also the narrow white rump. **JUVENILE** recalls an adult female, but the underparts and underwing coverts are orange-red and unstreaked. **VOICE** – mainly silent. **HABITAT AND STATUS** Montagu's Harrier is a summer visitor to the region, migrating here from wintering grounds in Africa. The species reaches the northern limits of its range in southern Britain, and no more than a handful of pairs nest here each year; passage migrants can also be seen in spring and autumn. In the recent past, breeding birds have favoured both arable farmland and heathland. OBSERVATION TIPS Nests that are discovered in time are usually guarded by appropriate conservation organisations. Although these are seldom publicised, for obvious reasons, news about sites where visitor access is permitted sometimes filters onto the grapevine. If you want to find a Montagu's Harrier for yourself, either visit a coastal birdwatching site in spring or autumn, or search suitable habitats during the breeding season; north Norfolk and the Hampshire–Wiltshire border are the most likely locations. Of course, if you discover a potential breeding pair, tell the RSPB or your local Wildlife Trust, but nobody else.

female

male

HEN HARRIER *Circus cyaneus* WINGSPAN 100–120cm

A distinctive raptor, and the harrier most likely to be encountered in the region. Typically, Hen Harriers are seen gliding at slow speed, low over the ground with almost effortless ease and seldom a wingbeat. In direct flight, the wingbeats are deep and powerful. The sexes are dissimilar and confusion with corresponding plumages of Montagu's Harrier is always a possibility. Time of year and habitat are useful pointers to identification: Hen Harrier is the only species you are likely to encounter in open country in the winter months. **ADULT MALE** has pale blue-grey plumage except for the white belly, white rump and the black wingtips. **ADULT FEMALE** is brown with darker barring on the wings and tail, streaking on the body underparts and a narrow white rump. **JUVENILE** is similar to an adult female, but the breast and underwing coverts are more reddish and the upperwing coverts are brighter and show more contrast. **VOICE** – mainly silent. HABITAT AND STATUS During the breeding season, Hen Harriers are found in upland and northern areas, typically favouring heather- and grass-covered moors. Between 500 and 1,000 pairs probably attempt to nest in the region each year. Sadly, the species is still illegally persecuted, particularly on grouse moors, and an appreciable number of nests are destroyed, and birds shot, each year. During the winter months, birds spread to more low-lying areas throughout the region, favouring heaths and coastal fields in particular. Influxes of birds from mainland Europe sometimes occur in harsh winters. OBSERVATION TIPS Hen Harriers are probably easiest to see in winter; the East Anglian coast (particularly north Norfolk) and the New Forest in Hampshire are always reliable locations. During the breeding season, a drive across Scottish moorland may yield sightings, and the species is almost guaranteed if you visit the Isle of Man or Orkney between May and July.

male

female

J
F
M
A
M
J
J
A
S
O
N
D

J
F
M
A
M
J
J
A
S
O
N
D

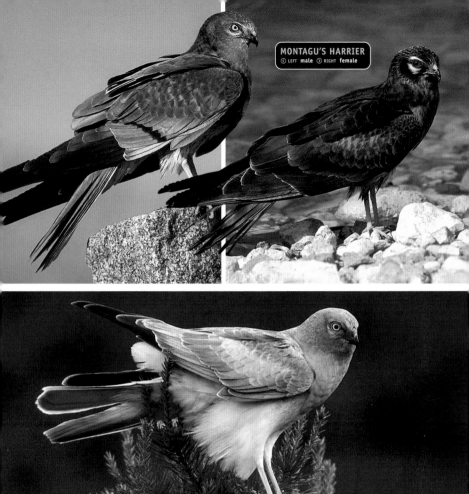

MONTAGU'S HARRIER
◁ LEFT **male** ▷ RIGHT **female**

HEN HARRIER
⌒ ABOVE **male** ▷ RIGHT **female**

BUZZARD *Buteo buteo* WINGSPAN 115–130cm

A bulky, broad-winged raptor and the commonest medium-sized bird of prey in the region. Observers are often alerted to the presence of distant, soaring birds by the distinctive call. Soars effortlessly, often with the broad, rounded wings held in a shallow 'V' and with the tail fanned out. The plumage is remarkably variable (seemingly all-dark and almost white birds are extreme examples of this), but most birds are brown overall. Given this plumage variability, the sexes are broadly similar, although females are larger than males. **ADULT** has rather uniformly brown upperparts.

!CONFUSION SPECIES!

**GOLDEN EAGLE
IN FLIGHT**
Page 86

Seen perched, the breast is finely barred and typically paler than the throat or belly. In flight and when seen from below, the flight feathers and tail are grey and barred; there is a dark trailing edge to the wings and the tail shows a dark terminal band. The body and underwing coverts are contrasting dark (the carpal patch is usually darkest), and a pale breast band and pale band on the underwing coverts can sometimes be discerned. **JUVENILE** is similar to an adult but lacks the terminal dark band on the tail and obvious dark trailing edge to the wings. **VOICE** – utters a distinctive mewing *pee-ay*. HABITAT AND STATUS Once persecuted by gamekeepers to the point of local extinction in many parts of the region, and having declined further as the result of pesticide contamination, the Buzzard is staging something of a comeback. During the latter half of the 20th century, the species' stronghold was in Wales, Scotland and northern and western England, but from the mid-1990s onwards the range has been expanding eastwards. Continued persecution (poisoning and shooting) notwithstanding, it may not be long before Buzzards return to all suitable habitats across the region. There may well be as many as 15,000 pairs in the region and hopefully this figure is increasing. Typically, adult Buzzards are territorial residents, favouring a patchwork of open country (including farmland) with scattered woodland for nesting. Juvenile birds are forced to wander from their first winter onwards in search of new territories. OBSERVATION TIPS The species is not hard to observe in western and northern parts of the region. Buzzards are usually most vocal and easiest to observe at the start of the breeding season (February and March) and again when the young have fledged (June–August).

ROUGH-LEGGED BUZZARD *Buteo lagopus* WINGSPAN 125–140cm

A bulky, medium-sized and proportionately long-winged raptor. It is superficially similar to the Buzzard but in most cases individuals are separable with care, using plumage details and behaviour. In flight and from above, the pale base to the tail gives the Rough-legged Buzzard a white-rumped appearance, while from below the dark carpal patches and belly are striking. Birds hover more frequently than do Buzzards, often surprisingly low over the ground. The sexes are separable with care. **ADULT MALE** has brown upperparts, except for the white tail, which has a dark terminal band and a smaller second bar. From below, the underparts appear rather pale except for the dark head, carpal patches, wingtips and trailing edge to the wing; the pale tail is tipped with two dark bands. **ADULT FEMALE** is similar to an adult male but shows a dark belly and a single dark terminal band on the tail. **JUVENILE** is similar to an adult female but the dark markings (especially on the tail) are indistinct. **VOICE** – mainly silent. HABITAT AND STATUS The Rough-legged Buzzard is a winter visitor to the region from mainland Europe in variable numbers. In most years, there might be fewer than 20 records, mostly from sites close to the east coasts of England and Scotland. In exceptional years, influxes of up to 100 birds have occurred, factors contributing to their departure from mainland Europe including harsh weather conditions, low prey density, or both. The species favours open habitats, including coastal marshes and grassland. OBSERVATION TIPS To stand a chance of seeing this species, visit coastal areas in East Anglia or east Kent during the winter months. Rough-legged Buzzards spend lengthy periods unobtrusively perched or sitting on fenceposts, so you may have to wait a while before a potential candidate takes to the wing and allows certain identification.

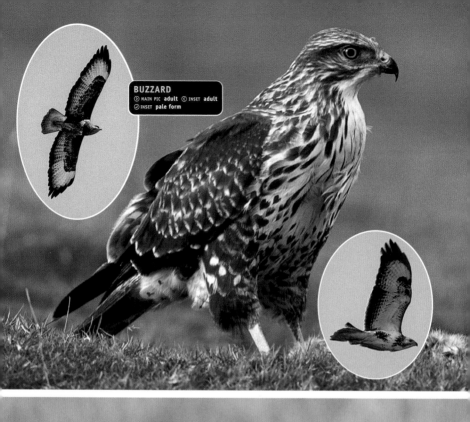

BUZZARD
⊙ MAIN PIC **adult** ⊙ INSET **adult**
⊙ INSET **pale form**

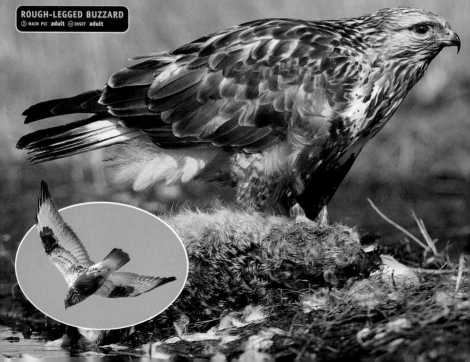

ROUGH-LEGGED BUZZARD
⊙ MAIN PIC **adult** ⊙ INSET **adult**

HONEY-BUZZARD *Pernis apivorus* WINGSPAN 135–150cm

An intriguing raptor with an unusual diet: it specialises in raiding the nests of bees and wasps, and its diet comprises both larvae and adults of these insects. In flight, it is superficially similar to a Buzzard but is separable with care. At a distance, note the proportionately longer tail and wings, and the fact that the wings are held slightly downcurved when soaring. A closer view reveals distinct plumage differences and the relatively small, elongated and almost cuckoo-like head. The sexes are similar. **ADULT** is rather variable, but typically it has brownish upperparts, pale underparts, a grey head and an evenly barred grey tail. At close range, the yellow eye and rather long, narrow bill can be appreciated. In flight and from below, note the evenly barred

!CONFUSION SPECIES!

BUZZARD IN FLIGHT Page 82

tail, dark carpal patch and conspicuous barring on the underwing. **JUVENILE** is similar to the adult but usually browner overall and with less distinct barring on the underwing coverts. **VOICE** – mainly silent. **HABITAT AND STATUS** The Honey-buzzard is a summer visitor to the region, spending the winter months in Africa. It is associated with areas of large and relatively undisturbed woodland where its insect prey are numerous. The precise number of breeding Honey-buzzards in the region varies annually and is shrouded in secrecy, mainly for fear of attracting the unwelcome attentions of egg-collectors. In most years it is likely that no more than a dozen or so pairs attempt to nest. The species is also seen on migration; in some autumns, a steady trickle of birds passes through the region during periods of easterly winds. OBSERVATION TIPS For the best chances of seeing a passage migrant Honey-buzzard, visit the east coast of England in early September when the wind is from an easterly or southeasterly direction. During the breeding season, visit the New Forest in Hampshire. However, be warned that the typical view obtained there will be of a distant, flying bird. Count yourself extremely fortunate if you manage to observe an individual perched in a tree or on the ground.

OSPREY *Pandion haliaetus* WINGSPAN 145–160cm

The classic fish-eating raptor, which invariably is associated with water. In soaring flight, with its rather long, narrow wings, an Osprey can look rather gull-like. However, when fishing it is unmistakable: it frequently hovers and then plunges, talons first, into the water. The sexes are similar. **ADULT** has mainly brown upperparts, except for the pale crown, while the underparts are whitish with a darker chest band. In flight and from below, looks rather pale, but note the dark carpal patch, dark band along the base of the flight feathers and dark terminal band on the barred tail. **JUVENILE** is similar to the adult but the darker markings (notably the dark tip to the tail and dark line at the base of the flight feathers) are less distinct. **VOICE** – utters various whistling calls. HABITAT AND STATUS

!CONFUSION SPECIES!

LARGER GULLS IN FLIGHT, seen from below Page 138

The Osprey is a migrant visitor to the region. It is seldom seen far from water, and even passage migrants habitually gravitate towards fish-rich reservoirs and lakes outside their breeding range. During the breeding season, large water bodies in northern Britain (particularly Scotland) are the favoured haunts of the species. Following a period of extinction, recolonisation of Scotland occurred in the 1950s. Subsequently the species spread naturally across much of that country and gained a presence in northern England, too. The Osprey has also been introduced to sites further south in England, notably Rutland Water, and hopefully it will become fully established there and elsewhere. OBSERVATION TIPS Passage-migrant Ospreys can be encountered by chance in spring and autumn; particularly in the latter season, birds sometimes linger for a few days at fish-rich lakes and flooded gravel pits as they head south. However, if you want a guaranteed sighting, then you need to visit one of the honeypot sites, such as the RSPB's Loch Garten reserve. However, you should have little difficulty finding the species elsewhere in Scotland if you visit suitable habitats at the right time of year.

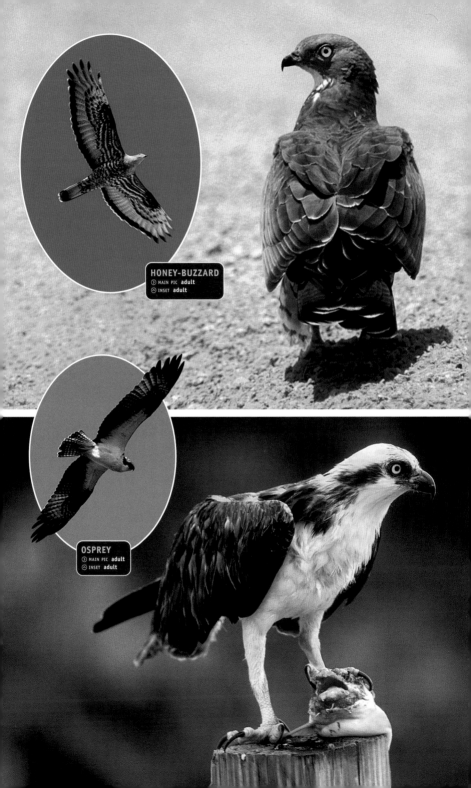

HONEY-BUZZARD
MAIN PIC **adult**
INSET **adult**

OSPREY
MAIN PIC **adult**
INSET **adult**

GOLDEN EAGLE *Aquila chrysaetos* WINGSPAN 190–225cm

A majestic and impressive raptor. Seen at a great distance in flight (when the size may not be apparent) it could perhaps be confused with a soaring Buzzard. However, even in silhouette, a closer view reveals significant differences, notably the proportionately longer wings, which narrow appreciably towards the base, and the relatively long tail. Catches live prey such as Mountain Hares and Red Grouse, but also feeds on carrion, especially in winter. The sexes are similar, but adults, juveniles and sub-adults are separable with care. **ADULT** has mainly dark brown plumage, with paler margins to the feathers on the back and golden-brown feathers on the head and neck. The tail is dark-tipped and barred but, in flight and against the sky, it can look rather uniformly dark. **JUVENILE** is similar to the adult, but note the striking white patches at the base of the outer flight feathers; the tail is mainly white but has a broad, dark tip. **SUB-ADULT** gradually loses the white elements of juvenile plumage by successive moults over several years. **VOICE** – mainly silent. HABITAT AND STATUS The Golden Eagle is a resident of remote, upland regions in north and northwest Britain. Scotland remains its stronghold, with 400 or so pairs present, but the species also has a toehold in northern England, too. Human disturbance, particularly in the vicinity of potential nest sites, often dictates whether any given area of open moorland and mountains will be occupied by Golden Eagles. Sadly, the species is still persecuted by gamekeepers and others with a commercial interest in these habitats. During the winter months, immature birds disperse and occasionally wander south of the species' usual range. OBSERVATION TIPS If you spend just a few days travelling around the Scottish Highlands and Islands, you will be unlucky not to see the species. Be warned, however, that most sightings are likely to involve rather distant views of soaring birds. Spend a day walking in the Cairngorm Mountains, though, and you might be lucky enough to have a closer, and more prolonged, encounter.

!CONFUSION SPECIES!

**BUZZARD
IN FLIGHT**
Page 82

WHITE-TAILED EAGLE *Haliaeetus albicilla* WINGSPAN 190–240cm

An immense raptor that is even larger and longer-winged than a Golden Eagle. In soaring flight, note the long, broad and parallel-sided wings, and the relatively short, wedge-shaped tail (which is only white in adult birds); often the neck looks rather long as well. Despite their size, White-tailed Eagles are surprisingly manoeuvrable, capable of catching fish and waterbirds while hunting low over water. The sexes are similar, but adults and juveniles are separable. **ADULT** has mainly brown plumage that is palest on the head and neck. At rest, the white tail is often obscured by the wings. At close range, the yellow bill and legs can be discerned. In flight and from below, it looks mainly dark except for the paler head and neck, and the white tail. **JUVENILE** is similar to an adult but it appears darker overall and the tail is uniformly dark.

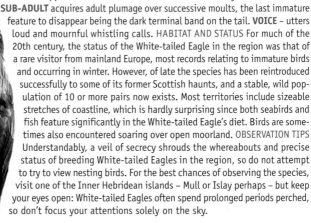

adult

SUB-ADULT acquires adult plumage over successive moults, the last immature feature to disappear being the dark terminal band on the tail. **VOICE** – utters loud and mournful whistling calls. HABITAT AND STATUS For much of the 20th century, the status of the White-tailed Eagle in the region was that of a rare visitor from mainland Europe, most records relating to immature birds and occurring in winter. However, of late the species has been reintroduced successfully to some of its former Scottish haunts, and a stable, wild population of 10 or more pairs now exists. Most territories include sizeable stretches of coastline, which is hardly surprising since both seabirds and fish feature significantly in the White-tailed Eagle's diet. Birds are sometimes also encountered soaring over open moorland. OBSERVATION TIPS Understandably, a veil of secrecy shrouds the whereabouts and precise status of breeding White-tailed Eagles in the region, so do not attempt to try to view nesting birds. For the best chances of observing the species, visit one of the Inner Hebridean islands – Mull or Islay perhaps – but keep your eyes open: White-tailed Eagles often spend prolonged periods perched, so don't focus your attentions solely on the sky.

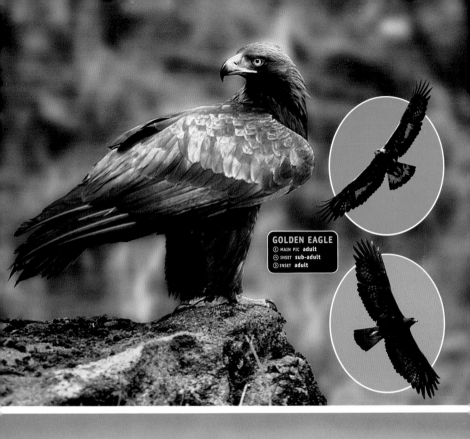

GOLDEN EAGLE
ⓒ MAIN PIC **adult**
ⓘ INSET **sub-adult**
ⓘ INSET **adult**

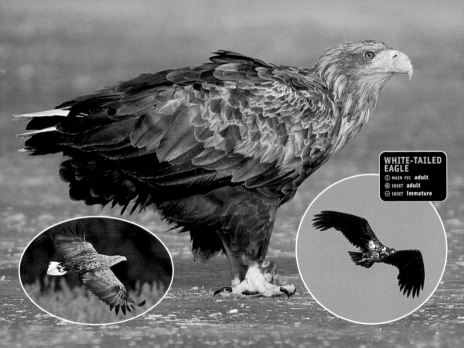

WHITE-TAILED EAGLE
ⓒ MAIN PIC **adult**
ⓘ INSET **adult**
ⓘ INSET **immature**

KESTREL *Falco tinnunculus* WINGSPAN 65–80cm

A widespread and familiar small falcon and the region's commonest raptor. The species habitually hovers where lookout perches are not available, scanning the ground below for small mammal prey; it will also take small birds and insects. Hunting Kestrels are also a familiar sight along motorway verges. The sexes are dissimilar. **ADULT MALE** has a spotted, orange-brown back, a blue-grey head, and a blue-grey tail that has a black terminal band. The underparts are creamy-buff with bold black spots on the body. In flight and from above, the dark outer wing contrasts with the orange-brown inner wing and back. **ADULT FEMALE** has barred brown upperparts with underparts that are pale creamy-buff and adorned with dark spots. In flight and from above, the contrast between the brown inner wing and dark outer wing is less distinct than with the male, and the tail is barred along its length. **JUVENILE** resembles an adult female but the upperparts are more reddish-brown. **VOICE** – utters a shrill and insistent *kee-kee-kee*. HABITAT AND STATUS The Kestrel can be found in all kinds of open, grassy places and as a consequence it occurs across almost the whole of the region. Favoured habitats include meadows and commons, roadside verges, coastal grassland and moors. Kestrels have even colonised surprisingly urban areas, ledges on buildings replacing tree-holes and cliff ledges as nesting sites. The species' success, and hence the density at which it occurs in any given area, is directly related to the abundance or otherwise of prey, mainly small mammals such as Short-tailed Voles and Wood Mice. In most years, however, 50,000 pairs may attempt to breed. Upland Kestrels tend to vacate their territories during the winter months, moving to lower-lying regions and joining the essentially resident birds that occur there. OBSERVATION TIPS Few tips are needed for observing Kestrels. A relatively short drive along a stretch of motorway or dual carriageway is likely to yield sightings of the species. For more prolonged views, coastal birds often provide the best opportunities – sometimes a cliff-top walk may reward the observer with an eye-level view of a hovering bird.

!CONFUSION SPECIES!

SPARROWHAWK
IN FLIGHT
Page 76

female

male

MERLIN *Falco columbarius* WINGSPAN 60–65cm

A tiny falcon, and the region's smallest raptor. Typically seen flying low over the ground in dashing, hunting flight while pursuing prey such as Meadow Pipits. Also perches for extended periods on lookout, using fenceposts or rocky outcrops. A soaring Merlin could perhaps be confused in silhouette with a small Peregrine; by contrast, its low, dashing flight is vaguely reminiscent of a Sparrowhawk. The sexes are dissimilar. **ADULT MALE** has blue-grey upperparts and buffish, streaked and spotted underparts. In flight and from above, note the contrast between the blue-grey back, inner wings and tail with the dark wingtips and dark terminal band on the tail. **ADULT FEMALE** has brown upperparts and pale underparts that are adorned with large, brown spots. In flight and from above, the upperparts look rather uniformly brown, with numerous bars on the wings and tail. **JUVENILE** closely resembles an adult female. **VOICE** – mainly silent, although a shrill *kee-kee-kee* is uttered in alarm near the nest. HABITAT AND STATUS Merlins can be found in Britain throughout the year but their summer and winter distributions show marked differences. During the breeding season, upland moorland is favoured, typically where heather species predominate. In winter, these areas are largely vacated, in the main because prey species such as Meadow Pipits and Skylarks are absent; at such times, Merlins are found on lower-lying districts, a significant proportion of records being coastal. Perhaps 1,000 or more pairs of Merlins breed in the region, and numbers are boosted in winter by young of the year and by winter visitors from Iceland. OBSERVATION TIPS Merlins are vulnerable (and still persecuted) during the breeding season, so no attempt should be made observe the species at the nest. However, take a drive, or walk, across a heather moor in Wales, northern England or Scotland and you stand a good chance of seeing the species, albeit briefly, on the wing. During the winter months, visit areas of coastal grassland.

!CONFUSION SPECIES!

PEREGRINE
IN FLIGHT
Page 90

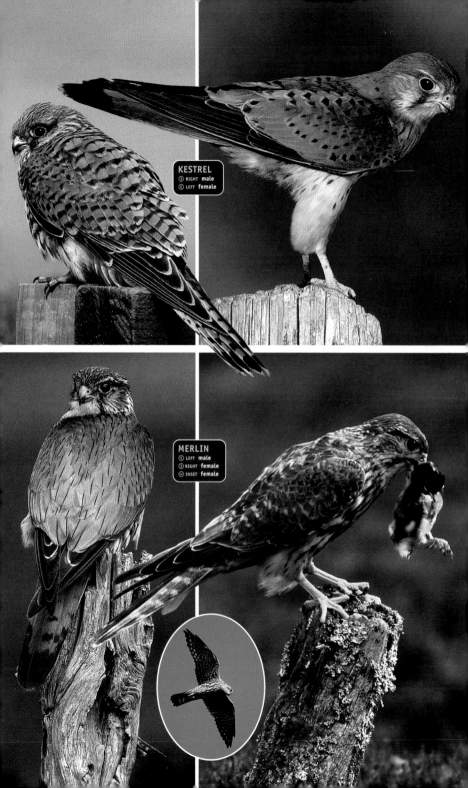

KESTREL
→ RIGHT **male**
← LEFT **female**

MERLIN
← LEFT **male**
→ RIGHT **female**
⌄ INSET **female**

HOBBY *Falco subbuteo* WINGSPAN 70–85cm

An elegant, Kestrel-sized raptor that is sometimes seen in stooping pursuit of prey or in soaring flight. Its aerial mastery allows it to catch prey as fast and as agile as Swifts, hirundines and even dragonflies. Generally though, the Hobby is rather unobtrusive and is surprisingly easy to overlook during the breeding season. In silhouette, it looks to have proportionately longer and narrower wings than a Peregrine, and a longer tail, too; at times, it can also recall an outsized Swift. The sexes are similar. **ADULT** has blue-grey upperparts and pale, dark-streaked underparts. At close range, note the dark moustachial markings, the white cheeks and the reddish-orange 'trousers'. **JUVENILE** is similar to an adult but lacks the reddish 'trousers' and the underparts look buffish overall. **VOICE** – utters a shrill *kiu-kiu-kiu* in alarm. HABITAT AND STATUS The Hobby is a summer visitor to the region, with the majority of breeding records coming from south and southeast England. Most adults arrive back on their territory in late April and depart again by mid-August, although passage migrants sometimes linger later in the season in coastal districts. During the breeding season, heathland and areas of farmland with scattered woods are favoured; on migration, a Hobby could turn up almost anywhere. Between 500 and 1,000 pairs are probably present in the region in the summer months. OBSERVATION TIPS Hobbies are thinly distributed across farmland in much of the southern half of England. However, they are not easy to find in such habitats. Probably the best opportunities come by visiting flooded gravel pits in the region in early May, when newly emerged dragonflies (a favourite food of recently arrived Hobbies) should be abundant. Other than that, a visit to the New Forest in Hampshire, or any other sizeable area of southern heathland, is a good idea.

!CONFUSION SPECIES!

SPARROWHAWK IN FLIGHT Page 76

PEREGRINE *Falco peregrinus* WINGSPAN 95–115cm

A robust and stocky falcon and, without doubt, one the region's most impressive raptors. The Peregrine often soars on rather broad, bowed wings, but it stoops with its wings swept back at phenomenal speed on prey such as pigeons. The sexes are similar. **ADULT** has dark blue-grey upperparts and pale, barred underparts. Note the characteristic dark mask on the face and the powerful yellow legs and feet. In flight and from above, it looks rather uniform in colour, although the rump may appear paler; from below, the pale underparts are distinctly barred and the contrast between the pale cheeks and throat, and dark moustache, is usually striking. **JUVENILE** is similar to an adult, but the upperparts are brownish while the paler underparts are suffused with buffish-orange. **VOICE** – utters a loud and distinctive *kek-kek-kek* in alarm. HABITAT AND STATUS The Peregrine is a widespread resident in Scotland, Wales, parts of Ireland, and northern and southwestern England. The species' current status is a far cry from the situation in the 1950s and 1960s, when the population crashed as a consequence of organochlorine pesticide contamination. Since the withdrawal of these chemicals, the Peregrine has staged a dramatic comeback and has now even begun to colonise towns and cities in southern England. More typically, however, birds favour windswept mountains and coastal cliffs, although the more inhospitable upland regions are often abandoned in winter in favour of lower-lying districts. There are probably in excess of 1,000 pairs of Peregrines in the region and, hopefully, this figure is set to rise. OBSERVATION TIPS Although it is entirely possible to see Peregrines these days in places as unlikely as London, Chichester or even Basingstoke, stretches of rugged coastline in southwest England, west Wales and Scotland offer the best chances of seeing this dramatic species. In spring, displaying birds often call to one another and in late summer family parties are similarly vocal.

!CONFUSION SPECIES!

KESTREL IN FLIGHT Page 88

J F M A M J J A S O N D

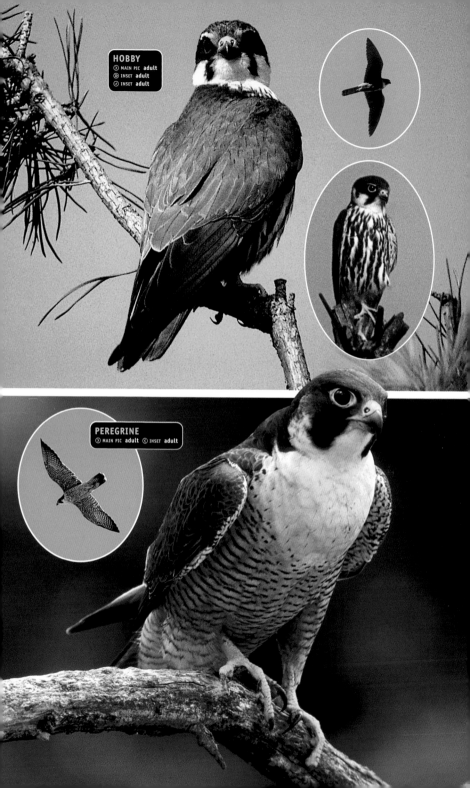

HOBBY
⟩ MAIN PIC **adult**
⟩ INSET **adult**
⟩ INSET **adult**

PEREGRINE
⟩ MAIN PIC **adult** ⟨ INSET **adult**

RED-LEGGED PARTRIDGE *Alectoris rufa* LENGTH 32–34cm

A dumpy and well-marked gamebird. The Red-legged Partridge is often seen in small parties (coveys), particularly outside the breeding season. The species is understandably wary, since it is widely hunted. It prefers to run from danger, but when forced to take to the air it flies low on stiffly held wings. The sexes are similar. **ADULT** has a red bill and legs, and a white throat that is bordered with a gorget of black spots. The plumage is otherwise mainly blue-grey and warm buff except for the black and white barring on the flanks. **JUVENILE** has grey-buff plumage with a suggestion of the adult's dark markings. Juveniles are seldom seen unaccompanied by adult birds. **VOICE** – utters a loud *ke che-che, ke che-che, ke che-che* call. HABITAT AND STATUS The Red-legged Partridge is typically associated with arable farmland where mature hedgerows and scattered woods dot the landscape. However, the species can also be found on heathland and coastal grassland. It is not native to the region and was introduced for hunting; indeed, the current population is maintained at artificially high levels by the release (by shooting interests) of captive-bred birds each autumn; tens, if not hundreds, of thousands of birds are released and several hundred thousand are shot each year. Consequently, it is difficult to assess accurately the species' true population in the region. OBSERVATION TIPS The species is most vocal in the spring, when 'singing' males are sometimes conspicuous. At other times of year, look for small parties of birds feeding unobtrusively around field margins.

GREY PARTRIDGE *Perdix perdix* LENGTH 29–31cm

A well-marked gamebird. The species is generally wary because it is heavily persecuted in many parts of the region. Grey Partridges are often seen in small parties that prefer to run from danger rather than fly. The sexes are separable with care. **ADULT MALE** has mainly grey, finely marked plumage, but with an orange-buff face, a large chestnut mark on the belly, maroon stripes on the flanks and a streaked back. **ADULT FEMALE** is similar to the male but the marking on the belly is small and rather indistinct. **JUVENILE** is grey-buff with a suggestion of the adult's dark markings. **VOICE** – utters a choked and harsh *kierr-ikk* call. HABITAT AND STATUS The Grey Partridge favours open grassland and, more particularly, arable farmland with mature hedgerows. It is native to the region. Once abundant, its population has declined dramatically over the last 50 years or so as a direct consequence of modern farming methods. In particular, the application of pesticides and herbicides has had a catastrophic effect upon the numbers and diversity of farmland insects, a vital element in the diet of chicks. Hopefully, more enlightened attitudes in farming may soon prevail and the trend may be reversed. Currently though, there may be 150,000 pairs of Grey Partridge in the region. OBSERVATION TIPS The species is easiest to observe outside the breeding season, when small parties can be found feeding in open fields.

QUAIL *Coturnix coturnix* LENGTH 16–18cm

A tiny and secretive gamebird. The Quail is extremely hard to see, but the male's presence is easily detected by its distinctive call. If flushed (a rare event), it flies on relatively long, bowed wings. The sexes are separable with care. **ADULT MALE** has mainly brown, streaked plumage that is palest and unmarked on the belly. The head is adorned with dark stripes, and the otherwise pale throat has a black centre and is defined by dark lines. **ADULT FEMALE** is similar to the male but has a pale throat. **JUVENILE** is similar to an adult female. **VOICE** – song is a diagnostic, trisyllabic phrase, often rendered as 'wet-my-lips'. HABITAT AND STATUS The Quail is a migrant visitor to the region and numbers vary from year to year. Typically, there might be a few hundred calling males in the region as a whole, but in 'invasion' years there could be 1,000 or more. Arable farmland is the preferred habitat for the species. OBSERVATION TIPS If you spend enough time driving around lowland arable farmland in the south of the region in May and June, then you stand a reasonable chance of hearing a Quail. Seeing one is a different matter altogether. You might be lucky enough to glimpse one as it runs between one area of cover and another, but most birdwatchers have to wait years before they see the species in the region.

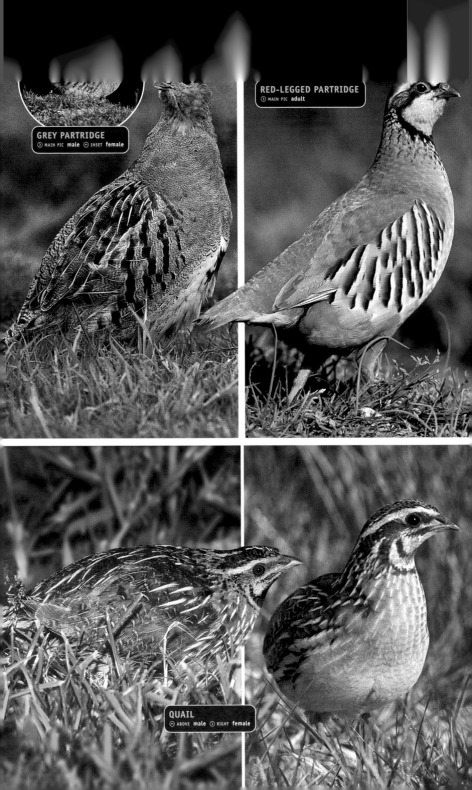

GREY PARTRIDGE
>> MAIN PIC **male** >> INSET **female**

RED-LEGGED PARTRIDGE
>> MAIN PIC **adult**

QUAIL
>> ABOVE **male** >> RIGHT **female**

RED GROUSE *Lagopus lagopus scoticus* LENGTH 37–42cm

A familiar gamebird, associated with upland moors. Red Grouse are not unduly wary, but if alarmed they take to the air explosively. Their flight comprises bouts of rapid wingbeats interspersed with long glides on bowed wings; both sexes have uniformly dark upperwings, but white underwing coverts. The sexes are dissimilar and separable with care. **ADULT MALE** has essentially chestnut-brown plumage with fine markings on the body that are visible at close range;

droppings

note also the conspicuous red wattle over the eye. **ADULT FEMALE** has paler, more buffish-grey and marbled plumage than the male; this affords her excellent camouflage when sitting on the nest. **JUVENILE** resembles an adult female but with less clear plumage markings. **VOICE** – utters a distinctive, nasal call that is sometimes rendered *go-back, go-back, go-back*. HABITAT AND STATUS The Red Grouse is restricted to areas of heather moorland and feeds primarily on the shoots of Ling and related plant species. In many parts of its upland range, its favoured habitats are managed (e.g. by selective burning) by shooting interests to encourage fresh plant growth, and hence the birds themselves. Elsewhere, upland afforestation and overgrazing by sheep are factors adversely affecting the species' range and abundance. Hundreds of thousands of birds are shot each year, but despite this and variations in numbers due to natural causes, more than 200,000 pairs probably breed in the region in most years. OBSERVATION TIPS Visit an area of heather moorland, particularly in northern England or Scotland, and you should have little difficulty seeing a Red Grouse. In the spring, territorial males are sometimes surprisingly tolerant of close observation.

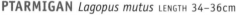

male

PTARMIGAN *Lagopus mutus* LENGTH 34–36cm

A hardy gamebird, and a true mountain species in the region. Despite its size, and the fact that it is not particularly wary, Ptarmigan can be surprisingly difficult to spot: they feed unobtrusively among rocks and vegetation, and seasonal variation in the plumage affords them excellent camouflage at all times. In flight, both sexes reveal striking white wings and a black tail. Ptarmigan often form small flocks outside the breeding season. The sexes are separable with care at all times. **ADULT MALE** in winter has pure white plumage except for the dark eye, lores and bill. In spring and summer it has mottled and marbled greyish-buff upperparts, the amount of white on the back decreasing as the season progresses.

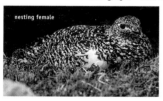

nesting female

The belly and legs are white at all times, while the striking red wattle fades by midsummer. **ADULT FEMALE** in winter is essentially pure white; only the eye and bill are black. In spring and summer it has buffish-grey upperparts that are finely barred; the extent of white on the back diminishes with time. **JUVENILE** resembles a uniformly brown female. **VOICE** – utters a rattling *kur-kurrrr* call. HABITAT AND STATUS Ptarmigan are confined to the Scottish Highlands, favouring rocky ground with an abundance of lichens, mosses and other mountain vegetation. Although they are probably commonest above 1,000m in most parts of their range, the further north you travel so their lower altitudinal limit decreases. Some 10,000 or more pairs probably occur within the species' rather limited range. OBSERVATION TIPS Ptarmigan are found on most Scottish mountain ranges but are probably easiest to see in the Cairngorms. Here, the birds that occur in the vicinity of the ski lift are often particularly confiding, although their camouflage still makes their initial discovery surprisingly difficult.

male, spring

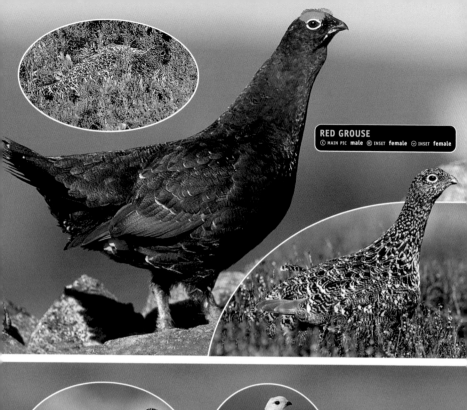

RED GROUSE
MAIN PIC **male** INSET **female** INSET **female**

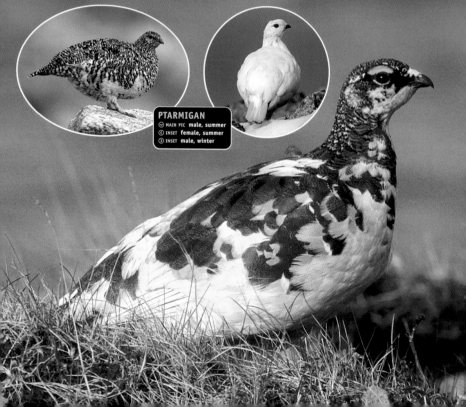

PTARMIGAN
MAIN PIC **male, summer**
INSET **female, summer**
INSET **male, winter**

BLACK GROUSE *Tetrao tetrix* LENGTH 40–55cm

A bulky and distinctive moorland gamebird. The Black Grouse is best known for its lekking behaviour, where groups of displaying males gather at traditional sites early in the morning to attract the interest of nearby females. The sexes are dissimilar and males are larger than females. **ADULT MALE** has mainly dark plumage; at close range, note the red wattle above the eye. Displaying birds fan to reveal their white undertail coverts and elevate and spread their tails, which then look lyre-shaped. In flight, the tail looks proportionately long and forked, and the wings reveal striking white bars. **ADULT FEMALE** has orange-brown plumage that is finely marked with dark bars. In flight, the wings show a narrow white bar. **JUVENILE** resembles a small female with subdued markings. **VOICE** – displaying males utter a bubbling, cooing call. HABITAT AND STATUS Black Grouse are associated with moorland, and do best in areas where a mosaic of habitats is found, including patches of grassland, heather moorland, bilberry stands and adjacent woodland. Numbers are in decline, as is the species' range, but the population probably numbers some 30,000 birds. OBSERVATION TIPS The best way to see Black Grouse is at a traditional lek, where most activity occurs around dawn. Since the birds are extremely sensitive to disturbance, observations should be restricted to those that can be made from a car. Hillwalkers occasionally flush feeding birds from cover.

CAPERCAILLIE *Tetrao urogallus* LENGTH 60–90cm

A huge and impressive gamebird. The species is sometimes disturbed from cover, when it explodes into flight, revealing its proportionately long wings and tail. The male is almost half as big again as the female and the sexes are markedly dissimilar in terms of plumage. **ADULT MALE** looks all dark at a distance, but a closer view reveals a greenish sheen on the breast, brownish wings and a red wattle above the eye. Note also the rounded white spot at the base of folded forewing. When displaying, the tail is fanned out and elevated. **ADULT FEMALE** has grey-brown plumage that is finely barred except for the plain orange-brown patch on the front of the breast. **JUVENILE** resembles a small, dull female. **VOICE** – male utters a bizarre sequence of clicking sounds followed by a noise that is said to resemble that of a cork being pulled from a bottle. HABITAT AND STATUS The Capercaillie is restricted to areas of mature Scots Pine; it can be found both in relict areas of native Caledonian pinewoods and in long-established plantations, too. The species became extinct in the region in the 18th century, but was reintroduced to some of its former haunts in the 19th century. Nowadays, the population probably comprises several thousand birds. OBSERVATION TIPS Unless you are privileged enough to be able to visit a traditional lekking site, an encounter

with a Capercaillie is likely to be a chance affair. Walk through a likely looking conifer woodland within the species' range and you might see an individual feeding along a track; don't simply scan the ground, though, because Capercaillies will often also perch in trees. Look for telltale droppings and dustbowls on forest tracks to indicate the species' presence in the area. Forests on the fringes of the Cairngorms probably offer the best chances for encountering the species.

displaying male

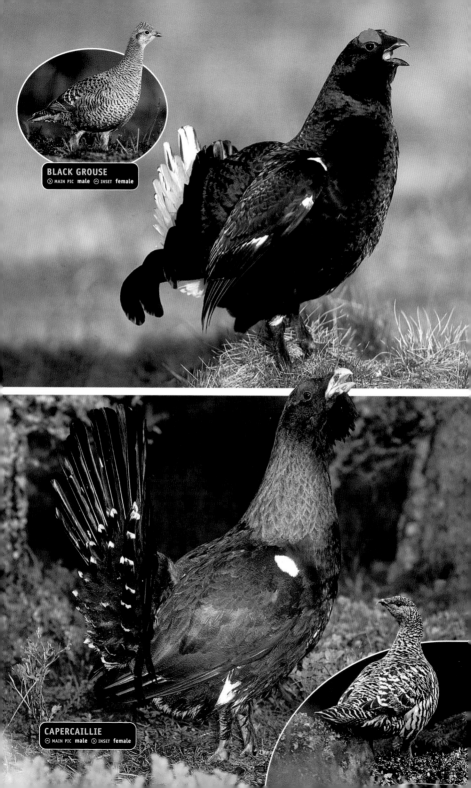

BLACK GROUSE
⊘ MAIN PIC **male** ⊘ INSET **female**

CAPERCAILLIE
⊘ MAIN PIC **male** ⊘ INSET **female**

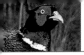

PHEASANT *Phasianus colchicus*

LENGTH, INCLUDING TAIL 65–90cm (MALE); 55–70cm (FEMALE)

The male is a colourful and unmistakable gamebird; the female is also difficult to confuse with other species. The male's territorial call is now a familiar sound in the countryside. Pheasants take to the wing noisily and explosively when flushed. The sexes are strikingly dissimilar. **ADULT MALE** has orange-brown body plumage, a blue-green sheen on the head, a large and striking red wattle, and a long, orange and barred tail; some birds sport a white collar. In recent years, captive-bred forms with essentially violet-blue plumage have been released. **ADULT FEMALE** is mottled buffish-brown with a shorter tail than the male. **JUVENILE** resembles a small, short-tailed and dowdy female. **VOICE** – territorial male utters a loud, shrieking call, which is followed by a bout of vigorous wing beating. In alarm, a loud *ke-tuk, ke-tuk, ke-tuk* is uttered as the bird flies away. HABITAT AND STATUS The Pheasant is not native to the region, although it may well have been established here since the 11th century. Nowadays, it is widespread and is associated typically with a mosaic of farmland and wooded habitats. Although around 3 million birds may form the core of a stable breeding population, the species' exact status is difficult to assess with any certainty. This is because an estimated 15 million captive-bred birds are released each autumn. Of these, around 7 million are shot during the winter months and a significant proportion of those that escape the guns succumb to natural causes. Many birders find it hard to reconcile the Pheasant's undeniable beauty with the impact (almost entirely negative) upon native wildlife of human activities undertaken in its name. OBSERVATION TIPS Take a walk or a drive in lowland countryside and you will surely see a Pheasant. The species provides most interest in late winter and early spring (after shooting has ceased), when territorial males begin displaying.

GOLDEN PHEASANT *Chrysolophus pictus*

LENGTH, INCLUDING TAIL 90–100cm (MALE); 60–80cm (FEMALE)

The male is gaudy and unmistakable; the female is superficially similar to a female Pheasant but easily separable on close inspection. It is secretive and hard to observe in the wild; views are typically brief. The sexes are dissimilar. **ADULT MALE** has mainly red body plumage, a golden-yellow crown and barred 'cape', a yellow rump, and blue on the wings and back; the tail is buffish with intricate dark markings. **ADULT FEMALE** is buffish-brown but with distinct dark barring all over (including the belly); note the contrast between the pale brown face and darker crown and nape. **JUVENILE** recalls a small, short-tailed female. **VOICE** – territorial male utters a shrill, disyllabic call. HABITAT AND STATUS The Golden Pheasant is native to China. Following releases in the 19th and 20th centuries the species is now established in a few spots; perhaps 1,000 or so birds currently live wild in the region. It favours dense, dark woodland, typically where the woodland floor is bare. OBSERVATION TIPS The species is hard to observe. Males are seen most frequently in February, just as territories are being established. Check bird reports for counties that correspond to its mapped distribution to discover known locations.

LADY AMHERST'S PHEASANT *Chrysolophus amherstiae*

LENGTH, INCLUDING TAIL 100–120cm (MALE); 60–80cm (FEMALE)

The male is showy and unmistakable; the female recalls a female Golden Pheasant but is separable on close inspection. It is a shy bird and hard to observe. The sexes are strikingly dissimilar. **ADULT MALE** has body plumage that is mainly whitish below and black above; some of the dark feathers have a blue sheen. Black-edged white feathers form a cape, and there is red on the rear of the crown, and red and yellow on the rump. The tail is long and grey with intricate black markings. **ADULT FEMALE** is reddish-brown with greyish cheeks and a paler, unbarred belly. **JUVENILE** resembles a small, short-tailed female. **VOICE** – the male utters a shrieking song, typically at night. HABITAT AND STATUS Lady Amherst's Pheasant is native to China; 200 or so are now established in Bedfordshire and neighbouring counties; small numbers are also found in a handful of other sites in the region. The birds favour conifer plantations with limited ground cover. OBSERVATION TIPS The species is hard to observe. Walk quietly along forest tracks early in the morning in late winter.

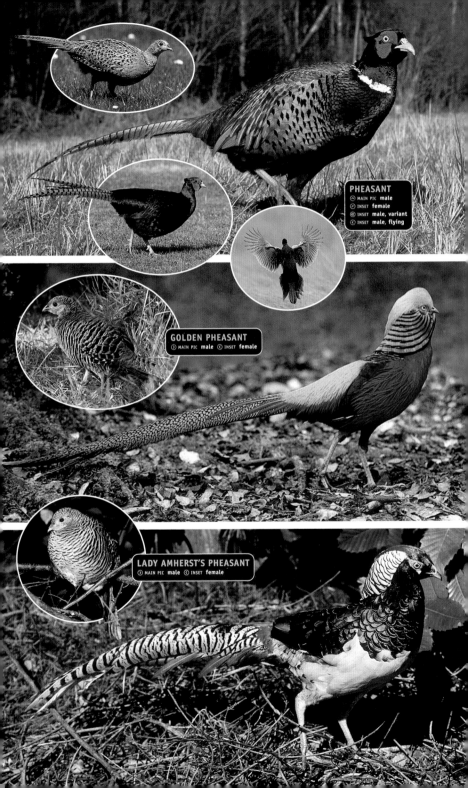

PHEASANT
- MAIN PIC **male**
- INSET **female**
- INSET **male, variant**
- INSET **male, flying**

GOLDEN PHEASANT
- MAIN PIC **male** INSET **female**

LADY AMHERST'S PHEASANT
- MAIN PIC **male** INSET **female**

WATER RAIL *Rallus aquaticus* LENGTH 23–28cm

A well-marked but extremely secretive wetland bird whose distinctive call is heard far more frequently than the bird itself is seen. In profile, note the dumpy body, short tail and long, slightly downcurved bill. Seen head on, the body appears laterally compressed. The sexes are similar. **ADULT** has mainly blue-grey underparts and reddish-brown upperparts; it shows black and white barring on the flanks and a long reddish bill and legs. **JUVENILE** is similar to an adult, but the bluish-grey elements of the underparts are pale. **VOICE** – utters a piercing pig-like squeal and various choking calls, typically from dense cover. HABITAT AND STATUS Water Rails favour extensive reedbeds and marshes with plenty of emergent vegetation. On migration and in winter, the species may turn up along well-vegetated stream margins and beside watercress beds. Water Rail numbers are notoriously difficult to census, but nine thousand or so pairs probably breed in the region; numbers are boosted in winter by influxes of birds from mainland Europe. OBSERVATION TIPS Water Rails are easiest to observe during the winter months, especially if you visit a wetland reserve and are prepared for a lengthy scan of reedbed and water margins from a hide. Alternatively, if you know one is in the area, you could try pursing your lips and imitating its call – you might just get a few seconds' view as a bird ventures out of cover to investigate.

SPOTTED CRAKE *Porzana porzana* LENGTH 20–22cm

A dumpy and rather secretive wetland bird. Typical views involve birds seen skulking along the margins of waterside vegetation. Its extremely long toes allow it to walk over rather flimsy floating plant cover. The sexes are similar. **ADULT** has mainly brown upperparts and blue-grey underparts, the whole adorned with white spots; note also the dark-centred feathers on the back and the striking barring on the flanks. The bill is yellow with a red base, there is black on the face and the undertail coverts are pale buff. The legs and feet are greenish. **JUVENILE** resembles an adult but it lacks the adult's dark face and throat, and the blue-grey elements of the plumage are rather buffish-grey. **VOICE** – the male's territorial call is a repetitive whiplash-like whistle, uttered after dark. HABITAT AND STATUS Although this migrant visitor is almost impossible to census accurately, it is likely that several dozen pairs probably breed in the region each year. Extensive, and typically inaccessible, marshy wetlands are favoured by Spotted Crakes, but on autumn migration birds sometimes turn up on much smaller wetland habitats. OBSERVATION TIPS Autumn migration provides the only realistic prospect of seeing this species in the region, so visit a wetland reserve in September and you might be lucky. Some migrant juveniles are indifferent to the presence of human observers.

CORNCRAKE *Crex crex* LENGTH 27–30cm

A secretive bird that is easy to hear (in the right locations) but can be almost impossible to see. It seldom emerges willingly from the cover of dense, grassy vegetation and is flushed only rarely. The sexes are similar. **ADULT** has sandy-brown upperparts, the dark feather centres giving it a rather 'scaly' appearance. The face, throat, breast and belly are blue-grey, while the flanks are barred chestnut and white. In flight, note the chestnut patch on the inner wing and the dangling legs. **JUVENILE** is more grey-brown than an adult and lacks distinctive markings. **VOICE** – territorial males utter a ceaseless *crek-crek, crek-crek* throughout the night and sometimes in daylight hours too. HABITAT AND STATUS This migrant visitor has declined catastrophically over the last century, both in terms of range and abundance. Changes in farming practices are responsible for its demise, notably the early rolling of grassland and cutting for silage, both of which destroy eggs and chicks. Nowadays, Corncrakes are restricted to hay meadows and damp grassland where appropriate cutting regimes still operate. A few hundred pairs probably still attempt to nest in the region, but who knows for how much longer? OBSERVATION TIPS Apart from a chance sighting of a migrant, to encounter a Corncrake you will have to visit one of its few remaining strongholds (an Outer Hebridean island, for example) during the breeding season. Even then, you may just get to hear a bird rather than see it.

!CONFUSION SPECIES!

FEMALE PHEASANT
Page 98

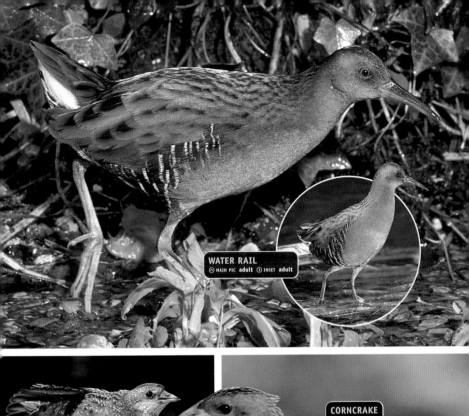

WATER RAIL
ⓐ MAIN PIC **adult** ⓑ INSET **adult**

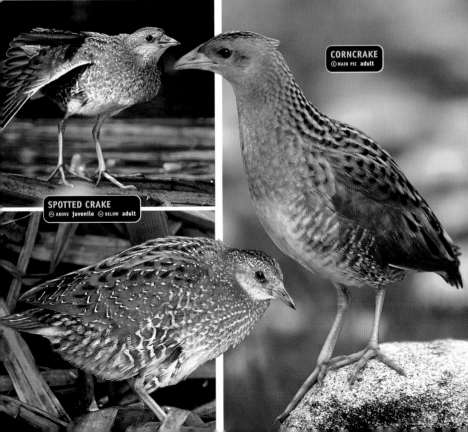

CORNCRAKE
ⓒ MAIN PIC **adult**

SPOTTED CRAKE
ⓐ ABOVE **juvenile** ⓥ BELOW **adult**

MOORHEN *Gallinula chloropus* LENGTH 32–35cm

A widespread and familiar wetland bird. The Moorhen swims with jerky movements and constantly flicks its tail; its flight looks rather laboured and the legs dangle. In natural surroundings, Moorhens are usually rather wary and disappear into cover when alarmed; by contrast, in urban areas they can become rather tame. The sexes are similar. **ADULT** can look all dark at a distance, but a close inspection reveals a slight contrast between the dark blue-grey head, neck and underparts, and the brownish back, wings and tail. It has a distinctive yellow-tipped red bill and frontal shield on the head, and the legs and long toes are yellow. There are white feathers on the sides of the undertail and a white line along the flanks. **JUVENILE** is greyish-brown but with white on the throat, the sides of the undertail coverts and along the flanks. **VOICE** – utters a loud and far-carrying *kurrrk*. HABITAT AND STATUS Moorhens can be found on all sorts of different wetland habitats, from village ponds and overgrown streams to flooded gravel pits and sizeable natural lakes. The common factor with all these habitats is a rich growth of submerged and emergent vegetation and associated invertebrate life. There are probably several hundred thousand breeding pairs of Moorhens in the region. However, during the autumn and winter, numbers are boosted by influxes of birds from mainland Europe. OBSERVATION TIPS Visit almost any lowland wetland habitat and you should be able to find Moorhens. Away from urban areas, the species is generally rather secretive during the breeding season, particularly when birds are on eggs or have very young chicks. At other times, they are usually much more conspicuous.

displaying

COOT *Fulica atra* LENGTH 36–38cm

A dumpy and robust waterbird that is often found in similar habitats to the Moorhen. It has lobed toes (sometimes seen when birds are walking on land) and these facilitate swimming. Coots feed by up-ending or by making shallow dives in the water; however, they will also graze waterside vegetation, too. During the breeding season, they construct large mound nests of water plants that are often in full view and conspicuous. Outside the breeding season, Coots often form large flocks. When taking off from the water, a bird typically runs along the surface, splashing its feet before finally getting airborne. The sexes are similar. **ADULT** has essentially all-dark plumage that is darkest on the head and neck. Note the white bill and frontal shield on the head, and the beady red eye. The legs are pale yellowish. In flight, note the white trailing edge to the otherwise dark, rounded wings. **JUVENILE** has dark greyish-brown upperparts and white on the throat and front of the neck. In this plumage it can recall a small grebe in winter plumage. **VOICE** – utters a loud and distinctive *kwoot* call. HABITAT AND STATUS Coots are associated with a variety of freshwater wetland habitats, including shallow lakes and flooded gravel pits, and even ponds and slow-flowing rivers. There may well be 20,000 or more resident pairs of Coots in the region. However, in autumn and winter the population is boosted to more than 100,000 individuals by influxes of birds fleeing harsher conditions in mainland Europe. OBSERVATION TIPS Coots present few problems when it comes to observation. Numbers are greatest during the winter months, but the species is probably at its most endearing in late spring, when adults are attending to the needs of their red- and blue-headed chicks.

!CONFUSION SPECIES!

JUVENILE COOT may be confused with RED-NECKED GREBE (*top*) and SLAVONIAN GREBE (*bottom*) in WINTER PLUMAGE Pages 28 & 30

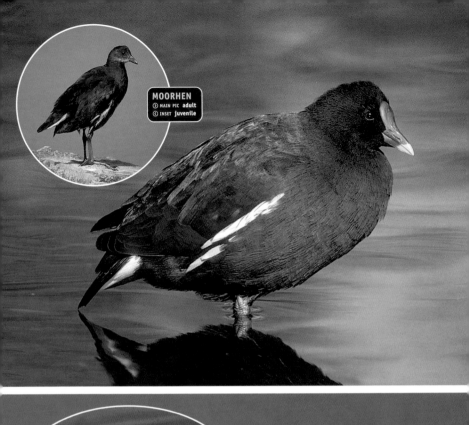

MOORHEN
> MAIN PIC **adult**
> INSET **juvenile**

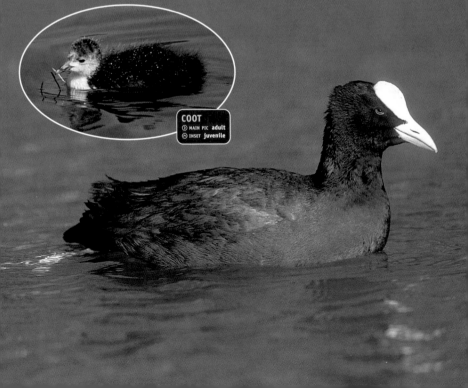

COOT
> MAIN PIC **adult**
> INSET **juvenile**

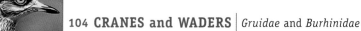

STONE-CURLEW *Burhinus oedicnemus* LENGTH 38–45cm

A relatively large and secretive, dry-country wader that is perhaps best known for
its eerie, wailing calls. In isolation, the Stone-curlew's well-marked plumage
appears distinctive and striking, but amongst grassland vegetation it affords
the bird superb camouflage, making its discovery a real challenge. In flight,
a Stone-curlew looks rather long-winged and almost gull-like, with a strik-
ing black and white pattern on the upperwing. The sexes are similar.
ADULT has streaked sandy-brown plumage; the black and white wingbars
can be discerned in standing birds but are most apparent in flight. At close
range, note the white stripes on the face, the long yellow legs, the black-
tipped yellow bill and the large yellow eyes. **JUVENILE** is similar to an adult but
the wingbars and facial markings are less distinctive. **VOICE** – utters strange, Curlew-like wailing calls,
mostly at dusk and throughout the night. HABITAT AND STATUS The Stone-curlew is a migrant visitor
to the region, the birds spending the winter months in countries bordering the Mediterranean; sever-
al hundred pairs breed in the region. Surviving fragments of grazed chalk downland and Breckland
heath are classic habitats for the species, but Stone-curlews also nest successfully on arable farmland
(on chalky and sandy soils) where the management regime suits their needs. OBSERVATION TIPS Stone-
curlews are hard to detect during the hours of daylight, so visit suitable areas at dusk or after dark
and listen for the calls. If you are lucky, return to the spot during the hours of daylight and search
carefully with binoculars. However, confine your observations to those that can be made from a car.
Stone-curlews are nervous and wary of people on foot, and are sensitive to disturbance. By walking
across a suitable area not only will you disturb the birds and affect their breeding success, but you
will also thwart your attempt to see the species: the birds will just skulk away into deep cover and
stay there until you leave. An easier alternative is to visit a Breckland reserve, such as Weeting Heath,
where the species is protected and relatively easy to see.

CRANE *Grus grus* LENGTH 100–120cm

A large, stately and long-legged bird. On the ground, it can be recognised, even
in silhouette, by its long-necked appearance and its shaggy, bushy tail end. In
flight, the wings are broad and long, and ideal for soaring and gliding; it flies
with its neck and legs outstretched. Cranes are typically extremely wary. The
sexes are similar. **ADULT** has mainly blue-grey plumage with a pattern of
black and white on the head and neck; the back sometimes appears rather
brown. Note also the patch of red on the hindcrown. **JUVENILE** is similar
to an adult but the head is pale buffish-grey and lacks the adult's black and

!CONFUSION SPECIES!

white markings. **VOICE** – utters a loud, trumpeted rolling *krrruu*.
HABITAT AND STATUS Although a handful of Cranes are effectively res-
ident in Norfolk, and successful breeding has occurred, the status of the species
in the region as a whole is essentially that of a scarce passage migrant and very occasional
winter visitor. Cranes are wary birds and typically favour large, open wetlands, although
migrants will sometimes settle for expansive arable and grassland fields on damp ground.
In most years, there are just a handful of records of this magnificent species, most occur-
ring from September to November or in February and March. Once in a while, however,

GREY HERON
Page 42

adverse weather conditions push migrating flocks off course in mainland Europe and more significant
numbers arrive in the region. OBSERVATION TIPS Look for this species in autumn and late winter, typ-
ically after periods of southeasterly winds. If left undisturbed, these visitors tend to stay for a few
days before continuing on their travels. Wide-open fields and marshes in eastern England and Scot-
land offer the best chances for the discovery of this species. The Crane's distinctive silhouette should
rule out the possibility of confusion with a Grey Heron on the ground; the fact that it flies with its
neck outstretched is another distinguishing feature.

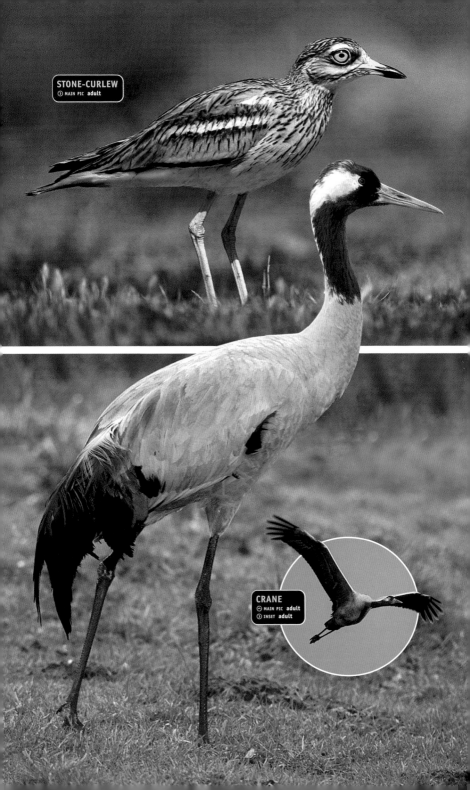

STONE-CURLEW
⊙ MAIN PIC **adult**

CRANE
⊙ MAIN PIC **adult**
⊙ INSET **adult**

AVOCET *Recurvirostra avosetta* LENGTH 43–45cm

A distinctive wader that is easily recognised by its black and white plumage. The Avocet feeds by sweeping its diagnostic, upcurved bill from side to side through water. It forms flocks outside the breeding season. The sexes are similar, although males have longer bills than females and more-contrasting plumage. **ADULT** has mainly white plumage with black elements on the crown, nape and wings. The legs are blue and the upcurved bill is black. **JUVENILE** is similar to an adult, but the black elements of the plumage are dark brown and less well defined. **VOICE** – utters a ringing *klueet-klueet* call. HABITAT AND STATUS During the breeding season, Avocets are associated with shallow, coastal lagoons with brackish water; typically, the birds nest on islands in the lagoons, many of which are managed, or even created, for this purpose. Perhaps 500 or so pairs breed in the region and it is fitting that, as the bird is the symbol of the RSPB, many nesting locations are on sites that are owned, or managed, by that organisation. In winter, the birds disperse and some leave the country. However, several hundred Avocets can still be found on estuaries in the region, mainly on the south and east coasts of England. OBSERVATION TIPS For guaranteed sightings of Avocets, visit one of the East Anglian coastal reserves in spring or summer: Titchwell and Minsmere (both RSPB reserves) have colonies. In winter, the Exe and Tamar estuaries in southwest England are both strongholds for the species.

OYSTERCATCHER *Haematopus ostralegus* LENGTH 43–45cm

A distinctive and noisy wader, the Oystercatcher is easily recognised by its striking black and white plumage, and by its loud alarm call. It uses its powerful bill to feed on molluscs and other invertebrates. Outside the breeding season, it is generally solitary or found in small groups; however, high-tide roosts can involve hundreds, if not thousands, of birds. The sexes are similar. **SUMMER ADULT** has essentially black upperparts and white underparts; there is a clear demarcation between the two on the breast. Note also the red bill, pinkish legs and beady red eye. **WINTER ADULT** is similar to a summer adult but note the white half-collar. **JUVENILE** is similar to a summer adult, but black elements of the plumage are brownish and the bill and leg colours are subdued. **VOICE** – utters a loud, piping *peep* call. HABITAT AND STATUS Although the Oystercatcher is often thought of as a bird of the coast, it also breeds far inland, especially in northern England and Scotland, although nests are seldom far from water. Several tens of thousands of pairs breed in the region, but in winter, when the species is more exclusively coastal, numbers are boosted considerably by influxes from mainland Europe. Outside the breeding season, estuaries and mudflats are favoured habitats. OBSERVATION TIPS Visit almost any estuary during the winter months and you will have no difficulty finding Oystercatchers. Human disturbance excludes the possibility of Oystercatchers breeding in much of southern Britain except where ground-nesting species are protected.

BLACK-WINGED STILT *Himantopus himantopus* LENGTH 34–38cm

An elegant black and white wader with a long, thin bill and almost ridiculously long red legs. Typically, it feeds by wading in rather deep water and catches invertebrates with its needle-like bill. The sexes are similar but usually separable on plumage details. **ADULT MALE** has a black back and wings, and variable amounts of black on the crown, nape and around the eye; otherwise, the plumage is white. The wings look all dark in flight. **ADULT FEMALE** is similar to the male but the head and neck are usually mainly white and the back is tinged with brown. **JUVENILE** is similar to an adult female but feathers on the back have pale margins and the wing has a white trailing edge. **VOICE** – utters a shrill *kyek, kyek* call. HABITAT AND STATUS Apart from the occasional long-staying visitor, the status of the Black-winged Stilt in the region is essentially that of a rare vagrant that might stay for a few days. Most records occur in spring (a handful each year) and visitors typically favour coastal wetland habitats such as brackish lagoons. OBSERVATION TIPS Black-winged Stilts are unmistakable and usually feed in the open, making observation easy. The best chance of discovering the species will come from a spring visit to coastal wetland in south or east England.

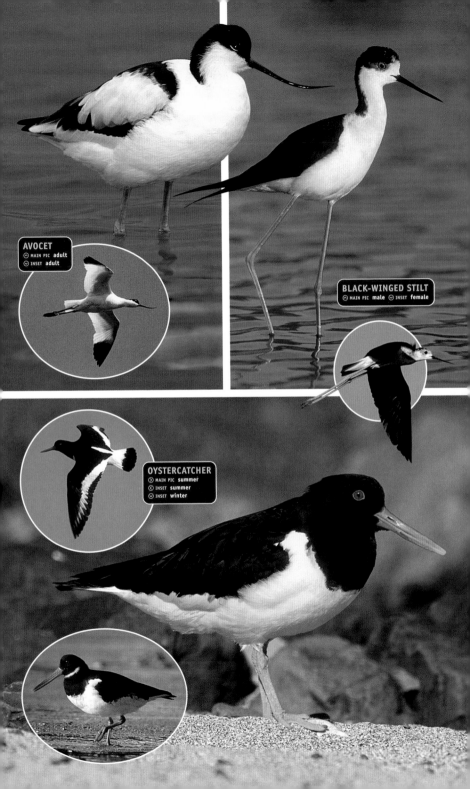

AVOCET
△ MAIN PIC **adult**
▽ INSET **adult**

BLACK-WINGED STILT
△ MAIN PIC **male** ▽ INSET **female**

OYSTERCATCHER
▷ MAIN PIC **summer**
◁ INSET **summer**
▽ INSET **winter**

RINGED PLOVER *Charadrius hiaticula* LENGTH 17–19cm

A small, dumpy wader that is associated mainly with coastal habitats. Feeds by running along sand or estuarine mud as if powered by clockwork and then standing still for a few seconds before picking a food item from the ground. All birds show a white wingbar in flight. The sexes are separable with care. **SUMMER ADULT MALE** has sandy-brown upperparts and white underparts, with a continuous black breast band and collar. Note the distinctive black and white markings on the face and the white throat and nape. The legs are orange-yellow and the bill is orange with a dark tip. **SUMMER ADULT FEMALE** is similar, but the black elements of plumage on the head are duller. **WINTER ADULT** is similar to a summer adult but most black elements of plumage on the head are replaced by sandy brown. The leg and bill colours are subdued. Note also the pale supercilium. **JUVENILE** is similar to a winter adult but the breast band is small and often incomplete. **VOICE** – utters a soft *tuu-eep* call. HABITAT AND STATUS Ringed Plovers typically nest on sandy or shingle beaches but are excluded from most suitable sites in the south by human disturbance. Increasingly, inland habitats such as gravel-pit and river margins are used as well. Up to 10,000 pairs may attempt to nest. Outside the breeding season, the species is almost exclusively coastal and numbers are boosted by influxes of birds from mainland Europe. OBSERVATION TIPS Outside the breeding season, Ringed Plovers are easy to find on most estuaries and coastal mudflats in the region. In spring and early summer, look for the species on secluded beaches, but be careful not to disturb nesting birds.

LITTLE RINGED PLOVER *Charadrius dubius* LENGTH 15–17cm

A delicate and rather slim-bodied little plover. Although smaller than the Ringed Plover, the absence of that species' striking white wingbar is a better identification feature. The sexes are similar. **SUMMER ADULT** has sandy-brown upperparts and white underparts, with a black collar and breast band, and black and white markings on the head. A close view reveals the black bill, yellow legs and the characteristic yellow eye-ring. In females, the black elements of the plumage on the head are duller than in males. **JUVENILE** (and **WINTER ADULT** – not seen in the region) has the black elements of the plumage replaced by sandy brown. The breast band is usually incomplete, the leg and eye-ring colours are dull, and the head lacks the pale supercilium seen in a juvenile Ringed Plover. **VOICE** – utters a loud *pee-oo* call. HABITAT AND STATUS During the breeding season, Little Ringed Plovers are usually associated with inland freshwater habitats, notably the margins of flooded gravel pits and other man-made sites. Indeed, it was probably the growth in these artificial habitats that allowed the species to colonise the region originally in the latter half of the 20th century. Perhaps 1,000 or so pairs now breed here. The species is a summer visitor; migrants sometimes turn up at freshwater sites outside the breeding range and, to a lesser degree, on the coast. OBSERVATION TIPS Pay a spring visit to one of the flooded gravel pits that fringe the Thames corridor, or that occur elsewhere in the southern half of Britain, and you should find this species. It can turn up on almost any freshwater margin on migration.

KENTISH PLOVER *Charadrius alexandrinus* LENGTH 15–17cm

A dumpy little plover that is invariably found on the coast. The Kentish Plover looks overall much paler than species with which it might be confused. Note, however, the presence of a striking wingbar in flight. The sexes are dissimilar. **SUMMER ADULT MALE** has pale sandy-brown upperparts and white underparts. Note the sandy crown that is marked with black at the front and rufous at the back; it also has black through the eye and a black patch on the side of the breast. The legs and bill are black. **SUMMER ADULT FEMALE, JUVENILE** and **WINTER ADULT** are similar to the summer adult male, but the black elements of the plumage are replaced with pale sandy brown (the same colour as the rest of the upperparts); the legs are dull brown. **VOICE** – utters a soft *bruip* call. HABITAT AND STATUS The Kentish Plover is a scarce passage migrant to the region, with around several dozen records in most years. It is usually found on sandy estuaries; visitors seldom stay for long. OBSERVATION TIPS Visit a south-coast estuary in spring to stand a chance of finding this species; it is fairly regular at The Fleet, behind Chesil Beach in Dorset, for example. Distant birds are surprisingly easy to overlook.

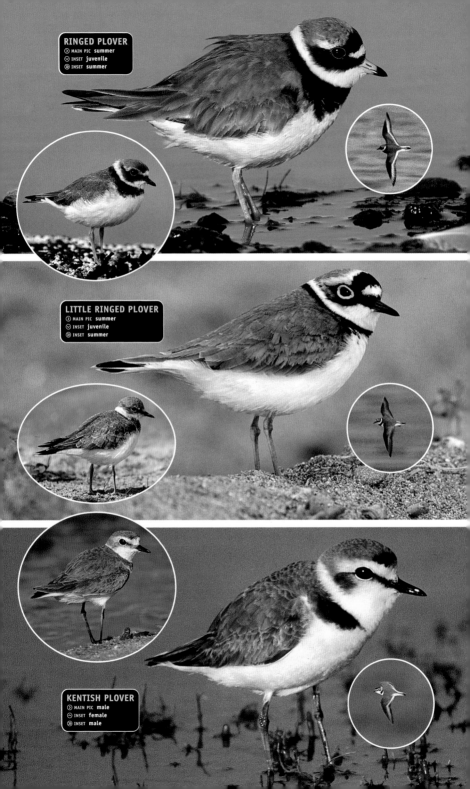

RINGED PLOVER
◇ MAIN PIC summer
◇ INSET juvenile
◇ INSET summer

LITTLE RINGED PLOVER
◇ MAIN PIC summer
◇ INSET juvenile
◇ INSET summer

KENTISH PLOVER
◇ MAIN PIC male
◇ INSET female
◇ INSET male

DOTTEREL *Charadrius morinellus* LENGTH 20–22cm

A dumpy and rather pot-bellied mountain wader that is beautifully marked and often quite tame. The Dotterel exhibits role reversal when nesting: the male, which is duller than the female, incubates the eggs. **SUMMER ADULT FEMALE** has a striking reddish-orange breast and belly that is separated from the blue-grey throat by a black-bordered white collar. On the head, the face is whitish and there is a striking white supercilium above the eye, and a darker cap. Otherwise, the upperparts are grey-brown, the feathers on the back having brown margins, and the undertail is white. The legs are yellow. **SUMMER ADULT MALE** is similar but the colours are duller. **WINTER ADULT** looks overall grey-buff, but it retains a broad, pale buff supercilium and shows a pale breast band. **JUVENILE** is similar to a winter adult but the back looks rather scaly, the darkish feathers having contrasting pale buff fringes. **VOICE** – utters a soft *pierrr* call. HABITAT AND STATUS The Dotterel is a rare migrant visitor to the region and most British birds spend the winter months in North Africa. More than 800 pairs are thought to breed in the region; the majority are found in the Scottish Highlands, although a few nest on mountains further south. During the breeding season, the species is more or less confined to plateau mountain tops, invariably above 1,000m, where moss and lichens dominate the low-growing vegetation. On migration (particularly in spring), small groups of birds, known as 'trips', sometimes linger for a day or so at regular stop-off points; these locations are typically hilltops with short vegetation and the highest point in any given area. OBSERVATION TIPS You will have to slog your way to the plateau of a Scottish mountain if you want to stand a chance of seeing a Dotterel during the breeding season. However, please note that the species is protected and must not be disturbed at the nest. Do not take advantage of the species' apparent tolerance of human visitors to its realm: nests are just as vulnerable to disturbance and predation as any other bird. If you want to see the species on spring migration, then visit one of its traditional stop-off points in early May; these are usually well documented in county bird reports. In the autumn, juvenile Dotterels sometimes linger for a few days on coastal grassland.

LAPWING *Vanellus vanellus* LENGTH 28–30cm

A distinctive wader that looks black and white at a distance, and that has a spiky crest. The rounded, black and white wings are striking in flight, as is the Lapwing's distinctive call. The sexes are usually separable in summer. **SUMMER ADULT MALE** has dark upperparts on which a green and purple sheen is visible at certain angles; the underparts are white except for the orange vent and the black foreneck. The black and white markings on the throat are striking. **SUMMER ADULT FEMALE** is similar, but the black markings on the foreneck and throat show patches of white; the crest is shorter than that of the male. **WINTER ADULT** is similar to a summer female but the throat and foreneck are white, the nape is flushed with buff and the feathers on the back have buffish fringes. **JUVENILE** is similar to a winter adult but the crest is short and striking pale fringes on the back feathers give it a scaly appearance. **VOICE** – utters a distinctive *pee-wit* call. HABITAT AND STATUS The Lapwing is a bird of open habitats, and during the breeding season it is found on undisturbed grazed grassland, moors and arable farmland where the crop has been planted in the spring. Although numbers have declined alarmingly as a result in changes in farming practices, around 200,000 pairs still breed in the region. Although Lapwings can be found throughout the year, the story of their status is not a straightforward one. Most British birds move within the region and are, to a degree, nomadic. Some even leave our shores, but numbers here are swollen considerably by influxes of birds from mainland Europe. OBSERVATION TIPS There can be few sights and sounds more evocative of the countryside than a Lapwing performing a noisy display flight over its territory in the spring. Thankfully, this can still be witnessed in many parts of the region. Although rather local in some areas, winter flocks are a common sight in the countryside at large.

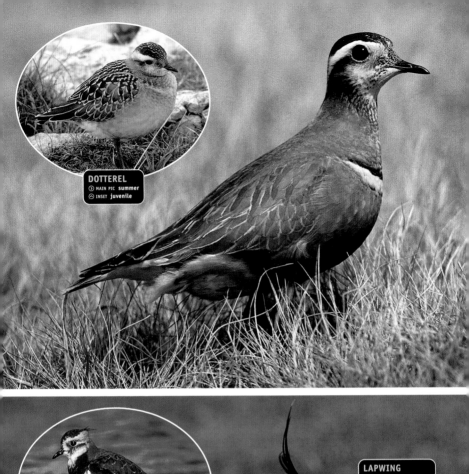

DOTTEREL
- ▷ MAIN PIC **summer**
- ◠ INSET **juvenile**

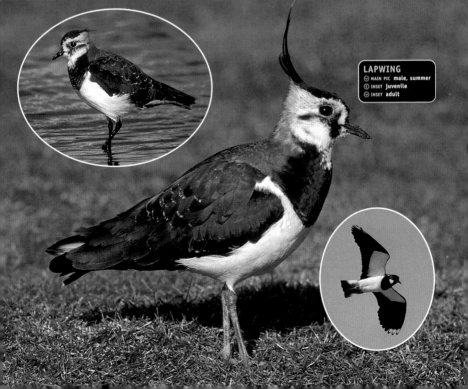

LAPWING
- ◡ MAIN PIC **male, summer**
- ◠ INSET **juvenile**
- ◡ INSET **adult**

GOLDEN PLOVER *Pluvialis apricaria* LENGTH 26–28cm

A plump and beautifully marked wader. During the breeding season, the sight and sound of Golden Plovers is evocative of the desolate upland regions that they frequent. The species forms flocks outside the breeding season and often associates with Lapwings. In flight, all birds show white underwings, including axillaries (armpits). The sexes are subtly dissimilar in summer, but separation is not always a straightforward matter (see below). **SUMMER ADULT** has spangled golden upperparts that are defined by, and separated from, the underparts by a band of white. In males that breed in the region, the belly is black, typically grading to grey on the neck and face. By contrast, females that breed in the region have far less distinct dark markings on the underparts and the face is often whitish. In the case of birds that breed further north in Europe (seen in the region in late winter and early spring), males typically show almost uniform black on the belly, neck and face, while females resemble males of the British race. To complicate matters further, all Golden Plover races and sexes show considerable variability. **WINTER ADULT** loses all traces of black on the underparts; the head and neck become streaked golden-buff while the belly is white. **JUVENILE** is similar to a winter adult. **VOICE** – utters a *peeoo* flight call and has a plaintive *pu-peeoo* whistling song. HABITAT AND STATUS Golden Plovers breed on remote upland moors and lower mountain slopes, and are restricted mainly to the northern half of the region; perhaps 20,000 or so pairs nest in the region. In winter, flocks are more widespread and are typically associated with grassland and arable fields. Influxes of birds from Iceland and mainland Europe boost our numbers considerably, possibly by an order of magnitude. OBSERVATION TIPS If you walk the moors and hills of northern England and Scotland, you should have no trouble coming across Golden Plovers; their evocative calls will alert you to their presence. In winter, drive around open farmland in the lowlands for long enough and you will surely come across a flock.

female, summer

GREY PLOVER *Pluvialis squatarola* LENGTH 27–29cm

A plump-bodied and well-marked coastal wader. The species nests in the high Arctic and is best known in winter plumage. However, breeding plumage is often seen in newly arrived birds in late summer and, prior to their departure, in early spring too. In flight, all birds reveal striking black axillaries (armpits) on the otherwise white underwings. Grey Plovers are typically rather solitary outside the breeding season. The sexes are subtly dissimilar in summer plumage. **WINTER ADULT** looks grey overall at a distance. On close inspection, the upperparts are spangled with black and white and the underparts are whitish. The legs and bill are dark. **SUMMER ADULT** has striking black underparts that are separated from the spangled grey upperparts by a broad white band. In females, the underparts are often a rather mottled (as opposed to uniform) black. **JUVENILE** resembles a winter adult, but typically shows a rather buff wash to the plumage, leading to potential for confusion with a Golden Plover. **VOICE** – utters a diagnostic and trisyllabic *pee-oo-ee* call, not unlike a human wolf-whistle. HABITAT AND STATUS The Grey Plover is a non-breeding visitor to the region. It is almost exclusively coastal, favouring estuaries and mudflats, and several tens of thousands of birds are present in the region in most years. OBSERVATION TIPS Visit almost any estuary during the winter months and you should find Grey Plovers without difficulty. The distinctive call is often the first clue to the species' presence in an area.

winter

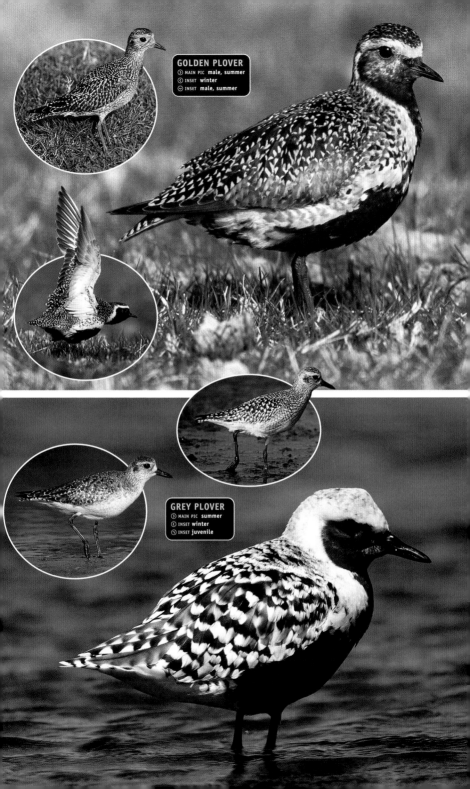

GOLDEN PLOVER
- MAIN PIC **male, summer**
- INSET **winter**
- INSET **male, summer**

GREY PLOVER
- MAIN PIC **summer**
- INSET **winter**
- INSET **juvenile**

DUNLIN *Calidris alpina* LENGTH 17–21cm

An active little sandpiper and, in most areas, the archetypal small, coastal wader in winter. Across its extensive breeding range, the Dunlin is rather variable in terms of its size and the intensity of its breeding plumage; more striking still is the variability in the species' bill length. Several different races, covering a range of bill lengths, occur in the region outside the breeding season, often in sizeable flocks. The sexes are subtly different in summer, but separation is not a straightforward matter (see below). **SUMMER ADULT** has a reddish-brown back and cap, and whitish underparts that show a bold black belly and streaking on the neck. The intensity of many of these features varies according to race and, generally speaking, males of any given race are more boldly marked than females. Male Dunlins that breed in northeast Europe and Siberia have the brightest markings (and also the longest bills). **WINTER ADULT** has rather uniform grey upperparts and white underparts. **JUVENILE** has reddish-brown and black feathers on the back; all these feathers have pale fringes, some of which align to form 'V' patterns. The underparts are whitish, but with black streak-like spots on the flanks and breast; the head and neck are brown and streaked. **VOICE** – utters a *preeit* call; the 'song' of displaying birds, delivered in flight, comprises a series of whistling calls. HABITAT AND STATUS During the breeding season, Dunlins are associated with damp moorland and mountain habitats, and several thousand pairs nest in the region. Outside the breeding season, a dramatic influx occurs and the species becomes our most numerous coastal wader in winter, when many hundreds of thousands are present. The region is also an important staging post for passage migrant Dunlin heading to and from northern breeding grounds and wintering quarters in southern Europe and North Africa. OBSERVATION TIPS The Dunlin is numerous on almost all estuaries in the region outside the breeding season. Although you will have no difficulty seeing it, it is worthwhile spending time to get to know it in all its variable plumage and structural forms. This will stand you in good stead when it comes to identifying other small waders.

CURLEW SANDPIPER *Calidris ferruginea* LENGTH 19–21cm

A small but elegantly proportioned wader. Although the Curlew Sandpiper is similar to the Dunlin, it is separable with care: the white rump and the relatively long and obviously downcurved bill are reliable features at all times. The sexes are subtly different in summer, but variability means that separation is problematic in the field. **SUMMER ADULT** has a spangled reddish-brown, black and white back and (briefly) brick-red on the face, neck and underparts; the latter feature often appears mottled in moulting birds seen on passage in the region. Males are typically more brightly coloured than females, but variability means that reliable separation is not usually possible in Britain. **WINTER ADULT** (seldom seen in the region) has greyish upperparts and white underparts. **JUVENILE** (the commonest plumage encountered in the region) has pale-edged feathers on the back, giving it a scaly appearance, a white belly and a buffish breast; note also the striking pale supercilium. **VOICE** – utters a soft *prrrp* call. HABITAT AND STATUS The Curlew Sandpiper breeds in the high Arctic and its status in the region is that of a rather scarce passage migrant. Birds are typically found on estuaries and on coastal pools, often in the company of Dunlins. OBSERVATION TIPS The species is most numerous in autumn, when juvenile birds predominate. In late August and early September, a day trip to a suitable stretch of coast might yield a handful of sightings after a prolonged search among assorted waders.

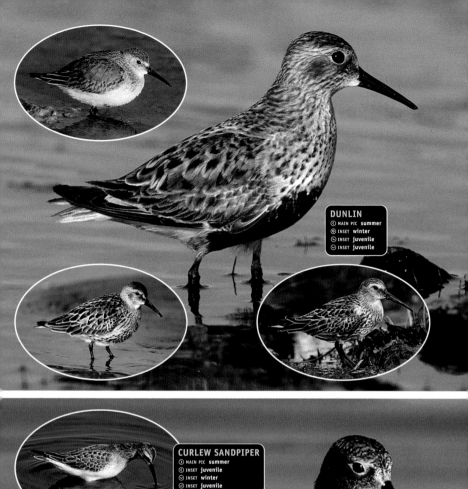

DUNLIN
- ⟨⟩ MAIN PIC **summer**
- ⟨P⟩ INSET **winter**
- ⟨L⟩ INSET **juvenile**
- ⟨⟩ INSET **juvenile**

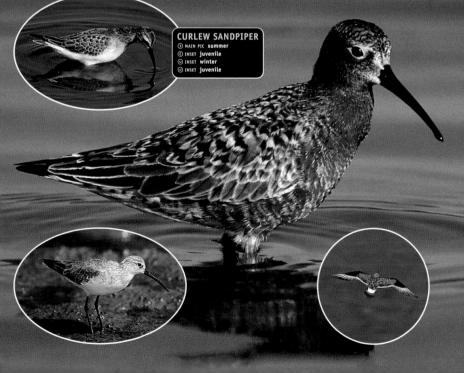

CURLEW SANDPIPER
- ⟨⟩ MAIN PIC **summer**
- ⟨⟩ INSET **juvenile**
- ⟨⟩ INSET **winter**
- ⟨⟩ INSET **juvenile**

LITTLE STINT *Calidris minuta* LENGTH 13–14cm

A tiny wader that recalls a miniature, short-billed Dunlin. Its constant and frantic feeding activity is a clue to the species' identity, especially when seen in the company of other waders. The legs and bill are dark in all birds. The sexes are similar. **SUMMER ADULT** has white underparts, reddish-brown on the back and a variable suffusion of rufous-orange on the head and neck. Note the yellow 'V' on the mantle, and the pale supercilium that forks above the eye. **WINTER ADULT** has grey upperparts and white underparts, with white on the face between the bill and the eye. **JUVENILE** has white underparts. The reddish-brown and black feathers on the back and wings have pale fringes, some of which align to form white 'V' mark-

!CONFUSION SPECIES!

DUNLIN
Page 114

ings. There is a buffish-orange flush on the side of the breast and the head markings are distinctive: note the pale supercilium that forks above the eye, the pale forecrown and the dark centre to the crown. **VOICE** – utters a shrill *stip* call. HABITAT AND STATUS The Little Stint is a regular passage migrant through the region, more numerous in autumn than in spring, when juveniles outnumber adults by a considerable margin. Little Stints are found in small numbers among feeding Dunlins on estuaries. However, the drying margins of coastal pools are even more suitable and groups of a dozen or more are not uncommon; occasionally, it turns up inland as well. Birds also overwinter on estuaries in small numbers. OBSERVATION TIPS If you visit an estuary in late August or September, you stand a good chance of finding Little Stints. When feeding beside Dunlins, you should spot the size difference straight away. The Little Stint's frenetic, pecking feeding action (Dunlins tend to probe) is another identification clue.

TEMMINCK'S STINT *Calidris temminckii* LENGTH 14–15cm

A tiny, rather slim-bodied wader. Compared to a Little Stint, note the short legs (which are yellowish, not black), the proportionately longer tail and wings, and the slightly downcurved bill (a Little Stint's bill is straight). Also, Temminck's Stint shows a clear demarcation between the dark breast and the white underparts at all times, and striking white outer tail feathers are seen in flight. The sexes are similar. **SUMMER ADULT** has grey-brown upperparts, and is streaked grey on the head, neck and breast, many of the back feathers having dark centres. The underparts are white. **WINTER ADULT** (not likely to be seen in the region) has rather uniform grey-brown upperparts and white underparts. **JUVENILE** has white underparts and brownish upperparts; the feathers on the back have

!CONFUSION SPECIES!

COMMON
SANDPIPER
Page 128

pale fringes, creating a scaly appearance. **VOICE** – utters a trilling call. HABITAT AND STATUS The Temminck's Stint is a scarce passage migrant; adults appear in spring, while juveniles predominate in autumn. An observer would be doing well to see more than a handful of individuals in a year. Migrants favour the margins of shallow freshwater pools. A handful of Temminck's Stints also breed in the Scottish Highlands; understandably, their whereabouts are kept secret. OBSERVATION TIPS For the best chances of observation, visit East Anglia in late April or early September. Distant birds can sometimes be separated from Little Stints by their more deliberate – almost creeping – feeding action.

SANDERLING *Calidris alba* LENGTH 20cm

A small, robust wader. Small flocks feed along the edges of breaking waves on sandy beaches, running at great speed. A striking white wingbar can be seen in flight, and the legs and bill are black at all times. The sexes are similar. **WINTER ADULT** has rather uniform grey upperparts and white underparts. **SUMMER ADULT** (sometimes seen in late spring or early autumn) is flushed with red on the head and neck, and has a scattering of dark-centred feathers on the back; the underparts are white. **JUVENILE** is similar to a winter adult but many of the back feathers have dark centres. **VOICE** – utters a sharp *plit* call. HABITAT AND STATUS The Sanderling is a locally common non-breeding visitor to the region. Some 20,000 or so birds probably spend the winter here, mostly on sandy beaches and estuary mudflats. OBSERVATION TIPS Visit almost any undisturbed sandy beach in winter and you should discover small groups of Sanderlings. At high tide, they sometimes forage along the strandline with Turnstones.

!CONFUSION SPECIES!

DUNLIN
Page 114

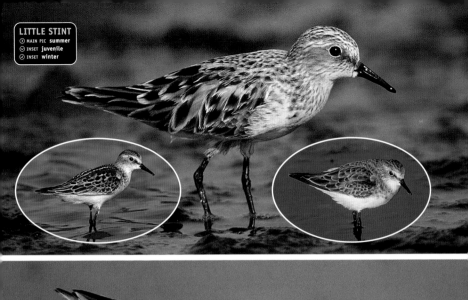

LITTLE STINT
- MAIN PIC **summer**
- INSET **juvenile**
- INSET **winter**

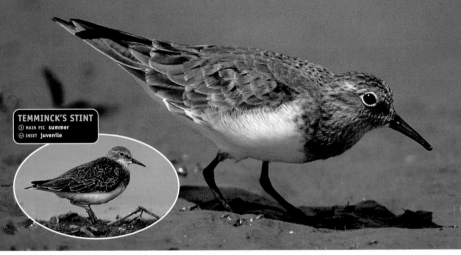

TEMMINCK'S STINT
- MAIN PIC **summer**
- INSET **juvenile**

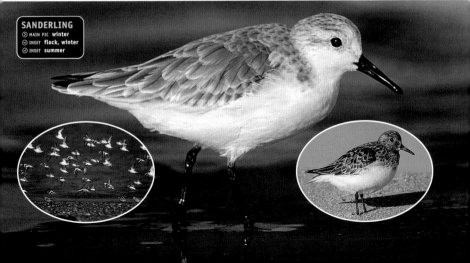

SANDERLING
- MAIN PIC **winter**
- INSET **flock, winter**
- INSET **summer**

KNOT *Calidris canutus* LENGTH 23–25cm

A dumpy and robust wader. Both the legs and bill are relatively short and stout. In winter, the Knot forms large flocks, which fly in tight formation. A white wingbar is visible in flight, but otherwise the species lacks distinctive features in non-breeding plumage. The sexes are similar. **WINTER ADULT** has rather uniform grey upperparts and white underparts. The bill is dark and the legs are dull yellowish-green. **SUMMER ADULT** (sometimes seen in this plumage in late spring or early autumn) has orange-red on the face, neck and underparts; many of the feathers on the back have black and red centres and grey fringes. Both the legs and bill are dark. **JUVENILE** resembles a winter adult but the feathers on the back have pale fringes and dark submarginal bands, creating a scaly appearance. Overall there is a buffish tinge to the plumage, particularly on the breast. **VOICE** – utters a sharp *kwet* call. HABITAT AND STATUS The Knot breeds in the high Arctic and its status in the region is that of a non-breeding visitor. During the winter months, several hundred thousands birds can be found on estuaries and mudflats around the coast, and Britain and Ireland are important for the species in a global context. In autumn, newly arrived migrants (particularly juveniles) are sometimes found on rather atypical coastal habitats such as rocky shores. OBSERVATION TIPS Most sizeable estuaries in the region host wintering flocks of Knots. Feeding birds can be found by scanning the mudflats at low tide, but the species is most spectacular as the tide rises and forces birds to take to the wing. At such times, Knots form large flocks that fly in tight formation as they search for suitable roosting sites. The species is particularly abundant in The Wash; spectacular roosts can be seen at the RSPB's Snettisham reserve, given suitable tide conditions.

summer

PURPLE SANDPIPER *Calidris maritima* LENGTH 21cm

A delightful, plump-bodied wader. The Purple Sandpiper is rather unobtrusive and is surprisingly easy to overlook. However, when discovered, it often endears itself to birdwatchers because of its confiding habits: feeding birds can often be watched for prolonged periods at a range of just a few metres. The legs are yellowish in all birds and the bill, which is relatively long and slightly downcurved, has a yellowish base. A white wingbar can be seen in flight. The sexes are similar. **WINTER ADULT** is rather uniform blue-grey on the head, breast and upperparts, but is darkest on the back; the belly is white and there are darkish streaks on the flanks. **SUMMER ADULT** (sometimes seen in late spring) has reddish-brown and black feathers on the back, and the rufous crown and dark ear coverts contrast with the otherwise paler, streaked grey-brown face. **JUVENILE** recalls a winter adult but the feathers on the back, many of which are rufous, have pale margins, creating a scaly appearance; the neck, breast and flanks are streaked. **VOICE** – utters a sharp *kwit* call in flight. HABITAT AND STATUS Although a handful of pairs of Purple Sandpipers breed in Scotland each year, you are very unlikely ever to come across one there. This is partly because they are so rare, but also because nesting birds sit tight, and are so well camouflaged in the tundra-like habitats they favour, that they are almost impossible to see. The species is best known, and easiest to see, as a non-breeding visitor to the region. Perhaps as many as 20,000 birds spend the winter here and they are invariably associated with rocky shores and headlands. OBSERVATION TIPS Purple Sandpipers typically feed in small, unobtrusive flocks just where the waves are breaking on rocky shores. They can be surprisingly hard to detect as they forage for invertebrates in gullies or among seaweed. Seemingly suitable areas for the species are often not occupied and the birds tend to congregate towards the outermost point of any rocky headland.

summer

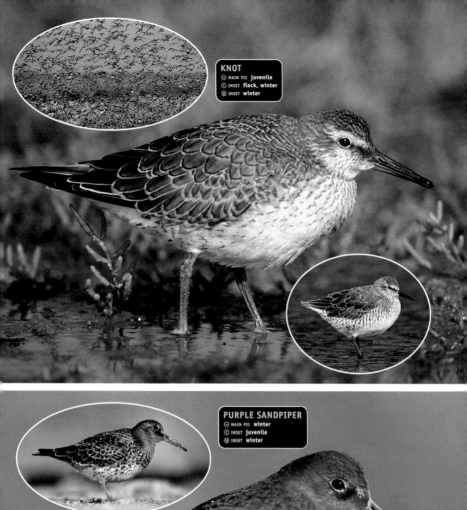

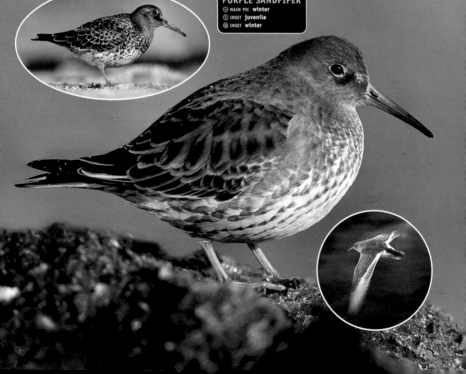

WHIMBREL *Numenius phaeopus* LENGTH 40–45cm

A slightly smaller cousin to the Curlew, but with an appreciably shorter bill. The head markings are diagnostic and the call is distinctive enough to allow certain identification even when the bird in question cannot be seen. In flight, all birds look similar to a Curlew, the dark upperwings and barred tail contrasting with the white rump and lower back. The sexes are similar. **ADULT** has grey-brown to buffish-brown plumage that has fine, dark streaking on the neck and breast. The head pattern comprises two broad, dark lateral stripes on the otherwise pale crown; or to put it another way, there is a pale supercilium and a pale median stripe on an otherwise dark crown. **JUVENILE** is similar to an adult, but the plumage is overall warmer buff in appearance. **VOICE** – the distinctive bubbling call comprises typically seven notes that descend slightly in pitch from start to finish. The song is confusingly similar to that of a Curlew. HABITAT AND STATUS A couple of hundred pairs of Whimbrels probably nest in the region each year, the majority of which are found on Shetland. Typical breeding habitat for the species is boggy moorland, especially where tussocks of grass and Ling provide slightly elevated nesting sites. However, the Whimbrel is probably better known as a widespread and fairly common passage migrant in spring and autumn, with the majority of sightings occurring on the coast. A few Whimbrels also overwinter in the south of the region each year. OBSERVATION TIPS Passage-migrant Whimbrels are usually found on estuaries and mudflats, and the presence of distant birds can be detected by listening for their distinctive calls. April and September are the key months. Migrants may also turn up on rocky shores if no suitable alternative is available in the vicinity. If you visit the Shetland Isles in the spring, you should certainly see and hear Whimbrels on their breeding grounds.

CURLEW *Numenius arquata* LENGTH 53–58cm

A large and distinctive wader, and the commonest of its kind in the region to have a long, downcurved bill. The onomatopoeic call is evocative of lonely, windswept uplands during spring and summer, and estuaries and coastal wetlands at other times of the year. In flight, all birds reveal rather uniform upperparts, darkest on the outer half of the wing, a white rump and lower back, and narrow dark barring on the tail. The sexes are similar, although on average males have shorter bills than females. **ADULT** has mainly grey-brown plumage that is streaked and spotted on the neck and underparts; the belly is rather pale. **JUVENILE** is similar to an adult, but it looks overall more buffish-brown, has fine streaks on the neck and breast, and has an appreciably shorter bill. **VOICE** – utters a characteristic *curlew* call and delivers a bubbling song on breeding grounds. HABITAT AND STATUS The Curlew can be found throughout the year in the region. During the breeding season it is associated mainly with northern and upland habitats although grassland and heathland sites are sometimes used further south. Perhaps 40,000–50,000 pairs nest in the region. Outside the breeding season, Curlews tend to be almost exclusively coastal, the majority favouring estuary mudflats as feeding grounds. Influxes of birds from mainland Europe augment the numbers of resident birds considerably, and the winter population may be almost double that present in the summer. OBSERVATION TIPS The Curlew is a large and distinctive bird, with a call that is instantly recognisable, and so the discovery of the species should not present a problem. However, in spring and autumn there is potential for confusion with a migrant Whimbrel; both species are regular on the coast at such times. A look at the bill length and head pattern of any suspect bird will soon dispel any uncertainty.

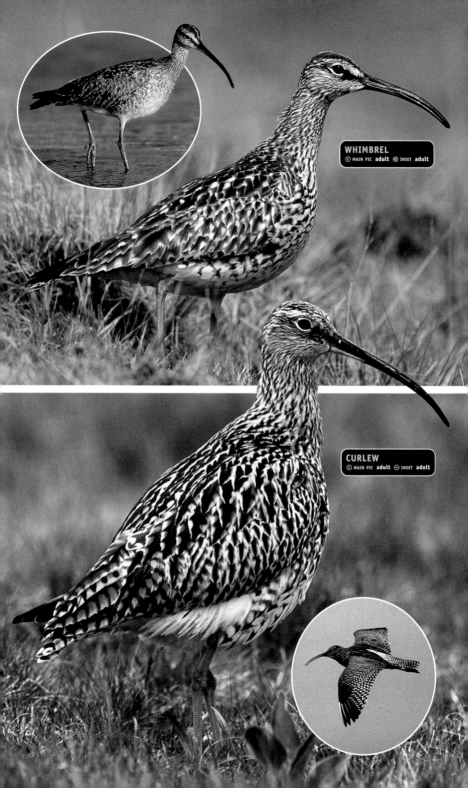

WHIMBREL
MAIN PIC adult INSET adult

CURLEW
MAIN PIC adult INSET adult

BLACK-TAILED GODWIT *Limosa limosa* LENGTH 38–42cm

A large and long-legged wader with an incredibly long bill that is straight, or only very slightly upturned. In flight, all birds reveal a striking contrast between the black tail, the white rump and the conspicuous white wingbars on the upper-wing; on the underwings, the whitish coverts contrast with the dark flight feathers. Compared to a Bar-tailed Godwit, note the appreciably longer tib-iae (the upper section on the leg). The sexes are dissimilar in summer. **SUMMER ADULT MALE** has reddish-orange on the face, neck and breast. The back is greyish but spangled with reddish-brown and the belly is whitish with barring on the flanks. Birds of the race *islandica*, destined to depart for Icelandic breeding grounds, have darker red body plumage than males that breed in southern Britain (race *limosa*). All birds have an orange base to the bill. **SUMMER ADULT FEMALE** is similar to a summer adult male but the reddish elements of the body plumage are much less extensive and intense. **WINTER ADULT** has rather uniform body plumage that is palest on the belly; the undertail is white and the base of the bill is pink. **JUVENILE** recalls a winter adult but has a rich orange suffusion to the neck and breast, and pale fringes and dark spotting to feathers on the back. **VOICE** – utters a *kwe-we-we* call in flight. HABITAT AND STATUS A few dozen pairs of Black-tailed Godwits breed in the region, the Ouse and Nene washes being strongholds for the species. Wet grassland is the preferred habitat at this time of year. Outside the breeding season, there is an influx of Icelandic birds and perhaps as many as 15,000 birds winter in the region. At this time of year they favour muddy estuaries for feeding. OBSERVATION TIPS Black-tailed Godwits are most numerous, and hence easiest to see, outside the breeding season; most estuaries in southern England and southern Ireland are likely to hold good numbers of the species. In late winter and early autumn, you stand a good chance of seeing adult birds in complete or partial breeding plumage.

juvenile

BAR-TAILED GODWIT *Limosa lapponica* LENGTH 35–40cm

A large wader with a rather dumpy body. The bill is incredibly long and subtly, but distinctly, upturned. When compared to a Black-tailed Godwit, note the shorter-legged appearance (the tibiae are shorter). In flight, note the absence of a wingbar on the upperwing; the white on the rump extends as a wedge to the lower back and the tail is barred. If the bill is not seen, a winter bird in flight can look rather like a Curlew. The sexes are dissimilar in summer, and breeding-plumage birds are sometimes seen in the region even though the species does not nest here. **SUMMER ADULT MALE** has reddish-orange on the head, neck and underparts. The back is spangled grey, black and pale buff and the bill is all dark. **SUMMER ADULT FEMALE** has a buffish-orange wash to the head, neck and breast, a pale belly and a greyish back. **WINTER ADULT** has a rather uniform grey-brown head, neck and upperparts; the underparts are pale and the bill is pink at the base. **JUVENILE** recalls a winter adult but it has a buffish wash to the head, neck and upperparts. **VOICE** – utters a sharp *kve-wee* call in flight. HABITAT AND STATUS The Bar-tailed Godwit breeds in the Arctic and is a non-breeding visitor to Britain and Ireland. Birds typically favour estuaries and sandy and muddy beaches, hunting for prey such as Lugworms and Ragworms on rising and falling tides; several tens of thousands of birds occur here each year. OBSERVATION TIPS Bar-tailed Godwits are usually easy to discover during the winter months on estuaries around almost the entire coastline in the region. They are readily distin-guishable from Black-tailed Godwits in flight and, with experience, even lone feeding individuals should not present an identification problem so long as the leg length, and the shape and length of the bill, can be studied.

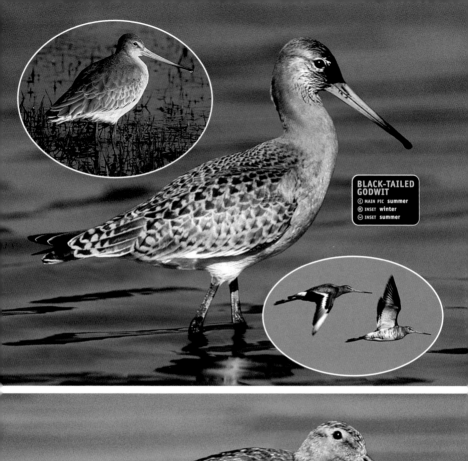

BLACK-TAILED GODWIT
- ☉ MAIN PIC **summer**
- ⊗ INSET **winter**
- ☉ INSET **summer**

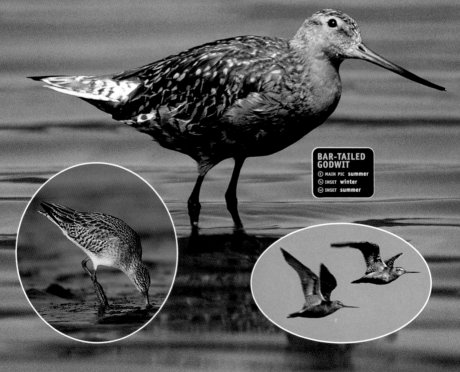

BAR-TAILED GODWIT
- ☉ MAIN PIC **summer**
- ☉ INSET **winter**
- ☉ INSET **summer**

REDSHANK *Tringa totanus* LENGTH 28cm

A medium-sized wader that often announces its presence to an observer with its shrill alarm call. In flight, all birds can be recognised by the broad, white trailing edge to the wings, the white back and rump, and the trailing red legs. The sexes are similar. **SUMMER ADULT** is mainly grey-brown above and pale below, but the back is heavily marked with dark spots and the neck, breast and flanks are heavily streaked. There is a faint, pale supercilium and eye-ring, and the base of the straight bill is reddish. **WINTER ADULT** has rather uniform grey-brown upperparts, including the head, neck and breast, with paler, mottled underparts. The colours on the bill and legs are less intense than in the summer. **JUVENILE** recalls a winter adult, but the plumage is overall browner, the feathers on the back have pale notches and margins, and the legs and base of the bill are dull yellow. **VOICE** – utters a yelping *tiu-uu* alarm call. The song is musical and yodelling. HABITAT AND STATUS During the breeding season, Redshanks favour areas of undisturbed damp grassland, moors and the margins of marshes; around 30,000–40,000 pairs may breed in the region, the majority in northern England and Scotland. Outside the breeding season, when an influx of birds from elsewhere in Europe boosts the population to several hundreds of thousands of birds, Redshanks are more exclusively coastal. In addition to estuaries and mudflats, the species is also found on coastal grasslands and marshes. OBSERVATION TIPS Visit almost any area of estuary or mudflat around the coast and you should have no difficulty finding Redshanks; the species is most numerous outside the breeding season.

SPOTTED REDSHANK *Tringa erythropus* LENGTH 29–30cm

An elegant cousin of the Redshank that has proportionately longer legs and a longer bill. In flight, all birds can be distinguished by the uniform upperwings that lack the Redshank's white trailing edge. Spotted Redshanks have a distinctive flight call and at close range the slightly downcurved tip of the bill can be discerned. They feed in a rather deliberate manner, often in water that is deep enough to require them to swim from time to time. The sexes are similar. **SUMMER ADULT** (sometimes seen in the region in late spring and summer) has almost black body plumage with a white eye-ring and dotted white fringes to the back feathers. Note, however, that in the region it is more usual to encounter birds in incomplete breeding plumage. In any case, females are typically much more mottled on the underparts than males. Typically, the legs of birds in breeding plumage are dark. **WINTER ADULT** has pale grey upperparts and rather clean, whitish underparts. The legs are reddish and note the rather striking pale supercilium. **JUVENILE** recalls a winter adult, but the plumage is overall much darker and the underparts are heavily barred; the legs are orange-yellow. **VOICE** – utters a diagnostic *tchewit* call in flight. HABITAT AND STATUS The Spotted Redshank occurs in the region as a regular passage migrant in small numbers. The species often departs for its breeding grounds surprisingly late in spring, and returning birds sometimes reappear as early as July. Consequently, birds in partial or complete breeding plumage can sometimes be seen. Perhaps 100 or more Spotted Redshanks also spend the winter here. They favour estuaries and coastal pools at all times. OBSERVATION TIPS Get to know the Spotted Redshank's distinctive call and you will have a head start when it comes to finding the species. A visit to an estuary on the south or east coasts of England will provide the best opportunities for discovery, and August and September are probably the best months for the species.

incomplete summer

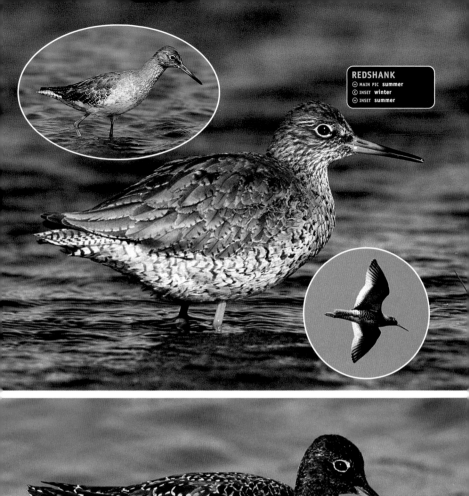

REDSHANK
- ⊙ MAIN PIC **summer**
- ⊙ INSET **winter**
- ⊙ INSET **summer**

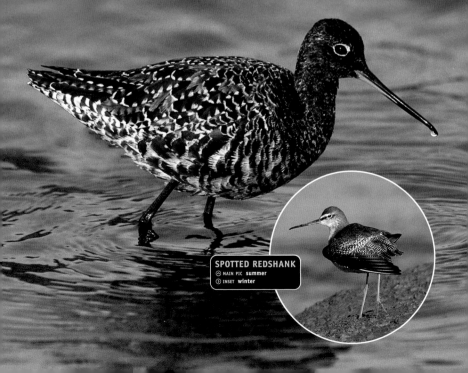

SPOTTED REDSHANK
- ⊙ MAIN PIC **summer**
- ⊙ INSET **winter**

GREENSHANK *Tringa nebularia* LENGTH 30–34cm

An elegant and long-legged wader. It can look very white at a distance, but a close view reveals finely patterned feathers on the upperparts. At all times, Greenshanks have yellowish-green legs and a long, slightly upturned bill that has a greyish base. In flight, all birds show uniform upperwings (wingbars are absent) and a white rump and wedge up the back. The Greenshank feeds in a deliberate, probing manner. The sexes are similar. **SUMMER ADULT** has mainly grey-brown upperparts, but many of the back feathers have black centres. The head, neck and breast are heavily streaked but the underparts are otherwise white. **WINTER ADULT** is rather uniformly pale grey above and white below. **JUVENILE** recalls a winter adult, but the upperparts are darker and browner. **VOICE** – utters a distinctive *tchu-tchu-tchu* call. HABITAT AND STATUS During the breeding season, Greenshanks favour extensive blanket bogs in Scotland, and the Flow Country of Caithness and Sutherland is a stronghold for the species. Perhaps 1,000 or so pairs nest in the region, and a significant proportion of these birds probably spends the winter months in Britain and Ireland too. The species is also known as a passage migrant, with birds that breed further north in mainland Europe stopping off on their way to and from wintering grounds in southern Europe or North Africa. Although migrant birds sometimes visit freshwater sites inland, the majority of passage and wintering Greenshanks favour coastal habitats, typically estuaries and brackish pools. OBSERVATION TIPS Greenshanks are easiest to observe outside the breeding season and on the coast. Numbers are greatest in the autumn, but if you visit an estuary in the southern half of the region during the winter months you should have no difficulty in discovering at least a handful of birds in a single day.

RUFF *Philomachus pugnax* LENGTH 23–29cm

An extremely variable wader, both in terms of its size and its appearance. The Ruff's proportionately rather small head is one of its most consistent characteristics. Note also the slightly downcurved bill and the orange-yellow legs. In flight, all birds show a narrow white wingbar and broad white sides to the rump. Males are smaller than females (which are known as Reeves) and, during the breeding season, they are adorned with unique head decorations. **SUMMER ADULT MALE** has brownish upperparts, many of whose feathers have black tips and bars. For a brief period (typically only on breeding grounds), males acquire facial warts and a set of variably coloured ruff and crest feathers. Each male is slightly different, but the ruff feathers are usually a uniform colour (black, white or chestnut are typical). **SUMMER ADULT FEMALE** has grey-brown upperparts, many of whose feathers have dark tips and bars; the underparts are pale. **WINTER ADULT** has rather uniform grey-brown upperparts and pale underparts. **JUVENILE** recalls a winter adult but is suffused with buff all over and the feathers on the back have pale fringes, creating a scaly appearance. **VOICE** – mainly silent. HABITAT AND STATUS During the breeding season, Ruffs are associated with flood meadows and marshes. Just a handful of birds breed in the region and the species is far better known as a passage migrant that is more common in autumn than spring. At such times, Ruffs favour coastal freshwater pools and sometimes feed on nearby ploughed fields. Most birds winter in Africa, but perhaps 500–1,000 remain in the region, and the south and east coasts of England hold the greatest proportion of these. OBSERVATION TIPS If you visit an area of coastal freshwater pools during migration, you stand a good chance of finding a few Ruffs. August and September are the prime months and, not surprisingly, juvenile birds predominate. Count yourself extremely fortunate if you see a male Ruff in full breeding plumage, even in spring: migrant birds seldom possess their head adornments.

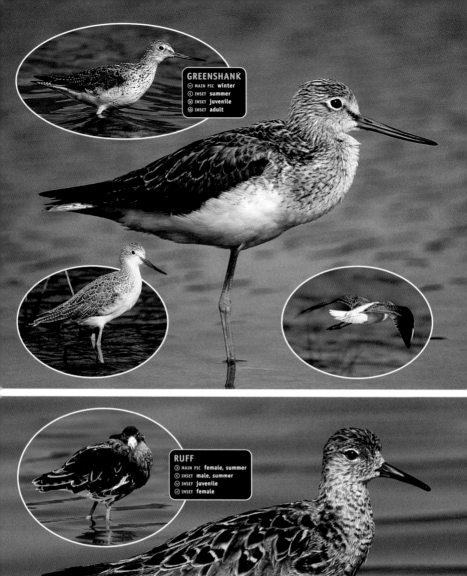

GREENSHANK
- ⊙ MAIN PIC **winter**
- ◖ INSET **summer**
- ⊙ INSET **juvenile**
- ⊛ INSET **adult**

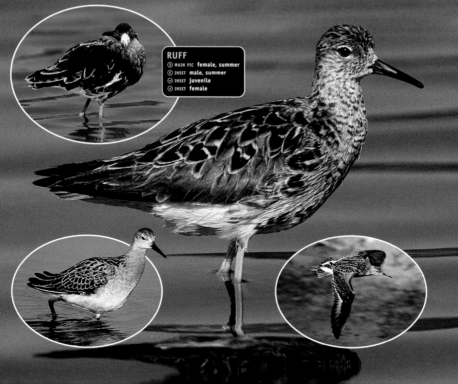

RUFF
- ⊙ MAIN PIC **female, summer**
- ◖ INSET **male, summer**
- ⊙ INSET **juvenile**
- ⊙ INSET **female**

COMMON SANDPIPER *Actitis hypoleucos* LENGTH 18–20cm

An active little wader with a characteristic bobbing gait. Overall, the Common Sand-piper looks rather plump-bodied but with a rather elongated tail end. It flies on bowed, fluttering wings and typically is seen flying just a metre or so above water; note the striking white wingbar but the absence of a white rump. The sexes are similar. **ADULT** has warm brown upperparts with a rather faint pat-tern of dark centres and barring to the feathers on the back and wings. The head and neck are grey-brown and there is a clear demarcation between the dark breast and the white underparts; note that the white extends up the sides of the breast. **JUVENILE** is similar to an adult, but the feathers on the wing coverts are strikingly barred. **VOICE** – utters a whistling *tswee-wee-wee* call in flight. HABITAT AND STATUS During the breeding season, Common Sandpipers are found beside upland and northern rivers, streams, lakes and lochs. There may be around 15,000 or more pairs in the region, with the greatest concentration in Scotland; northern England, Wales and northwest Ireland are also important for the species. In spring and autumn, the Common Sandpiper is a widespread and fairly com-mon passage migrant, turning up at a variety of inland sites but mainly found around the coast. Fewer than 100 probably spend the winter here, the majority heading south to Africa. OBSERVATION TIPS If you spend enough time walking beside streams and lakes in Scotland or northern England you will come across this species sooner or later, typically bobbing its way among waterside stones. It would be unusu-al to come across more than a handful of birds during a day trip to the coast at migration times.

GREEN SANDPIPER *Tringa ochropus* LENGTH 21–23cm

An elegant, but rather plump-bodied wader. The Green Sandpiper has a bobbing gait and can look rather black and white in harsh light. It feeds unobtrusively and is often first observed when flushed from the margins of a pond or ditch. At such times, the conspicuous white rump and yelping alarm call help with identifica-tion. Note that the tail is marked with a few broad dark bands but usually looks all dark. The sexes are similar. **ADULT** has rather dark brown upperparts, adorned with small pale spots. The head and neck are streaked, and there is a clear demarcation between the dark, streaked breast and the clean white underparts. The pale supercilium is bold only in front of the eye and the legs are greenish-yellow. **JUVENILE** is similar to an adult but the pale spotting on the upper-parts is more noticeable. **VOICE** – utters a trisyllabic *chlueet-wit-wit* flight call. HABITAT AND STATUS A widespread and fairly common passage migrant throughout the region. However, several hundred birds overwinter, mostly in the south. On migration, the species can be found on a variety of freshwater habi-tats, including pond and lake margins, and small and overgrown streams and ditches. OBSERVATION TIPS For the best chance of finding this species, visit a watercress bed in southern England in winter. During periods of severe weather, Green Sandpipers are more likely to feed in the open because, while the habi-tat's margins may freeze, typically the feeder stream for the watercress will keep flowing.

WOOD SANDPIPER *Tringa glareola* LENGTH 19–21cm

A small wader with elegant proportions. The Wood Sandpiper has longer legs than its similar-sized cousins and these are yellowish at all times. The pale supercil-ium is prominent both in front of, and behind, the eye. In flight, all birds reveal a white rump and narrow dark bars on the tail. The sexes are similar. **ADULT** has brownish, spangled upperparts. The head and neck are streaked, and the rather faint streaking and spotting on the breast merges with the pale underparts without a clear demarcation. **JUVENILE** is similar to an adult but the upperparts are browner and more conspicuously marked with pale buff spots. **VOICE** – utters a distinctive *chiff-chiff-chiff* flight call. HABITAT AND STATUS The Wood Sandpiper is best known in the region as a passage migrant. It is widespread and fairly common, particularly so in autumn, and turns up (mainly in ones and twos) on freshwater pools close to the coast, and to a lesser extent inland as well. A handful of pairs attempt to breed each year, their range restricted to boggy ground in the Scottish Highlands. OBSERVATION TIPS August and September are the best months to look for this species. Wood Sandpipers can be surpris-ingly easy to overlook if they are feeding amongst marginal or emergent vegetation.

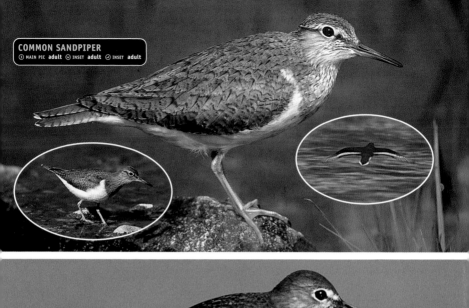

COMMON SANDPIPER
⊙ MAIN PIC **adult** ⊙ INSET **adult** ⊙ INSET **adult**

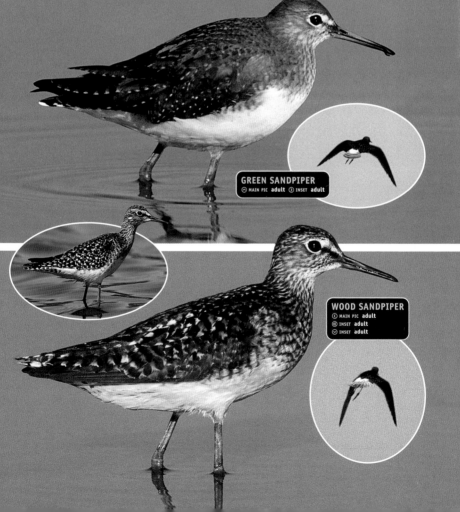

GREEN SANDPIPER
⊙ MAIN PIC **adult** ⊙ INSET **adult**

WOOD SANDPIPER
⊙ MAIN PIC **adult**
⊙ INSET **adult**
⊙ INSET **adult**

WOODCOCK *Scolopax rusticola* LENGTH 35–38cm

A distinctive wader with a dumpy body, long bill and rather short legs. The cryptic colours and pattern of the plumage make the Woodcock incredibly difficult to see among leaf litter. The species is largely nocturnal. Not surprisingly, therefore, most encounters with the species are limited to chance occasions when a bird is flushed, or a flight silhouette is seen of a displaying (Roding) bird in spring. The sexes are similar. **ADULT** and **JUVENILE** have marbled chestnut, black and white plumage, which is palest and more extensively barred on the underparts. Note the large eyes that are located high on the head, giving the bird almost complete all-round vision. **VOICE** – males utter soft duck-like calls and explosive squeaks in a crepuscular display flight that is referred to as roding. HABITAT AND STATUS The Woodcock is associated with wooded habitats; both mixed and deciduous woodland are favoured. A mosaic of open areas and dense canopy cover are favoured in the breeding season, and damp ground is needed for feeding. Woodcock numbers are impossible to assess with any accuracy, but several tens of thousands of pairs probably breed in the region. Numbers increase dramatically in winter as a result of influxes of birds from as far away as Russia. Sadly, hundreds of thousands are shot here each year. OBSERVATION TIPS Apart from a chance encounter, the best opportunities for seeing a Woodcock come in the spring: visit likely looking woodland at dusk and watch and listen for roding birds.

JACK SNIPE *Lymnocryptes minimus* LENGTH 18–20cm

A tiny and dumpy wader. Although similar to a Snipe, it is appreciably smaller and the bill and legs are relatively shorter; the markings on the head and back are also more striking. The Jack Snipe moves in a distinctive manner, pumping its body up and down as it walks. It is easy to overlook because it feeds unobtrusively among waterside vegetation and is very reluctant to fly, preferring instead to crouch motionless until danger has passed. The sexes are similar. **ADULT** and **JUVENILE** have essentially brown upperparts with intricate, cryptic dark markings on the feathers. There are striking yellow stripes on the back, on which a greenish sheen can sometimes be discerned. The head is strikingly marked with dark and pale buff stripes; note in particular the forked, pale supercilium. The neck and breast are streaked and the underparts are white. **VOICE** – mostly silent. HABITAT AND STATUS The Jack Snipe is a winter visitor to the region. It favours the muddy margins of pools and marshes where the dead stems of rushes and grasses provide a near-perfect match for its cryptic plumage. It is impossible to assess its numbers accurately, but several tens of thousands of birds are probably present in the region as a whole; sadly, many thousands of these are shot each year. OBSERVATION TIPS Jack Snipe are always a challenge to observe. For the best chances of seeing one, visit the Scilly Isles in October.

SNIPE *Gallinago gallinago* LENGTH 25–28cm

A distinctive wader that is easily recognised by its dumpy, rounded body, rather short legs and its incredibly long, straight bill. The latter is used to probe vertically downwards in soft mud, in the manner of a sewing machine. The sexes are similar. **ADULT** and **JUVENILE** have mainly buffish-brown upperparts that are beautifully patterned with black and white lines and bars. Note the distinctive stripes on the head, the streaked and barred breast and flanks, and the white underparts. **VOICE** – utters one or two sneeze-like *kreech* calls when flushed. Snipe perform a 'drumming' display in the breeding season, although the peculiar humming sound does not have vocal origins, being produced instead by vibrating tail feathers. HABITAT AND STATUS Snipe are invariably associated with waterlogged or boggy ground. During the breeding season, marshes, meadows and moorland bogs are favoured; several tens of thousands of pairs probably breed in the region, the bulk of the population being found in Scotland, Ireland and northern England. Snipe are more widespread and numerous in winter, and are found in a wider variety of freshwater habitats. The winter population probably exceeds 100,000 birds but, sadly, tens of thousands of these are shot each year. OBSERVATION TIPS Snipe are particularly visible during the breeding season, when territorial birds often perch conspicuously on fenceposts or mounds of vegetation, or perform their diagnostic aerial displays overhead. Outside the breeding season, observations are often restricted to birds that are flushed from cover.

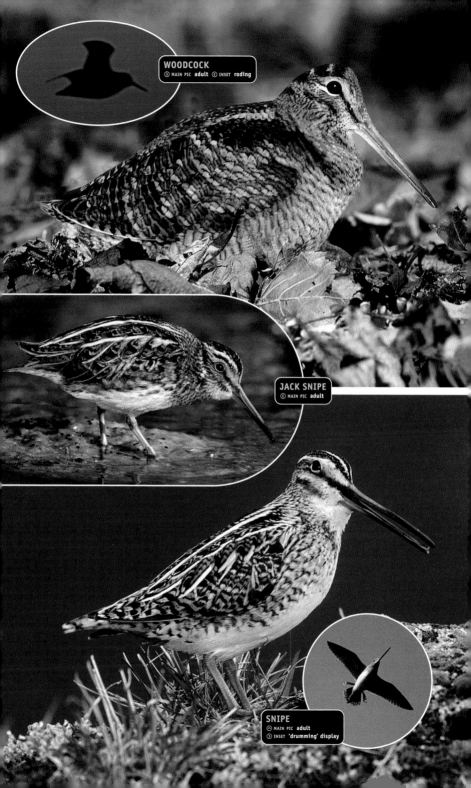

WOODCOCK
MAIN PIC **adult** INSET **roding**

JACK SNIPE
MAIN PIC **adult**

SNIPE
MAIN PIC **adult**
INSET **'drumming' display**

TURNSTONE *Arenaria interpres* LENGTH 23cm

A robust and pugnacious little wader. The Turnstone has a short, stout and trian-
gular bill that is used to turn stones and tideline debris in search of seashore inver-
tebrates. All birds have reddish-orange legs and show a striking black and white
pattern in flight. The sexes are similar. **SUMMER ADULT** has extensive areas of
orange-red on the back, white underparts, and bold black and white markings
on the head. Males have brighter back colours than females and more dis-
tinct black head markings. **WINTER ADULT** has essentially grey-brown upper-
parts, including the head and neck. The breast is marked with a blackish band
that shows a clear demarcation from the white underparts. **JUVENILE** is similar
to a winter adult, but the upperparts are paler and the back feathers have pale
fringes. **VOICE** – utters a rolling *tuk-ut-ut* in flight. HABITAT AND STATUS Although the Turnstone is occa-
sionally suspected of breeding in Scotland, it is essentially a non-breeding visitor to the region. It is found
exclusively on the coast, and several tens of thousands of birds are present in the winter months. The ideal
location is a rocky shore with an extensive strandline. OBSERVATION TIPS Turnstones can be found on most
beaches and estuaries in winter. Small numbers linger into May and often have returned by August – these
birds are often seen in breeding plumage.

RED-NECKED PHALAROPE *Phalaropus lobatus* LENGTH 18cm

A delightful and confiding little wader. The Red-necked Phalarope uses its all-dark,
needle-like bill to pick small invertebrates from the water's surface; typical-
ly this is done while swimming. The species shows role reversal at the nest
and breeding females are brighter than males. **SUMMER ADULT FEMALE** has
brown upperparts and many back feathers have yellow-buff margins. Note
also the white throat, dark cap and the reddish-orange neck; the grey breast
and mottled flanks grade into the white underparts. **SUMMER ADULT MALE**
is similar, but colours are duller. **WINTER ADULT** has mainly grey upperparts
and white underparts, with a greyish hindcrown and nape and a black patch
through the eye. **JUVENILE** recalls a winter adult, but it has brown upper-
parts with pale buff fringes to the back feathers; it gradually acquires grey back feathers in autumn. **VOICE**
– occasionally utters a sharp *kip* call. HABITAT AND STATUS The Red-necked Phalarope is a common nest-
ing species in the Arctic. Britain and Ireland are at the southern limit of its breeding range and so, not
surprisingly, our tiny nesting population is restricted to the far north, the Shetland Islands being a strong-
hold. It winters far out to sea and is best known in our region as passage migrant. It is more regular in
autumn than in spring, and it usually appears on coastal pools after gales. OBSERVATION TIPS If you visit
the Shetland Islands in spring you stand a chance of seeing Red-necked Phalaropes in breeding plumage.
The species is vulnerable at the nest and is protected by law, so admire any birds that you see from a dis-
tance. Following severe westerly gales in September, the species sometimes turns up on coastal pools.

GREY PHALAROPE *Phalaropus fulicarius* LENGTH 20–21cm

A charming little wader, typically seen swimming, often spinning rapidly or
picking invertebrates off the water's surface. Most individuals are oblivious
to human observers. The bill is shorter and stouter than that of a Red-necked
Phalarope, and it has a yellow base. The sexes are dissimilar only in breed-
ing plumage (very occasionally seen in the region). **WINTER ADULT** has grey
upperparts, white underparts, a dark crown and nape, and a black 'panda'
mark through the eye. **SUMMER ADULT FEMALE** has striking orange-red
plumage on the neck and underparts, a dark crown and white facial patch,
and buff-fringed dark feathers on the back. **SUMMER ADULT MALE** is simi-
lar but the colours are much duller. **JUVENILE** recalls a winter adult, but the
breast, neck and back are tinged buff and the back feathers are dark with buff fringes. **VOICE** – utters a
sharp *pit* flight call. HABITAT AND STATUS The Grey Phalarope passes through on migration, mostly in
autumn, although there are occasional winter records, and (in breeding plumage) in the spring. It is a
true seabird outside the breeding season and so most records are coastal, involving birds forced close to
land during gales. After bad storms, the species sometimes turns up on inland lakes. OBSERVATION TIPS
After westerly or southwesterly gales in September or October, visit the coast to look for this species.

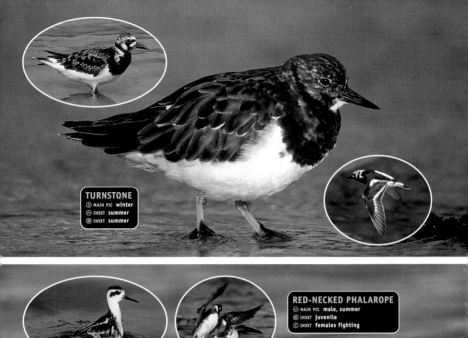

TURNSTONE
> MAIN PIC **winter**
> INSET **summer**
> INSET **summer**

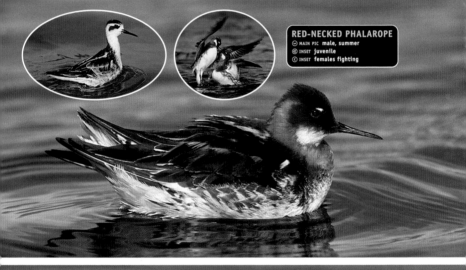

RED-NECKED PHALAROPE
> MAIN PIC **male, summer**
> INSET **juvenile**
> INSET **females fighting**

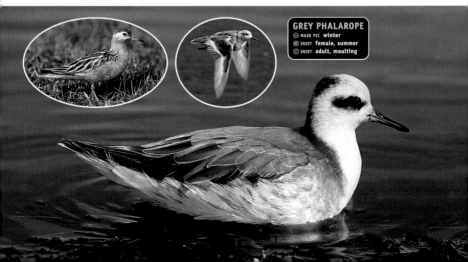

GREY PHALAROPE
> MAIN PIC **winter**
> INSET **female, summer**
> INSET **adult, moulting**

BLACK-HEADED GULL *Larus ridibundus* LENGTH 35–38cm

The most numerous medium-sized gull in the region. The Black-headed Gull's plumage varies according to its age and the time of year, but it can be recognised at all times by the white leading edge to the outer wings. It is typically seen in single-species flocks and breeds colonially. The sexes are similar. **SUMMER ADULT** has a grey back and upperwings, white underparts and a chocolate-brown hood. The legs and bill are red, and note the subtle white eye-ring. In flight, the trailing edge of the outer wing is black, this feature being narrow on the upperside but more extensive below. **WINTER ADULT** loses the dark hood, the white head being adorned with dark smudges above and behind the eye; in other respects the plumage is similar to a summer adult. **JUVENILE** has an orange-brown flush to the upperparts, some dark feathering on the back, dark smudges on the head and a dark tip to the tail. Note also the dark trailing edge to the wings and the rufous panels on the upperwings and back. It acquires adult plumage by its second winter through successive moults. **FIRST-WINTER BIRD** retains many juvenile plumage details, but it loses the rufous elements and gains a uniform grey back. **FIRST-SUMMER BIRD** still has a juvenile-type pattern on the wings but gains a dark hood. **VOICE** – a noisy species with raucous calls that include a nasal *kaurrr*. HABITAT AND STATUS This widespread and numerous species is found in a wide variety of habitats. The Black-headed Gull is perhaps commonest around the coast and on inland freshwater locations, but it turns up in urban settings as well as on farmland; the species often follows the plough. Black-headed Gulls breed beside upland lakes and on coastal marshes; around 200,000 pairs probably nest in the region. Numbers are boosted in winter by influxes of birds from mainland Europe, and several million may be present outside the breeding season. OBSERVATION TIPS You would be hard pushed to miss this species at any time of year. It is found in almost all habitats in the region, with the exception perhaps of woodlands and mountain tops.

MEDITERRANEAN GULL *Larus melanocephalus* LENGTH 36–38cm

An attractive gull. Although superficially similar to the Black-headed Gull, it is separable in all plumages with experience. The Mediterranean Gull's bill is stouter at all times and the adult's rather uniformly pale wings are a reliable identification feature throughout the year. In the region, the species is typically found among flocks of Black-headed Gulls. The sexes are similar. **SUMMER ADULT** has a pale grey back and wing coverts, and white flight feathers; in flight, the entire wing can look white. There is a black hood, which accentuates the striking white 'eyelids'; the bill is mainly deep red, but with a yellow tip defined by a black sub-terminal band. The legs are also deep red. **WINTER ADULT** loses the dark hood, the whitish head being marked instead with dark smudges above and behind the white 'eyelids', giving the bird a menacing look. **JUVENILE** has grey-brown upperparts with pale margins to the back feathers. The pale head and neck are separated from the white underparts by a darkish flush on the breast. The bill and legs are dark and there is a dark terminal band on the tail. In flight, note the pale grey inner-wing band on the otherwise mainly dark upperwings. **FIRST-WINTER BIRD** is similar to a juvenile but it acquires a plain grey back and dark smudges above and behind the eye. Adult plumage is acquired by the third winter through successive moults. **SECOND-YEAR BIRD** resembles adult (at their respective times of year) but has limited but variable amounts of black in the wingtips. **VOICE** – utters a distinctive *cow-cow-cow* call. HABITAT AND STATUS Whatever the time of year, Mediterranean Gulls occur in loose association with Black-headed Gulls. Small numbers (probably fewer than 100 pairs) breed in the region, mainly in discrete colonies on coastal marshes in south and east England. Outside the breeding season, birds turn up in Black-headed Gull flocks almost anywhere in the southern half of the region, although most are recorded along the English south coast. OBSERVATION TIPS Although Mediterranean Gulls are rather widespread in winter, the English south coast is still the best place to see the species: the Weymouth area, the Solent and Folkestone are winter hotspots. Fortunately for observers, Mediterranean Gulls are opportunistic feeders and not infrequently loiter around coastal car parks in the hope of picking up scraps of food.

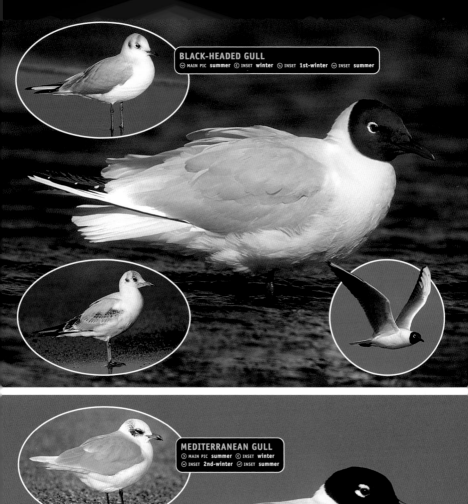

BLACK-HEADED GULL
- MAIN PIC **summer** INSET **winter** INSET **1st-winter** INSET **summer**

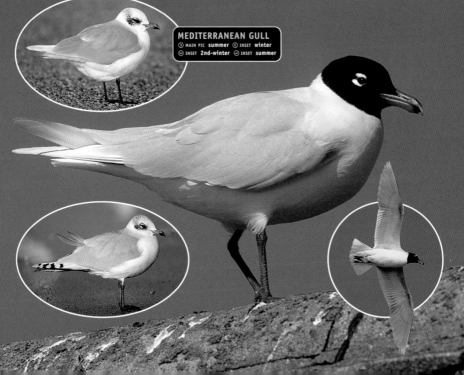

MEDITERRANEAN GULL
- MAIN PIC **summer** INSET **winter**
- INSET **2nd-winter** INSET **summer**

YELLOW-LEGGED GULL *Larus cachinnans* LENGTH 52–60cm

Superficially similar to the Herring Gull and formerly treated as a race of that species. An adult's yellow legs are its best distinguishing features. Typically, Yellow-legged Gulls seen in the region consort with other large gull species. The sexes are similar. **SUMMER ADULT** has a grey back and upperwings (darker than an adult Herring Gull) with more black and less white in the wingtips. **WINTER ADULT** is similar, sometimes with a limited amount of dark streaking on the head. **JUVENILE** and **FIRST-WINTER BIRDS** have a grey-brown back and wing coverts, and otherwise dark wings. The head, neck and underparts, although streaked, are markedly paler than those of a Herring Gull of a similar age. Full adult plumage is acquired over the next three years through successive moults in a similar manner to the Herring Gull. **VOICE** – similar to a Herring Gull. HABITAT AND STATUS The species is a non-breeding visitor to the region, seen most frequently in winter. However, numbers and distribution fluctuate and a scattering of birds is generally always present at any given time. OBSERVATION TIPS Look for Yellow-legged Gulls among flocks of Herring Gulls at rubbish tips and reservoir roosting sites.

HERRING GULL *Larus argentatus* LENGTH 56–62cm

A noisy and familiar bird, and typically the most numerous large gull species in the region. The Herring Gull often follows boats in inshore waters and can become bold when it is fed regularly. The sexes are similar. **SUMMER ADULT** has a blue-grey

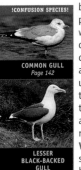

!CONFUSION SPECIES!

COMMON GULL
Page 142

LESSER BLACK-BACKED GULL
Page 138

back and upperwings, with white-spotted, black wingtips; the plumage is otherwise white. The legs are pink, the bill is yellow with an orange spot near the tip, and the eye is yellow with an orange-yellow orbital ring. **WINTER ADULT** is similar, but typically it acquires dark streaks on the head and nape. **JUVENILE** and **FIRST-WINTER BIRDS** are mottled grey-brown with streaked underparts. The legs are dull pink, the bill is dark and the spotted pale tail has a dark tip. Full adult plumage is acquired over the next three years through successive moults. **SECOND-WINTER BIRD** is similar but has a grey back and grey areas on the upperwing. The tail is dark-tipped but otherwise white. **THIRD-WINTER BIRD** resembles a winter adult but has more black on the wingtips and a hint of a dark tail band. **VOICE** – utters a distinctive *kyaoo* and an anxious *ga-ka-ka*. HABITAT AND STATUS During the summer months, the Herring Gull is essentially a coastal bird and more than 100,000 pairs breed in the region. Typically, it nests colonially on sea cliffs and islands, but seaside rooftops are increasingly being used. During the winter months, Herring Gull numbers are boosted by birds from mainland Europe and becomes widespread across the whole of the region, with concentrations at rubbish dumps. OBSERVATION TIPS You will have no problem spotting a Herring Gull in the region.

LITTLE GULL *Larus minutus* LENGTH 25–28cm

A dainty gull and the smallest in the region. At times, and particularly in immature plumage, its buoyant flight gives it more than a passing resemblance to a small tern. The sexes are similar. **SUMMER ADULT** has pale grey upperwings with white wingtips; note also the dark hood, the dark bill and the short, reddish legs. In flight, the upperwings reveal a white trailing edge and a rounded white wingtip; the underwings are dark with a contrasting white trailing edge. **WINTER ADULT** is similar but it loses the dark hood; the otherwise white head has dark smudges on the crown and ear coverts. **JUVENILE** has a striking black bar (forming the letter 'W') on the upperwings and back. There are dark markings on the mantle, nape and ear coverts, and a dark tail band, but the plumage (including the underwing) is otherwise white. **FIRST-WINTER BIRD** is similar to a juvenile but the back is uniformly pale grey, hence the dark bar is seen only on the wings. Full adult plumage is acquired through successive moults over the next two years. **VOICE** – utters a sharp *kyeck* call. HABITAT AND STATUS The Little Gull is a regular passage migrant and winter visitor in the region. The majority of records are coastal. Several hundred birds may be present in Britain and Ireland during the winter months. OBSERVATION TIPS Visit the coast after a gale in autumn or winter and you may find a lone Little Gull flying above the breakers. The east and south coasts of England, and Irish Sea coasts, are good spots.

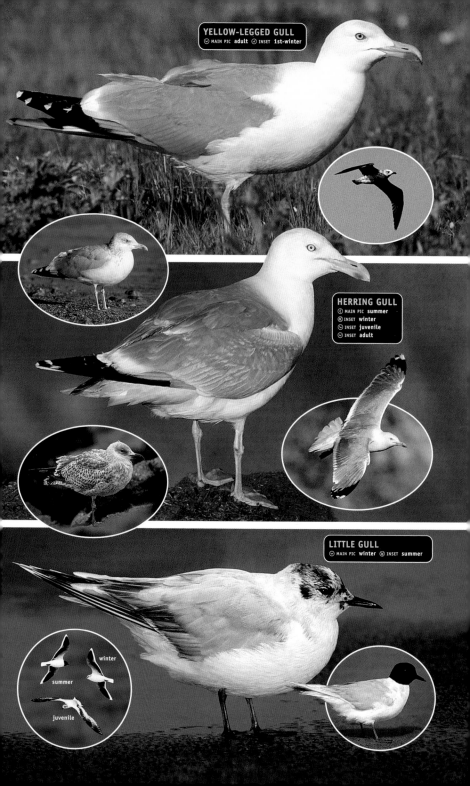

YELLOW-LEGGED GULL
MAIN PIC **adult** · INSET **1st-winter**

HERRING GULL
MAIN PIC **summer**
INSET **winter**
INSET **juvenile**
INSET **adult**

LITTLE GULL
MAIN PIC **winter** · INSET **summer**

winter

summer

juvenile

LESSER BLACK-BACKED GULL *Larus fuscus* LENGTH 55–60cm

A well-marked gull, of similar size and proportions to a Herring Gull. At a distance, the adult's dark grey back and upperwings help in identification, while a closer view will reveal the bright yellow legs. However, there is potential for confusion with an adult Yellow-legged Gull: both have yellow legs and the precise upperwing hue of both species is variable, so that extreme examples resemble one another. The sexes are similar. **SUMMER ADULT** has a dark grey back and upperwings. The black wingtips are appreciably darker than the rest of the upperwing, although birds from the Baltic are almost uniformly black across the entire upperwing. There is a white trailing edge to the inner two-thirds of the upperwing and the rest of the plumage is white. The bill is yellow with an orange spot. The iris is yellow and the orbital ring red. **WINTER ADULT** is similar, but with streaks on the head and neck and duller leg and bill colours. **JUVENILE** and **FIRST-WINTER BIRDS** have

!CONFUSION SPECIES!

HERRING GULL
Page 136

streaked and mottled grey-brown plumage, palest on the head. The upperwings appear uniformly dark brown and the tail is whitish with a dark terminal band. The eye and bill are dark. Full adult plumage is acquired over the next three years through successive moults. **SECOND-WINTER BIRD** is similar to a first winter, but it has a grey back with pinkish legs and a dark-tipped pink bill; the underparts and tail are paler with less streaking. **THIRD-WINTER BIRD** resembles a winter adult, but has more streaking on the head and neck, and a hint of a dark terminal band on the tail. **VOICE** – utters a distinctive *kyaoo* and an anxious *ga-ka-ka*. HABITAT AND STATUS The Lesser Black-backed Gull is a widespread and locally common breeding species in the region, and it is likely that more than 50,000 pairs nest here. The species is colonial, and favoured nesting sites include well-vegetated sea cliffs and islands, although inland sites are also used to an extent. Outside the breeding season, many Lesser Black-backs leave the region and move to the coasts of the Mediterranean and North Africa. However, thanks in part to an influx from mainland Europe, several tens of thousands of birds remain here for the winter. At such times, they are typically found inland, feeding on farmland and on rubbish tips, and roosting on reservoirs and lakes. OBSERVATION TIPS A visit to a Lesser Black-backed Gull colony, such as Skomer Island, is a memorable experience. Outside the breeding season, look for the species feeding on fields or for groups flying to and from roosting sites at dawn and dusk.

GREAT BLACK-BACKED GULL *Larus marinus* LENGTH 64–79cm

Our largest gull species. Although it bears a passing resemblance to a Lesser Black-backed Gull, it always looks more bulky and the adult's back and upperwings are much darker. Note also that the bill is massive and the legs are pink in adult birds. The sexes are similar. **ADULT** has an almost uniformly dark back and upperwings, although the wingtips sometimes appear marginally darker than the rest of the wings in good light. Note the white patch at the very tip of the wings and the broad white trailing edge running along almost the entire length of the wing. The plumage is otherwise white. The bill is yellow with an orange spot. **JUVENILE** and **FIRST-WINTER BIRDS** have mottled and streaked grey-brown plumage. In flight, the brown upperwings reveal pale panels on the upperwing coverts and inner primaries. The bill is dark, the legs are dull pink and the whitish tail has a dark terminal band. Full adult plumage is acquired over the next three years. It is not until the third winter that the back becomes dark; by this time the bill is pale pink with a dark tip. **VOICE** – utters a deep *kaa-ga-ga* call. HABITAT AND STATUS The Great Black-backed Gull is almost entirely coastal during the breeding season, the population comprising around 20,000 pairs. Many nests are found in the vicinity of mixed seabird colonies and pairs are territorial; seabird chicks are an important part of the diet of these birds. Outside the breeding season, the species is more widespread inland and numbers are boosted by influxes from northern mainland Europe. OBSERVATION TIPS Visit a seabird cliff in spring and you should spot this species, although typically nesting pairs are solitary so you will only find a handful of birds. In winter, look for the Great Black-backed Gull among flocks of other gulls; usually it is the least numerous of our resident large gulls.

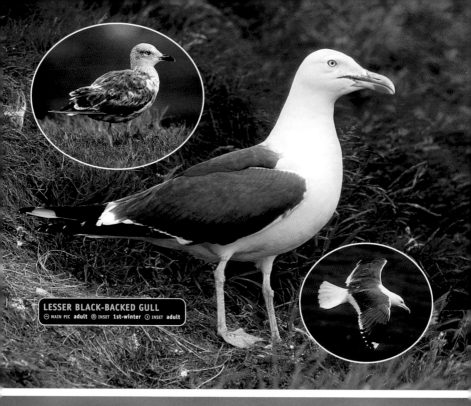

LESSER BLACK-BACKED GULL
▶ MAIN PIC **adult** ⊗ INSET **1st-winter** ◇ INSET **adult**

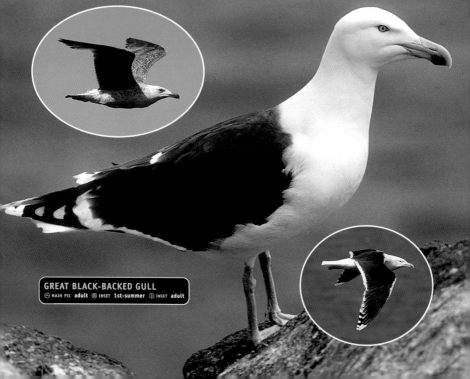

GREAT BLACK-BACKED GULL
▶ MAIN PIC **adult** ⊗ INSET **1st-summer** ◇ INSET **adult**

GLAUCOUS GULL *Larus hyperboreus* LENGTH 62–68cm

A bulky gull that is pale in all plumages. It comes close to the Great Black-backed Gull in terms of size, but in terms of plumage it is closer to a Herring Gull, apart from its diagnostic white primary feathers. The bill is massive and the legs are pinkish at all times. The sexes are similar. **WINTER ADULT** has a pale grey back and upperwings, but the tips of the wings are white and there is a broad white trailing margin to the wings, most obvious in flight. Otherwise, the plumage is mainly white, although a variable extent of dark streaking can be seen on the head and neck. The eye is relatively small, with a pale iris, and the orbital ring is yellow. **SUMMER ADULT** (sometimes seen in late winter) is similar, but the dark streaking on the head and neck is lost. **JUVENILE** and **FIRST-WINTER BIRDS** are mainly pale buffish-grey, but the primary feathers are extremely pale (almost white). The bill is pink with a small black tip. Adult plumage is acquired over the next three years through successive moults. **SECOND-WINTER BIRD** is overall very pale, but with darker streaks on the head and neck, and darker marbling elsewhere. **THIRD-WINTER BIRD** is overall extremely pale, but with faint dark streaking on the head and neck. **VOICE** – utters a *kyaoo* and an anxious *ga-ka-ka*, similar to, but deeper than, a Herring Gull's calls. HABITAT AND STATUS The Glaucous Gull is a non-breeding visitor to the region from nesting grounds in the Arctic. Although a few birds may occasionally linger year round in northern England and Scotland, the species is best known in the winter months. Several hundred Glaucous Gulls probably occur in most years. The species is commoner in the north of the region, and the majority are found on the coast, with smaller numbers at inland reservoirs and lakes. OBSERVATION TIPS Glaucous Gulls are arch scavengers and are often found in the vicinity of fish quays, harbours and coastal car parks. Inland, rubbish tips frequented by other large gull species offer additional opportunities for discovering the species.

!CONFUSION SPECIES!

HERRING GULL
Page 136

ICELAND GULL *Larus glaucoides* LENGTH 52–60cm

An attractive, pale gull. It recalls a Glaucous Gull in all plumages, but note the Iceland Gull's smaller size and its less bulky and longer-winged appearance. The rather rounded head and relatively small bill lend an almost pigeon-like quality to the outline of the head. The legs are pink at all times. The sexes are similar. **WINTER ADULT** has a pale grey back and upperwings with white primary feathers and a white trailing edge to the wings. The plumage is otherwise white, although there are dark streaks on the head and neck. The bill is yellowish with an orange spot and the yellowish eye has a red orbital ring. **SUMMER ADULT** is similar but it loses the dark streaking on the head and neck. **JUVENILE** and **FIRST-WINTER BIRDS** are pale grey-buff with white primaries. The bill is dark with a hint of a pale pink base. Adult plumage is acquired over the next three years through successive moults. **SECOND-WINTER BIRD** looks very pale overall, with faint grey-buff marbling. The bill is pale greyish-pink with a narrow dark tip or sub-marginal band. **THIRD-WINTER BIRD** is similar to a second-winter bird but is even paler (sometimes looks almost pure white). **VOICE** – utters a distinctive *kyaoo* and an anxious *ga-ka-ka*, similar to a Herring Gull but higher pitched. HABITAT AND STATUS The Iceland Gull is a non-breeding visitor to the region from the Arctic. Numbers vary from year to year, but typically there are fewer than 100 records in Britain and Ireland in most seasons. Most records come from coastal sites, notably harbours and other potential food sources. However, the species does turn up inland at rubbish tips and reservoir roosts on occasions. OBSERVATION TIPS Northern and western coasts in the region tend to be best for this species, and the best opportunities for discovery come during cold snaps in January and February. Search for Iceland Gulls among flocks of other large gulls.

winter

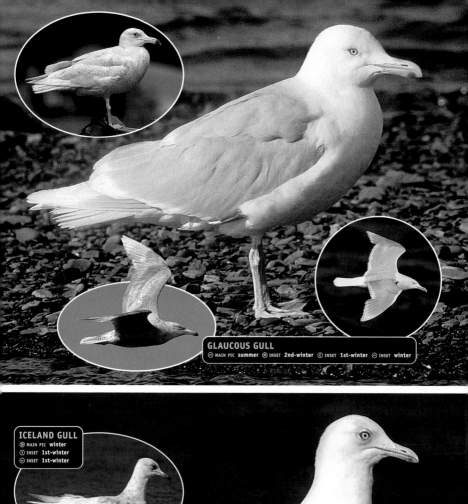

GLAUCOUS GULL
⊙ MAIN PIC **summer** ⊚ INSET **2nd-winter** ⊙ INSET **1st-winter** ⊖ INSET **winter**

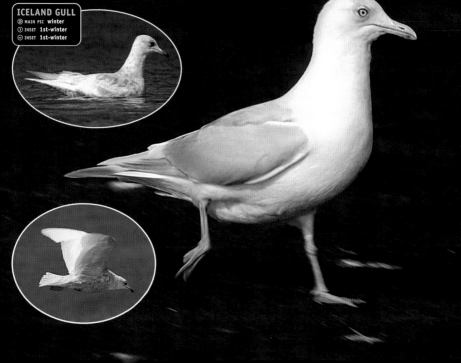

ICELAND GULL
⊙ MAIN PIC **winter**
⊙ INSET **1st-winter**
⊖ INSET **1st-winter**

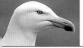

COMMON GULL *Larus canus* LENGTH 40–42cm

A medium-sized gull with a rather dainty bill. Both the bill and body proportions allow separation from larger and smaller gull species. The sexes are similar. **SUMMER ADULT** has a grey back and upperwings, although the latter have black tips adorned with striking white spots and a broad white trailing margin. The plumage is otherwise white. The bill is uniform greenish-yellow and the legs are yellowish-green. **WINTER ADULT** is similar, but there is dark streaking on the head and neck; the bill has duller colours and a dark sub-terminal band.

!CONFUSION SPECIES!

HERRING GULL
Page 136

JUVENILE has pale-margined brown feathers on the back and upperwings. The head and underparts are pale with dark streaking, while the neck and breast often look grubby. Adult plumage is acquired over the next two years. **FIRST-WINTER BIRD** is similar to a juvenile, but it has a grey back and the bill is pink with a dark tip. **SECOND-WINTER BIRD** is similar to an adult, but the black markings on the outerwing are more extensive and the band on the bill is broader. **VOICE** – calls include a mewing *keeow*. HABITAT AND STATUS Most Common Gull colonies are located close to water. Outside the breeding season, when influxes of birds from mainland Europe boost numbers, it is widespread across the region, feeding on farmland and grassy fields. Several tens of thousands of pairs breed in the region, but the winter population numbers several hundreds of thousands of birds. OBSERVATION TIPS Visit northern England, Scotland or northwest Ireland if you want to see the species in the breeding season. In winter, it is far more widespread and it becomes locally common.

KITTIWAKE *Rissa tridactyla* LENGTH 38–42cm

An attractive and delicate-looking gull. The Kittiwake is a true seagull whose non-breeding period is spent entirely at sea. The sexes are similar. **SUMMER ADULT** has a blue-grey back and upperwings, with pure black wingtips; otherwise the plumage is entirely white. The bill is yellow while both the eyes and legs are dark. In flight, the wingtips look like they have been dipped in black ink. **WINTER ADULT** is similar, but the head is marked with grubby patches behind the eye. **JUVENILE** has striking black 'V' markings on each upperwing; the back and upperwing coverts are grey and there is a triangle of white on the flight feathers. Note also the dark tip to the tail, the black half-collar and the dark markings on the head; the bill is dark. **FIRST-**

WINTER BIRD is similar to a juvenile but it gradually loses the dark half-collar and black tail tip. **VOICE** – the diagnostic *kittee-wake, kittee-wake* call can be heard at most seabird colonies. HABITAT AND STATUS The Kittiwake nests colonially, and perhaps 500,000 pairs may breed in the region. Typically, pairs build a sizeable nest on coastal cliff ledges, but man-made structures, including dockside factories, are increasingly being used. Most birds spend the non-breeding period far out to sea, although small numbers can usually be found around harbours during the winter months. OBSERVATION TIPS The Kittiwake is a delight to watch during the breeding season, and at many colonies the birds are accustomed to human observers. Dunbar Harbour (in southern Scotland) and the Farne Islands offer splendid opportunities for observation.

SABINE'S GULL *Larus sabini* LENGTH 30–35cm

A well-marked and distinctive seabird. The sexes are similar. **SUMMER ADULT** has a blue-grey back and upperwings, a dark hood, dark wingtips with white spots and a dark bill with a yellow tip. In flight, the upperwing pattern is striking and diagnostic: there are triangular patches of black, white and grey. The tail is forked. **WINTER ADULT** is similar, but dark smudges on the nape replace the dark hood. **JUVENILE** has a similar upperwing pattern to an adult, but the triangle of grey on the back and upperwing coverts is replaced by scaly grey-brown. The forked tail is dark-tipped. **VOICE** – silent in the region. HABITAT AND STATUS Sabine's Gulls occasionally linger in the West-

ern Approaches in late summer, but the species is essentially an offshore passage migrant through British and Irish seas, with most records occurring from August to October. OBSERVATION TIPS You need to make a real effort to see a Sabine's Gull because the species does not come close to land by choice. Late-summer pelagic boat trips from Cornwall usually encounter small numbers. Westerly gales in September and early October occasionally force birds close to headlands in the southwest.

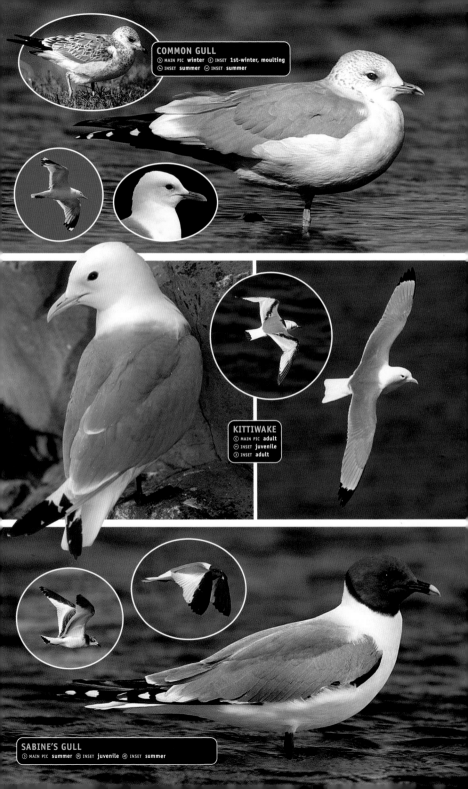

COMMON GULL
- ⟩ MAIN PIC **winter** ⟨ INSET **1st-winter, moulting**
- ⟨ INSET **summer** ⟨ INSET **summer**

KITTIWAKE
- ⟨ MAIN PIC **adult**
- ⌒ INSET **juvenile**
- ⟩ INSET **adult**

SABINE'S GULL
- ⟩ MAIN PIC **summer** ⟨ INSET **juvenile** ⟨ INSET **summer**

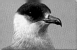
GREAT SKUA *Catharacta skua* LENGTH 50–60cm

A large and bulky seabird with gull-like proportions. However, the Great Skua's relatively large head, dark legs and dark, hook-tipped bill (at all ages) soon confirm its identity. In flight, which is powerful and direct, all birds show a conspicuous white wing patch (actually the pale bases of the outer flight feathers). The Great Skua is in part a scavenger, but it will also kill seabirds such as Puffins and parasitise birds as large as Gannets by forcing them to regurgitate their last meal. The sexes are similar. **ADULT** has chocolate-brown plumage that is streaked and spotted with buff. At close range, note the mane of golden-brown feathers on the nape. **JUVENILE** has similar proportions to an adult, but the back and head are rather uniformly dark

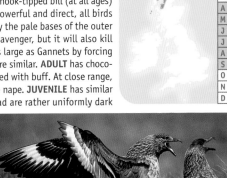

| J |
| F |
| M |
| A |
| M |
| J |
| J |
| A |
| S |
| O |
| N |
| D |

brown while the neck and underparts are rufous-brown and unmarked. **VOICE** – mainly silent. HABITAT AND STATUS Although Great Skuas are seen occasionally in midwinter, the species is essentially a summer visitor and passage migrant to the region. Several thousand pairs breed here, all in northern Scotland; Orkney and Shetland are particular strongholds. Great Skuas nest in loose colonies that are normally sited on moorland in the vicinity of seabird cliffs.

displaying adults

During the breeding season, birds that are not incubating can be seen chasing seabirds out to sea or loafing around on cliffs. Outside the breeding season, they are found at sea; passage birds are most easily observed from headlands during onshore gales. OBSERVATION TIPS If you want to see Great Skuas during the breeding season, then visit the Scottish islands. Hermaness, on the Shetland island of Unst, is a particular stronghold. Be warned, however, that the birds are aggressively territorial – if you happen to stray too close to a nest by mistake, they will dive-bomb you, sometimes even drawing blood with their sharp claws. In spring and autumn, migrant Great Skuas are seen from ferry crossings, although the species can also be observed at regular sea-watching sites, typically when onshore gales are blowing.

POMARINE SKUA
Stercorarius pomarinus LENGTH 50–60cm

A large and impressive seabird. The Pomarine Skua shares some plumage patterns with the Arctic Skua but, in many respects, it has the proportions of a Great Skua. The flight pattern is direct, with deep, powerful wingbeats, and at all ages there is a limited white patch (at the base of the primaries) in the outer wing. The sexes are similar, but adults occur in two colour morphs. **PALE-MORPH ADULT** (the commonest of the two forms) has a white neck and belly but otherwise dark grey-brown plumage. Note the yellow flush on the cheeks and the striking and distinct dark breast band. The bill is pinkish with a dark tip and the tail streamers are long and spoon-shaped. **DARK-**

| J |
| F |
| M |
| A |
| M |
| J |
| J |
| A |
| S |
| O |
| N |
| D |

!CONFUSION SPECIES!

ARCTIC SKUA
Page 146

MORPH ADULT is similar except that the plumage is uniformly dark grey-brown. **JUVENILE** has variably dark, grey-brown plumage that is strongly barred on the undertail coverts, rump and underwing coverts. Note the dark-tipped pale bill and the blunt-ended tail. **VOICE** – silent in the region. HABITAT AND STATUS The Pomarine Skua breeds in the high Arctic and its status in the region is that of a passage migrant. Outside the breeding season, and on migration, it is a true seabird that seldom comes close to land by choice. OBSERVATION TIPS Rather precise weather conditions are needed in order to stand a chance of seeing a Pomarine Skua in the region: specifically, onshore and often adverse winds of Force 6 or above. In spring on the south coast of England, southeasterly gales can sometimes yield sightings from Portland in Dorset to Beachy Head in Sussex. At a similar time of year, northwesterly winds sometimes bring birds close to land off northwest Ireland and the Outer Hebrides. In autumn, northeasterlies sometimes yield sightings along the north Norfolk coast, while southwesterly winds are needed in southwest England and Wales. Juvenile birds sometimes linger at coastal locations for a few days before resuming their migration.

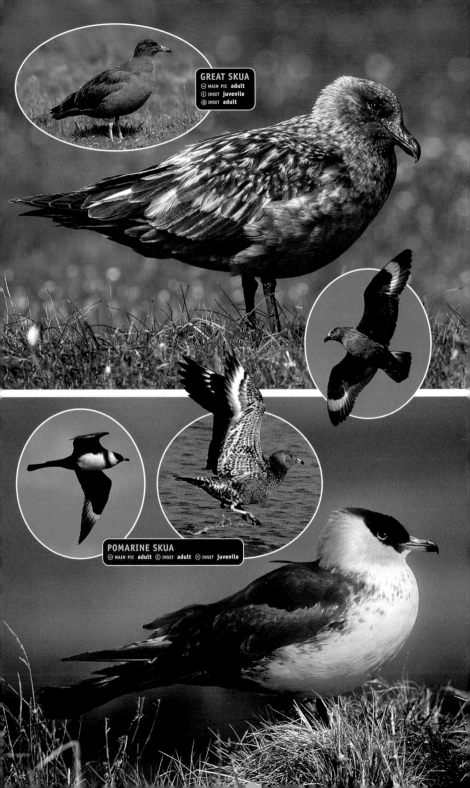

GREAT SKUA
- MAIN PIC **adult**
- INSET **juvenile**
- INSET **adult**

POMARINE SKUA
- MAIN PIC **adult**
- INSET **adult**
- INSET **juvenile**

ARCTIC SKUA *Stercorarius parasiticus* LENGTH 46–60cm

An elegant seabird that is buoyant and graceful on the wing. The deep, powerful wingbeats and narrow, pointed wings can sometimes give the Arctic Skua an almost falcon-like jizz. It feeds by parasitising seabirds such as Arctic Terns and Kittiwakes, forcing them to relinquish their last meal. When chasing quarry, it is incredibly aerobatic. All birds have a white patch near the tip of the wing, but only adults have the pointed tail streamers that extend beyond the wedge-shaped tail. The sexes are similar, but adults occur in two colour morphs. **PALE-PHASE ADULT** has a white neck, breast and belly; there is a dark cap and otherwise the plumage is a uniform dark grey-brown. Note the faint yellowish flush on the cheeks. **DARK-PHASE ADULT** is uniformly dark grey-brown. **JUVENILE** is variably rufous-brown but often rather dark. When compared to a juvenile Pomarine Skua, note the rather dainty, dark-tipped pale bill and the wedge-shaped tail that bears tiny central projections. **VOICE** – utters nasal calls near the nest. HABITAT AND STATUS The Arctic Skua is a summer visitor to Scotland and a passage migrant in spring and autumn elsewhere in the region. Several thousand pairs breed here, and Orkney and Shetland are strongholds. On migration, the species is invariably seen at sea, either from ferries or passing the coast during periods of strong, onshore winds. OBSERVATION TIPS Arctic Skuas are comparatively easy to see around the coasts of Orkney and Shetland during the spring and summer months, and good numbers breed at many of the reserve areas on these islands. Further south, you might expect a daily tally of Arctic Skuas in double figures at regular sea-watching sites, given favourable weather conditions in the form of strong, onshore winds.

!CONFUSION SPECIES!

POMARINE SKUA
Page 144

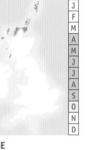

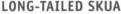

dark phase

LONG-TAILED SKUA

Stercorarius longicaudus LENGTH 36–55cm

An elegant and distinctive seabird. Although it shares some characteristics with the Arctic Skua, it is relatively easy to identify, even at a distance. In flight, the Long-tailed Skua's rather long, pointed wings lack the white patch seen in its cousin's outer wing. As the name suggests, adults possess extremely long central tail streamers. The sexes are similar. **ADULT** is uniform grey-brown on the back and upperside of the inner wing; this contrasts with the dark outer half of the wing and trailing margin of the inner wing. The cap is dark and the neck and underparts are whitish; note the faint yellow flush on the cheeks, seen at close range. **JUVENILE** is variably grey-brown, with some individuals being rather dark. Note the rather wedge-shaped tail; typically, the belly and nape are relatively pale, with a hint of a darker breast band. Compared to a juvenile Arctic Skua, the bill is stubbier, the outer half being darker than the inner half. **VOICE** – silent in the region. HABITAT AND STATUS The Long-tailed Skua is scarce passage migrant in the region. It is something of a prize for most birdwatchers, partly because of its graceful elegance, but also because it is a challenge to see. No doubt it passes through British and Irish waters in good numbers, but relatively few individuals ever come close enough to the shore to be seen. OBSERVATION TIPS If you put in enough full days at well-known sea-watching sites, when conditions are right in autumn, you should eventually see a Long-tailed Skua. Westerly winds are ideal for the Cornish coast, while northeasterly gales are optimum for the north Norfolk coast. In spring, there is a regular passage of birds off the Outer Hebrides during strong northwesterlies. Just occasionally, storm-driven Long-tailed Skuas turn up at inland reservoirs and lakes in autumn; rather bizarrely, juvenile birds in particular are sometimes found feeding in ploughed fields.

adult

ARCTIC SKUA
▷ MAIN PIC **adult, dark phase** ◓ INSET **juvenile**
◒ MAIN PIC **adult, light phase**

LONG-TAILED SKUA
▷ MAIN PIC **adult** ◁ INSET **juvenile**

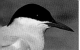

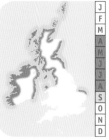

ARCTIC TERN *Sterna paradisaea* LENGTH 33–35cm

An elegant and graceful seabird, the Arctic Tern's flight is buoyant. The sexes are similar. **ADULT** (seen only in summer plumage in the region) has grey upperparts with a black cap, and paler underparts that are palest on the throat and cheeks and darkest (grey looking) on the belly. Note the uniformly blood-red bill, the very short, red legs and the long tail streamers. In flight and from below, the flight feathers look pale and translucent, with a narrow, dark trailing edge to the primaries; from above, the wings look rather uniformly grey. **JUVENILE** has white underparts, an incomplete dark cap and scaly grey upperparts. In flight and from above, note the dark leading edge and white trailing edge to the inner wing. The legs are dull red and the bill is typically dark. **VOICE** – utters a harsh *krt-krt-krt* call near the nest. HABITAT AND STATUS Famous for its long-haul migrations to and from its Antarctic wintering grounds, the Arctic Tern is a summer visitor and passage migrant to Britain and Ireland. Several tens of thousands of pairs breed here, mostly in the northern half of the region, with Orkney and Shetland being strongholds. It breeds in colonies, typically on dunes and flat, coastal land. Birds plunge-dive to catch fish at sea and sometimes bathe in coastal freshwater pools. OBSERVATION TIPS Arctic Terns are easy to see if you visit the Scottish islands in spring and summer. For the ultimate experience, visit the Farne Islands in Northumberland.

COMMON TERN *Sterna hirundo* LENGTH 33–35cm

A widespread and familiar tern that is similar to, but separable from, the Arctic Tern. The Common Tern plunge-dives after surface-feeding fish and sizeable numbers gather where the feeding is good. The sexes are similar. **SUMMER ADULT** has grey upperparts, a black cap and whitish underparts. Compared to an Arctic Tern, note the black-tipped orange-red bill and the proportionately longer red legs; the underparts are typically paler. In flight and from below, only the inner primaries look translucent and the wings have a rather diffuse dark tip; from above, the outer primaries have dark tips and shafts. **WINTER ADULT** (sometimes seen in this plumage in late summer) is similar, but acquires white on the forehead and a dark carpal bar; the bill and legs become dark. **JUVENILE** has white underparts, an incomplete dark cap and scaly grey upperparts; both the leading and trailing edges of the inner wing are dark when seen from above. **VOICE** – utters various harsh calls, including *kreeear*. HABITAT AND STATUS The Common Tern is a widespread summer visitor to the region, and more than 10,000 pairs nest here. Although the species is commonest on the coast, small colonies can also be found inland on flooded gravel pits and reservoirs; here their breeding success is often enhanced by the creation of islands or nesting rafts. Common Terns are also common passage migrants, mainly on the coast. OBSERVATION TIPS The species is easy to see on the coast, and on large inland freshwater bodies, in south and east England. It tends to be more exclusively coastal elsewhere in the region.

ROSEATE TERN *Sterna dougallii* LENGTH 35–38cm

Our rarest breeding tern and one that is threatened throughout its world range. The Roseate Tern is similar to both its Common and Arctic cousins, but it is separable with care. The sexes are similar. **SUMMER ADULT** has pale grey upperparts, a dark cap and whitish underparts on which a pinkish flush can sometimes be discerned. Note the red-based dark bill (this sometimes appears all dark), the red legs and long tail streamers. In flight, it looks strikingly pale, particularly on the underside; from above, note the dark outer primaries. **WINTER ADULT** (sometimes seen in this plumage in late summer) has white on the forehead and it loses the long tail streamers. **JUVENILE** has white underparts, an incomplete dark cap and scaly grey upperparts; the upperwings are rather uniform except for the dark leading edge to the inner wing. **VOICE** – utters a disyllabic *chew-vik* call. HABITAT AND STATUS The Roseate Tern is a summer visitor to the region and its entire population probably numbers just a few hundred pairs; most of these are found in Ireland and all are coastal. OBSERVATION TIPS Roseate Terns are sometimes seen on migration around the coast, but the best chance to see the species will come from visiting one of its protected colonies. Small numbers occur on the Farne Islands, but even here views are necessarily distant to avoid disturbance to the birds.

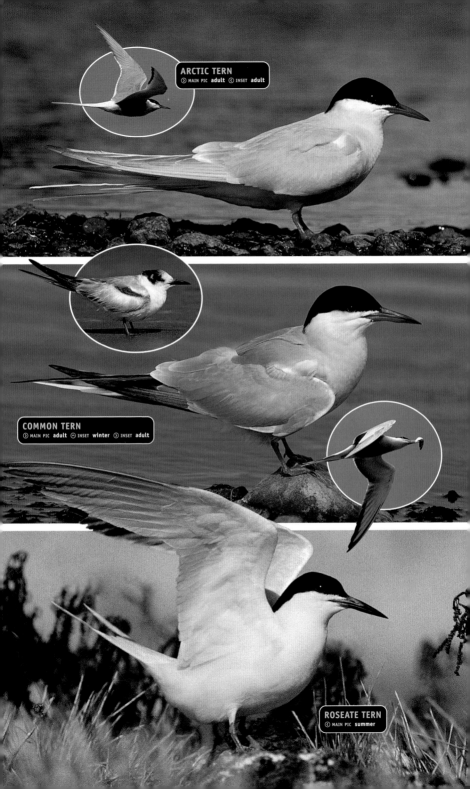

ARCTIC TERN
❯ MAIN PIC adult ❯ INSET adult

COMMON TERN
❯ MAIN PIC adult ❯ INSET winter ❯ INSET adult

ROSEATE TERN
❯ MAIN PIC summer

LITTLE TERN *Sterna albifrons* LENGTH 24cm

The smallest pale tern in the region. The Little Tern's flight is buoyant and it fre-
quently hovers before plunge-diving into shallow water for small fish and shrimps.
The sexes are similar. **SUMMER ADULT** has a grey back and upperwings and a
mainly black cap, although the forehead is white; the plumage is otherwise pure
white. Note the black-tipped yellow bill and the yellow-orange legs. In flight,
the wingtips are noticeably dark. **WINTER ADULT** (begins to acquire this
plumage from late summer onwards) is similar, but the forehead becomes
entirely white and leg and bill colours become dark. **JUVENILE** is similar to
a winter adult, but the back appears scaly and the leading edge of the wing
is dark. **VOICE** – utters a raucous *cree-ick* call. HABITAT AND STATUS The Lit-
tle Tern is a summer visitor to the region. It breeds in scattered colonies around the coast and a couple
of thousand pairs nest in the region, typically favouring shingle and sandy islands and beaches. Despite
attempts that are often made to improve the species' breeding success, Little Terns suffer catastrophic
losses in some years. OBSERVATION TIPS It is extremely unusual to see a Little Tern anywhere other than
on the coast. During the summer months, birds are found in the general vicinity of colonies. Their abil-
ity to fish, or rather the precise area where they feed, is strongly influenced by the state of the tide. On
occasions, they switch to brackish lagoons on the landward side of seawalls and at such times they will
sometimes hover right in front of observers. The Solent and north Norfolk coast are good for the species.

SANDWICH TERN *Sterna sandvicensis* LENGTH 38–41cm

An elegant seabird with a powerful, buoyant flight on long, narrow wings. The Sand-
wich Tern announces its presence with a loud and distinctive call and dives fre-
quently after fish. The sexes are similar. **SUMMER ADULT** is pale grey on the back
and upperwings; it has a dark, crested cap, but otherwise the plumage is white.
The legs are black and the long, narrow bill is black with a yellow tip. In
flight, the wings can look almost pure white, but at closer range some of the
outer primaries are seen to be dark. **WINTER ADULT** (seen in this plumage
from late summer onwards) is similar, but the forehead is white. **JUVENILE**
is similar to a winter adult, but the back is barred and scaly. **VOICE** – utters
a harsh *chee-urrick* call. HABITAT AND STATUS The Sandwich Tern is a sum-
mer visitor and is often one of the first migrants to arrive in spring. It is restricted to coastal habitats.
More than 10,000 pairs breed in the region, forming colonies on beaches and islands and sometimes nest-
ing alongside Black-headed Gulls. OBSERVATION TIPS Once you can recognise the Sandwich Tern's dis-
tinctive call, you will be aware of its presence even before you see it. It is easiest to see in the vicinity
of colonies, and so areas such as the Solent, the north Norfolk coast, Anglesey and the Farne Islands are
hotspots. However, small numbers can be seen passing most headlands in spring and autumn.

BLACK TERN *Chlidonias niger* LENGTH 24cm

An elegant wetland bird whose plumage varies considerably according to time of year
and its age. The Black Tern's buoyant and aerobatic flight is used to good effect
when hawking insects or picking food items from the water's surface. The sexes
are similar. **SUMMER ADULT** has mainly grey upperparts, but the head and neck,
along with the breast and belly, are black; note the white undertail and forked
tail. The bill and legs are dark. **WINTER ADULT** (this plumage is acquired
gradually between July and September) has darker grey upperparts and
entirely white underparts, and the black on the head is restricted to the cap,
nape and ear coverts. Birds in intermediate stages of moult can look a bit 'moth-
eaten'. The bill is dark and legs are dull red. **JUVENILE** is similar to a winter adult
but the back is brownish-grey and scaly. **VOICE** – mainly silent in the region. HABITAT AND STATUS The
Black Tern is almost invariably associated with freshwater wetland habitats, be they marshes, lakes or
flooded gravel pits. In the past, it has been a rare and erratic breeder, but in reality its status today is
that of a regular passage migrant in small numbers. OBSERVATION TIPS Black Terns occur in spring and
autumn. Typically, they are seen in ones and twos, but occasionally small flocks may gather at good feed-
ing sites. Given that there are breeding colonies in adjacent areas of mainland Europe, it is not surpris-
ing to find that, the majority of birds turn up in south and east England, often during southeasterly winds.

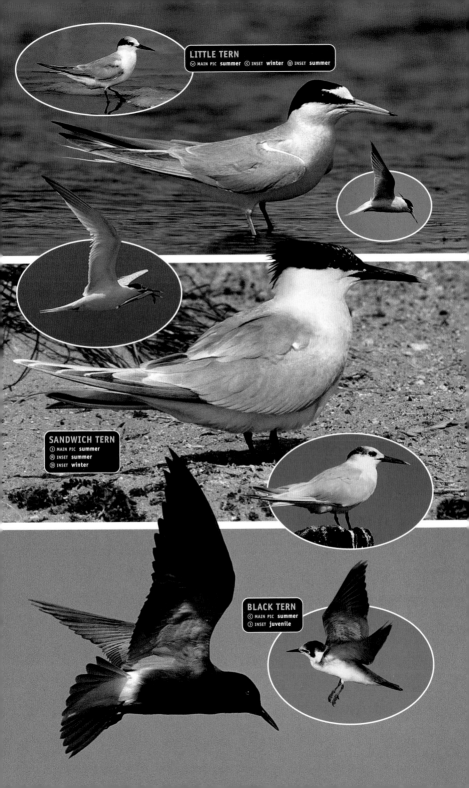

LITTLE TERN
◉ MAIN PIC **summer** ◉ INSET **winter** ◉ INSET **summer**

SANDWICH TERN
▷ MAIN PIC **summer**
⊗ INSET **summer**
⊗ INSET **winter**

BLACK TERN
◉ MAIN PIC **summer**
▷ INSET **juvenile**

PUFFIN *Fratercula arctica* LENGTH 28–30cm

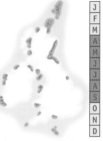

An endearing and unmistakable seabird. At many colonies, observers can get close and excellent views of Puffins. It looks rather black and white at a distance, and flies on narrow wings with whirring wingbeats. The Puffin swims well and dives frequently in search of fish. The sexes are similar. **SUMMER ADULT** has mainly black upperparts but the face is dusky white; the underparts are white with a clear demarcation from the black neck. The legs are orange-red and the bill is huge, flattened and marked with red, blue and yellow. **WINTER ADULT** is similar, but it has a dark grey face and a bill that is appreciably smaller and duller. **JUVENILE** is similar to a winter adult, but it has a relatively small bill that is rather dark and dull. **VOICE** – utters strange groaning calls at the nest. HABITAT AND STATUS The Puffin is a true seabird and it only comes ashore during the breeding season. It breeds in colonies and nests in burrows on grassy, sloping cliffs and islands. The largest colonies comprise thousands – in some cases tens of thousands – of pairs and the population in the region as a whole numbers several hundreds of thousands of pairs. This may seem a lot, but it represents a fraction of the numbers thought to have been present a century or so ago. Reasons for the decline include overfishing and pollution of the marine environment. Outside the breeding season, Puffins are found far out to sea. Typically, only storm-driven, sick or oiled birds are seen close to land at this time of year. OBSERVATION TIPS The sight, sound and smell of a large Puffin colony combine so that a visit to one is an unforgettable birdwatching experience. Among the most spectacular are those on Hermaness and Noss, both on Shetland, and on Skomer Island in Pembrokeshire. Perhaps the best time to visit a colony is in late June and July, when birds will be returning to the nest with beaks full of sandeels.

adult, winter

RAZORBILL *Alca torda* LENGTH 38–41cm

A bulky and distinctive seabird with essentially black and white plumage. The Razorbill is easily recognised at close range by its distinctive bill shape. It swims well, dives frequently and flies low over the water on whirring wingbeats. The sexes are similar. **SUMMER ADULT** has a black head, neck and upperparts, while the underparts are white; note the neat white wingbar. The bill is large and flattened; at close range, vertical ridges and white lines can be seen. **WINTER ADULT** is similar, but it acquires a partly white face (the throat and cheeks) and the bill is smaller. **JUVENILE** recalls a winter adult, but note the slightly smaller bill. Juveniles are accompanied by a parent bird on the water for the first few weeks of life; typically, they move well away from land and are seldom seen. **VOICE** – mostly silent but it sometimes utters croaking calls near the nest. HABITAT AND STATUS During the breeding season, the Razorbill favours rocky coasts and is a constituent member of most seabird colonies in the west and north of the region. There may be around 150,000 pairs in the region, although the density at which they occur is far less than with the Puffin or Guillemot. Typical nesting sites include boulder slopes and crevices on cliff ledges. Outside the breeding season, Razorbills are found at sea and healthy birds are seldom seen close to land. Like many other seabird species, the Razorbill is extremely vulnerable to oil spills. OBSERVATION TIPS Although seldom numerous, Razorbills are usually conspicuous at seabird cliffs, and off-duty birds often sit around on prominent rocks near the nest. The species is perhaps easiest to see at some of the seabird colonies on Shetland and Orkney. If you visit in June and July you should see birds returning to the cliffs with their bills full of sandeels and other small fish.

adult, winter

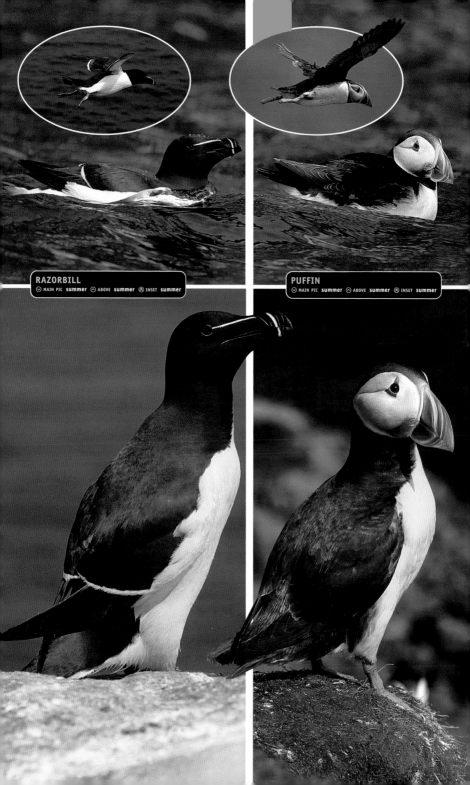

RAZORBILL
⊙ MAIN PIC **summer** ⌃ ABOVE **summer** ⊛ INSET **summer**

PUFFIN
⊙ MAIN PIC **summer** ⌃ ABOVE **summer** ⊛ INSET **summer**

BLACK GUILLEMOT *Cepphus grylle* LENGTH 31–33cm

A charming and distinctive auk. Black Guillemots are often seen quite close to the shore, off rocky coasts and jetties, typically singly or in small groups. They swim well and dive frequently in search of bottom-dwelling fish. The sexes are similar. **SUMMER ADULT** has mainly dark, sooty-brown plumage except for the striking white patch on the wing; this feature is conspicuous on standing, swimming and flying birds. At close range, note the red legs and the orange-red gape. **WINTER ADULT** has scaly grey upperparts and white underparts; the black tail, black wings and contrasting, unmarked white wing patch are retained, however. Note also the dark bill and eye. **FIRST-WINTER BIRD** is similar to a winter adult, but the white wing patch contains dark markings. **VOICE** – utters high-pitched whistling calls. HABITAT AND STATUS The Black Guillemot is resident year round in inshore waters of Ireland and the north and west of Scotland; Shetland and Orkney are strongholds. The population numbers several tens of thousands of individuals. These are normally thinly scattered along suitable coasts and the species is only ever locally common in the vicinity of suitable breeding areas, such as raised boulder beaches. OBSERVATION TIPS To see this species, visit the north of mainland Scotland or the northern Scottish islands. Between May and July birds are present at scattered breeding colonies and birds sometimes sit on rocks close to the sea. At all other times scan the water for swimming birds.

J
F
M
A
M
J
J
A
S
O
N
D

GUILLEMOT *Uria aalge* LENGTH 40–42cm

A robust and familiar seabird, best known for its large and densely packed breeding colonies. The Guillemot swims well and dives frequently. It flies on whirring wingbeats and the relatively narrow wings are also used when swim-ming underwater. The sexes are similar. **SUMMER ADULT** has a chocolate-brown head and upperparts (darker in northern birds than southern ones) and white underparts. The bill is dark, dagger-like and straight. Some birds (so-called 'bridled' Guillemots) show a white 'spectacle' around the eye. **WIN-TER ADULT** is similar but with more white on the head, notably the white cheeks and throat; note the black line running back from the eye. **JUVENILE** recalls a winter adult, but note the slightly smaller bill. Juveniles are accom-panied by a parent bird on the water for the first few weeks of life; typically, they move well away from land. **VOICE** – utters nasal, growling calls at breeding colonies. HABITAT AND STATUS The Guillemot is a locally numerous member of some seabird colonies. Precipitous cliff ledges are favoured, and here hun-dreds, sometimes thousands, of birds stand side by side. Close to half a million pairs probably breed in the region. Outside the breeding season, Guillemots are found exclusively at sea and only oiled or sickly birds are likely to come close to land at that time of year. The species suffers badly during oil spills. OBSER-VATION TIPS Guillemots are easy to see, from May to July, at their larger breeding colonies. Prime loca-tions include the Farne Islands, Elegug Stacks in Pembrokeshire, St Abb's Head, and Noss in Shetland.

J
F
M
A
M
J
J
A
S
O
N
D

LITTLE AUK *Alle alle* LENGTH 18–19cm

A tiny seabird and the smallest auk in the region. The Little Auk's dumpy appearance is in part a result of its short neck and tiny, stubby bill. It flies on rapid, whirring wingbeats; bizarrely, it can look almost Starling-like on the wing. Little Auks swim well and dive frequently. Juveniles do not occur in the region. The sexes are similar. **WINTER ADULT** has a black cap, nape and back, and white underparts; at close range, white lines on the wings and a tiny white crescent above the eye can sometimes be discerned. **SUMMER ADULT** (this plumage is not seen in the region) has a black head, neck and upperparts, and white underparts. **VOICE** – silent in the region. HABITAT AND STATUS The Little Auk is a winter visitor to the region from its Arctic breeding grounds. It is presumed to occur in good numbers in the seas around Britain and Ireland (particularly the northern North Sea), but it seldom comes close to land by choice. OBSERVATION TIPS Sadly, many birdwatchers' first experience of a Little Auk is the discovery of a winter tideline corpse. However, put in a bit of time and effort and you stand a good chance of seeing the species alive. Visit the east coast of England and southern Scotland in January or February: Little Auks sometimes pass close to land during strong onshore gales.

J
F
M
A
M
J
J
A
S
O
N
D

!CONFUSION SPECIES!

RAZORBILL IN WINTER
Page 152

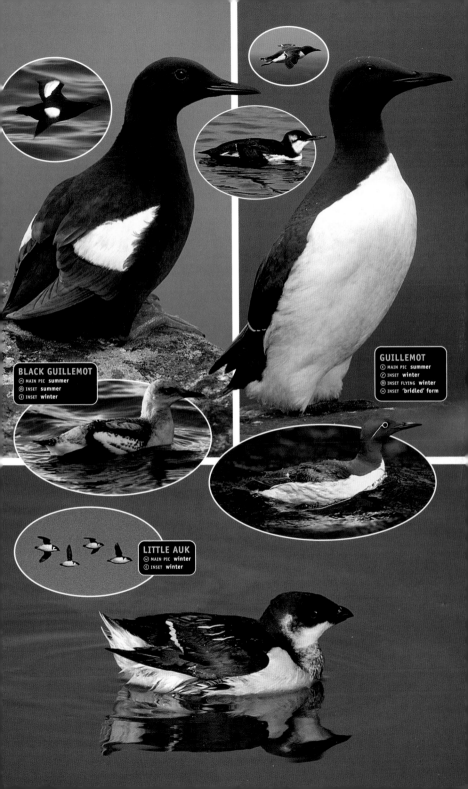

BLACK GUILLEMOT
- ⊙ MAIN PIC **summer**
- ⊛ INSET **summer**
- ⊳ INSET **winter**

GUILLEMOT
- ⊙ MAIN PIC **summer**
- ⊘ INSET **winter**
- ⊛ INSET FLYING **winter**
- ⊝ INSET **'bridled' form**

LITTLE AUK
- ⊝ MAIN PIC **winter**
- ⊲ INSET **winter**

WOODPIGEON *Columba palumbus* LENGTH 41cm

A plump and familiar bird of lightly wooded open country. Its 'song' is a familiar sound of the countryside, as is the loud clatter of wings heard when a bird flies off in alarm, or when aerial displays are performed in the spring. The Woodpigeon forms sizeable flocks outside the breeding season. The sexes are similar. **ADULT** has mainly blue-grey plumage with pinkish-maroon on the breast. Note the distinctive white patch on the side of the neck and, in flight, the prominent, transverse white wingbars that are accentuated by the dark wingtips; there is also a dark terminal band on the tail. **JUVENILE** is similar to the adult, but the white mark on the neck is missing. **VOICE** – sings a series of *oo-OO-oo, oo-oo* phrases. HABITAT AND STATUS The Woodpigeon is by far the most numerous of its kind to be found on farmland, and it is one of the few birds not to have suffered under the regime of modern farming. The popularity of oilseed rape as a crop has been of particular benefit and its population in the region probably numbers several million individuals. Typical habitats for the species are arable farmland and grassland fields with a mosaic of hedgerows and scattered woodlands. In addition, it is found increasingly in urban settings where, in contrast to their rural cousins, birds often become tolerant of people, sometimes even tame. On farmland, large numbers of Woodpigeons are shot each year. OBSERVATION TIPS You should have no difficulty in seeing this species almost anywhere in mainland Britain and Ireland throughout the year, although sizeable flocks are evident mainly in winter.

STOCK DOVE *Columba oenas* LENGTH 33cm

Superficially similar to the Woodpigeon but with slimmer proportions. The Stock Dove is separable from that species using plumage details as well. For much of the year it tends to be rather solitary and thinly distributed, and sizeable flocks form mainly outside the breeding season. In direct, level flight, the wings tend to be flicked more than is the case with a Woodpigeon. The sexes are similar. **ADULT** has rather uniform blue-grey upperparts and paler grey underparts; there is a pinkish-maroon flush to the breast and an iridescent green patch on the side of the neck. Note the two narrow black bars on the upper surface of the inner wing and the broad, dark trailing edge. **JUVENILE** is

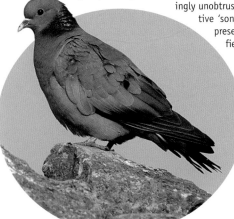

!CONFUSION SPECIES!

ROCK DOVE
Page 158

similar but the wing bars are faint. **VOICE** – during the breeding season, utters a diagnostic and repetitive *oo-u-look* call. HABITAT AND STATUS During the breeding season, the Stock Dove is associated with areas of wooded farmland, mainly in lowland England and Wales. Unlike the Woodpigeon, which constructs a twig nest, the Stock Dove nests in tree-holes. At other times of year, the species is sometimes found in small flocks feeding in arable fields. The population in the region probably exceeds 200,000 individuals. OBSERVATION TIPS Stock Doves are surprisingly unobtrusive during the breeding season and the distinctive 'song' is the best way of determining the species' presence in an area. At other times, search arable fields, particularly ones where weedy margins and strips are present, because weed seeds form an important part of the species' diet.

adult

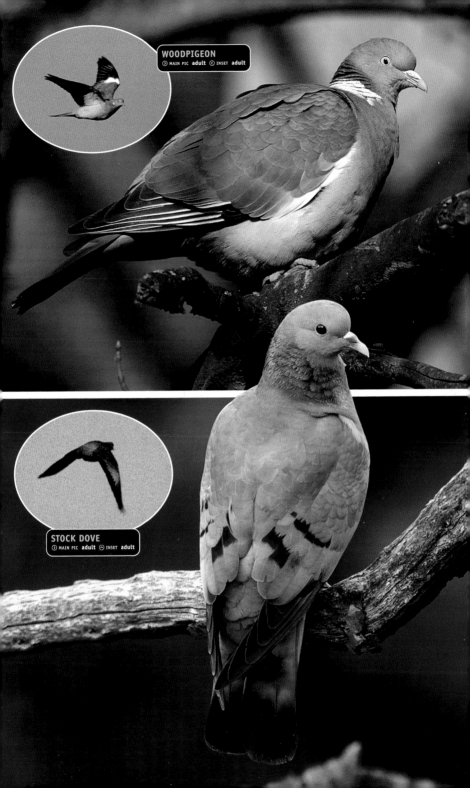

WOODPIGEON
⊘ MAIN PIC **adult** ⊙ INSET **adult**

STOCK DOVE
⊘ MAIN PIC **adult** ⊙ INSET **adult**

FERAL PIGEON/ROCK DOVE *Columba livia* LENGTH 33cm

The Feral Pigeon is the domesticated descendant, and typically the urban coun-
terpart, of the Rock Dove, which is a shy bird of wild and untamed cliffs and
coasts. Feral Pigeons occur in a wide variety of colour forms, but true Rock
Doves show little or no variability and are comparatively distinctive. Both
Feral Pigeons and Rock Doves form flocks; in the case of the former, these
can number hundreds of birds. The sexes are similar. **ADULT** and **JUVENILE
ROCK DOVES** have blue-grey plumage that is palest on the upperwings and
back, and flushed pinkish-maroon on the breast. Note the two
dark wingbars, seen in standing birds, and the dark-tipped tail. In
flight, note the small white rump patch; the upperwings reveal a dark
trailing edge, plus a narrow wingbar, while the under-
wings are white. **FERAL PIGEONS** occur in a spec-
trum of colour forms from almost black to pure
white. Some birds are very similar in appear-
ance to the ancestral Rock Dove. **VOICE** –
utters a range of cooing calls. HABITAT
AND STATUS The Rock Dove is restricted to coasts
and cliffs in the north and west of the region and
is generally considered to be rather scarce. However,
its precise status is rather difficult to assess because
in many areas Feral Pigeons have returned to their
ancestral haunts. Feral Pigeons are often abundant
(to the point of becoming a nuisance) in most towns
and cities in the region. Smaller numbers are also found
in the vicinity of farms and may be seen feeding along-
side Woodpigeons in arable fields. OBSERVATION TIPS You will
have no problem seeing this species; the only difficulty will arise
when it comes to trying to make the distinction between ancestral-like Feral Pigeons and genuine
Rock Doves. In order to see the latter, you must visit rugged coasts in the north and west of Ireland
and Scotland.

!CONFUSION SPECIES!

STOCK DOVE
Page 156

white form

COLLARED DOVE *Streptopelia decaocto* LENGTH 32cm

Despite being a comparatively recent addition to the British and Irish lists, the
Collared Dove is now a familiar sight in the region. Its distinctive call is also
well known, particularly in urban areas, as is its gliding display flight per-
formed on bowed, outstretched wings. The sexes are similar. **ADULT** has
mainly sandy-brown plumage with a pinkish flush to the head and under-
parts. Note the dark half-collar on the nape. The black wingtips and white
outer tail feathers are most noticeable in flight. The bill is dark and the
legs are reddish. **JUVENILE** is similar but it has duller colours and the black
half-collar is absent. **VOICE** – utters a repetitive (and, for many people, mild-
ly irritating) song that comprises a much-repeated *oo-oo-oo* phrase. HABITAT AND
STATUS The Collared Dove spread northwest across Europe during the first half of the 20th
century and was first recorded in Britain in the 1950s. Since its arrival, however, it has prospered and
now the population probably numbers more than 150,000 individuals. The species is often associated
with urban areas and is a frequent visitor to many gardens. However, it is also fairly common on arable
farmland, typically occurring in the vicinity of farm buildings and grain spills rather than open fields.
OBSERVATION TIPS Unless you live in an upland area in a remote part of the region, you are likely to
be familiar with the Collared Dove as a garden bird. In such settings, the birds are often rather tame,
and not infrequently they travel around in pairs, even in winter.

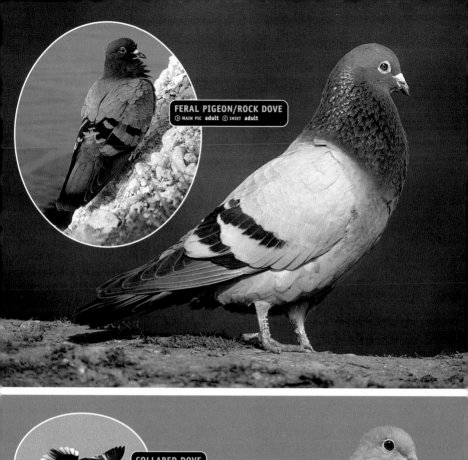

FERAL PIGEON/ROCK DOVE
◉ MAIN PIC **adult** ◉ INSET **adult**

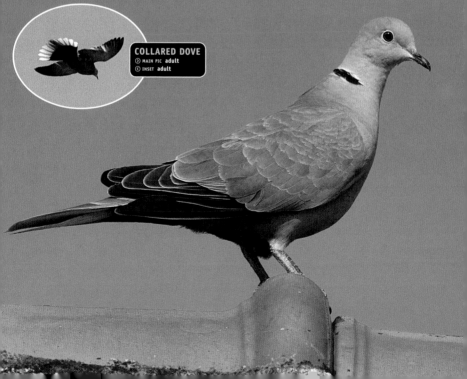

COLLARED DOVE
◉ MAIN PIC **adult**
◉ INSET **adult**

TURTLE DOVE *Streptopelia turtur* LENGTH 27cm

An attractive and well-marked species. The Turtle Dove has the proportions of a Collared Dove but is appreciably smaller. It has a fast, direct flight with rather jerky, flicking wingbeats and is often first detected by its distinctive song. The sexes are similar. **ADULT** is blue-grey on the head, neck and underparts with a slight pinkish-buff flush on the breast. The back and wing coverts are chestnut, the dark feather centres and pale margins creating a scaly appearance. The long, mainly black tail appears wedge-shaped in flight due to the white corners. At close range, note the black and white barring on the neck. **JUVENILE** is similar but the colours are duller and the neck markings are absent. **VOICE** – song is a diagnostic, purring *coo*. HABITAT AND STATUS The Turtle Dove is a summer visitor to the region, migrating from wintering grounds in Africa. It is associated with lowland arable farmland, as well as areas of scrub and downland, and eastern England is the species' stronghold in the region. Several tens of thousands of pairs are probably present each year, but nevertheless Turtle Doves are vulnerable and in decline. The widespread use of herbicides on farmland (the seeds of so-called 'weeds' are important in the Turtle Dove's diet), combined with the fact that the species is shot mercilessly on migration in the Mediterranean region, are contributory factors. OBSERVATION TIPS Turtle Doves can be seen in spring and autumn at coastal migration spots in south and east England. Visit an area of lowland farmland in eastern England from May to July and you stand a good chance of seeing and hearing the species on breeding territory; Kent and East Anglia are strongholds.

!CONFUSION SPECIES!

COLLARED DOVE
Page 158

| J |
| F |
| M |
| A |
| M |
| J |
| J |
| A |
| S |
| O |
| N |
| D |

CUCKOO *Cuculus canorus* LENGTH 33–34cm

A rather secretive summer visitor. The male Cuckoo's familiar, onomatopoeic call is heard far more often than the bird itself is seen during the first six weeks or so after its arrival. Birds occasionally perch on fenceposts or wires overlooking potential egg-laying sites. In low-level flight the Cuckoo recalls a Sparrowhawk and it is sometimes mobbed in a similar way. The species is renowned for its unusual, parasitic breeding behaviour: the female lays an egg in a songbird's nest, and having evicted its companion eggs or chicks, the young Cuckoo is fed by its hosts until it fledges. There are differences between the sexes. **ADULT MALE** and **MOST FEMALES** have a blue-grey head, neck and upperparts; the underparts are white and barred. At close range, note the yellow eye. **SOME ADULT FEMALES** are brown and barred on the head, neck and upperparts, the underparts being white with dark bars. **JUVENILE** is similar to an adult female, but note the white nape patch. **VOICE** – male utters a distinctive *cuck-oo* song; the female has a bubbling call. HABITAT AND STATUS The Cuckoo's distribution is dictated by the range of the songbirds that it uses for nest parasitism; classic host species include the Meadow Pipit, Dunnock and Reed Warbler. Although several tens of thousands of Cuckoos may arrive in the region each spring, the species is in decline. Factors behind change may include the general decline in songbird populations in the region (although species such as the Dunnock are still numerous) and the decline in insect diversity and abundance on farmland (adult Cuckoos feed primarily on caterpillars). OBSERVATION TIPS In the past, letter-writers to *The Times* newspaper vied for the honour of having heard the first Cuckoo of spring; typically, this would be in the third or fourth week of April. Sadly, nowadays in many parts of southern England it has become something of privilege to actually hear a Cuckoo at all, without making a special effort to go and find one. Having said this, if you visit an extensive wetland area with reedbeds, or an area of heathland or open country, you still stand a good chance of hearing, and perhaps seeing, the occasional bird in May. From June onwards, males stop delivering their distinctive songs and the species becomes much more difficult to find.

!CONFUSION SPECIES!

**SPARROWHAWK
IN FLIGHT**
Page 76

| J |
| F |
| M |
| A |
| M |
| J |
| J |
| A |
| S |
| O |
| N |
| D |

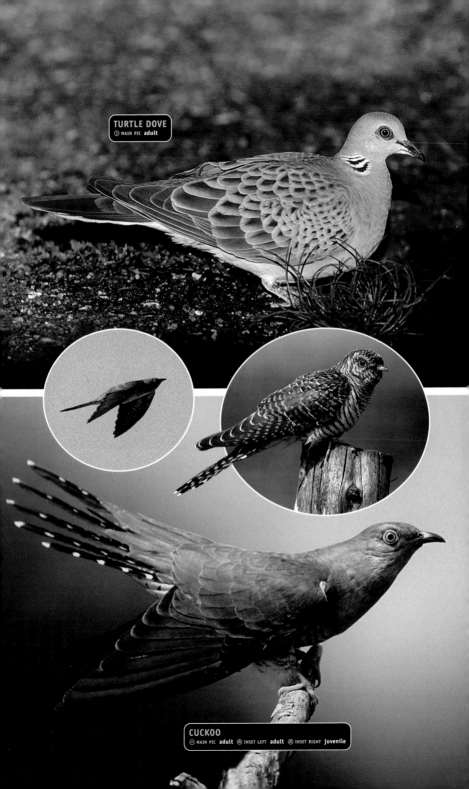

TURTLE DOVE
MAIN PIC **adult**

CUCKOO
MAIN PIC **adult** INSET LEFT **adult** INSET RIGHT **juvenile**

BARN OWL *Tyto alba* LENGTH 34–38cm

A beautiful owl that can appear ghostly white when caught in car headlights. The Barn Owl is usually crepuscular or nocturnal although it occasionally hunts in the late afternoon. Its flight is leisurely and slow on rounded wings. The sexes are similar. **ADULT** and **JUVENILE** have orange-buff upperparts that are speckled with tiny black and white dots. The facial disc is heart-shaped and white. In flight, the underwings are pure white. Darker-breasted continental birds sometimes turn up in winter. **VOICE** – the blood-curdling shriek is one of the most frightening sounds of the countryside at night. HABITAT AND STATUS The Barn Owl is a vulnerable resident species but several thousand pairs are still present in the region. Small mammals, and in particular voles, feature heavily in its diet; consequently, it is restricted to areas of rough, relatively undisturbed grassland and the margins of marshes and wetland. Intensive farming methods effectively exclude it from large tracts of land and, in many agricultural areas, roadside verges and field margins are the only places left where Barn Owls can find food. A reduction in the number of derelict farm buildings has also had an impact on the species, although nest-box schemes are helping to address this problem. OBSERVATION TIPS Sadly, many bird-watchers have seen more Barn Owls lying dead beside the road than they have live individuals. Given the species' mainly nocturnal habits, it is difficult to reverse this situation other than by chance, although nighttime drives along country lanes sometimes yield sightings. Visit one of the large wetland reserves in East Anglia, particularly in late winter, and you might see one feeding in the late afternoon.

SNOWY OWL *Nyctea scandiaca* LENGTH 55–65cm

A huge and unmistakable species. The Snowy Owl is often active during the day; even if it is not, the open nature of its favoured habitats, and its sheer size, make it conspicuous. The sexes are dissimilar. **ADULT MALE** has essentially pure white plumage; at close range the feathered feet and yellow eyes can be seen. **ADULT FEMALE** and **FIRST-WINTER MALE** are mainly white, but note the grey spots on the upperparts and grey barring below. **FIRST-WINTER FEMALE** is heavily marked with dark barring on all parts except the head. **VOICE** – mainly silent in the region. HABITAT AND STATUS The Snowy Owl has attempted to breed in Shetland, and solitary birds occasionally linger there in summer, but it is essentially a rare winter visitor to Britain and Ireland. Given its Arctic origins, it is not surprising that most records come from the north; typically vagrants favour stony moorland and mountain tops. OBSERVATION TIPS You will need luck to see a Snowy Owl in the region. Apart from twitching one, you will have to visit the Shetland Islands in winter to stand a chance of finding your own.

TAWNY OWL *Strix aluco* LENGTH 38–40cm

The most common and familiar owl in region, although it is more frequently heard than seen. The Tawny Owl roosts unobtrusively during the day among branches and foliage of trees; sometimes it is discovered and mobbed by small songbirds. The flight is leisurely on broad, rounded wings. The sexes are similar. **ADULT** and

young

JUVENILE have variably chestnut-brown or grey-brown plumage. At close range, note the streaked underparts (which can look rather pale) and the dark streaks on the well-marked upperparts. The eyes are dark. In flight, the underwings can look rather pale. **YOUNG BIRDS** typically leave the nest while they still appear distinctly downy and white. **VOICE** – utters a sharp *kew-wick* and the well-known hooting calls; the species is most vocal in late winter and early spring, when territorial boundaries are under dispute. HABITAT AND STATUS The Tawny Owl is a resident species of woodland habitats where small mammal prey – mainly mice and voles – are common; it also occurs in gardens and suburban parks with mature trees. As the species is nocturnal and unobtrusive, it is difficult to gauge its precise status, although there are probably several tens of thousands of birds in the region. OBSERVATION TIPS Visit an area of suitable woodland at dusk in January and February and, if Tawny Owls are present, you are sure to hear them. On a daytime walk in the same woodland, listen for the telltale alarm calls of mobbing songbirds.

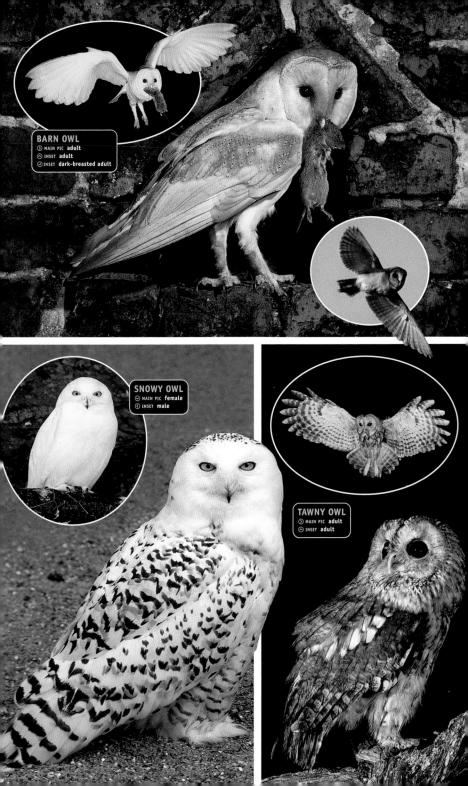

BARN OWL
- MAIN PIC **adult**
- INSET **adult**
- INSET **dark-breasted adult**

SNOWY OWL
- MAIN PIC **female**
- INSET **male**

TAWNY OWL
- MAIN PIC **adult**
- INSET **adult**

SHORT-EARED OWL *Asio flammeus* LENGTH 35–40cm

A large and well-marked owl that is often seen hunting in daylight. The Short-eared Owl's flight is leisurely and slow; it glides frequently, and flies holding its rather long, round-tipped wings rather stiffly. Birds usually quarter the ground at low levels, but displaying birds sometimes rise to considerable heights. Short-eared Owls are also frequently seen sitting on fenceposts or on grassland tussocks. The sexes are similar. **ADULT** and **JUVENILE** have essentially buffish-brown plumage that is heavily spotted and streaked on the upperparts, including the neck; the underparts are paler but they too, are streaked. The facial disc is rather round; note the staring yellow eyes and short 'ear' tufts. **VOICE** – displaying birds will sometimes utter deep hoots. HABITAT AND STATUS Although Short-eared Owls can be found in the region throughout the year, the summer and winter distributions of the species are rather different. Typically, it nests on upland heather and grassland moors. However, once nesting has been completed, birds tend to disperse widely, and during the winter months more inhospitable uplands are abandoned altogether in favour of lowland marshes, grassland and heathland. Coastal areas are particularly favoured in winter, when an influx of birds from mainland Europe boosts the numbers. Because the species' range and abundance is strongly influenced by cycles in small mammal prey populations, it is hard to be precise about the Short-eared Owl's status. However, several thousand individuals are probably present in the region in most years. OBSERVATION TIPS The uplands of southern Scotland are a particularly good location for the species during the breeding season, as is Mainland in the Orkney Islands. In winter, a visit to the coast in south or east England is likely to be rewarding, although numbers vary from year to year. While Short-eared Owls are widespread at inland sites in winter, they tend to be rather nomadic and so finding one is partly a matter of luck.

LONG-EARED OWL *Asio otus* LENGTH 32–35cm

A well-marked and strictly nocturnal species. Long-eared Owls are occasionally caught in car headlights after dark, but most people's experience of the species will be a partial view of a bird at a daytime winter roost. In flight, it could be mistaken for a Short-eared Owl, but note the orange-buff patch that contrasts with the otherwise dark upperwing. When alarmed, a Long-eared Owl may adopt a rather strange, elongated posture with the 'ear' tufts raised. The sexes are similar. **ADULT** and **JUVENILE** have dark brown upperparts and paler underparts; however, the whole body is heavily streaked. At close range, note the rounded, orange-buff facial disc and the staring orange eyes. The 'ear' tufts are appreciably longer than those of a Short-eared Owl. **VOICE** – mainly silent, but a series of deep hoots is sometimes heard in spring. HABITAT AND STATUS The Long-eared Owl typically nests in isolated conifer plantations and scrub thickets where these occur in the vicinity of open country for hunting. Large tracts of mature woodland (as favoured by Tawny Owls) are usually avoided. Several thousand pairs probably breed in the region. Outside the breeding season, birds tend to disperse and roosting sites can then include patches of coastal scrub, hawthorn and blackthorn hedgerows, and wooded thickets on the fringes of marshland; an influx of birds from mainland Europe boosts numbers at this time of year. OBSERVATION TIPS Unless a deliberate attempt is made to study the species in the breeding season, most Long-eared Owl sightings are made in winter. However, the species is so unobtrusive and well camouflaged that it is easily overlooked even then. Indeed, even when a bird is discovered roosting in a relatively small bush, it can be hard to obtain more than a partial view, such is the species' ability to blend in with its surroundings. Count yourself extremely lucky if you find one for yourself.

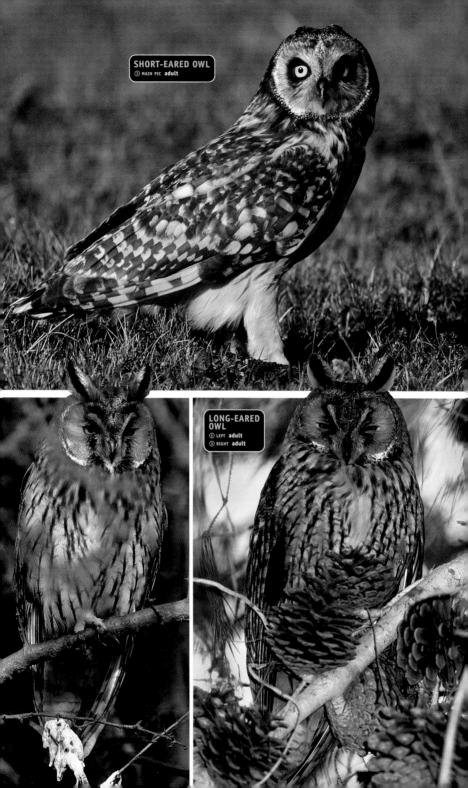

SHORT-EARED OWL
⊙ MAIN PIC **adult**

LONG-EARED OWL
⊙ LEFT **adult**
⊙ RIGHT **adult**

LITTLE OWL *Athene noctua* LENGTH 22cm

The smallest owl in the region, recognised even in silhouette by its dumpy outline and short tail. The Little Owl is also one of the easiest to see, since it is often active during the hours of daylight. When perched and curious, it often bobs its head and body. The sexes are similar. **ADULT** has brown upperparts adorned with whitish spots and pale underparts that have dark streaks. Note the staring yellow eyes. **JUVENILE** is similar but less well marked and it lacks spotting on the head. **VOICE** – calls include a strange, cat-like *kiu*, uttered repeatedly and agitatedly in the early evening. HABITAT AND STATUS The Little Owl was introduced to the region from mainland Europe in the 19th century and is now widespread and fairly common as far north as southern Scotland; it is absent from Ireland. Around 10,000 pairs are probably resident here, and the species favours open country habitats, typically comprising a mosaic of fields and hedgerows. Little Owls nest in tree-holes and cavities in stone walls and old buildings. OBSERVATION TIPS Listen for the distinctive calls at dusk to discover whether Little Owls are present in a given area. Because they are partly diurnal, and often perch in the open on fenceposts and dead branches, they are usually easy to see.

SWIFT *Apus apus* LENGTH 16–17cm

A familiar summer visitor that is invariably seen in flight. Indeed, apart from when it is nesting, the Swift spends its entire life in the air, eating, sleeping and mating on the wing. A large gape facilitates the capture of flying insects. It is easily recognised by its anchor-shaped outline and mainly dark plumage. The sexes

!CONFUSION SPECIES!

SWALLOWS and MARTINS Page 174

are similar. **ADULT** has essentially blackish-brown plumage, although in good light a pale throat can be discerned. The tail is forked but it is often held closed in active flight. **JUVENILE** is similar, but the plumage is overall darker while the throat is whiter and the forehead can look rather pale. **VOICE** – loud, shrill, screaming calls are often heard from parties of birds as they chase one another overhead or at breakneck speed through narrow streets. HABITAT AND STATUS Nesting Swifts are typically associated with man-made structures – churches and lofts are favoured. At other times, birds are seen in the air, often congregating where insects are numerous. Swifts are common breeding birds in the south, but scarce in the far north. Many tens of thousands of pairs breed in the region as a whole. OBSERVATION TIPS Swifts are easy to see in late spring and early summer in most low-lying villages and towns. Typically, adults will have vacated nesting sites by early August.

NIGHTJAR *Caprimulgus europaeus* LENGTH 25–27cm

An unusual and intriguing bird whose nocturnal habits and cryptic plumage markings make it difficult to see in the daytime. The Nightjar takes to the wing at dusk to hawk for insects, when it looks long-winged and narrow-tailed. It sits motionless on the ground during the day and it will only flush if approached extremely closely. The sexes can be separated with care. **ADULT MALE** is adorned with intricate brown, grey and black markings that, in combination, resemble tree bark. In flight, note the rather striking white patches near the tip of the wings and the corners of the tail. **ADULT FEMALE** and **JUVENILE** are similar to the adult male, but lack the white wing and tail markings. **VOICE** – male utters a distinctive churring song for hours on end, after dark. HABITAT AND STATUS The Nightjar is a migrant visitor to the region. It is associated mainly with lowland heathland, but it also occurs on heather moors at higher altitudes in Wales and northern England; the species also colonises ground where conifer plantations have been felled. Several thousand pairs probably still breed in the region, although numbers have declined markedly in recent decades. Habitat destruction and the use of agricultural pesticides (causing a decline in numbers of insect prey) are undoubtedly factors influencing the decline. OBSERVATION TIPS Visit an area of southern heathland at dusk in May and you should hear male Nightjars churring. With luck, you may catch twilight glimpses of birds on the wing too. If you are not feeling self-conscious, try holding a white handkerchief in each hand, at arm's length, and then move your arms up and down in mock flight. Whether or not you succeed in attracting the attention of a male Nightjar, you will certainly arouse comment among your companions.

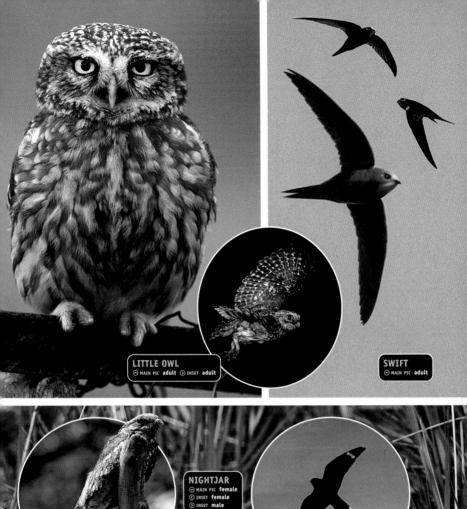

LITTLE OWL
⌃ MAIN PIC **adult** ⌃ INSET **adult**

SWIFT
⌃ MAIN PIC **adult**

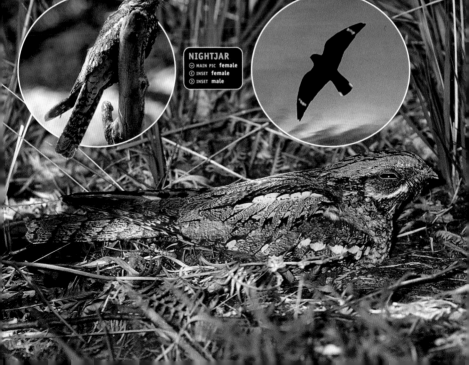

NIGHTJAR
⌄ MAIN PIC **female**
⌃ INSET **female**
⌃ INSET **male**

HOOPOE *Upupa epops* LENGTH 25–28cm

An elegant and distinctive bird. Despite its well-marked appearance, the Hoopoe's habit of creeping along the ground, often feeding in furrows, can make it surprisingly difficult to spot. However, in flight, the species is conspicuous and unmistakable, being transformed by its broad wings into a striking black and white bird; the effect is emphasised by its slow, butterfly-like flight pattern. The Hoopoe's long, downcurved bill is used to probe the ground for invertebrates. The sexes are similar. **ADULT** and **JUVENILE** have mainly pale pinkish-brown plumage, but with striking black and white barring on the wings and back; a white rump is revealed in flight. The erectile crest of barred, pink feathers is raised in excitement. **VOICE** – utters a diagnostic *hoo-poo-poo* call.
HABITAT AND STATUS Although the Hoopoe has been known to breed here, its status in the region is really that of a scarce but regular visitor in spring and autumn – in a good year there might be 100 or more records in the region. Hoopoes favour areas of short grassland, with the majority of birds turning up near the coast. OBSERVATION TIPS If you want to discover a Hoopoe for yourself you need to visit a coastal migration hotspot in spring or autumn; the species is regular on the Scilly Isles in spring, for example. Fortunately, many birds stay for a few days – occasionally even weeks – if they find good feeding areas, and hence most Hoopoes are twitchable.

J F M A M J J A S O N D

BEE-EATER *Merops apiaster* LENGTH 26–29cm

A stunningly beautiful bird that is on the wish list of many British birdwatchers. The Bee-eater sometimes perches on dead branches, but more typically it is seen in flight: it is extremely aerobatic, capable of catching insects on the wing but equally fond of just circling and gliding. The sexes are similar. **ADULT** has a chestnut crown and nape, grading to yellow on the back and rump; the upper surface of the tail is green and there are two projecting central tail feathers. The underparts are blue except for the black-bordered yellow throat. In flight, the wings show chestnut and blue on the upper surface. A close view of a perched bird reveals a dark mask through the eye and a white forecrown. **JUVENILE** is similar but the colours are duller and the tail projections are absent. **VOICE** – utters a bubbling *pruuupp* call, which is so distinctive that it allows even extremely distant birds to be identified with certainty. The call is ubiquitous in the Mediterranean and is frequently dubbed – inappropriately in the context of Britain – onto soundtracks of TV programmes, presumably in an attempt to convey a sense of summer. HABITAT AND STATUS Although the occasional pair has bred successfully here (in 2001, for example), the Bee-eater's status in the region is really that of a rare visitor. Records in spring presumably relate to migrants that have overshot the species' main breeding range in southern Europe; adults seen in early summer are probably dispersing failed breeders while juveniles seen in autumn are disorientated migrants. Most records relate to solitary birds but, just occasionally, small parties are involved. OBSERVATION TIPS Bee-eaters typically appear during periods of warm, southerly or southeasterly airflows and could turn up almost anywhere. They only linger if the feeding is good, and even then it is unusual for one to stay in one place for more than a few hours. The only realistic prospect of being able to twitch the species will arise if a bird is observed going to roost and you are able to get to the spot before dawn the next morning. To stand any chance of finding one for yourself, you must be familiar with the call: on the move, Bee-eaters are high-fliers and, short of perpetually scanning the skies with binoculars, it is only by hearing a distant bird that you will be aware of its presence.

J F M A M J J A S O N D

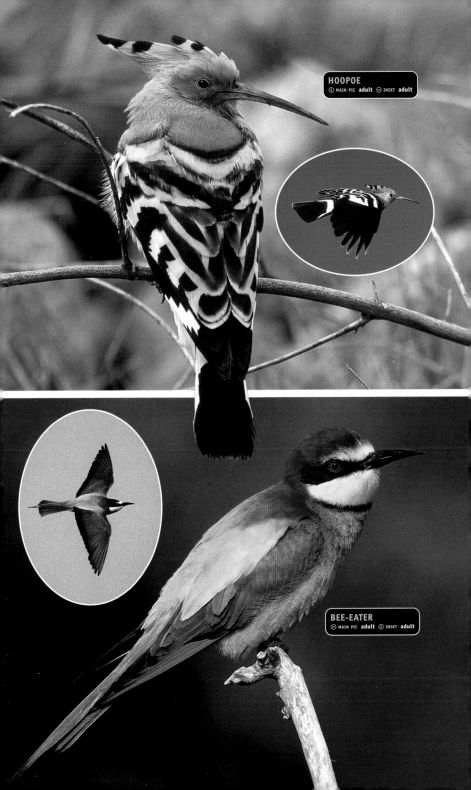

HOOPOE
◁ MAIN PIC adult ◁ INSET adult

BEE-EATER
△ MAIN PIC adult ◁ INSET adult

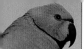
RING-NECKED PARAKEET *Psittacula krameri* LENGTH 40–42cm

An established alien species and a rather bizarre addition to the British list. The colourful Ring-necked Parakeet is colourful and has a distinctive, long-tailed outline in flight. The sexes are similar. **ADULT MALE** has mainly green plumage, but dark flight feathers are noticeable on the wing. Note also the red bill and eye-ring, and the pinkish neck ring that is dark-bordered towards the lower margin; this links to the black throat. **ADULT FEMALE** is similar, but it lacks any markings on the neck or throat. **VOICE** – often announces its presence (including in flight) with loud, squawking calls. HABITAT AND STATUS A feral population (escapees from captivity and their progeny), numbering several thousand birds, is now established in parts of the region. The suburban western fringes of London are a stronghold, and it looks particularly incongruous when seen flying over the M4 or against the bleak backdrop of the industrial complexes that fringe Heathrow Airport. OBSERVATION TIPS Ring-necked Parakeets are often first detected by their raucous calls. If you live along the Thames/M4 corridor between London and Windsor, you are certain to encounter the species sooner or later by chance.

KINGFISHER *Alcedo atthis* LENGTH 16–17cm

A dazzlingly attractive bird with a dagger-like bill, and a favourite among British birdwatchers. Although the Kingfisher's plumage is undeniably striking, the colours can look rather muted when the bird sits in shade. With a diet of fish, it is hardly surprising that the species is tied to water. Kingfishers often perch on overhanging branches and plunge headlong into the water. They are sometimes seen in low-level flight speeding along rivers. The sexes are separable with care. **ADULT MALE** has orange-red underparts and mainly blue upperparts; the electric-blue back is seen to best effect in flight. The legs and feet are red and the bill is all dark. **ADULT FEMALE** is similar, but the base of the lower mandible is flushed red. **JUVENILE** is similar to an adult, but the colours are duller and the tip of the bill is pale. **VOICE** – utters a distinctive, thin and high-pitched call in flight. HABITAT AND STATUS The Kingfisher is a widespread resident of rivers, streams, flooded gravel pits and lakes. Although scarce in, or absent from, upland and northern districts, it is widespread in much of lowland England, Wales, southern Scotland and Ireland. Key factors determining its presence are an abundance of small fish and suitable steep banks in which to excavate nesting burrows. Several thousand pairs are found in the region as a whole. The species is mainly sedentary, although some dispersal occurs in summer (if streams and rivers dry up) or in harsh winters (if water bodies freeze over). OBSERVATION TIPS Kingfishers can be rather unobtrusive and are easily overlooked. Sit beside a suitable stretch of water and, with patience, you may eventually see one fly by. Good fishing perches are used time and time again.

WRYNECK *Jynx torquilla* LENGTH 16–17cm

An extraordinary member of the woodpecker family. The Wryneck is renowned for having plumage markings so intricate that they afford it superb camouflage. The bird's unusual name derives from its occasional habit of twisting its neck round. It feeds mainly on the ground, and is especially fond of ants. In flight, it could be mistaken for a large warbler, or even a Dunnock. The sexes are similar. **ADULT** has upperparts with grey, brown, buff and black markings so intricate that they create an effect like tree bark. The underparts are pale and barred, but flushed yellow-buff on the throat and flanks. Note the dark stripes through the eye and down the crown, nape and centre of the back. **JUVENILE** is similar, but the crown stripe is less distinct. **VOICE** – mostly silent, although territorial birds utter raptor-like piping calls. HABITAT AND STATUS Sadly, the days when the Wryneck was a widespread breeding bird in the region are long gone. Although a handful of pairs nests in the Scottish Highlands (in park-like woodland), its status in England and Wales is now that of a scarce passage migrant. Most records come from coastal districts in south and east England, and in autumn; the species is rare in Ireland. Migrants favour areas of short-turf with scattered bramble patches. OBSERVATION TIPS You stand the best chance of seeing a Wryneck if you visit the south or east coast of England in the first couple of weeks in September, particularly during, or just after, periods of easterly or south-easterly winds. The north Norfolk coast is an especially rewarding destination at this time.

RING-NECKED PARAKEET
⌄ MAIN PIC **adult** ⌄ INSET **adult**

KINGFISHER
⌃ MAIN PIC **adult** ⌄ INSET **adult**

WRYNECK
⌄ MAIN PIC **juvenile**

GREAT SPOTTED WOODPECKER *Dendrocopus major* LENGTH 23–24cm

The larger and commoner of our two pied woodpeckers. Often seen climbing tree trunks or in undulating flight. Excavates timber by drilling with its bill. The sexes are similar but separable with care. **ADULT MALE** is mainly black on the back, wings and tail, with white 'shoulder' patches and narrow white barring; the underparts are mainly grubby white. The head pattern is distinctive: the face and throat are white, while the cap and nape are black and connect via a black line to a black stripe running from the base of the bill. Note also the red patch on the nape and the red vent. In flight, the white barring and shoulder patches are striking. **ADULT FEMALE** is similar to the adult male, but the red nape patch is absent. **JUVENILE** recalls the adult male but note the red crown and subdued red vent colour. **VOICE** – all birds utter a loud *tchick* alarm call. In spring, males 'drum' loudly to proclaim territorial ownership. HABITAT AND STATUS A widespread and generally common resident in woodlands throughout southern and central England and Wales; it becomes less numerous further north in its range. Several tens of thousands of pairs are probably present in the region as a whole. Also a frequent garden visitor to peanut feeders. OBSERVATION TIPS Easily detected by its loud alarm call and most vocal in spring. Also easy to attract to the garden with feeders.

Great Spotted
Woodpecker

LESSER SPOTTED WOODPECKER

Dendrocopus minor LENGTH 14–15cm

Lesser Spotted
Woodpecker

Britain's smallest woodpecker. Rather unobtrusive and easily overlooked. The sexes are similar but separable with care. **ADULT MALE** has a black back and wings with white barring that creates a ladder-back appearance. The underparts are grubby white with dark streaking. The face is white, while the nape is black and a black stripe runs from the bill, around the ear coverts and to the sides of the breast. Note the white-flecked red crown (cf. juvenile Great Spotted Woodpecker). In flight, shows strong white barring on the otherwise black back and wings. **ADULT FEMALE** and **JUVENILE** are similar to the adult male but with a black crown. **VOICE** – male utters a loud, raptor-like piping call in spring. Drumming is rapid but rather faint. HABITAT AND STATUS Favours deciduous woodland and parkland; often associated with alders. Thinly spread across Wales and central and southern England; numbers may be declining, but probably there are still several thousand pairs in the region as a whole. OBSERVATION TIPS Seldom easy to find except by chance. Springtime (when males are most vocal) offers the best opportunities for detection, so listen out for calls or 'drumming'.

GREEN WOODPECKER *Picus viridis* LENGTH 32–34cm

Despite its size and colourful plumage, this can be a tricky species to observe well. Climbs trees and excavates timber, but also feeds on the ground, using its long tongue to extract ants from subterranean nests. Flight is undulating. The sexes are similar but separable with care. **ADULT MALE** has greenish-olive upperparts and whitish underparts. Head is adorned with a red crown, a black 'mask' and a red-centred black 'moustache'. In flight, the yellowish rump is striking. **ADULT FEMALE** is similar to the adult male but the 'moustache' is all black. **JUVENILE** recalls the adult male but is heavily spotted. **VOICE** – the *yaffling* call is distinctive and the song comprises a dozen or so yelping, call-like notes. HABITAT AND STATUS Found in open woodland, parks and gardens. Relatively common in central and southern England and Wales, but it becomes scarcer further north in its range; there are probably more than 10,000 pairs in the region as a whole. OBSERVATION TIPS Easily overlooked during the summer months when leaves are on the trees, so try to become familiar with its distinctive call. The species is typically rather wary and often actively hides by shuffling around the other side of a tree trunk from an observer.

male

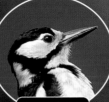

**GREAT SPOTTED
WOODPECKER**
ⓐ male ⓑ female

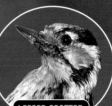

**LESSER SPOTTED
WOODPECKER**
ⓐ female
ⓑ male

**GREAT SPOTTED
WOODPECKER**
ⓒ juvenile

GREEN WOODPECKER
ⓐ male

**GREEN
WOODPECKER**
ⓑ female

SWALLOW *Hirundo rustica* LENGTH 19–21cm

A familiar migrant visitor that can be recognised in flight by its pointed wings and long tail streamers. The appearance of the first Swallows in early April is considered by many people to herald the arrival of spring. The sexes are similar, although on average males have longer tail streamers than females. **ADULT** has blue-black upperparts and white underparts, except for the dark chest band and brick-red throat and forecrown. **JUVENILE** is similar, but it has shorter tail streamers and a pale, buffish-red throat. **VOICE** – utters a sharp *vit* call in flight; the male sings a twittering song, often while sitting on overhead wires near the nest site. HABITAT AND STATUS The Swallow is common and widespread during the summer months, and there are probably more than 500,000 pairs in the region at this time. While nesting, Swallows are usually associated with the margins of rural villages and farmyards; typically, they nest under eaves or in barns or sheds, attaching a half-cup-shaped nest of mud to a wall or rafter. On migration, in spring and autumn, birds often congregate over freshwater lakes and roost in reedbeds in large numbers. OBSERVATION TIPS Swallows are usually easy to see during the breeding season, since nesting pairs often perch conspicuously and are comparatively unafraid of people. Prior to their departure from breeding areas in late summer, considerable numbers are often seen perched side by side on roadside wires, sometimes in the company of House Martins.

!CONFUSION SPECIES!

SWIFT
Page 166

SAND MARTIN *Riparia riparia* LENGTH 12cm

The smallest hirundine in the region. The Sand Martin is typically seen hawking for insects over water, sometimes even picking them off the surface. The sexes are similar. **ADULT** has sandy-brown upperparts and mainly white underparts; note, however, the brown breast band. The tail is short and forked. **JUVENILE** is similar, but it has pale margins to the feathers on the back that create a scaly appearance. **VOICE** – utters a range of rasping twitters. HABITAT AND STATUS The Sand Martin is a widespread summer visitor to the region that nests colonially, excavating burrows in sandy banks beside rivers and sand and gravel quarries. Several hundred thousand pairs probably breed in the region, although at times in the recent past the population has been much higher. Feeding typically takes place over water in the vicinity of the breeding colony. OBSERVATION TIPS Sand Martins are usually relatively easy to find during the summer months. Nesting colonies often comprise hundreds of individuals and there is usually so much activity that they are obvious. The Sand Martin is often one of the first migrants to arrive in spring and one of the last to leave in autumn; at such times the birds often gather in large numbers over lakes and lagoons in the south.

HOUSE MARTIN *Delichon urbica* LENGTH 12–13cm

A familiar and welcome summer visitor that is easily recognised in flight by its rather black and white appearance and its conspicuous white rump. The sexes are similar. **ADULT** has mainly blue-black upperparts with a striking and contrasting white rump; the underparts are white. **JUVENILE** is similar, but the underparts are rather grubby white and the upperparts are duller. **VOICE** – utters a distinctive *prrrt* call in flight. The twittering song is often delivered from overhead wires in the vicinity of the nest. HABITAT AND STATUS The House Martin is a summer visitor to the region. As its name suggests, it is typically associated with houses during the breeding season, and the rather spherical mud nest is constructed under eaves and overhangs in loose colonies; in more natural settings, birds sometimes breed on cliffs and near cave entrances. Several hundred thousand pairs are probably present in the region as a whole during the summer months. During the breeding season, feeding often takes place in the vicinity of the nesting site. On migration, birds often congregate over fresh water, catching insects in low-level flight. OBSERVATION TIPS House Martins can be found in most parts of the region, although they are decidedly scarce in the far north. They are invariably associated with houses, and most towns and villages can boast small colonies. Soon after their arrival in spring, birds can be seen gathering sticky mud from puddles; it is fascinating to watch them carry this back to the nest site, where it is mixed with saliva and applied.

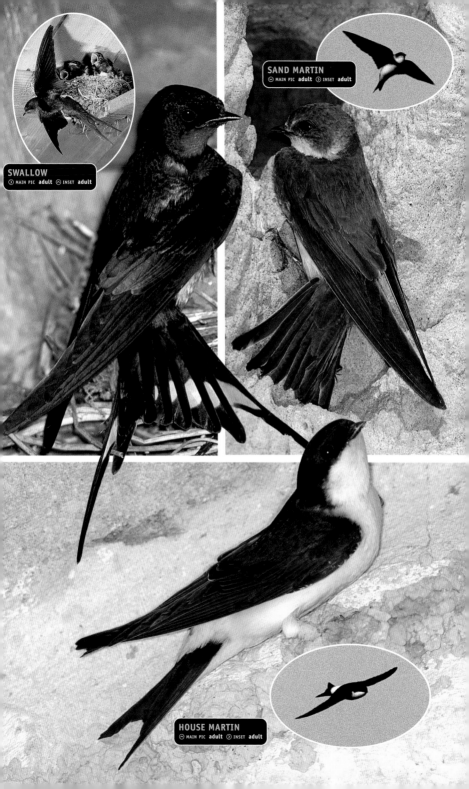

SWALLOW
⊙ MAIN PIC **adult** ⊙ INSET **adult**

SAND MARTIN
⊙ MAIN PIC **adult** ⊙ INSET **adult**

HOUSE MARTIN
⊙ MAIN PIC **adult** ⊙ INSET **adult**

SKYLARK *Alauda arvensis* LENGTH 18cm

A rather nondescript, streaked brown bird that is best known for its incessant trilling and fluty song; this is generally delivered in flight. The sexes are similar. **ADULT** has streaked, sandy-brown upperparts and paler underparts, the breast being marked with streaks and flushed with buff. There is a short crest that is raised occasionally. In flight, note the whitish trailing edge to the wings and the white outer tail feathers. **JUVENILE** is similar, but the pale feather-er margins on the back give it a scaly appearance and the brown feathers on the face and crown have pale tips. **VOICE** – the song is a rapid and varied mixture of trilling and whistling notes; elements of mimicry may be included as well. The call is a rolling *chrrrp*. HABITAT AND STATUS The Skylark is invariably associated with grassy habi-tats, ranging from meadows, moors and heaths to arable farmland. Although the species has declined alarmingly in many parts of the region, due to changes in farming practices, it is still common and widespread, especially compared to other open-country bird species. Several million birds are probably present during the summer months, and outside the breeding season the numbers are boosted when many more migrate here from mainland Europe. During the winter months, Skylarks are absent from many of their upland breed-ing sites, and flocks tend to concentrate in lowland districts. OBSERVATION TIPS At one time, it would have been difficult to go for a country walk anywhere in lowland Britain without hearing Skylarks singing overhead, almost regardless of the time of year so long as the sun was shining. Nowadays, although the species is still common in areas of rough grassland, it is absent from many arable farms. The trend towards autumn ploughing and sowing has meant that winter stubble fields – a source of weed seeds and spilt grain – are a thing of the past in many regions. During the breeding season, insects are an important dietary component for Skylarks; the virtual absence of suitable prey species from most crop fields, due to pesticide application, must have a bear-ing on the Skylark's decline as a nesting species on intensively farmed land.

!CONFUSION SPECIES!

MEADOW PIPIT
Page 180

CORN BUNTING
Page 258

WOODLARK *Lullula arborea* LENGTH 15cm

A small and proportionately short-tailed lark. The Woodlark is rather unobtrusive, and were it not for its wonderful, yodelling song, it would be easy to overlook it, even during the breeding season. The song is often delivered in flight but sometimes while the bird is perched in a tree. It would be unusual to see more than a handful of Woodlarks together at one time but, outside the breeding season, the species does associate loosely with flock-forming songbirds such as Skylarks. The sexes are similar. **ADULT** has sandy-brown, streaked upperparts and mainly pale underparts, although the breast is streaked and flushed with buff. Note the chestnut ear coverts, pale supercil-ium and the black and white marking at the joint of the leading edge to the wing. **JUVENILE** is similar, but pale margins to the feathers on the back give it a scaly appear-ance. **VOICE** – song is a series of fluty, yodelling notes; the call is a yodelling *deet-luee*, reminiscent, in terms of tone, of a snatched phrase from the song. HABITAT AND STATUS As a breeding bird, the Woodlark has rather precise habitat requirements: it is associated typically with heathland sites, notably favouring areas where a mosaic of short turf (for feeding) and longer grassland (for nesting) occurs; despite the species' name, trees are not a prerequisite. It also occurs on the margins of conifer plantations, typically where these have been planted on land that previously would have supported heathland habitats; however, in such areas Woodlarks thrive only where felling has created wide, open clearings. Several hundred pairs probably breed in the region and the majority of these are found in the counties of Hampshire and Surrey. Woodlarks tend to be rather nomadic outside the breeding sea-son and some individuals may leave Britain altogether. OBSERVATION TIPS In order to do justice to the species, you should try to hear it singing. To do so, visit an area of suitable heathland in Surrey or Hampshire in April. Woodlarks are often most vocal in the early mornings and late afternoons. Out-side the breeding season, the species is a real challenge to find, so get to know its distinctive call.

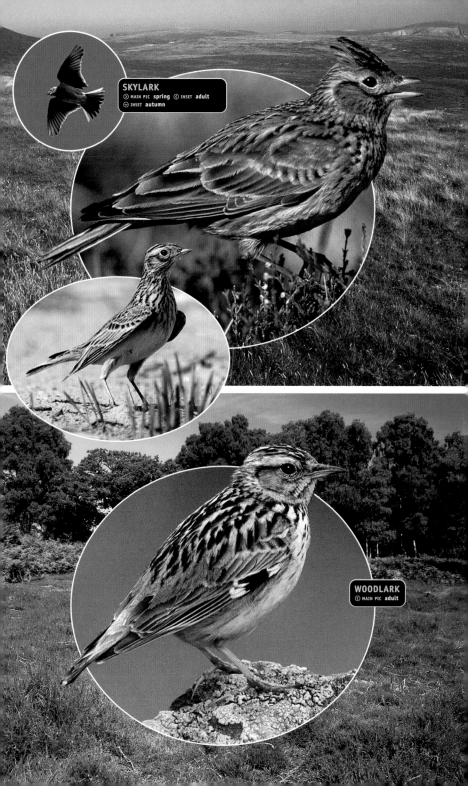

SKYLARK
⟩ MAIN PIC **spring** ◑ INSET **adult**
◔ INSET **autumn**

WOODLARK
◔ MAIN PIC **adult**

SHORT-TOED LARK *Calandrella brachydactyla* LENGTH 14–15cm

A small and rather dumpy lark with a stubby, finch-like bill. The Short-toed Lark is rather unobtrusive and easy to overlook, as it creeps along the ground in an almost mouse-like fashion. The sexes are similar. **ADULT** has sandy-brown upperparts that are marked with faint streaking. The head is adorned with a streaked, brown (sometimes reddish-brown) crown, a pale supercilium, brown cheeks and a whitish throat. The underparts are mainly whitish, but note the dark patch and faint streaking on the side of the breast. On the closed wing, the tertial feathers are long and mask the primaries; note also the

!CONFUSION SPECIES!

SKYLARK
Page 176

row of dark-centred feathers with pale margins. **JUVENILE** is similar, but it has more extensive streaking on the breast and the feathers on the back have pale fringes. **VOICE** – calls include a sharp *chrrrp-chrrrp*. The song (unlikely to be heard in the region) consists of rapid, trilling phrases, typically delivered in rather short bursts, as if the bird is having to pause to catch its breath. HABITAT AND STATUS The Short-toed Lark is a rather rare visitor to the region; typically, it turns up at migration times and there are perhaps a dozen or so records in most years. The species breeds in southern Europe and winters in Africa. Those birds that turn up in Britain and Ireland in spring are presumed to be migrants that have overshot their usual range; autumn records often refer to juveniles that have become disorientated. The majority of Short-toed Larks are discovered in coastal districts or on offshore islands. They usually favour areas of short grassland, often concentrating their feeding efforts around bare patches of ground; ploughed and stubble fields are used on occasions. OBSERVATION TIPS May and September are probably the prime months for discovering Short-toed Larks in the region, but you will need to visit the coast to stand a reasonable chance of finding one, or bumping into one that has been discovered by somebody else. Birds usually stay for a few days if the feeding is good, so the species is usually twitchable.

SHORELARK *Eremophila alpestris* LENGTH 16–17cm

This is a distinctive and well-marked lark, but as it feeds unobtrusively it can be difficult to locate when it is foraging among saltmarsh plants. The sexes are similar, although generally females have duller head markings than males. **SUMMER ADULT** (some seen in autumn and late spring) has grey-brown or sandy-brown upperparts that are streaked on the back but unstreaked on the nape. The underparts are mainly white, but note the striking black breast band and faint buff streaks on the flanks. The head is yellow but is adorned with a black band through the eye and ear coverts, and has a black forecrown that extends backwards to form two projecting 'horns'. **WINTER ADULT** is similar, but the colours and markings on the head are less distinct and the 'horns' are absent. **JUVENILE** has a pattern of markings reminiscent of an adult, but the upperparts are adorned with pale spots. **VOICE** – flight call is a thin *see-seer*. HABITAT AND STATUS Although it has bred in Scotland in the past, the Shorelark's status in the region is essentially that of a scarce winter visitor. It is restricted to coastal habitats and typically favours areas of saltmarsh vegetation. The total wintering population in the region probably numbers a few hundred individuals and the species is usually discovered in small feeding flocks, comprising, say, three to ten birds. OBSERVATION TIPS The Shorelark's main range in the region is the east coast of England, with East Anglia and north Kent being particular strongholds. For the best chance of seeing the species, visit one of its well-known haunts in November or early December. For example, if you were to take a walk along the north Norfolk coast at this time of year, and visit suitable saltmarsh habitats, you would stand a reasonable chance of finding a feeding flock, or at least meeting other birdwatchers who could point you in the right direction.

winter

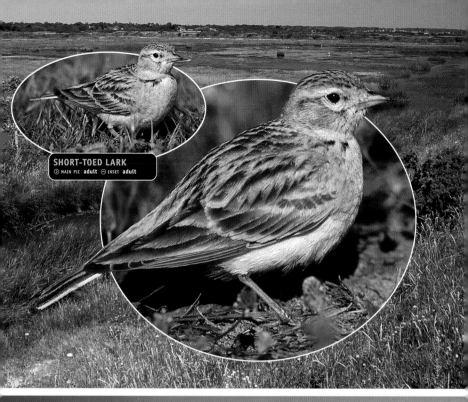

SHORT-TOED LARK
⊚ MAIN PIC **adult** ⊚ INSET **adult**

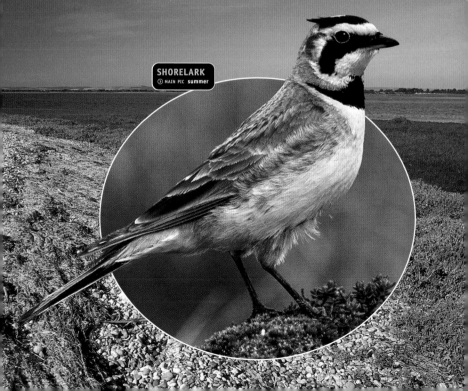

SHORELARK
⊚ MAIN PIC **summer**

MEADOW PIPIT *Anthus pratensis* LENGTH 14–15cm

A widespread but rather nondescript, streaked brown bird, the Meadow Pipit is a ground-dwelling species that feeds on invertebrates. Outside the breeding season, it is often found in loose flocks. The sexes are similar. **ADULT** has streaked brown upperparts and pale underparts adorned with dark streaks; there is a buffish-yellow flush to the flanks and breast that is particularly noticeable in autumn. The throat is pale and unmarked and there is a pale eye-ring; note also the hint of a short, pale supercilium. The legs are pinkish and the outer tail feathers are white. **JUVENILE** is similar to an adult but the streaking on the underparts is less extensive. **VOICE** – utters a *pseet-pseet-pseet* call and has a descending song that is delivered in flight but that typically starts and ends on the ground. HABITAT AND STATUS The Meadow Pipit is common, widespread and present in the region year round. During the breeding season, it favours rough grassy habitats from coastal meadows, heaths and downs to grassy moors on the lower slopes of mountains; probably several million pairs breed in the region. Outside the nesting season, the species is still widespread, although it is most numerous in lowland areas in the southern half of the region; Meadow Pipits commonly feed on the seashore at this time of year. An influx of birds from Iceland and northern Europe boosts the wintering population. OBSERVATION TIPS You should have little difficulty finding Meadow Pipits in the region at any time of year. Get to know the call as this will enable you to identify distant birds with certainty and will help you distinguish this species from its superficially similar cousins.

!CONFUSION SPECIES!

SKYLARK
Page 176

TREE PIPIT *Anthus trivialis* LENGTH 15cm

Superficially similar to a Meadow Pipit, but separable with care and experience using plumage details, voice and habitat preferences. The sexes are similar. **ADULT** has sandy-brown upperparts that are adorned with dark streaks. The underparts are pale, whitish and unmarked on the throat and belly, but boldly streaked and flushed with yellow-buff on the breast and flanks. There is a rather striking pale supercilium and a dark sub-moustachial stripe. The legs are pinkish and the outer tail feathers are white. **JUVENILE** is similar to an adult. **VOICE** – flight call is a buzzing *spzzzt*. The song (delivered in flight but starting from a tree perch) comprises an accelerating trill that ends with thin, drawn-out notes as the bird parachutes down, usually to a different tree-top perch. HABITAT AND STATUS The Tree Pipit is a widespread migrant summer visitor to the region, commonest in Wales, the west and north of England, and in western Scotland. More than 100,000 pairs probably breed in the region and the classic habitat is open woodland with grassy glades and clearings; heaths with scattered trees are also favoured by the species. OBSERVATION TIPS The Tree Pipit's call and song (including its mode of delivery) offer the best means for quick and certain identification. When perched in a tree, a bird will often pump its tail up and down, which is another useful clue to its identity.

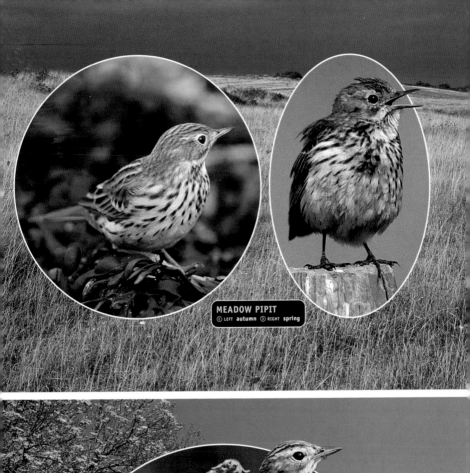

MEADOW PIPIT
◁ LEFT **autumn** ▷ RIGHT **spring**

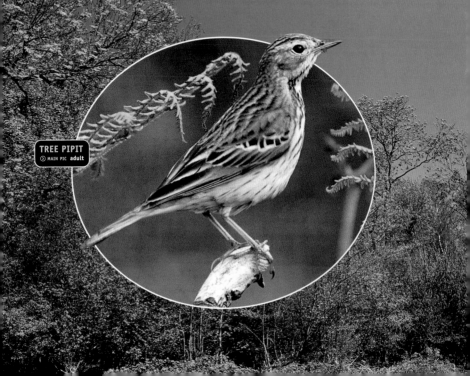

TREE PIPIT
▷ MAIN PIC **adult**

WATER PIPIT *Anthus spinoletta* LENGTH 16–17cm

A comparatively bulky pipit formerly treated as a race of Rock Pipit. As its name suggests, the Water Pipit is invariably associated with freshwater habitats; typically, it is solitary in the region. The sexes are similar. **WINTER ADULT** has streaked dark buffish-brown upperparts. The underparts are pale but are streaked and flushed with buffish-brown on the breast and flanks. The throat is white and unmarked, and there is a striking whitish supercilium and contrasting dark eye-stripe. The legs are dark, the bill is dark-tipped and the outer tail feathers are white. **SUMMER ADULT** (sometimes seen in late winter) is similar, but the underparts are almost unmarked and flushed pinkish on the breast; the back is brown while the head and neck are grey except for the pale throat and supercilium. Both the legs and bill are dark. **JUVENILE** (not seen in the region) resembles a winter adult. **VOICE** – utters a single *pseet* call. HABITAT AND STATUS The Water Pipit is essentially a winter visitor to the region, although some individuals seen in spring and autumn may be passage migrants. Numbers recorded vary from year to year, but in a good season 100 or so individuals may be discovered. The majority of birds are found on watercress beds in southern England, although freshwater marshes elsewhere are also favoured to a lesser extent. OBSERVATION TIPS Although not especially rare, the Water Pipit can be difficult to track down and so birdwatchers should not expect to see one every year. For the best chance of a sighting, visit watercress beds in Hampshire and its adjacent counties between November and March.

ROCK PIPIT *Anthus petrosus* LENGTH 16–17cm

A bulky and rather dark pipit that is invariably found within sight of the sea. The sexes are similar. **ADULT** and **JUVENILE** have streaked dark grey-brown upperparts and rather grubby whitish underparts that are heavily streaked on the breast and blanks. The throat is pale and there is an indistinct pale supercilium and eye-ring; note the dark sub-moustachial stripe. The legs and bill are dark and the outer tail feathers are grey. **VOICE** – utters a single *pseet* call and has a Meadow Pipit-like song that is delivered in flight, but starts and ends on a cliff-side rocky outcrop. HABITAT AND STATUS The Rock Pipit is exclusively coastal in its distribution. During the breeding season, it favours rocky coasts and cliffs and is commonest in the north and west; several tens of thousands of pairs nest in the region. Outside the breeding season, it is more widespread around the coast and it is often found feeding on the strandline on beaches. OBSERVATION TIPS The Rock Pipit's overall dark appearance and its exclusively coastal habitat preference are good clues to its identity. Walk a stretch of rocky coast in the west and north of the region in the spring and you are sure to come across the species.

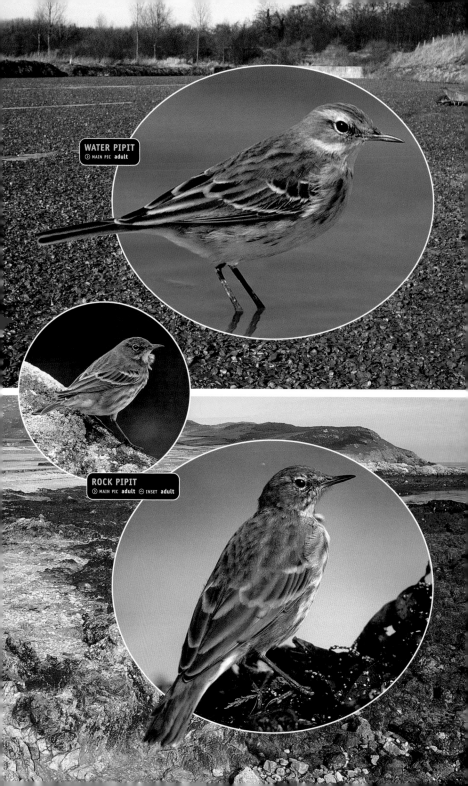

WATER PIPIT
⊙ MAIN PIC **adult**

ROCK PIPIT
⊙ MAIN PIC **adult** ⊙ INSET **adult**

YELLOW WAGTAIL *Motacilla flava flavissima* LENGTH 16–17cm

A delightful, long-tailed bird. The Yellow Wagtail sometimes perches on barbed-wire fences in its favoured wetland habitats; it searches for insects on the ground, sometimes feeding at the feet of grazing animals. The sexes are dissimilar. **ADULT MALE** has greenish-yellow upperparts and striking yellow underparts that extend to the face; note the yellow supercilium, white outer tail feathers and the whitish wingbars. **ADULT FEMALE** is similar to an adult male, but the plumage is duller and the yellow coloration less intense. **JUVENILE** has olive-buff upperparts and pale underparts; note the whitish throat, yellow flush to the undertail, white outer tail feathers and the pale wingbars. **Blue-headed Wagtail *M. f. flava* (**the race from mainland Europe) sometimes turns up in the region. Only the male is distinctive: it is similar to a male Yellow Wagtail, but note the bluish cap and ear coverts, and the white supercilium. Female and juvenile birds are similar to their Yellow Wagtail counterparts. **VOICE** (all birds) – utters a distinctive *tsree-ee* call. HABITAT AND STATUS The Yellow Wagtail is a summer visitor to the region. Favoured nesting habitats include water meadows and damp, grazed grassland. The species has declined markedly in recent years as a result of changes in farming practices: land drainage and increased intensification are the main culprits. Nevertheless, several tens of thousands of pairs probably still breed in the region. Yellow Wagtails also turn up outside their breeding range on migration, particularly in areas of short grassland near the coast. OBSERVATION TIPS Learn to recognise the Yellow Wagtail's distinctive call and you will be able to detect the presence of distant and flying birds. The species is probably commonest as a breeding bird in central England and on coastal land bordering the Thames estuary, from Kent to Essex.

Blue-headed Wagtail

GREY WAGTAIL *Motacilla cinerea* LENGTH 18cm

An elegant bird with a strikingly long tail that it continually pumps up and down. The Grey Wagtail is invariably associated with flowing fresh water and often perches on mid-stream boulders. The sexes are dissimilar. **SUMMER ADULT MALE** has blue-grey upperparts and lemon-yellow underparts. Note the black bib, contrasting white sub-moustachial stripe and the white supercilium. The bill is dark, the legs are reddish and the outer tail feathers are white. **SUMMER ADULT FEMALE** is similar, but the bib is typically whitish and variably marked with grey, while the underparts are paler and the yellow coloration striking only on the vent. **WINTER ADULTS** are similar to their respective summer plumages but they have white throats. **JUVENILE** and **FIRST-WINTER BIRDS** resemble a winter adult female. **VOICE** – utters a sharp *chsee-tsit* call in flight. HABITAT AND STATUS The Grey Wagtail is invariably associated with fast-flowing stony watercourses. During the breeding season it is usually found beside streams and rivers; it is almost absent from low-lying regions in eastern England. Some 40,000 or so pairs probably nest in the region. Outside the breeding season, some northern and upland districts are abandoned and the species turns up in a wider variety of habitats in the south, notably on watercress beds and the margins of flooded gravel pits. OBSERVATION TIPS The species is easiest to see during the breeding season, when a visit to almost any suitable stream or river in the western half of the region is likely to yield sightings.

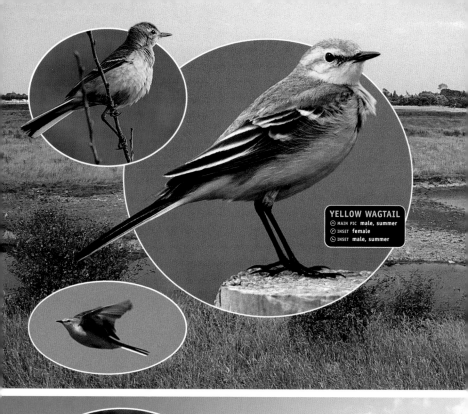

YELLOW WAGTAIL
- ⌖ MAIN PIC **male, summer**
- ⌖ INSET **female**
- ⌖ INSET **male, summer**

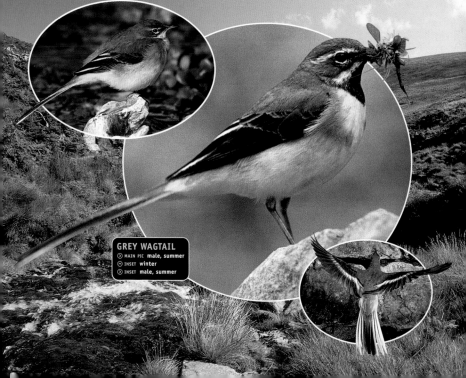

GREY WAGTAIL
- ⌖ MAIN PIC **male, summer**
- ⌖ INSET **winter**
- ⌖ INSET **male, summer**

PIED WAGTAIL *Motacilla alba yarrellii* LENGTH 18cm

A familiar black, grey and white bird. The Pied Wagtail has a bounding flight and the distinctive habit of pumping its tail up and down. The sexes are dissimilar. **SUMMER ADULT MALE** has mainly white underparts and black upperparts, but note the white face and striking white wingbars. The legs and bill are dark and the outer tail feathers are white. **WINTER ADULT MALE** is similar, but the throat is white and the black on the breast is less extensive. **ADULT FEMALE** recalls an adult male in the appropriate seasonal plumage but the back is dark grey, not black. **JUVENILE** and **FIRST-WINTER BIRDS** have greyish upperparts (note the black rump, however) and whitish underparts; the whitish wingbars are striking and the face sometimes reveals a faint yellowish wash. **VOICE** – utters a loud *chissick* call. HABITAT AND STATUS The Pied Wagtail is associated with areas of bare ground and short grassland. It is found in the vicinity of farms and near the coast, as well as in urban locations such as playing fields and car parks. During the breeding season it is widespread throughout the region, and several hundred thousand pairs nest here. During the winter months, most birds from upland regions and the far north move south and west. OBSERVATION TIPS Wherever you live in Britain, you should have little difficulty finding this species, especially during the summer months. Most school playing fields and supermarket car parks have their own resident pair.

WHITE WAGTAIL *Motacilla alba alba* LENGTH 18cm

The mainland European counterpart of the Pied Wagtail. Adult males of the two races are separable with care in summer and winter plumages; female and immature birds are more problematic. In terms of their habitat preferences, behaviour and voice, however, Pied and White Wagtails are identical. The sexes are dissimilar. **SUMMER ADULT MALE** has a grey back and rump with a clear demarcation from the black nape and hindcrown. The throat and breast are black, but in other respects it resembles a male Pied Wagtail. **WINTER ADULT MALE** has grey upperparts, including the nape and crown; the underparts are white but note the black breast band. **ALL OTHER BIRDS** are similar to their Pied Wagtail counterparts, except that both the back and rump are uniform grey. **VOICE** – utters a sharp *chissick* call, identical to that of a Pied Wagtail. HABITAT AND STATUS The White Wagtail replaces the Pied Wagtail in the Channel Islands and a few pairs also breed in Scotland, particularly on the Shetland Islands, where Pied × White mixed pairs are sometimes discovered as well. Elsewhere, it is a fairly common passage migrant, the majority turning up on the coast in the western half of the region. Migrant numbers are difficult to estimate because of the difficulty of separating immature and non-breeding birds from their Pied Wagtail counterparts. IDENTIFICATION TIPS Unless you like a real challenge, be content with looking for, and identifying, adult male birds.

WREN *Troglodytes troglodytes* LENGTH 9–10cm

A tiny bird that can be recognised by its dumpy proportions, mainly dark brown plumage and its habit of frequently cocking its tail upright. The Wren is rather unobtrusive as it creeps through low vegetation in search of insects, and it can look rather mouse-like. Fortunately, the species is extremely vocal and the presence of unseen birds is often detected on hearing the distinctive call. The sexes are similar. **ADULT** and **JUVENILE** have dark reddish-brown upperparts with barring on the wings and tail. The underparts are greyish-white with a buff wash to the flanks; note also the striking, pale supercilium. The bill is needle-like and the legs are reddish. **VOICE** – utters a loud, rattling alarm call and the song is loud and warbling, ending in a trill. HABITAT AND STATUS The Wren is an extremely widespread resident species in the region. It is found in a wide variety of habitats, from woodlands and hedgerows to scrub patches, gardens and coastal cliffs, the common factor being dense undergrowth. It even occurs on offshore islands, but is least numerous in northern and upland districts. Although the population fluctuates from year to year (Wrens suffer badly in severe winters), in good seasons there might be a minimum of 10 million birds in the region. OBSERVATION TIPS Listen out for the distinctive call to ascertain whether the species is present in any given area. Although Wrens prefer to feed in the undergrowth, they typically emerge from cover periodically and perch in the open briefly.

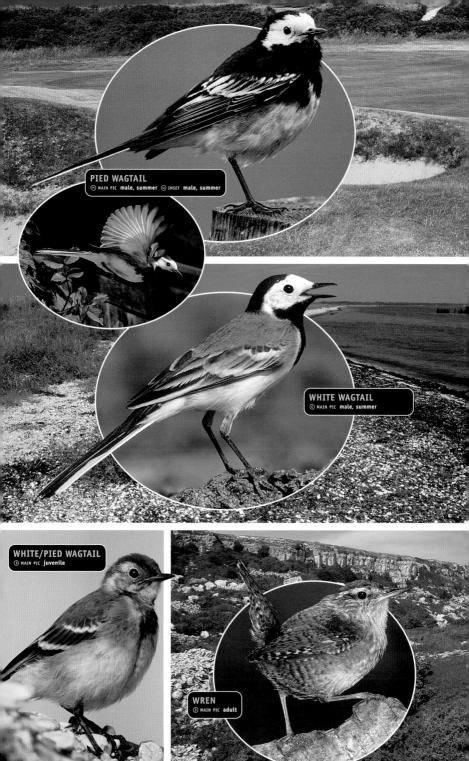

PIED WAGTAIL
◇ MAIN PIC **male, summer** ◇ INSET **male, summer**

WHITE WAGTAIL
◉ MAIN PIC **male, summer**

WHITE/PIED WAGTAIL
◉ MAIN PIC **juvenile**

WREN
◉ MAIN PIC **adult**

WAXWING *Bombycilla garrulus* LENGTH 18cm

A distinctive and much-admired bird. Waxwing visitors to the region are often remarkably indifferent to human observers, allowing superb views to be obtained. In flight, the silhouette is rather Starling-like. The sexes are similar. **ADULT** has mainly pinkish-buff plumage that is palest on the belly. Note the crest, the black throat and black mask through the eye. The rump is grey, the undertail is chestnut and dark tail has a broad yellow tip (narrower in females than males). The wings have white and yellow margins, and red, wax-like projections. **FIRST-WINTER BIRD** is similar, but the white margins to the flight feathers are absent, as are the red, wax-like projections. **VOICE** – utters a trilling call. HABITAT AND STATUS The Waxwing is a winter visitor to the region from northern mainland Europe. Given the origins of these immigrants, it is hardly surprising that most are recorded in eastern Britain. Numbers vary from year to year. In most seasons, several hundred may be present, but if the berry crop fails in northeastern Europe the influx may involve thousands of birds. OBSERVATION TIPS Waxwings are only found where berry-bearing bushes flourish. By the end of the winter, when most berries have been consumed in the countryside at large, Waxwings are often forced to move to urban areas. To the delight of birdwatchers, they will feed on Rowan and Pyracantha berries in gardens and car parks, typically remaining until the supply of food has been exhausted.

DIPPER *Cinclus cinclus* LENGTH 18cm

A dumpy bird that is invariably associated with water. The Dipper is typically seen perched on boulders in fast-flowing streams and rivers, or flying on whirring wing-beats low over the water. At a distance, and in harsh light, it can look black and white. The Dipper submerges readily, swimming underwater and walking on the bottom while searching for invertebrates. The sexes are similar. **ADULT** is dark grey-brown on the wings, back and tail. The head is reddish-brown and the throat and breast are white, appearing like a bib. The belly grades from reddish-chestnut at the front to blackish-brown at the rear. The legs and feet and stout and powerful. **JUVENILE** has the proportions of an adult, but the upperparts are greyish while the underparts are pale but heavily barred everywhere except on the throat. **VOICE** – utters a shrill *striitz* call. HABITAT AND STATUS The Dipper is associated with fast-flowing streams and rivers where caddisfly larvae and mayfly nymphs are common, often occurring in similar locations to the Grey Wagtail. It is a resident species, commonest in the west and north of the region and effectively absent from central and eastern England. There are probably in excess of 10,000 pairs in the region as a whole. Just occasionally, a mainland European Dipper turns up in the region in winter; this race can be recognised by its uniformly dark brown belly. OBSERVATION TIPS Visit almost any fast-flowing stream or river in central Wales, northern England or southern Scotland and you stand a good chance of finding a Dipper. Look for regularly perched-upon boulders, whitewashed with droppings; if you sit quietly in the vicinity, a Dipper will come and sit there sooner or later.

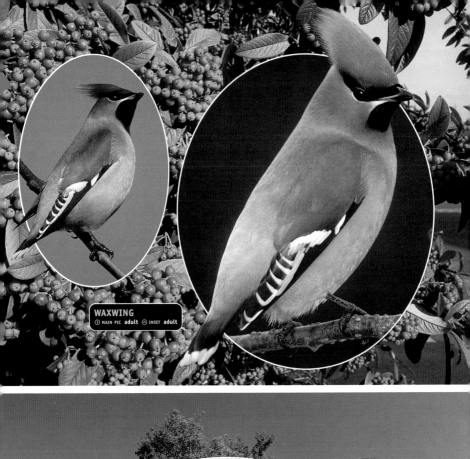

WAXWING
⊘ MAIN PIC **adult** ⊘ INSET **adult**

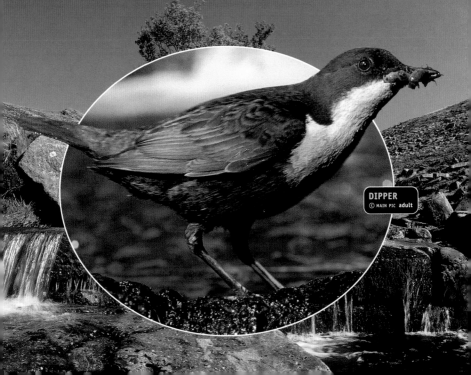

DIPPER
◁ MAIN PIC **adult**

DUNNOCK *Prunella modularis* LENGTH 13–14cm

A rather House Sparrow-like bird but with a thin, warbler-like bill. Generally rather skulking, but males are comparatively bold and conspicuous in spring. The sexes are similar throughout the year. **ADULT** shows heavy streaking on its chestnut-brown back. The underparts are mostly bluish-grey, but the flanks are boldly streaked with brown and chestnut. The face is bluish-grey with brown streaking on the ear coverts and crown. Note also the faint pale wingbar. The bill is needle-thin and dark, and the legs are reddish-pink. **JUVENILE** is similar to the adult but with bolder streaking. **VOICE** – the song is energetic and warbler-like; it is usually delivered from a prominent perch or the highest tangle in a bramble patch. Dunnocks can be heard singing from early March onwards. The alarm call is a thin, piping *tseer*. HABITAT AND STATUS A widespread and rather common resident of woodlands, hedgerows, gardens and similar habitats – in fact, almost anywhere that harbours low, dense cover such as bramble patches. Several million birds are probably present in the region as a whole. OBSERVATION TIPS The Dunnock feeds quietly and unobtrusively, mainly on the ground and generally close to cover. If the view of the bird is partial, it can look almost mouse-like. Consequently, despite the species' relative abundance, it can be difficult to locate unless you are familiar with its alarm call. Dunnocks are easiest to see in spring, when males in particular exhibit a reversal in the species' typically retiring behaviour and frequently sit out in the open and sing in an uninhibited manner.

ROBIN *Erithacus rubecula* LENGTH 13–14cm

A familiar British bird and, indeed, one of the nation's favourites if greetings cards are anything to go by. Often bold and inquisitive in garden settings but usually much less so in the countryside at large. Strongly and conspicuously territorial. The sexes are similar throughout the year. **ADULT** is almost unmistakable, with its striking orange-red face, throat and breast; this is bordered

!CONFUSION SPECIES!

REDSTART
Page 194

by blue-grey to the sides, but there is a sharp demarcation from the white belly. The upperparts are buffish-brown and there is a faint buff wingbar. **JUVENILE** has brown upperparts, marked with pale buff spots and teardrop-shaped streaks, while the pale buff underparts are adorned with darker spots and crescent-shaped markings. With a poor view, a juvenile Robin could perhaps be confused with a Nightingale, although the former's streaked and spotted appearance soon allows certain identification. **VOICE** – the Robin's rather plaintive, melancholy song can be heard in almost any month of the year although, understandably, the species is most vocal in spring. The alarm call is a sharp *tic*. HABITAT AND STATUS A widespread and common resident in most of England, Wales and Ireland; its distribution is rather more patchy in Scotland, becoming distinctly scarce in the far north. Several million pairs are probably present in the region as a whole. Passage migrants, from mainland Europe, pass through Britain, mainly in the autumn. OBSERVATION TIPS In many parts of Britain, the Robin is one of the easiest songbirds to find and to observe well. Indeed, in locations such as gardens and car parks, Robins often actively seek out human visitors in the hope of picking up scraps of food.

juvenile

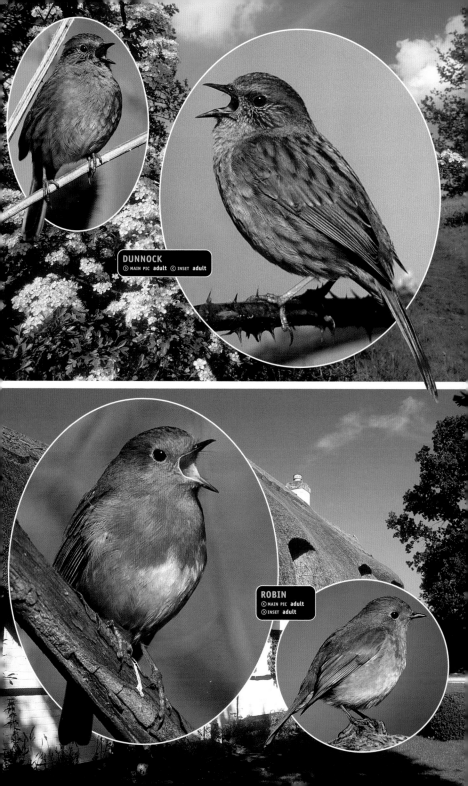

DUNNOCK
MAIN PIC adult INSET adult

ROBIN
MAIN PIC adult
INSET adult

NIGHTINGALE *Luscinia megarhynchos* LENGTH 16–17cm

A rather secretive bird that is best known for its powerful, musical song; this is delivered both by day and at night, and is audible over a considerable range. Silent birds are unobtrusive and easily overlooked. The sexes are similar. **ADULT** and **JUVENILE** have rich brown upperparts overall; the tail and rump are warmer reddish-chestnut than the back, and note the hint of grey on the face and sides of the neck. The underparts are a rather uniform greyish-white, suffused pale buffish-brown on the breast. **VOICE** – the song is rich and varied, and includes fluty whistles and clicking sounds; typically, the bird starts with a rich, whistling *tu-tu-tu-tu*, before embarking on the more complex repertoire. HABITAT AND STATUS The Nightingale is a migrant summer visitor to the region. The classic habitat for the species is coppiced woodland that has reached a stage in its cycle of maturity where dense undergrowth has developed. A few thousand pairs breed in the region, the majority being found south and east of an imaginary line drawn between Dorset and the Wash. Like so many of our bird species, the Nightingale has declined in recent years. While habitat loss or degradation have undoubtedly had an impact, there may be other factors at work: the species has abandoned many previously occupied coppiced woodland areas that, on the face of it, are still eminently suitable. Intriguingly, in many parts of mainland Europe the Nightingale is much more catholic in its choice of habitats and even the most unpromisingly small patches of scrub usually hold a pair or two. OBSERVATION TIPS Nightingales are occasionally seen on migration – mainly in the spring – around the coast, the typical view being a glimpse of the reddish tail as the bird disappears into cover. The best way to encounter the species is to listen for the song on breeding territory. Although Nightingales will sing quite happily during the daytime, they are often most vocal at dusk, so take an evening stroll in early May in a likely looking area in southeast England and you might be lucky.

BLUETHROAT *Luscinia svecica* LENGTH 13–14cm

A compact and perky Robin-sized bird that feeds on the ground. The Bluethroat is distinctive in all plumages, but adult males are stunningly beautiful. Although unobtrusive, migrants are often not particularly shy. At all times, the red sides to the base of the tail are diagnostic. The sexes are dissimilar. **ADULT MALE** has mainly grey-brown upperparts and whitish underparts. Note, however, the iridescent blue throat and breast, bordered below by concentric bands of black, white and red. Typically, there is either a white or a red spot in the centre of the throat, depending on the race involved. There is also a prominent white supercilium. In autumn, the blue coloration on the throat may appear incomplete (pale feather fringes mask the true colour and have yet to be worn away). **FIRST-AUTUMN MALE** is similar to an adult male, but the throat and supercilium are creamy-white while the blue coloration is restricted to a band on the lower throat. The black defining breast band links to a dark malar stripe, and note also the creamy sub-moustachial stripe. **ADULT FEMALE** resembles a first-autumn male, but the supercilium, throat and sub-moustachial stripe are white, not creamy; the amount of blue on the throat is variable. **FIRST-WINTER FEMALE** recalls an adult female but the red and blue throat colours are entirely absent. **VOICE** – utters a sharp *tchick* call. HABITAT AND STATUS Although the Bluethroat is occasionally suspected of breeding in the region, and has done so in the past, its true status is that of a scarce but regular passage migrant. In a good year, 100 or so individuals may be observed, with most records coming from coastal migration hotspots, mainly on the east coast. Migrants typically favour areas of bare ground or short grass with nearby bramble patches or scrub areas into which they can disappear if alarmed. OBSERVATION TIPS If you want to find your own Bluethroat, keep an eye on the weather in early May and during September. During periods of easterly and southeasterly winds there is a chance that migrants will arrive on the North Sea coasts of England and Scotland; anywhere from the Suffolk coast to the Shetland Islands can produce results. Whether or not you come across one for yourself is really a matter of pot luck; fortunately, migrant Bluethroats sometimes stay put for a few days, so there is scope for being able to twitch somebody else's discovery.

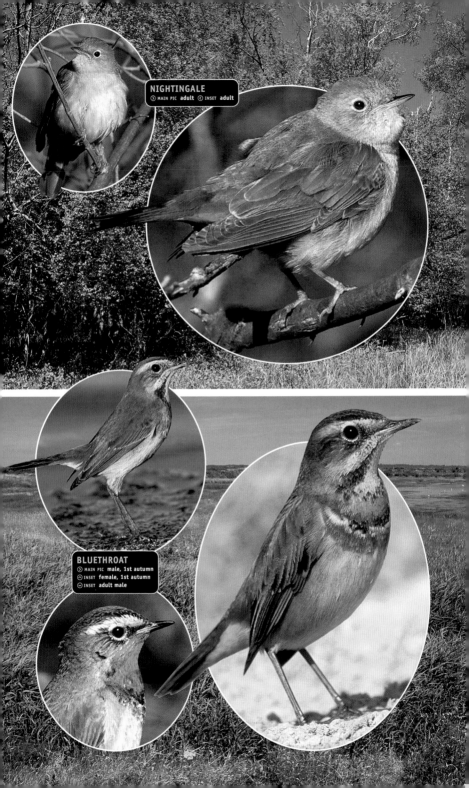

NIGHTINGALE
> MAIN PIC **adult** > INSET **adult**

BLUETHROAT
> MAIN PIC **male, 1st autumn**
> INSET **female, 1st autumn**
> INSET **adult male**

REDSTART *Phoenicurus phoenicurus* LENGTH 14cm

An attractive Robin-sized species, males of which are particularly striking. In all plumages, the Redstart has a distinctive dark-centred red tail that is continu-

!CONFUSION SPECIES!

ally pumped up and down when the bird perches. The sexes are dissimilar. **ADULT MALE** has a grey back, nape and crown, a black face and throat, and orange-red underparts that are most colourful on the breast. Note the white forehead and supercilium. The legs and bill are dark. **ADULT FEMALE** has grey-brown upperparts and head, and an orange wash to the rather pale underparts. **FIRST-WINTER BIRDS** recall their respective adult plumages, but pale feather fringes make the colours duller and give a barred or scaly appearance to the underparts; in the case of males, the pale fringes obscure the markings on the head. **VOICE** – utters a soft *huiit* call and a sharp ticking when alarmed. The song is tuneful but melancholy. HABITAT AND STATUS The Redstart is a bird of open woodland (Sessile Oak is a particular favourite), typically where there are scattered mature trees, a limited understorey and short ground vegetation. This migrant visitor is most numerous in Wales, the southwest and north of England, and in Scotland; around 100,000 pairs may breed. The species is very rare in Ireland. It nests in holes, usually in gnarled trees but occasionally in stone walls. OBSERVATION TIPS Redstarts are easiest to see on breeding territory, so visit likely looking woodlands in the west and north of Britain in May. As the birds can be rather unobtrusive, get to know the song to help you pinpoint territorial males. The species uses regular perches, such as dead branches, from which to make aerial sorties after insects. Redstarts are sometimes seen on migration as well, usually around the coast; they are easier to find in spring than in autumn.

ROBIN
Page 190

male

BLACK REDSTART *Phoenicurus ochruros* LENGTH 14cm

A bold and perky bird that often perches conspicuously, quivering its striking red tail. Unlike its cousin, the Redstart, this species has red only on its tail; in all birds, the plumage is otherwise mainly grey or grey-brown. Some individuals can be remarkably confiding. The sexes are dissimilar. **ADULT MALE** has mainly slate-grey body plumage that is darkest (almost black in spring) on the face and breast. Note the white wing patch and whitish lower belly. The legs and bill are dark. **ADULT FEMALE** and **IMMATURE BIRDS** have rather uniform grey-brown body plumage that is darkest on the wings and palest on the lower belly. A pale eye-ring emphasises the dark eye. **VOICE** – utters a whistling call. The song comprises various whistles and curious crackling, static-like phrases. HABITAT AND STATUS The Black Redstart is a scarce breeding species in the region, with between 50 and 80 pairs attempting to nest each year. The species is more numerous as a passage migrant, and a proportion of the autumn influx remains in the region, boosting the winter population; several hundred birds are generally present from October to March. During the breeding season, Black Redstarts favour industrial and urban locations, often nesting in buildings, both used and derelict. At other times, most records come from coastal districts; here, the birds often feed on insects that flourish along the strandline on rocky beaches. OBSERVATION TIPS Black Redstarts are easiest to find outside the breeding season. March is a particularly good month, because wintering birds should still be present and the first migrants from southern Europe will have started to arrive. The species is most easily discovered on the south coast of England, from Cornwall to Kent. You would be unlucky not to see at least one individual if you visited Portland at this time of year.

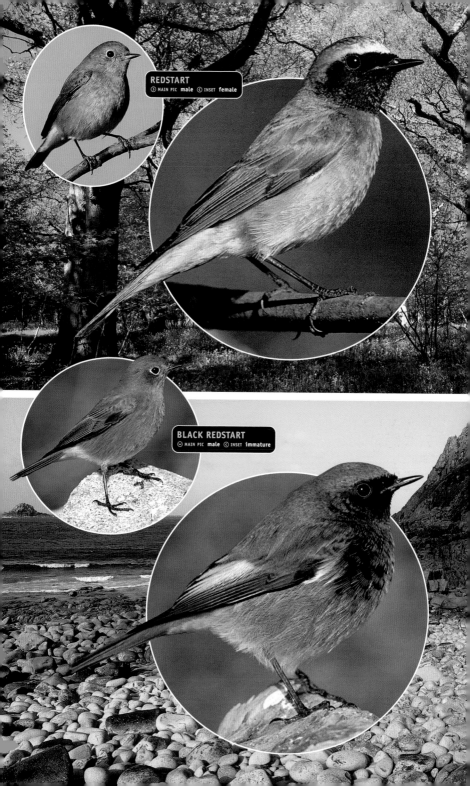

REDSTART
❯ MAIN PIC **male** Ⓒ INSET **female**

BLACK REDSTART
❯ MAIN PIC **male** Ⓒ INSET **immature**

STONECHAT *Saxicola torquata* LENGTH 12–13cm

A small and compact bird with a relatively short, dark tail. When perched, the Stonechat frequently flicks its tail while uttering a harsh alarm call. The sexes are dissimilar. **ADULT MALE** has a blackish head, white on the side of the neck and a dark back. The breast is orange-red and this grades into the pale underparts. The bill and legs are dark and note also the spotted brown rump. In autumn, pale feather fringes make the head appear paler. **ADULT FEMALE** recalls an adult male but the colours are muted; in particular, the head and back are rather uniformly streaked brown and the pale patch on the side of the neck is grubby. **FIRST-WINTER BIRD** has streaked sandy-brown upperparts and head, and buffish-orange underparts. **VOICE** – utters a harsh *tchak* call, like two pebbles being knocked together. The rapid, warbling song is rather Whitethroat-like. HABITAT AND STATUS The Stonechat is a bird of heaths, commons, and gorse-slopes near the coast. Most adults are year-round residents of suitable territories, and several tens of thousands of pairs are present in the region; first-winter birds often disperse to the coast. OBSERVATION TIPS Stonechats are easy to find if you visit a suitable habitat: birds often perch conspicuously and announce their presence with harsh, agitated calls.

!CONFUSION SPECIES!

ROBIN
Page 190

WHINCHAT *Saxicola rubetra* LENGTH 12–14cm

Superficially similar to the Stonechat but separable on plumage details. Male Whinchats, in particular, are strikingly marked and colourful. In all birds the short tail is mainly dark but the sides to its base are whitish. The sexes are dissimilar. **ADULT MALE** has brown, streaked upperparts with a striking white stripe above the eye. The margins of the throat and ear coverts are defined by a pale stripe, but the throat itself, along with the breast, is orange; the underparts are otherwise whitish. The bill and legs are dark. **ADULT FEMALE** has a plumage pattern similar to that of an adult male but the colours and contrast are less intense; in particular, the supercilium is grubby white and the breast is only subtly flushed with orange. **FIRST-WINTER BIRD** is similar to an adult female but the upperparts appear more spotted. **VOICE** – utters a whistling *tic-tic* alarm call. The song is rapid and warbling. HABITAT AND STATUS The Whinchat is a summer visitor and favours rough grassy slopes with scattered scrub. The population has declined in recent years and its range has contracted too, due in part to changes in agricultural land use. Now, perhaps 20,000 or so pairs are present during the breeding season; it is locally common only in Wales and northern Britain. Migrants are often seen near the coast. OBSERVATION TIPS Whinchats perch conspicuously, often using barbed-wire fences or a tall plant.

WHEATEAR *Oenanthe oenanthe* LENGTH 14–16cm

A familiar bird of open country. The Wheatear often perches with a rather upright posture. The call is distinctive and, in all plumages, note the diagnostic white rump and black 'T' marking on the otherwise white tail. In other plumage respects, the sexes are dissimilar. **ADULT MALE** has a blue-grey crown and back, a black mask and wings, and pale underparts with an orange-buff wash on the breast. Note the white supercilium. The legs and bill are dark. **ADULT FEMALE** has mainly grey-brown upperparts that are darkest on the wings. The face, throat and breast are pale orange-buff and the underparts are otherwise whitish. Note the pale supercilium. **FIRST-WINTER BIRD** has grey-brown to buffish-brown upperparts. The underparts are pale with a buffish-orange wash to the face, throat and flanks; in some races that pass through the region on migration, this suffusion is more extensive and intense. Note the pale supercilium. **VOICE** – utters a sharp and distinctive *chak* alarm call, like two pebbles being knocked together. The song is fast and warbling. HABITAT AND STATUS The Wheatear is a summer visitor to the region, typically associated with short, grazed turf and open moors, and common only in the west and north; it is scarce and local as a breeding species in lowland southern and eastern England. 50,000 or more pairs breed in the region, while passage migrants contribute to the species' presence in spring and autumn. OBSERVATION TIPS Wheatears are usually easy to see if you visit the right habitats in the west and north of the region. On the coast, it is often one of the first migrants to appear in spring (from early March onwards) as well as one of the last to leave.

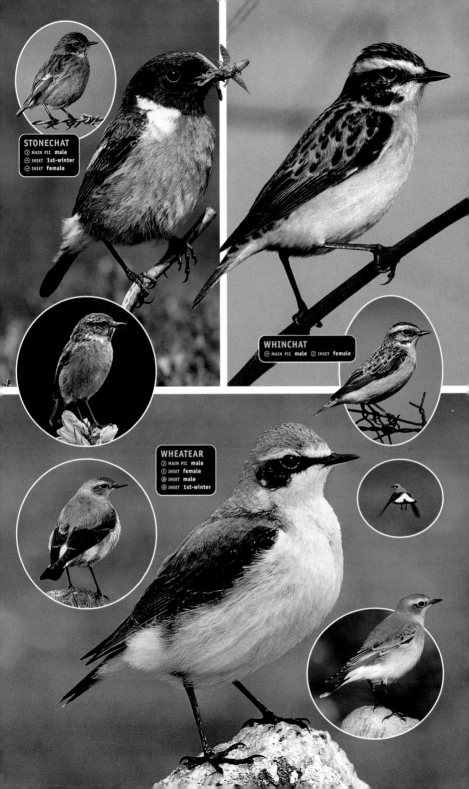

STONECHAT
- ▷ MAIN PIC **male**
- ⊙ INSET **1st-winter**
- ⊙ INSET **female**

WHINCHAT
- ⊙ MAIN PIC **male** ▷ INSET **female**

WHEATEAR
- ▷ MAIN PIC **male**
- ◁ INSET **female**
- ▷ INSET **male**
- ⊕ INSET **1st-winter**

BLACKBIRD *Turdus merula* LENGTH 25–27cm

A ground-dwelling bird with thrush-like proportions. The Blackbird is a familiar species across much of Britain and Ireland, partly because of its predilection for gardens and suburban locations, but also because it is so numerous. The sexes are dissimilar. **ADULT MALE** has uniformly blackish plumage. The legs are dark but the bill and eye-ring are yellow. **FIRST-WINTER MALE** is similar to an adult male but the bill is dark and the eye-ring is dull. **ADULT FEMALE** and **FIRST-WINTER FEMALE** have brown plumage that is darkest on the wings and tail, and palest on the throat and breast; the breast is streaked. **JUVENILE** is similar to an adult female but the back and underparts are marked with pale spots. **VOICE** – utters a harsh and repeated *tchak* alarm call; this is often heard at dusk, or if a prowling cat is discovered. The male is an excellent songster with a rich and varied repertoire. HABITAT AND STATUS In addition to gardens and parks, the Blackbird occurs in areas of woodland and scrub, as well as on farmland, moors and coasts. The species is present in the region as a whole throughout the year and several million pairs breed here. Outside the breeding season, birds from northern and upland districts tend to move to lower lying districts and the population as a whole may treble during the winter months as a result of influxes of birds from northern mainland Europe. OBSERVATION TIPS You should have no difficulty seeing and hearing Blackbirds almost anywhere in the region, although in northern and upland districts the species can be rather scarce in winter.

RING OUZEL *Turdus torquatus* LENGTH 25–26cm

A distinctive species that, in many ways, is the upland counterpart of its much more widespread and familiar cousin, the Blackbird. The Ring Ouzel is alert and wary, and is typically associated with wild and remote locations. The sexes are dissimilar. **ADULT MALE** has mainly black plumage, but note the striking white crescent on the breast and the pale fringes to the feathers on the wing. The legs are dark, the bill is yellowish and, at close range, pale fringes to the feathers on the dark underparts can be discerned. **ADULT FEMALE** resembles an adult male, but overall the dark elements of the plumage are browner and the pale crescent on the breast is grubby white. **FIRST-WINTER BIRD** looks rather uniformly dark with pale feather fringes all over; a hint of the adult's pale crescent on the breast can sometimes be discerned. **VOICE** – utters a harsh *tchuck* alarm call. The song comprises short bursts of fluty phrases. HABITAT AND STATUS The Ring Ouzel is a summer visitor to the region, and during the breeding season it is associated typically with rugged moorland habitats and lower mountain slopes; territories often incorporate rocky outcrops from which the birds mount a wary lookout for intruders. Dartmoor is the species' southernmost outpost, although it is easier to find in upland districts of Wales, northern England and Scotland. Several thousand pairs probably breed in the region as a whole. Ring Ouzels are sometimes encountered on migration, with most records coming from rocky, coastal districts in the western half of the region. OBSERVATION TIPS In order to see a Ring Ouzel, you will need to visit rugged upland habitats during the breeding season. Observation of the species is by no means guaranteed, however, and do not expect to get the same confiding views as you would with a Blackbird: it is a wary species and you will probably need to use a telescope. Migrant Ring Ouzels tend to be flighty and nervous and, in most cases, birds are only ever seen by one or two observers.

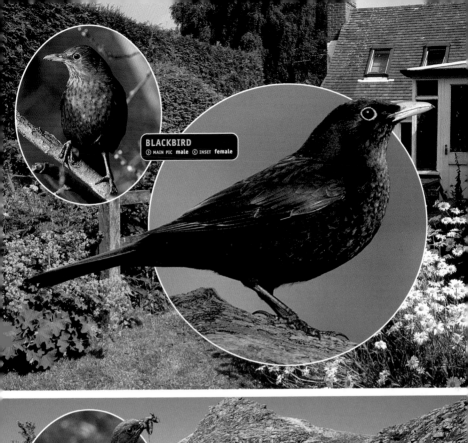

BLACKBIRD
MAIN PIC **male** INSET **female**

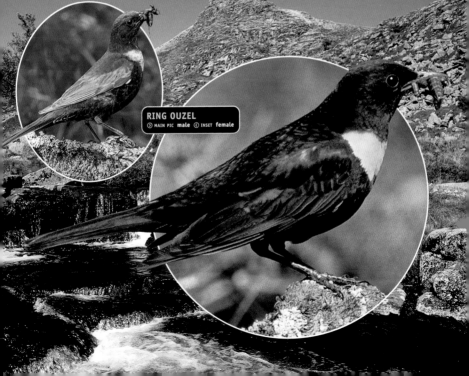

RING OUZEL
MAIN PIC **male** INSET **female**

FIELDFARE *Turdus pilaris* LENGTH 24–26cm

A large and plump thrush. The Fieldfare is typically encountered in large, winter flocks, often in the company of Redwings. The sexes are similar. **ADULT** has a blue-grey head and a chestnut back; note the pale supercilium. The breast and flanks are washed with orange-yellow and heavily spotted, while the rest of the underparts are whitish. In flight, note the pale grey rump and the white underwings. **JUVENILE** is similar to an adult, but note the pale spots on the wing coverts. **VOICE** – utters a harsh *chack-chack-chack* call; night-migrating flocks can sometimes be detected by these calls. The song (seldom heard in the region) comprises short bursts of rather subdued fluty phrases. HABITAT AND STATUS The Fieldfare's status in the region is essentially that of a common winter visitor, and perhaps a million or more birds may be present from October to March. Numbers vary from year to year, however, and the species tends to be nomadic. Whether or not it is present in a given area will depend upon weather conditions and food supplies there and elsewhere in the region. Wintering Fieldfares often congregate in areas where berries and fallen fruit are in good supply soon after their arrival. Once these food sources have been depleted, however, they are more usually associated with farmland; they roost in hedgerows and adjacent woodland. In addition to the species' occurrence as a winter visitor, small numbers of Fieldfares (a dozen or so pairs) usually nest in the region each year. Most breeding records come from northern Britain, and the species favours open woodland habitats for nesting. OBSERVATION TIPS Fieldfare flocks can turn up almost anywhere in the region, but if you drive around the countryside in midwinter you should come across the species within the space of an hour or so. If snow blankets the ground, put out apples on your garden lawn: if conditions are desperate enough, you might get a visit from a Fieldfare or two.

!CONFUSION SPECIES!

MISTLE THRUSH
Page 202

REDWING *Turdus iliacus* LENGTH 20–22cm

A small but well-marked and attractive thrush. The Redwing forms flocks outside the breeding season and often associates with related species, notably Fieldfares. The sexes are similar. **ADULT** has grey-brown upperparts and pale underparts with neat dark spots and an orange-red flush on the flanks and underwings. Note also the prominent white stripes above the eye and below the cheeks. **JUVENILE** is similar but with pale spots on the upperparts and subdued colours on the flanks. **VOICE** – utters a thin, high-pitched *tseerp* in flight; this call is often heard on autumn nights as migrating flocks pass overhead. The song (seldom heard in the region) comprises short bursts of whistling and fluty phrases. HABITAT AND STATUS The Redwing is a common winter visitor to the region and in most years a million or so birds may be present. The species is usually associated with areas of farmland, but in addition it occurs in open woodland, where birds forage amongst the leaf litter for earthworms and other invertebrates; berries and fallen fruit are also eagerly exploited while supplies remain in the countryside at large. However, because of the fickle nature of their food supplies, and of the winter weather, Redwing flocks tend to be nomadic, seldom staying in the same area for more than a few days. In addition to the species' status as a winter visitor, several dozen pairs usually attempt to breed in the region, mainly in northwest Scotland; they favour areas of open woodland. OBSERVATION TIPS Redwings are usually easy to find in areas of open countryside and farmland during the winter months. In harsh weather, they sometimes visit rural gardens and can also turn up on playing fields in more suburban locations.

!CONFUSION SPECIES!

SONG THRUSH
Page 202

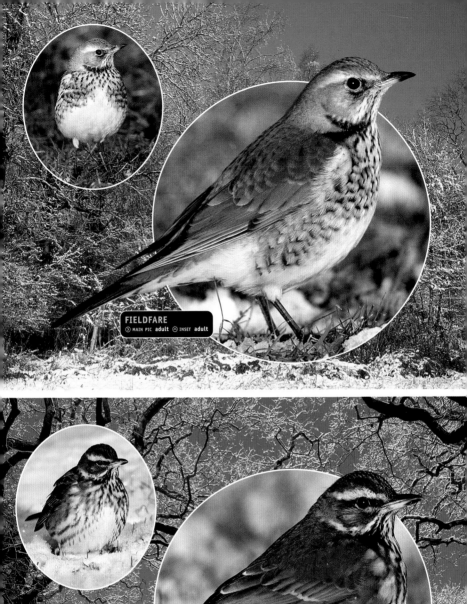

FIELDFARE
⊙ MAIN PIC **adult** ⊙ INSET **adult**

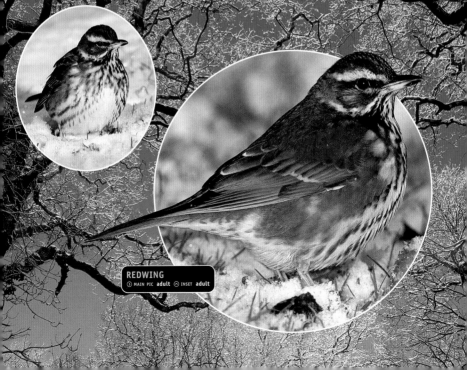

REDWING
⊙ MAIN PIC **adult** ⊙ INSET **adult**

SONG THRUSH *Turdus philomelos* LENGTH 23cm

A dainty and well-marked thrush. Despite its subdued coloration, the Song Thrush ranks as a favourite among birdwatchers, and its beautiful and distinctive song contributes in no small way to its appeal. The sexes are similar. **ADULT** has warm brown upperparts with a hint of an orange-buff wingbar. The underparts are pale but well marked with dark spots; note the yellowish-buff wash to the breast. In flight, the orange-buff underwing coverts are a use-

!CONFUSION SPECIES!

REDWING
Page 200

ful clue to identity. **JUVENILE** is similar to an adult but the markings and colours are less intense. **VOICE** – utters a thin *tik* call in flight. The song is loud and musical, and comprises phrases that are repeated two or three times. HABITAT AND STATUS The Song Thrush is found in a wide variety of habitats that boast a mosaic of open ground and dense vegetation, together with a selection of trees and shrubs. Consequently, it occurs in woodland, parks and mature gardens. Perhaps a million or so pairs breed in the region, although it is least common in northern and upland districts. Outside the breeding season, many Song Thrushes from northern Britain move south and some even migrate to the Continent. However, overall the population is boosted by influxes of birds from northern mainland Europe. Although the Song Thrush is still relatively common in the region, it has declined markedly in recent decades. Changes in farming practices, including the application of ever more 'efficient' insecticides and molluscides (which obviously reduce the amount of available food), have undoubtedly contributed to the species' decline. OBSERVATION TIPS Song Thrushes tend to be rather secretive during the breeding season and so the species is more easily observed during the winter months. However, for stunning views of the species at any time of year, visit the Scilly Isles, where birds are remarkably tame, often feeding within a metre of observers. If you want to encourage Song Thrushes in the garden, don't use pesticides in any shape or form and discourage cats by whatever means you see fit.

adult

MISTLE THRUSH *Turdus viscivorus* LENGTH 27cm

A bulky bird that is appreciably larger than the Song Thrush. Despite its size, the Mistle Thrush is often rather unobtrusive, and were it not for its distinctive call and song, it would be easy to overlook it. The sexes are similar. **ADULT** has grey-brown upperparts with a suggestion of a white wingbar. The underparts are pale but marked with large dark spots and the flanks are washed orange-buff. In flight, note the white underwings and the white tips to the outer

!CONFUSION SPECIES!

FIELDFARE
Page 200

tail feathers. **JUVENILE** recalls an adult, but the back is adorned with white, teardrop-shaped spots. **VOICE** – utters a loud and distinctive rattling alarm call. The loud song contains brief phrases and long pauses; it is often sung in dull weather, even when it is raining. HABITAT AND STATUS The Mistle Thrush can be found in the region throughout the year. During the breeding season, it is widespread in mainland areas and several hundred thousand pairs probably nest here. Outside the breeding season, many northern and upland districts are vacated and a proportion of the population migrates to the Continent. However, overall the population is probably boosted in the winter months as a result of influxes of birds from northern mainland Europe. Mistle Thrushes are found in areas of open woodland, parks and mature gardens. OBSERVATION TIPS Listen for the distinctive song during the breeding season; the Mistle Thrush is often the only species that sings with vigour on rainy days. The rattling alarm call and white underwings are diagnostic. During the winter months, individual Mistle Thrushes will often establish a territory centred on fruit- and berry-bearing bushes and trees, which they will defend against all-comers. At such times, they are often bold and conspicuous.

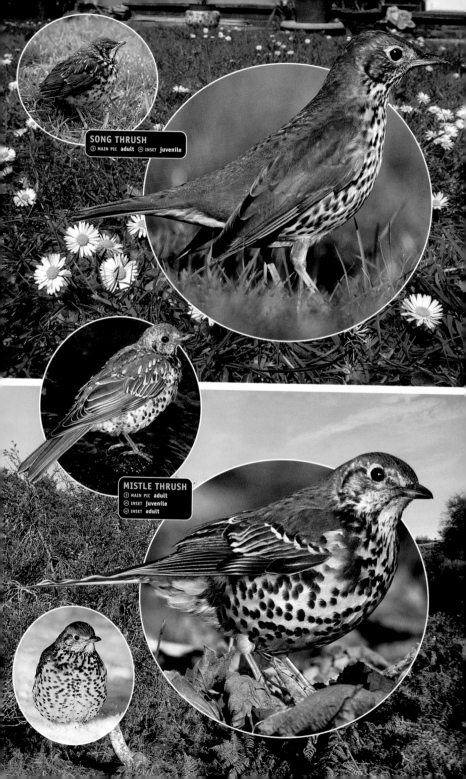

SONG THRUSH
> MAIN PIC **adult** ⊙ INSET **juvenile**

MISTLE THRUSH
> MAIN PIC **adult**
⊙ INSET **juvenile**
⊙ INSET **adult**

CETTI'S WARBLER *Cettia cetti* LENGTH 14cm

A relatively bulky but unobtrusive wetland warbler whose loud, explosive song is often the first indication of its presence in an area. The Cetti's Warbler is vaguely reminiscent of an outsized Wren and often cocks its rounded tail up in a similar manner to that species. The sexes are similar. **ADULT** and **JUVENILE** have dark reddish-brown upperparts, including the tail. The underparts are contrastingly pale, with a whitish throat, grey on the face and breast, and grey-buff on the belly. The legs are reddish and the bill is dark-tipped. **VOICE** – utters a loud *pluut* call. The song is an explosive *chee, chippi-chip-pi-chippi*. The species is most vocal in spring, but snatches of song are sometimes heard at other times of the year. HABITAT AND STATUS The Cetti's Warbler colonised Britain in the latter half of the 20th century and now there are probably several hundred pairs present in the region. The species is confined to the south, occurring from Cornwall and west Wales to Kent and north Norfolk. Territorial adults appear to be sedentary, and so presumably dispersing young birds are responsible for the expansion in the species' range. Cetti's Warblers favour the scrubby margins of marshes and isolated clumps of bushes in extensive reedbeds. OBSERVATION TIPS Cetti's Warblers' precise habitat requirements mean that they are confined to a comparatively small number of locations within the region, so study your local County Bird Reports to discover prime spots near you. In spring, if you visit the RSPB's reserve at Radipole Lake, near Weymouth in Dorset, or Titchfield Haven LNR in Hampshire, you would be unlucky not to hear a singing Cetti's Warbler. Seeing one is a different matter, however, because they can be rather skulking.

SAVI'S WARBLER *Locustella luscinioides* LENGTH 14–15cm

A specialist warbler of reedbed habitats. The Savi's Warbler is a tricky species to see, and most observers have to content themselves with hearing its song and catching occasional, and usually partial, views of the songster. The sexes are similar. **ADULT** and **JUVENILE** have uniformly warm brown upperparts. The underparts are paler but flushed buffish-brown on the breast and flanks; the undertail coverts are warm buffish-brown. **VOICE** – the call is a sharp *tviit*. The song is reeling and endless, with a mechanical or insect-like quality to it. It is delivered mainly at night, but not infrequently in the early morning and late afternoon too. HABITAT AND STATUS The Savi's Warbler is a rare summer visitor to the region. Around a dozen or so singing males are noted each year and the species is restricted to extensive wet reedbeds, mainly in East Anglia and Kent. OBSERVATION TIPS Given the nature of its preferred habitat – vast, inundated reedbeds – this species is always going to be difficult to observe. You only stand a chance of hearing Savi's Warblers that happen to have set up territory close to elevated sites of public access, such as raised walkways or stilt hides. Fortunately, territorial males often sing for several weeks after their arrival in late April, so obliging birds can usually be heard by plenty of visitors. However, you will need hours of patience, and a good deal of luck, to see one; views are invariably obscured by hundreds of swaying reed stems in the foreground.

GRASSHOPPER WARBLER *Locustella naevia* LENGTH 13cm

A rather skulking and unobtrusive warbler. The Grasshopper Warbler is heard far more frequently than it is seen. The sexes are similar. **ADULT** has streaked olive-brown upperparts; the underparts are paler but flushed buffish-brown on the breast. Like other members of the genus *Locustella*, the Grasshopper Warbler has long undertail coverts; they are adorned with dark streaks. **JUVENILE** is similar but the underparts are usually tinged with a more intense yellow-buff suffusion. **VOICE** – utters a sharp *tssvet* call. As the name suggests, the Grasshopper Warbler's reeling song has an insect-like, almost mechanical, quality to it; it is delivered mainly at night. HABITAT AND STATUS The Grasshopper Warbler is a summer visitor to the region. Several thousand pairs breed here and it favours rank grassland with bramble patches and clumps of rushes. The species is widespread, although it is seldom numerous in any one location; it is scarce or absent from many northern and upland districts. OBSERVATION TIPS Visit a likely looking area at dusk in May and listen for the Grasshopper Warbler's distinctive song. Just once in a while, the songster will sing from an elevated perch, such as a bramble patch.

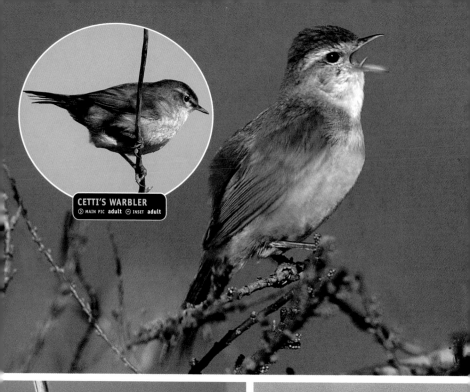

CETTI'S WARBLER
> MAIN PIC **adult** > INSET **adult**

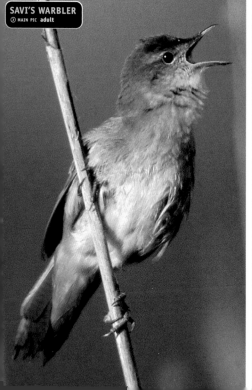

SAVI'S WARBLER
> MAIN PIC **adult**

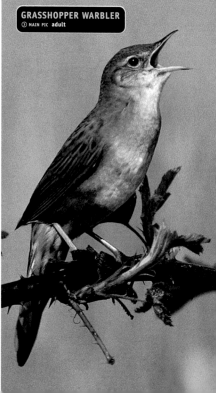

GRASSHOPPER WARBLER
> MAIN PIC **adult**

MARSH WARBLER *Acrocephalus palustris* LENGTH 13–14cm

Superficially very similar to a Reed Warbler but separable using the song and choice of habitat. Subtle plumage and structural differences also exist between the Marsh Warbler and its relative. The sexes are similar. **ADULT** has grey-brown upperparts (typically not as warm as Reed Warbler) including the rump; the pale under-parts are suffused yellow-buff. Note the pinkish legs and the hint of a pale supercilium and eye-ring. **JUVENILE** is similar to an adult, but the upper-parts are warmer brown and the rump is rather reddish-brown; the pale underparts are washed with buff. It is very similar to a juvenile Reed Warbler and extensive experience of both is required to separate them in the field. Note, however, the juvenile Marsh Warbler's pinkish (not grey) legs. **VOICE** – utters a sharp *tche* call. The song is rich and varied, the species being an amazing mimic whose repertoire includes both other European songsters as well as species from its African wintering grounds. HABITAT AND STATUS The Marsh Warbler is a rare summer visitor to the region. Several dozen singing males usually establish them-selves here each year, the majority in southern England – Kent and the West Midlands being hotspots. A further 20 or 30 are usually seen (or heard) briefly on migration in locations not suitable for nesting. Breeding birds favour areas of rank waterside vegetation, often along the margins of streams, where plants such as Stinging Nettles flourish. OBSERVATION TIPS Although there is plenty of suitable habitat in the region, the Marsh Warbler remains a stubbornly local bird. So, although individuals do occasionally set up territory outside their usual range, the best chances of finding the species are had from visiting south-east England in May. Spring migrants, newly arrived at coastal sites, occasionally sing on the day of their arrival; however, such birds typically stay for only a day or two before continuing their journey.

REED WARBLER *Acrocephalus scirpaceus* LENGTH 13–14cm

A familiar wetland warbler. The Reed Warbler has rather nondescript brown plumage, but fortunately its song is distinctive enough to allow identification even when the bird itself cannot be seen. The sexes are similar. **ADULT** has sandy-brown upperparts with a reddish-brown flush to the rump. The underparts are pale with a buffish flush to the flanks. The legs are dark and the bill is thin and needle-like. Note the hint of a pale supercilium and eye-ring. **JUVENILE** is similar to an adult, but the upperparts are warmer brown and the underparts are more intensely flushed with buff. **VOICE** – utters a sharp *tche* call. The song contains grating and chattering phrases, some of which are repeated two or three times, plus some elements of mimicry. HABITAT AND STATUS The Reed War-bler is a locally common summer visitor to the region. Several tens of thousands of pairs breed here, the majority confined to southern and eastern Britain. Within this range, habitat is the factor that deter-mines its precise occurrence because it is restricted to reedbeds. The woven, cup-shaped nest is attached to upright reed stems. The Reed Warbler is a favourite host for the Cuckoo. OBSERVATION TIPS Visit almost any large reedbed in southern or eastern England in May and you should hear Reed Warblers singing. Song-sters clamber up reed stems or occasionally use bushes from which to sing. On migration, Reed Warblers sometimes turn up in rather atypical habitats. Get to know the species well on its breeding territory where you can be sure of its identity before you embark on more challenging tests of your identification skills.

SEDGE WARBLER *Acrocephalus schoenobaenus* LENGTH 12–13cm

A well-marked and distinctive wetland warbler. The Sedge Warbler has a lively and distinctive song that is a useful aid to identification. The sexes are similar. **ADULT** has dark-streaked sandy-brown upperparts and pale underparts that are flushed orange-buff on the breast and flanks. The head is marked with a dark-streaked crown, a striking pale supercilium and a dark eye-stripe. **JUVENILE** is similar to an adult but faint streaking can usually be discerned on the breast. **VOICE** – utters a sharp *chek* alarm call. The song comprises a series of rasping and grating phrases interspersed with trills and whistles. HABITAT AND STATUS The Sedge Warbler is a widespread summer visitor and several hundred thousand pairs breed here; favoured habitats include rank marshy vegetation and patches of scrub on the fringes of reedbeds. The species also turns up at coastal migration hotspots. OBSERVATION TIPS The easiest way to discover this species' presence in an area is to become familiar with its song.

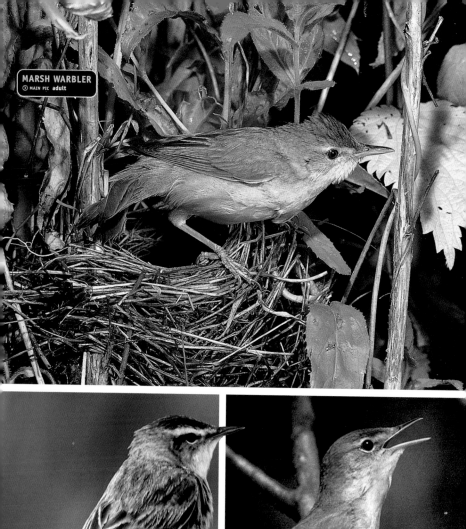

MARSH WARBLER
▷ MAIN PIC adult

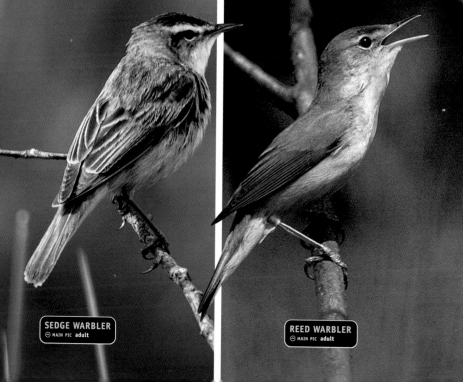

SEDGE WARBLER
⊙ MAIN PIC adult

REED WARBLER
⊙ MAIN PIC adult

GARDEN WARBLER *Sylvia borin* LENGTH 14–15cm

Although the Garden Warbler is visually rather nondescript, its lack of distinguishing plumage features is more than made up for by its attractive song. The sexes are similar. **ADULT** and **JUVENILE** have rather uniform grey-brown upperparts and pale underparts with a buffish wash, particularly on the breast and flanks. The legs are grey, the grey bill is relatively short and stubby, and note the subtle grey patch on the side of the neck; the latter is a useful identification feature, although it is not always easy to discern. **VOICE** – the call is a sharp *chek-chek*. The song is rich and warbling; it could be confused with that of a Blackcap but it is even more musical, some phrases having a thrush-like quality. HABITAT AND STATUS The Garden Warbler is a widespread and fairly common summer visitor to much of England and Wales; it occurs in southern Scotland but becomes scarce further north and in Ireland. A couple of hundred thousand pairs probably breed in the region as a whole, favouring areas of deciduous woodland and mature scrub. OBSERVATION TIPS Garden Warblers typically sing from dense cover and so it will take time before you get a good view of a songster. It is easy to confuse the song with that of a Blackcap, so be sure to check the identity of any mystery singing bird.

DARTFORD WARBLER *Sylvia undata* LENGTH 12–13cm

A perky little warbler that frequently cocks its tail up at an angle. Dartford Warblers occasionally perch conspicuously on prominent gorse stems, but more usually they are skulking and rather secretive. The sexes are dissimilar. **ADULT MALE** has blue-grey upperparts and reddish underparts with a white belly. Note the small white spots on the throat, the beady red eye and reddish eye-ring, and the pinkish-yellow legs. **ADULT FEMALE** is similar, but the colours are duller and the throat in particular is rather uniformly pale. **JUVENILE** is similar to an adult female but the colours are even more subdued, with the back and wings appearing brownish. **VOICE** – the distinctive *tchrr-tche* call is often the first clue to the species' presence in an area. The song is a rapid and scratchy warble. HABITAT AND STATUS The Dartford Warbler is a year-round resident in the region. Numbers vary from year to year (it suffers badly in cold winters), but 1,000 or more pairs probably breed in most seasons. The species is restricted to heathland in southern England, the majority being found in Hampshire, Dorset and Surrey. It favours sites where mature gorse bushes have attained a height of at least a metre. OBSERVATION TIPS Dartford Warblers are easiest to see in spring, when territorial males sing from conspicuous perches. The species is protected by law and must not be disturbed in the vicinity of the nest; observations must therefore be made from a respectful distance. In winter, young birds sometimes move to areas of coastal scrub.

BARRED WARBLER *Sylvia nisoria* LENGTH 15–16cm

A bulky and relatively large-billed warbler. Adults are easy to recognise but are seldom seen in the region. Juvenile Barred Warblers are more regularly encountered here, although their identification is problematic; in particular, overenthusiastic birdwatchers sometimes mistake a Garden Warbler for a Barred Warbler in this plumage. The sexes are dissimilar. **ADULT MALE** has blue-grey upperparts and pale underparts that are strongly marked with dark bars. Note the yellow eye, the pale wingbars and the pale tip to the tail. **ADULT FEMALE** is similar, but the eye is duller and the barring on the underparts is less intense. **JUVENILE** has grey-brown upperparts and pale underparts that are washed buff on the breast and flanks. Compared to a Garden Warbler, note the pale wingbars, the subtle crescent-shaped barring on the flanks and undertail coverts, the pale brown eye and the proportionately larger bill; the head shape also often appears more angular and less rounded. **VOICE** – utters a rattling *tchrrrr* alarm call. HABITAT AND STATUS The Barred Warbler is a rare passage migrant through the region, with most records occurring on the east coast, from Kent to the Shetland Islands; the vast majority of sightings are made in autumn. Some 100–150 birds might be found in a good year but, given the skulking nature of the species, many more must go undetected. Most migrant Barred Warblers are discovered near the coast in patches of dense vegetation (bramble patches are ideal). OBSERVATION TIPS Barred Warblers usually feed in cover, only occasionally showing well enough for identification to be confirmed.

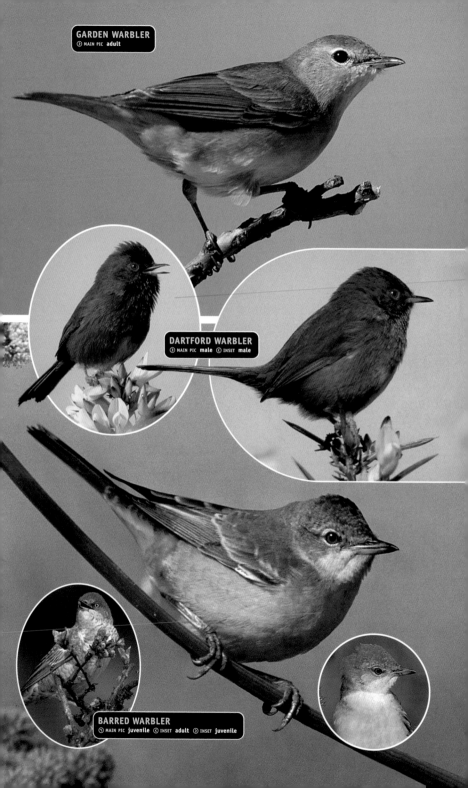

GARDEN WARBLER
⟩ MAIN PIC **adult**

DARTFORD WARBLER
⟩ MAIN PIC **male** ⟨ INSET **male**

BARRED WARBLER
⟩ MAIN PIC **juvenile** ⟨ INSET **adult** ⟩ INSET **juvenile**

LESSER WHITETHROAT *Sylvia curruca* LENGTH 12–13cm

A rather small and relatively short-tailed *Sylvia* warbler with retiring habits. Fortunately, the Lesser Whitethroat has a distinctive song that is easily recognisable. The sexes are similar. **ADULT** and **JUVENILE** have a blue-grey crown, a dark mask, and grey-brown on the back and wings. The underparts are pale, whitish on the throat but washed with pale buff on the flanks. The legs are dark, the grey bill is dark-tipped and the pale iris can sometimes be discerned. **VOICE** – utters a harsh *chek* alarm call. The song comprises a tuneless rattle, sung on one note, which is usually preceded by a short warbling phrase. HABITAT AND STATUS The Lesser Whitethroat is a summer visitor to the region. It is commonest in south and southeast England, and more than 50,000 pairs probably breed in the region as a whole. The species favours areas of mature scrub and hedgerows with dense ground cover. Consequently, it is seldom found in mature woodland or on open farmland. OBSERVATION TIP The distinctive song is by far the best clue to the species' presence in a given area; it can be heard from late April to early June. Lesser Whitethroats also turn up at coastal migration hotspots in spring and autumn.

WHITETHROAT *Sylvia communis* LENGTH 13–15cm

A familiar warbler of open country. Male Whitethroats in particular often perch conspicuously, allowing good views to be obtained. The sexes are separable with care. **ADULT MALE** has a blue-grey cap and face, a grey-brown back and rufous-brown edges to the feathers on the wings. The throat is strikingly white, while the remaining underparts are pale but suffused with pinkish-buff, especially on the breast. The legs are yellowish-brown and the bill is yellowish with a dark tip. The dark tail has white outer feathers. **ADULT FEMALE** and **JUVENILE** are similar to an adult male, but the cap and face are brownish and the pale underparts (apart from the white throat) are suffused with pale buff. **VOICE** – utters a harsh *check* alarm call. The song, which is sung from an exposed perch or in flight, is a rapid and scratchy warble. HABITAT AND STATUS The Whitethroat is a summer visitor to the region. It is a characteristic bird of scrub, overgrown hedgerows and heaths; gorse- and bramble-covered slopes by the sea are particularly favoured. More than 500,000 pairs probably breed in the region, and this widespread species is common except in the far north and in upland districts. OBSERVATION TIPS Visit almost any area of suitable scrub or heathland and you should have little difficulty seeing and hearing this species in the spring. It is also usually easy to find at coastal migration hotspots in spring and autumn.

BLACKCAP *Sylvia atricapilla* LENGTH 14–15cm

A well-marked and distinctive warbler. The Blackcap has an engaging and musical song, and is easy to identify in all plumages. The sexes are dissimilar. **ADULT MALE** has grey-brown upperparts and paler, dusky-grey underparts that are palest on the throat and undertail. Note the pale eye-ring and diagnostic black cap. **ADULT FEMALE** and **JUVENILE** have grey-brown upperparts, pale buffish-grey underparts (palest on the throat and undertail) and a reddish-chestnut cap; note also the pale eye-ring. **VOICE** – utters a sharp *tchek* alarm call. The song is a rich and musical warble; it is similar to that of the Garden Warbler, but lacks that species' thrush-like tones and usually contains jaunty, rather 'dancing' phrases. HABITAT AND STATUS Blackcaps can be found in a variety of habitats, from deciduous woodland with dense undergrowth to areas of scrub and mature gardens and parks. Several hundred thousand pairs probably nest in the region as a whole, and most, if not all, of these are summer visitors. Their departure in autumn often overlaps with the arrival of migrant Blackcaps from northern mainland Europe, and more than 1,000 of these birds probably remain in Britain and Ireland throughout the winter months. OBSERVATION TIPS Blackcaps are easy to find in most parts of the region during the breeding season, and territorial males are often in full song by mid-April. Overwintering birds are usually only encountered by chance, although some individuals become faithful visitors to garden bird-feeders.

!CONFUSION SPECIES!

MARSH TIT
Page 222

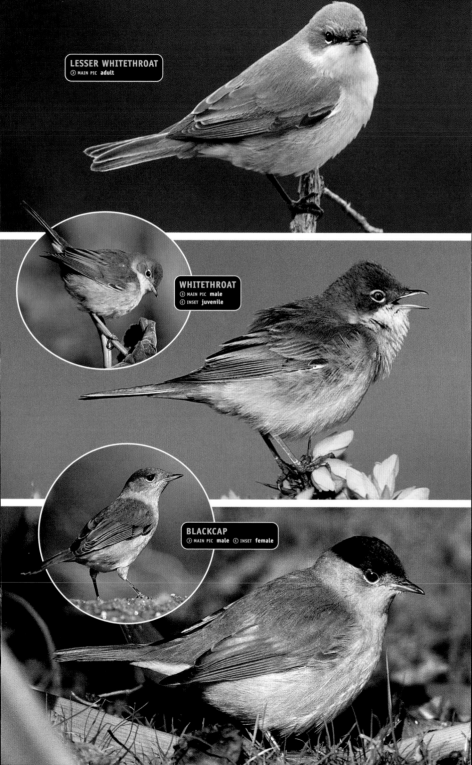

LESSER WHITETHROAT
⊙ MAIN PIC **adult**

WHITETHROAT
⊙ MAIN PIC **male**
⊙ INSET **juvenile**

BLACKCAP
⊙ MAIN PIC **male** ⊙ INSET **female**

CHIFFCHAFF *Phylloscopus collybita* LENGTH 11cm

A tiny warbler that is perhaps best known for its onomatopoeic song. The Chiffchaff is a restless feeder, constantly on the move among foliage in search of inverte-brates. The sexes are similar. **ADULT** and **JUVENILE** have grey-brown upperparts and pale, greyish underparts that are suffused with yellow-buff, particularly on the throat and breast. The bill is thin and needle-like while the legs are black; the latter feature is reliable in the separation of this species from the superficially similar Willow Warbler. **VOICE** – call is a soft *hueet*. The song is continually repeated *chiff-chaff* or *tsip-tsap*. It is heard most fre-quently in early spring, although migrants sometimes utter snatches of song in late summer. HABITAT AND STATUS The Chiffchaff is mainly a summer visitor to the region. Several hundred thousand pairs probably breed here and the species is commonest in the southern half of the region. During the breeding season, it is associated with mature deciduous wood-land with a dense understorey of shrubs. In autumn, most Chiffchaffs migrate south to wintering grounds in the Mediterranean region. However, several hundred birds remain here throughout the win-ter months, the majority of records coming from south and southwest England. OBSERVATION TIPS You should have little difficulty hearing and seeing Chiffchaffs in the spring, when males are singing. With silent birds, concentrate on observing the leg colour in order to be sure of the identity.

WILLOW WARBLER *Phylloscopus trochilus* LENGTH 11cm

Superficially very similar to the Chiffchaff but separable with care on plumage details and colour. The Willow Warbler also has subtly different habitat prefer-ences from its cousin. The sexes are similar. **ADULT** has olive-green upperparts, a yellow throat and whitish underparts; note the pale supercilium. Overall, a Willow Warbler's plumage is brighter than that of a Chiffchaff and the pri-mary feathers project further relative to the exposed length of the tertials. Note the pale supercilium and pinkish-yellow legs. **JUVENILE** is similar, but overall the plumage is paler and more yellow, particularly on the under-parts. **VOICE** – utters a *hueet* call, similar to that of a Chiffchaff. The song comprises a tinkling, descending phrase that ends in a slight flourish; it is repeated endlessly by newly arrived birds in spring. HABITAT AND STATUS The Willow War-bler is a widespread and common summer visitor, with several million birds present here during the summer months. It can be found in wooded or partly wooded habitats almost anywhere, although birch woodland and areas of willow scrub are particularly favoured. OBSERVATION TIPS The Willow Warbler's song is an almost ubiquitous sound in spring. As with the Chiffchaff, concentrate on the leg colour to be certain about the identification of silent birds.

WOOD WARBLER *Phylloscopus sibilatrix* LENGTH 11–12cm

A comparatively large *Phylloscopus* warbler. The Wood Warbler has rather bright plumage colours, a distinctive song and precise habitat requirements. The sexes are similar. **ADULT** and **JUVENILE** have olive-green upperparts, a bright yellow throat and supercilium, and clean white underparts. Note also the rather dark eye-stripe and the pale pink legs. **VOICE** – utters a sharp *tsip* call. The song, which has been likened to the noise made by a coin spinning on a plate, starts with ringing notes and accelerates into a silvery trill. HABITAT AND STATUS The Wood Warbler is a summer visitor to the region. It favours mature woodlands with tall trees, limited ground cover and often a closed canopy; Ses-sile Oak woodlands in the west and north of the region are particularly favoured, as are beech woods elsewhere. Several tens of thousands of pairs probably breed in the region, with Devon, Wales and northwest Scotland being the species' strongholds. OBSERVATION TIPS The easiest way to find a Wood Warbler is to visit an area of suitable woodland and listen for the song in the spring. Because of its rather distinctive appearance, even silent birds on migration can be readily identified.

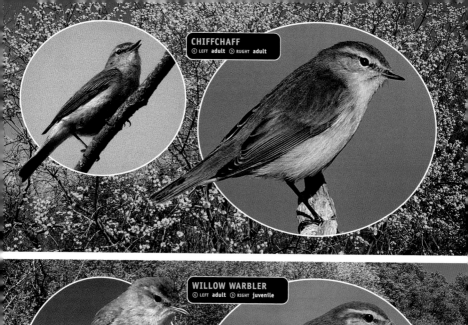

CHIFFCHAFF
ⓒ LEFT **adult** ⓓ RIGHT **adult**

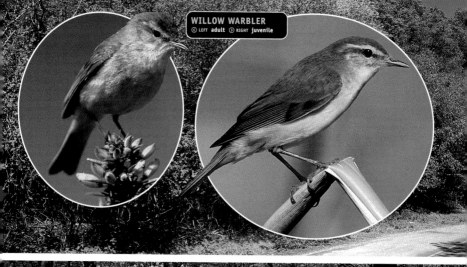

WILLOW WARBLER
ⓒ LEFT **adult** ⓓ RIGHT **juvenile**

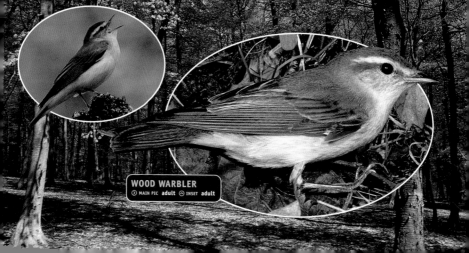

WOOD WARBLER
ⓓ MAIN PIC **adult** ⓔ INSET **adult**

MELODIOUS WARBLER *Hippolais polyglotta* LENGTH 12–13cm

A rather bulky warbler that recalls an outsized Willow Warbler. Like other members of the genus *Hippolais*, the Melodious Warbler differs from *Phylloscopus* warblers in having a proportionately large head, a peaked rather than rounded crown, a relatively large, broad-based bill and pale lores. The sexes are similar. **ADULT** has uniform olive-green upperparts with a brownish hue to the wings; the underparts are pale yellow, the colour being most intense on the throat and breast. The legs are greyish-brown and there is a pale eye-ring. Compared to an Icterine Warbler, the primaries project only a short distance beyond the tertials. **JUVENILE** is similar but the underparts are much paler; the very pale yellow suffusion is confined to the throat and breast. **VOICE** – utters a sharp *tchet* call. HABITAT AND STATUS The Melodious Warbler breeds as close to Britain as northwest France, but its status here is that of a scarce but regular passage migrant. In a good year, 40 or so may be observed in the region, with most being recorded in late summer and early autumn from the south and east coasts of England. Migrants are usually found in patches of coastal scrub. OBSERVATION TIPS Early September is a prime time to look for Melodious Warblers at coastal migration hotspots; most discoveries are made in the wake of south-easterly winds.

!CONFUSION SPECIES!

WILLIOW WARBLER
Page 212

1st-autumn

ICTERINE WARBLER *Hippolais icterina* LENGTH 12–13cm

Superficially very similar to a Melodious Warbler. However, the Icterine Warbler is separable with care from its cousin using subtle plumage characters as a guide. The sexes are similar. **ADULT** has greyish-green upperparts and pale yellow underparts. Compared to a Melodious Warbler, note the pale panel on the wings (created by pale feather fringes), the blue-grey legs and the long primary projections. **JUVENILE** is similar but the underparts are much paler. **VOICE** – utters a sharp *tchet* or rattling *tee-ter-tlueet*. HABITAT AND STATUS Although the Icterine Warbler breeds just across the English Channel in northern France, its status here is that of a scarce passage migrant. Between 50 and 100 are recorded in most years, mainly in autumn on the south and east coasts of England. OBSERVATION TIPS Following periods of southeasterly winds in September, the Icterine Warbler sometimes turns up at coastal migration hotspots; patches of scrub and bushes are ideal for the species. Beware of the potential for confusion with colourful juvenile Willow Warblers. Look for the pale wing panel and bluish legs in order to separate this species from the Melodious Warbler.

!CONFUSION SPECIES!

WILLIOW WARBLER
Page 212

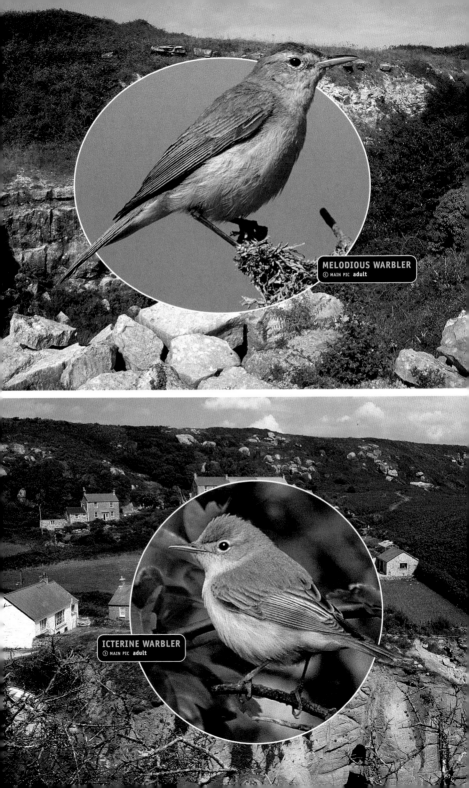

MELODIOUS WARBLER
© MAIN PIC **adult**

ICTERINE WARBLER
◎ MAIN PIC **adult**

YELLOW-BROWED WARBLER *Phylloscopus inornatus* LENGTH 9–10cm

A small but well-marked warbler. The Yellow-browed Warbler's size, appearance and restless, frenetic behaviour give it a passing resemblance to a Goldcrest; to add to the potential for confusion, it often associates with that species. The sexes are similar. **ALL BIRDS** have bright olive-green upperparts and whitish under-parts. Note, however, the narrow dark eye-stripe, the broad and long yellow supercilium, and the two pale yellow wingbars. The bill is needle-like and the legs are pinkish. **VOICE** – utters a distinctive, drawn-out *tsu-eet*, which can sound almost disyllabic. HABITAT AND STATUS The Yellow-browed Warbler is a scarce passage migrant in the region. In a good year, 200–300 birds are dis-covered, with most birds being recorded in late September and October; the east coast of England and the Scilly Isles are hotspots for the species. The occasional bird has been known to spend the winter here. OBSERVATION TIPS Yellow-browed Warblers are always a challenge to observe because they feed in the dense foliage of trees and shrubs and are constantly active; their small size means that they are often partly, or wholly, obscured for much of the time. The easiest way to locate one and follow its progress is to learn, and listen for, the distinctive call.

J
F
M
A
M
J
J
A
S
O
N
D

FIRECREST *Regulus ignicapillus* LENGTH 9–10cm

A tiny bird, and only marginally larger than a Goldcrest. The Firecrest has distinct, and diagnostic, markings and colours and, like its cousin, it is constantly active in search of small invertebrates. The sexes are dissimilar. **ADULT MALE** has yellow-green upperparts with two pale wingbars. The underparts are buffish-white but flushed golden-yellow on the sides of the neck. Note the dark eye-stripe, the broad white supercilium and the orange-centred black crown stripe. **ADULT FEMALE** is similar but the crown centre is yellow. **JUVENILE** is similar to an adult but it lacks the markings and colour on the crown. **VOICE** – utters a thin *tsuu-tsee-tsee* call. Its song comprises a series of thin, high-pitched notes and ends in a short trill. HABITAT AND STATUS The Firecrest is a rare breeding bird in the region, with perhaps 100 or more pairs present in most summers, mainly in southern England. At this time of year, it is found in areas of mature woodland, with territories often centred on large and mature conifer trees. Several hundred Firecrests also occur here in winter and are typically associated with coastal woodland and scrub, mainly in southern England. The species is also seen on autumn migration, sometimes locally in good numbers. OBSERVATION TIPS Consider yourself extremely fortunate if you discover a singing Firecrest during the summer months, because males typically sing from the very tops of tall trees and the song itself maybe almost inaudibly high-pitched for some observers. The species is perhaps easiest to see on migration in autumn; following easterly winds in October, north Norfolk, Portland Bill and the Scilly Isles usually host small numbers. Feeding birds sometimes come amazingly close to observers, but views typically last no more than a few seconds.

J
F
M
A
M
J
J
A
S
O
N
D

GOLDCREST *Regulus regulus* LENGTH 9cm

The smallest bird in the region. The Goldcrest bears a passing resemblance to a *Phylloscopus* warbler, but the proportionately large, white-ringed dark eye, the thick neck and the colourful crown stripe allow easy separation. Typically, it forages high in the tree canopy for invertebrates, sometimes hanging from twigs or hovering. The sexes are dissimilar. **ADULT MALE** has greenish upperparts with two pale wingbars, and yellow-buff underparts. Note the black-bordered orange crown and needle-like bill. **ADULT FEMALE** is similar but the crown colour is yellow. **JUVENILE** is similar to an adult but the crown markings and colours are absent. **VOICE** – utters a thin, high-pitched *tsee-tsee-tsee*. The song com-prises a series of high-pitched phrases and ends in a flourish. HABITAT AND STATUS The Goldcrest is a widespread and common woodland resident. It favours conifers, but the species can also be found in deciduous woodland and scrub, especially during the winter months. More than a million birds are probably present here during the breeding season; influxes of birds from north-ern mainland Europe may almost double the population during the winter months. OBSERVATION TIPS Being small and highly active, Goldcrests can be difficult to locate at first, so listen for their high-pitched calls. Winter Goldcrests often consort with mixed flocks of other woodland birds.

J
F
M
A
M
J
J
A
S
O
N
D

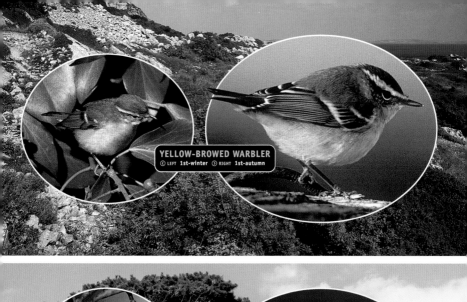

YELLOW-BROWED WARBLER
◁ LEFT **1st-winter** ▷ RIGHT **1st-autumn**

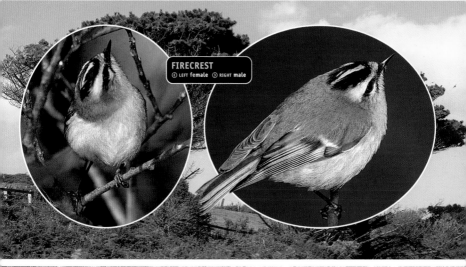

FIRECREST
◁ LEFT **female** ▷ RIGHT **male**

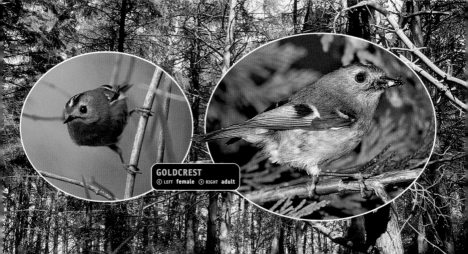

GOLDCREST
◁ LEFT **female** ▷ RIGHT **adult**

SPOTTED FLYCATCHER *Muscicapa striata* LENGTH 14cm

A charming and perky little bird that has rather undistinguished plumage. The Spotted Flycatcher can be recognised by its upright posture and habit of using regular perches from which to make insect-catching aerial sorties. The sexes are similar. **ADULT** has grey-brown upperparts, which are streaked on the crown, and pale greyish-white underparts that are heavily streaked on the breast. **JUVENILE** is similar, but there are pale spots on the back and dark spotting on the throat and breast. **VOICE** – utters a thin *tsee* call. The song is simple and includes thin, call-like notes. HABITAT AND STATUS The Spotted Fly-catcher is a widespread summer visitor to the region. During the breeding season, more than 100,000 pairs are probably present and the species is found in open woodland with sunny clearings, and in parks and gardens too; it often nests around habitation. Spotted Flycatchers are also seen in good numbers at coastal migration hotspots in spring and autumn. OBSERVATION TIPS The Spotted Flycatcher's thin call is not particularly striking, and consequently the species is surprisingly easy to overlook unless one of its insect-catching aerial sorties is observed.

PIED FLYCATCHER *Ficedula hypoleuca* LENGTH 12–13cm

A well-marked and distinctive insect-catching bird. The Pied Flycatcher has rather precise habitat requirements and it forages in the tree canopy. The sexes are dissimilar. **SUMMER ADULT MALE** has black upperparts, white underparts and a bold white band on the otherwise black wings; note also the small white patch at the base of the bill. **AUTUMN ADULT MALE, ADULT FEMALE (AT ALL TIMES)** and **FIRST-WINTER BIRDS** have a similar pattern to a summer adult male, but the black elements of the plumage are replaced by brown. **VOICE** – utters a sharp *tik* call repeatedly when alarmed. The song is sweet and ringing. HABITAT AND STATUS The Pied Flycatcher is a summer visitor to the region and several tens of thousands of birds are present each year. Hillsides and valleys cloaked in Sessile Oak woodland are particularly favoured and this habitat preference is reflect-ed in the species' westerly breeding range: it is most numerous in Devon, Wales and the Lake District. OBSERVATION TIPS Pied Flycatchers are easiest to locate on breeding territory in the spring, when the males are singing. After July, when the males usually become silent, the species can be hard to locate. It is also observed in small numbers at the coastal migration hotspots; it is easier to find in spring than in autumn. Pied Flycatchers are tree-hole-nesters and readily take to nest boxes. So if you live in a suit-ably wooded district within the species' British range, you stand a reasonable chance of attracting it to your garden by installing a few boxes of your own.

RED-BREASTED FLYCATCHER *Ficedula parva* LENGTH 11–12cm

A charming and compact little bird. The Red-breasted Flycatcher sometimes for-ages for insects unobtrusively in the tree canopy but often it will undertake aer-ial sorties from an exposed branch. It is usually encountered in first-winter plumage in the region. All birds can be recognised by the diagnostic and

!CONFUSION SPECIES!

striking white sides to the otherwise black tail. The sexes are dissimilar. **ADULT MALE** has a brown back, a blue-grey face, an orange-red throat and upper breast, and whitish under-parts; note also the relatively large, dark eye surrounded by a whitish eye-ring. **ADULT FEMALE** has entirely brown upperparts and whitish underparts, smudged buffish-brown on the sides of the

ROBIN
Page 190

breast. **FIRST-WINTER BIRD** is similar to an adult female, but the throat and breast are washed buffish and pale tips to the wing coverts can sometimes be discerned. **VOICE** – utters a rattling, Wren-like call. HABITAT AND STATUS The Red-breasted Flycatcher is a scarce but regular passage migrant through the region. Some 70 to 100 individuals may be recorded in a good year and almost all are seen in autumn. Passage migrants are usually discovered in patches of wood-land near the coast. OBSERVATION TIPS Look for this species after easterly and southeasterly winds in late September and early October. The Red-breasted Flycatcher is often first detected by its distinctive call, so try to become familiar with this by listening to recordings.

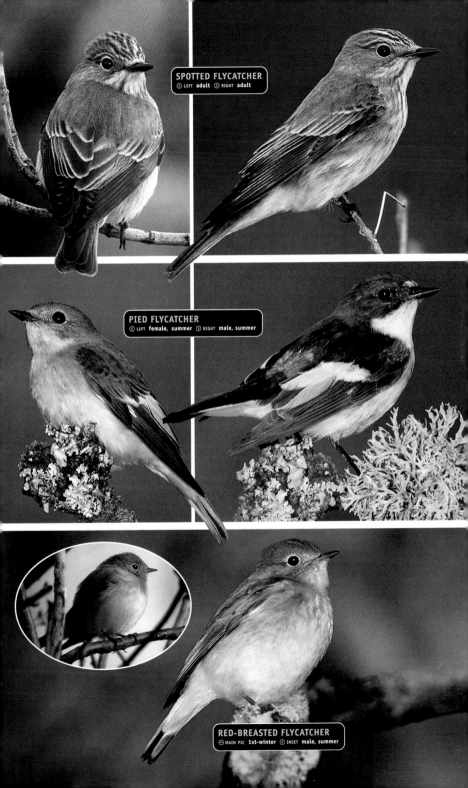

SPOTTED FLYCATCHER
Ⓒ LEFT **adult** Ⓢ RIGHT **adult**

PIED FLYCATCHER
Ⓒ LEFT **female, summer** Ⓢ RIGHT **male, summer**

RED-BREASTED FLYCATCHER
Ⓐ MAIN PIC **1st-winter** Ⓒ INSET **male, summer**

BLUE TIT *Parus caeruleus* LENGTH 11–12cm

A familiar and colourful little bird. In addition to its occurrence in the country-side at large, the Blue Tit is found in most gardens in the region, and is a frequent visitor to bird feeders in winter. The sexes are similar, although on average males have slightly brighter colours than females. **ADULT** has a greenish back, blue wings and yellow underparts. The mainly white head is demarcated by a dark blue collar, which connects to the dark eye-stripe and dark bib; the cap is blue. Note also the pale wingbar. The bill is short and stubby, and the legs are bluish. **JUVENILE** is similar to an adult but the colours are subdued, particularly the blue elements of the plumage. **VOICE** – call is a familiar, chattering *tser err-err-err*. The song contains whistling and trilling elements. HABITAT AND STATUS The Blue Tit is a common resident in the region and is widespread everywhere except on northern and smaller offshore islands; several million pairs are present here. Its favoured habitat is deciduous woodland, although the species is also frequently found in parks and gardens. Blue Tits nest in tree-holes and readily take to, and benefit from, the provision of nest boxes. OBSERVATION TIPS The Blue Tit must be one of the easiest birds to observe in Britain on a daily basis, because it is common in gardens and readily comes to peanuts and other food sources. Visit deciduous woodland in winter and you will find that Blue Tits are frequent members of the mixed flocks that roam widely in search of food at this time of year.

GREAT TIT *Parus major* LENGTH 14–15cm

A bold and familiar woodland bird that is also a frequent visitor to gardens. The Great Tit is well marked and colourful, with a song that is no less distinctive than its appearance. The sexes are separable with care. **ADULT MALE** has striking white cheeks that contrast markedly with the otherwise black head; the black throat continues as a thick black line down the centre of the breast on the otherwise yellow underparts. The upperparts are greenish and blue, but note the white wingbar. **ADULT FEMALE** is similar to an adult male but with a narrower black line on the breast. **JUVENILE** is marked with a plumage pattern that hints at that seen in the adult; overall, the colours are much duller and paler. **VOICE** – utters a harsh *tche-tche-tche* alarm call. The song is a striking variation on a *teecha-teecha-teecha* theme. HABITAT AND STATUS The Great Tit is widespread throughout much of the region, although absent from most northern Scottish islands. While it is scarce in upland districts, it is common elsewhere, particularly in wooded habitats; the population probably stands at several million pairs. In addition to areas of deciduous woodland, the Great Tit is also a frequent resident in gardens, in both rural and urban settings. The provision of peanut feeders and bird tables helps it through the winter months and, during the breeding season, it takes readily to nest boxes where the entrance hole is of a suitable size. In the countryside at large, the Great Tit nests in natural tree-holes. OBSERVATION TIPS You should have no difficulty in finding Great Tits almost anywhere in the region, in suitable habitats. On occasions, they can become remarkably bold when, for example, attracted into a garden with food; they tend to be a dominant force at peanut feeders, top of the pecking order among small birds.

male

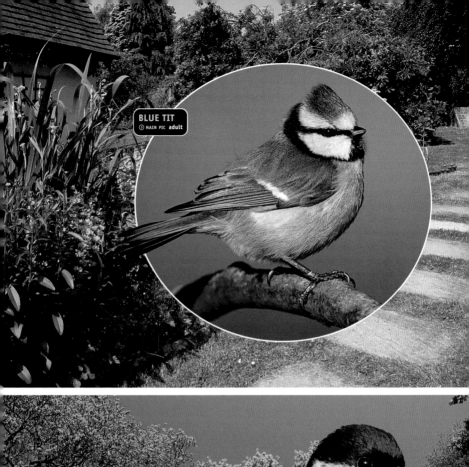

BLUE TIT
▶ MAIN PIC **adult**

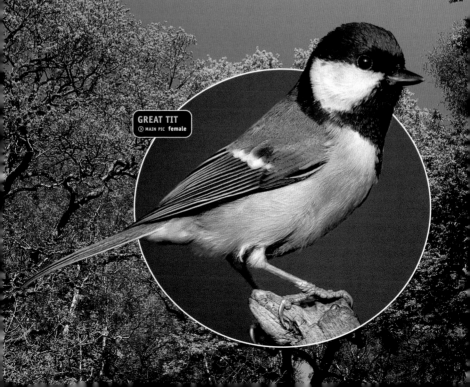

GREAT TIT
▶ MAIN PIC **female**

MARSH TIT *Parus palustris* LENGTH 12–13cm

A pugnacious little woodland bird. The Marsh Tit is superficially very similar to the Willow Tit and, for beginners, the two species can be frustratingly difficult to

!CONFUSION SPECIES!

BLACKCAP
Page 210

distinguish from one another. It is therefore worth spending time familiarising yourself with the subtle differences that exist in plumage and structure, as well as with the two birds' relatively distinctive and diagnostic calls. The sexes are similar. **ADULT** and **JUVENILE** have a black cap and bib; compared to a Willow Tit, the cap is glossy, not dull, and the bib is relatively small, although these features are not always easy to discern in the field. The cheeks are whitish, the upperparts are a uniform grey-brown and the underparts are pale grey-buff. The bill is short and the legs are bluish. **VOICE** – utters a loud *pitchoo* call. The song is a loud and repeated *chip-chip-chip*. HABITAT AND STATUS The Marsh Tit is a resident bird that is associated with deciduous woodland; where the tree cover is extensive and mature enough, it also occurs in parks and gardens. The species is commonest in the southern half of the region, and several tens of thousands of pairs probably occur here. The Marsh Tit nests in existing holes in trees and it will occasionally use nest boxes if these are placed in shady, out-of-the-way places. OBSERVATION TIPS To be certain of this species' identity (when compared to a Willow Tit) the best feature to use is the call, so try to become familiar with it by listening to recordings. Apart from the rather small size of the bib and the glossy black cap, another useful identification clue is the Marsh Tit's habit of visiting bird tables and feeders, and of foraging on the ground below for fallen leftovers.

adult

WILLOW TIT *Parus montanus* LENGTH 12–13cm

Superficially very similar to the Marsh Tit but separable with care. The voice is this species' most useful identification feature. Subtle structural and plumage differences also exist between the species, but these are not always as easy to discern in the field as you might suppose. The two species also favour subtly different habitats. The sexes are similar. **ADULT** and **JUVENILE** have a black cap and bib; compared to a Marsh Tit, the cap is dull, not shiny, and the bib is relatively large. The cheeks are whitish, the back is grey-brown and the underparts are pale grey-buff. Compared to a Marsh Tit,

!CONFUSION SPECIES!

COAL TIT
Page 224

the neck appears thicker (the species is often described as 'bull-necked') and a pale panel can usually be discerned on the otherwise grey-brown wings. The bill is short and the legs are bluish. **VOICE** – utters a distinctive and nasal *si-si tchay-thcay-tchay* call. The song is rather musical and warbling. HABITAT AND STATUS The Willow Tit is a resident species that is commonest in the southern half of Britain; it is entirely absent from Ireland. Although its distribution on a map is similar to that of the Marsh Tit, the two species are seldom found side by side in the same habitat. Willow Tits favour damp wooded areas – alder carr and waterside willow scrub are ideal; the species is sometimes also found in conifer plantations. Several tens of thousands of pairs probably breed in the region, and the Willow Tit excavates its own nest holes; the decaying stumps of birch trees are ideal for this purpose. OBSERVATION TIPS The Willow Tit seldom visits gardens and almost never comes to bird-feeders. Furthermore, its favoured habitats tend to be less well visited by casual birdwatchers, because they are usually damp underfoot and rather overgrown. Consequently, the Willow Tit is less familiar to many birdwatchers than its cousin the Marsh Tit. Although the species is by no means rare, you will need to make a special effort to see it. Try to become familiar with its distinctive call in advance of any visit.

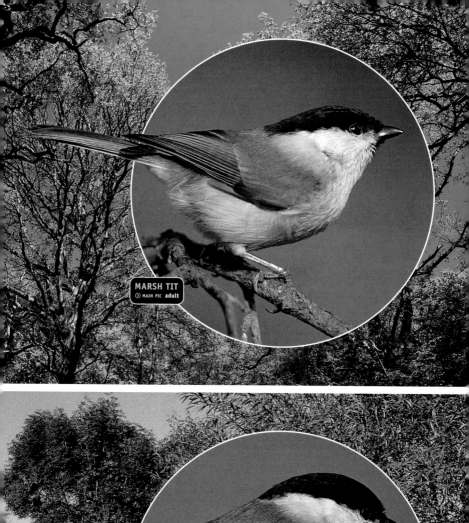

MARSH TIT
◉ MAIN PIC **adult**

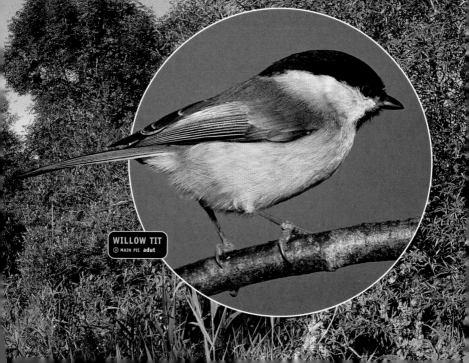

WILLOW TIT
◉ MAIN PIC **adut**

COAL TIT *Parus ater* LENGTH 11–12cm

A tiny and well-marked bird. The Coal Tit has rather warbler-like proportions and, indeed, it often feeds in a similarly energetic and acrobatic manner to this unrelated group of birds. The sexes are similar. **ADULT** has white cheeks and a white nape patch on an otherwise black head. The back and wings are bluish-grey and the underparts are pale pinkish-buff. Note the two white wingbars and the dark, needle-like bill. **JUVENILE** is similar to an adult, but the plumage colours and pattern are less striking. **VOICE** – utters a thin call. The song is a repeated *teechu-teechu-teechu*, higher pitched, more rapid and weaker than that of a Great Tit. HABITAT AND STATUS The Coal Tit is a resident bird, and many hundreds of thousands of pairs are probably present in the region. Although it is most numerous in conifer forests and plantations, it is also common in mixed and deciduous woodland. Consequently, it is widespread throughout the region as a whole, although absent from most northern islands. The species nests in tree-holes and it will occasionally use a nest box. Although Coal Tits are largely resident in the same general area throughout the year, the search for food does oblige them to become somewhat nomadic during the winter months. At such times, they often join mixed feeding flocks of other small woodland birds. OBSERVATION TIPS Singing Coal Tits are easy to locate during the breeding season. Through the winter months, look for them among roving mixed species flocks of woodland birds. They are also frequent visitors to garden bird-feeders in rural areas and, despite their small size and thin bills, they are adept at extracting peanut fragments and small seeds from them.

!CONFUSION SPECIES!

MARSH TIT
Page 222

WILLOW TIT
Page 222

adult

CRESTED TIT *Parus cristatus* LENGTH 11–12cm

A distinctive little bird that is easily recognised by its conspicuous crest. The Crested Tit has precise habitat requirements and a restricted range in the region. The sexes are similar. **ADULT** has a striking black-and-white barred crest. There is a black line through the eye and bordering the ear coverts on a head that is otherwise mainly whitish; in addition, note that the throat is black and a black collar demarcates the head. The upperparts are otherwise brown and the underparts are buffish-white. The bill is narrow and warbler-like. **JUVENILE** is similar to an adult but the plumage colours and markings are less striking. **VOICE** – utters a high trilling call. The song is a rapid, almost warbler-like series of call-like notes and whistles. HABITAT AND STATUS The Crested Tit is a resident species, but one with an extremely restricted range. It is found only in ancient Caledonian pine forests and mature and open Scots Pine plantations in the Highlands of Scotland. The presence of standing, dead tree stumps is vital because the species nests in holes excavated in decaying wood. Although the Crested Tit is not uncommon within its range, the population is unlikely to rise much above the current level (a thousand or so pairs) unless a dramatic spread of suitable habitat occurs, which is unlikely. Like many of its cousins, the Crested Tit feeds mainly on insects and other invertebrates during the summer months, but it supplements this diet with seeds at other times of the year. OBSERVATION TIPS Unless you visit precisely the right habitat in the correct part of Scotland, you stand virtually no chance of seeing a Crested Tit. The birds feed high in the trees for much of the time and are easiest to locate initially by listening for their calls. Sooner or later, one will descend to feed in lower branches and afford the observer less neck-breaking views.

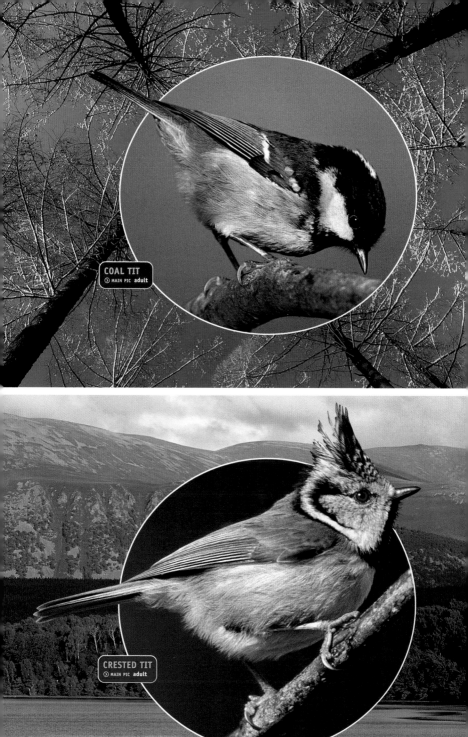

COAL TIT
> MAIN PIC **adult**

CRESTED TIT
> MAIN PIC **adult**

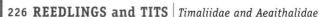

BEARDED REEDLING *Panurus biarmicus* LENGTH 16–17cm

A charming little reedbed specialist. The Bearded Reedling (sometimes referred to as the Bearded Tit) has a rather compact, rounded body and a proportionately very long tail. The distinctive call has earned the species the affectionate nickname of 'pinger' in birdwatching circles. It is adept at climbing reed stems, and the tail is moved constantly, in an agitated manner, by feeding birds. The flight is rather undulating on whirring wingbeats. Outside the breeding season, the Bearded Reedling is usually encountered in flocks of a dozen or more birds. The sexes are dissimilar. **ADULT MALE** is mainly sandy-brown on the body and tail, with black and white markings on the wings. The head is blue-grey, but note the conspicuous black 'moustaches' that flank the throat. At close range, note the beady yellow eye and yellow bill. **ADULT FEMALE** is similar, but the head is sandy-brown, palest on the throat. **JUVENILE** is similar to an adult female, but the back is blackish, the throat is whiter and the eye colour is darker and duller; the male has a yellow bill while that of the female is dark. **VOICE** – utters a diagnostic, high-pitched *ping* call. The soft, rasping song is seldom heard. HABITAT AND STATUS The Bearded Reedling is associated exclusively with extensive reedbeds. Several hundred pairs are probably present in the region in most years, although numbers are depleted in cold winters. The vast majority of records come from southern and eastern counties in England. Bearded Tits are essentially sedentary in their habits, and dispersal, when it does occur, is mainly in early autumn. OBSERVATION TIPS Given the nature of the Bearded Reedling's reedbed habitat, with its tall, swaying stems, the species is always going to be difficult to observe well. The presence of a flock is usually first detected by the distinctive call; subsequently, small parties of birds may be seen in flight as they move short distances from one feeding area to another. Bearded Reedlings are probably easiest to see well during the winter months, especially late in the season or when the weather is harsh. At such times, they sometimes feed close to the base of the reeds, often on the margins of open wetland areas close to paths or boardwalks. To stand a chance of seeing the species, visit a large reedbed nature reserve such as Stodmarsh NNR in Kent, or the RSPB reserves of Minsmere in Suffolk and Titchwell in Norfolk.

LONG-TAILED TIT *Aegithalos caudatus* LENGTH 14cm

A delightful and often confiding little bird with a proportionately very long tail and seemingly an almost spherical body. The Long-tailed Tit is often seen in rather animated flocks; it moves in a rather jerky fashion and has acrobatic feeding habits. In flight, which is rather undulating, birds resemble flying feather dusters. The sexes are similar. **ADULT** can look rather black and white at a distance. At close range, note the pinkish-chestnut patch on the scapulars and the whitish wing feather fringes on the otherwise black back and wings. The head is mainly whitish, with a broad, black band running above the eye; the underparts are whitish but suffused with pink on the flanks and belly. The bill is dark, short and stubby. **JUVENILE** is similar, but the pinkish elements of the plumage are absent and the face is more uniformly dark. **VOICE** – utters a rattling *tsrrr* contact call and a thin *tsee-tsee-tsee*. The soft, twittering song is easily overlooked. HABITAT AND STATUS The Long-tailed Tit is associated mainly with deciduous woodland, areas of scrub, particularly on heathland fringes, and mature hedgerows. Several hundred thousand birds are present in the region as a whole and, although the species is widespread, it is commonest in southern England and south Wales. During the breeding season, Long-tailed Tits construct beautiful and intricate ball-shaped nests, made from feathers and spiders' silk; and camouflaged with a coating of lichens; these are often built in the cover of dense, spiny bushes such as gorse, as a protection from predators. Outside the breeding season, Long-tailed Tits form flocks that are rather nomadic in their habits within the boundaries of a large winter territory. OBSERVATION TIPS Once you have learned the Long-tailed Tit's distinctive repertoire of calls, you will readily discover feeding flocks during the winter months. If you make a *pshhh* sound through pursed lips and clenched teeth, the birds will sometimes come close, in order to investigate the source of this strange sound.

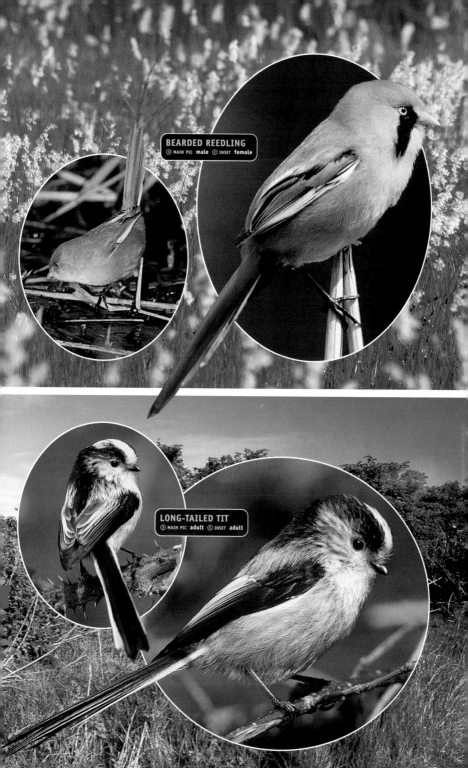

BEARDED REEDLING
MAIN PIC **male** · INSET **female**

LONG-TAILED TIT
MAIN PIC **adult** · INSET **adult**

TREECREEPER *Certhia familiaris* LENGTH 12–13cm

An unobtrusive little woodland bird. The Treecreeper is easily overlooked as it creeps up tree trunks, probing the bark for insects and spiders with its needle-like bill; overall, it can look almost mouse-like. The spiky tail is used as a support when climbing. Typically, the Treecreeper feeds by spiralling round and up a tree trunk, then dropping down to the base of an adjacent tree to repeat the process. The sexes are similar. **ADULT** and **JUVENILE** have streaked brown upperparts and silvery-white underparts that are subtly suffused with buff towards the rear of the flanks. Note the needle-like, downcurved bill, the grubby whitish supercilium and the broad, zigzag buffish barring on the wings. **VOICE** – utters a thin, high-pitched *tseert* call. The short song comprises a series of high-pitched notes and ends in a trill. HABITAT AND STATUS The Treecreeper is a rather sedentary resident. It favours deciduous and mixed woodlands although it is sometimes encountered in mature conifer plantations too. The species is widespread generally, although absent from, or scarce in, upland and northern districts. A few hundred thousand pairs probably breed in the region as a whole. Nests are usually constructed in crevices in and behind tree bark. OBSERVATION TIPS The easiest way of locating a Treecreeper in an area of woodland is to listen for its thin but distinctive call. The species is probably most readily observed during the winter months when the leaves have fallen from deciduous trees.

SHORT-TOED TREECREEPER *Certhia brachydactyla* LENGTH 12–13cm

The Short-toed Treecreeper is a widespread species in mainland Europe, but here it is restricted to the Channel Islands, where it replaces the Treecreeper. Subtle plumage and structural differences exist between the two closely related species. However, because you will almost certainly never see them side by side, these differences are rather academic. The Short-toed Treecreeper's most reliable identification feature in the field (apart from its distribution, of course) is its voice. The sexes are similar. **ADULT** and **JUVENILE** have streaked brown upperparts. The underparts are grubby white (darker than in the Treecreeper) with a strong buffish wash to the flanks. The needle-like bill is longer than a Treecreeper's and the hind claw is shorter. **VOICE** – utters a rather piercing *zeeht* call, quite unlike that of a Treecreeper. The song is shorter and more piercing than that of a Treecreeper. HABITAT AND STATUS The Short-toed Treecreeper favours valleys cloaked with deciduous woodland, and its occurrence in the region is restricted to the Channel Islands (mainly Jersey) where it is resident; the population numbers a few hundred pairs. OBSERVATION TIPS If you want to see this species, you will have to visit the Channel Islands. Like its more widespread cousin, the Short-toed Treecreeper can be rather unobtrusive, so listen for its penetrating call and song.

NUTHATCH *Sitta europaea* LENGTH 14cm

A rather dumpy and short-tailed woodland bird. The Nuthatch has the habit of descending tree trunks head-downwards in a jerky manner, a trait that, in the region, is unique to this species. The chisel-like bill is used to prise insects from tree bark and to hammer open acorns wedged into bark crevices. The sexes are rather similar. **ADULT** has blue-grey upperparts, a black eye-stripe, white cheeks and orange-buff underparts; on average, males have a more intense reddish-buff flush to the rear of the flanks than females. **JUVENILE** is similar, but the colours and eye-stripe are less intense. **VOICE** – utters an insistent and loud *zwiit*, which is repeated regularly if the bird is agitated. The song typically comprises a series of whistling notes. HABITAT AND STATUS The Nuthatch favours deciduous and mixed woodland, but it also occurs in gardens and parks where mature trees are present. More than 100,000 pairs probably breed in the region as a whole, although the species is commonest in southern and central England, and in Wales; its range only just extends to southern Scotland and Nuthatches are absent from Ireland. Nests are made in tree-holes, and mud is typically plastered around the entrance to reduce the size of the hole. OBSERVATION TIPS The Nuthatch is a vocal species and its distinctive call is probably the best clue to its presence in woodland. Within the species' range, it occurs in most suitable areas of woodland. It is also a frequent visitor to garden bird-feeders in rural areas.

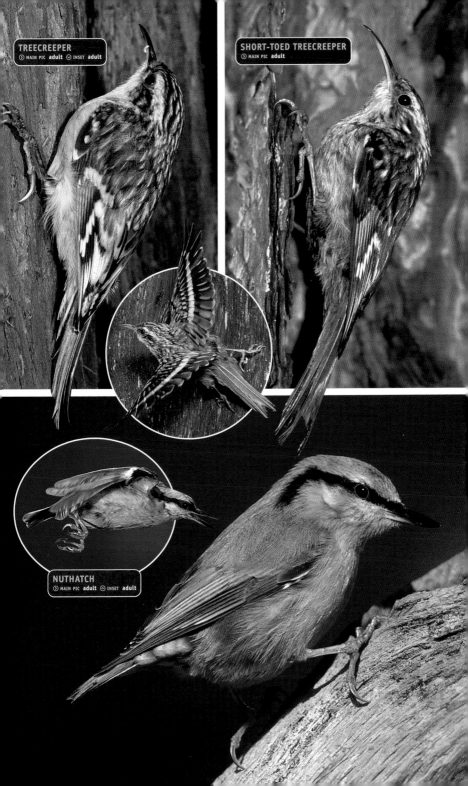

TREECREEPER
◇ MAIN PIC **adult** ◇ INSET **adult**

SHORT-TOED TREECREEPER
◇ MAIN PIC **adult**

NUTHATCH
◇ MAIN PIC **adult** ◇ INSET **adult**

RED-BACKED SHRIKE *Lanius collurio* LENGTH 16–18cm

A bold and distinctive passerine. Red-backed Shrikes often perch on exposed dead twigs or barbed-wire fences for extended periods, scanning for insects and other prey; these are dispatched using the powerful, hook-tipped bill. The sexes are dissimilar. **ADULT MALE** has a reddish-brown back, a blue-grey cap and nape, and whitish underparts that are flushed pink on the breast and flanks. Note the broad black band through the eye; the grey rump and the white sides to the base of the tail are most striking in flight. **ADULT FEMALE** is similar, but the colours are more muted, the dark eye patch is fainter and the underparts are adorned with dark vermiculations. **JUVENILE** has barred brown upperparts and pale underparts that are strongly marked with dark vermiculations; the dark eye patch is most prominent behind the eye. **VOICE** – utters a harsh *tchek* call when agitated. HABITAT AND STATUS A century or so ago, the Red-backed Shrike was a common and widespread summer visitor to the region. Today, sadly, it is all but extinct as a breeding bird and the majority of records relate to passage migrants seen in spring and autumn; 200 or so are recorded in a good year. Migrants are usually discovered in areas of scrub and hedgerows near the coast. OBSERVATION TIPS The Red-backed Shrike is easiest to discover in the autumn, following periods of southeasterly winds, and most records relate to juvenile birds. The species also occurs sparingly in the spring too.

GREAT GREY SHRIKE *Lanius excubitor* LENGTH 22–26cm

A bulky and impressive passerine. The Great Grey Shrike has predatory feeding habits, as you might guess from its powerful, hook-tipped bill. It spends much of the time perched on the tops of bushes or wires. However, it can also be remarkably elusive for such a comparatively large and well-marked species. The sexes are similar. **ADULT** has a grey cap and back, white underparts and a broad black mask through the eye; note the white patch on the wings at the base of the primaries, and the white sides to the long, black tail. **JUVENILE** (unlikely to be encountered in the region) is similar, but it has faint barring on the underparts and the black elements of the plumage are washed out. **VOICE** – utters a harsh, trilling call. HABITAT AND STATUS The Great Grey Shrike is a winter visitor to the region from breeding grounds in northern mainland Europe. In a good year, 100 or so may be observed. Most records come from heaths and open country with scattered bushes and wires. OBSERVATION TIPS The Great Grey Shrike is an almost annual visitor to the New Forest and on some of the larger Surrey heaths during the winter months; a scattering of records also occur elsewhere in the region.

WOODCHAT SHRIKE *Lanius senator* LENGTH 17–19cm

A bulky and well-marked bird. The Woodchat Shrike often perches on barbed-wire fences as well as low bushes, using these as lookouts. The sexes are separable with care. **ADULT MALE** has a chestnut cap and nape, a broad black mask running from the forecrown through the eye, and white underparts that are flushed faintly with peachy-buff on the flanks and breast. Note also the striking white patch on the scapulars, the white patch at the base of the primaries and the buffish-white patch at the base of the bill. In flight, the pale rump and white-margined black tail are obvious. **ADULT FEMALE** is similar, but the black and chestnut elements of the plumage are less intense, the white patch at the base of the bill is more extensive and there is faint barring on the underparts. **JUVENILE** has scaly grey-brown upperparts and paler underparts with faint vermiculations; note also the pale patch on the scapulars. **VOICE** – utters a harsh, trilling call when agitated. HABITAT AND STATUS The Woodchat Shrike is a scarce visitor to the region, with most records at migration times; 15 or 20 are recorded in a good year. In spring, adult birds appear here, while in late summer and autumn, dispersing juvenile birds sometimes turn up in coastal areas. Visiting Woodchat Shrikes favour areas of coastal scrub. OBSERVATION TIPS Look for Woodchat Shrikes during and after periods of warm, southerly and southeasterly winds. Most birds are found near the coast, and typically they perch prominently on wires and bushes. Birds that appear in spring and early summer tend to stay for a few days, to the delight of many birdwatchers.

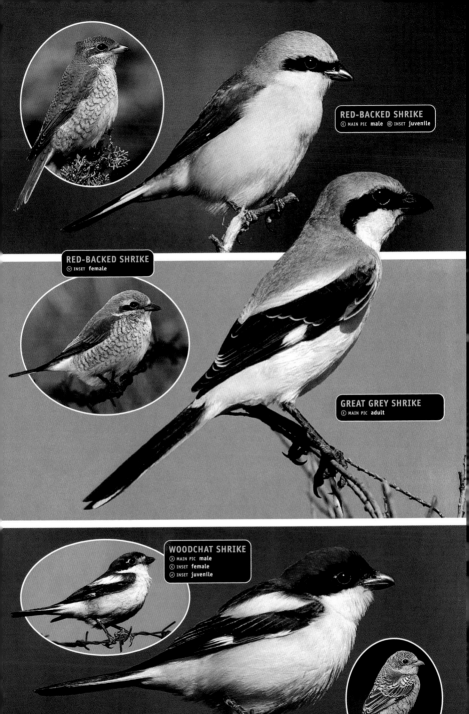

RED-BACKED SHRIKE
ⓒ MAIN PIC **male** Ⓡ INSET **juvenile**

RED-BACKED SHRIKE
ⓒ INSET **female**

GREAT GREY SHRIKE
ⓒ MAIN PIC **adult**

WOODCHAT SHRIKE
ⓐ MAIN PIC **male**
ⓒ INSET **female**
ⓓ INSET **juvenile**

STARLING *Sturnus vulgaris* LENGTH 20–22cm

A familiar bird of urban and rural areas. The Starling is extremely vocal and a proficient mimic of both animate and inanimate sounds. It forms sizeable flocks outside the breeding season. The Starling walks with a characteristic swagger, the flight is rather undulating and the wings look pointed and triangular in outline. The sexes are separable with care in summer. **ADULT SUMMER MALE** has essentially dark plumage with a green and violet iridescence discernible in good light. The legs are reddish and the bill is yellow with a blue base to the lower mandible. **ADULT SUMMER FEMALE** is similar, but a few pale spots can be seen on the underparts and the base of the lower mandible is pale yellow. **WINTER ADULT (BOTH SEXES)** has numerous white spots adorning the dark plumage. The bill is dark. **JUVENILE** is grey-brown, palest on the throat, and with a dark bill. **FIRST-WINTER BIRD** retains the grey-brown head and neck but acquires white-spotted dark plumage elsewhere. **VOICE** – has a varied repertoire of clicks and whistles. The song includes elements of mimicry of other birds, as well as man-made sounds such as car alarms and phone tones. HABITAT AND STATUS The Starling is widespread and abundant throughout the year. It nests in holes and cavities, including roofs, as well as more natural locations such as tree-holes. It feeds in areas of short grass, and during the winter months flocks that are hundreds, if not thousands, strong will descend on playing fields and grassland; winter flocks roost in woodlands, or on urban buildings. A million or more pairs of Starlings nest in the region, but outside the breeding season influxes of birds from mainland Europe boost the numbers significantly: tens of millions of birds may be present midwinter. OBSERVATION TIPS The Starling is one of the most widespread and familiar birds in the region. You should have no difficulty finding and identifying it.

ROSE-COLOURED STARLING *Sturnus roseus* LENGTH 20–22cm

A distinctive relative of the Starling that is separable from that species at all times. Vagrants to the region often associate with Starling flocks and are not infrequently seen in gardens. The sexes are similar. **ADULT** is unmistakable, the bright pinkish back and underparts contrasting with the otherwise dark head, neck, wings and tail. At close range, a metallic sheen can be seen on the dark elements of the plumage; note also the shaggy crest on the head. The bill and legs are pinkish. **FIRST-WINTER BIRD** has a similar plumage pattern but the pink elements are buffish-grey. **JUVENILE** has buffish-grey plumage and a yellow bill. **VOICE** – utters various Starling-like squawking and chattering calls. HABITAT AND STATUS The Rose-coloured Starling is an occasional visitor to the region in varying numbers. In most years there might be 10 or 15 records, but once in a while more significant influxes occur. Most birds are first discovered in spring or early winter. Fortunately, if an individual finds a good feeding area, and a flock of Starlings with which to associate, the chances are it will stay for a few weeks, or even months. OBSERVATION TIPS You will have no difficulty identifying an adult Rose-coloured Starling, but grubby first-winter birds can be difficult to pick out among a winter flock of Starlings. To identify a juvenile bird, concentrate on the plumage colour and, more significantly, the colour of the bill.

GOLDEN ORIOLE *Oriolus oriolus* LENGTH 22–24cm

A stunning and unmistakably colourful bird. Sightings of the Golden Oriole are invariably brief and the species is heard far more frequently than it is seen. The sexes are dissimilar. **ADULT MALE** has mainly bright yellow plumage, with black on the wings and tail. Note the red bill. **ADULT FEMALE** has a similar plumage pattern, but the yellow colour is less intense and the underparts are pale and faintly streaked. **JUVENILE** is similar to an adult female, but the upperparts are green and the underparts are more heavily streaked. **VOICE** – the song is a rich, fluty and tropical-sounding *wee-lo-weeow*, and variations on the theme. Various harsh calls, some rather Jay- or cat-like, are also uttered. HABITAT AND STATUS The Golden Oriole is a scarce summer visitor to the region. A few dozen pairs breed annually, mainly in mature poplar plantations in East Anglia, and 100 or more passage migrants are recorded in most years. OBSERVATION TIPS Despite its colourful appearance, the Golden Oriole can be tricky to observe. Listen for a snatch of the unmistakable song. You will have to put in hours of patient observation if you want to get more than just a view of a bird flying from one tree to another.

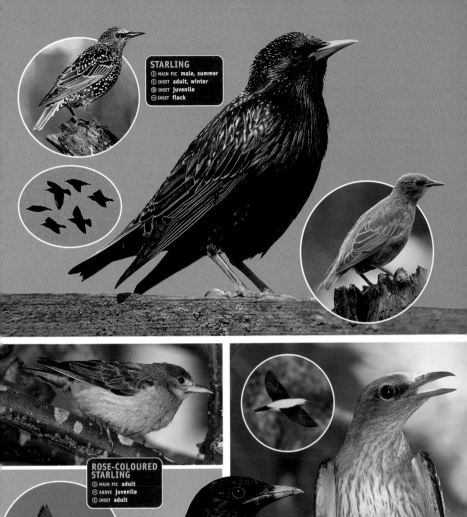

STARLING
- ▷ MAIN PIC **male, summer**
- ◁ INSET **adult, winter**
- ⊗ INSET **juvenile**
- ⊙ INSET **flock**

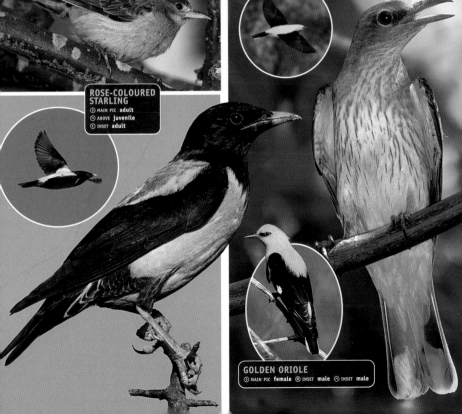

ROSE-COLOURED STARLING
- ▷ MAIN PIC **adult**
- △ ABOVE **juvenile**
- ◁ INSET **adult**

GOLDEN ORIOLE
- ▷ MAIN PIC **female** ⊗ INSET **male** △ INSET **male**

MAGPIE *Pica pica* LENGTH 45–50cm

A familiar and unmistakable black and white, long-tailed bird. The nest is a large, twiggy and long-lasting structure, usually built among dense tree branches. Outside the breeding season, the species is often seen in small groups. The Magpie is an opportunistic omnivore, its diet including fruit, insects, animal road kills and the eggs and young of birds; it will also happily scavenge discarded leftover food scraps in towns. The sexes are similar. **ADULT** and **JUVENILE** have mainly black plumage with a contrasting white belly and a white patch on the closed wing. At close range, and in good light, a bluish-green sheen can be seen on the wings and tail. In flight, the outer half of the short, rounded wings appears strikingly white. **VOICE** – utters a loud, rattling alarm call. HABITAT AND STATUS The Magpie is a widespread resident in the region, although it is scarce in, or absent from, upland and northern districts. The species is found in a wide variety of wooded and lightly wooded habitats, the common requirements being a wide range of potential food sources to suit its omnivorous diet, and dense shrubs and trees for nesting. Magpies are surprisingly common in urban areas. There are several hundred thousand pairs in the region as a whole. OBSERVATION TIPS You will have no difficulty finding Magpies in most lowland parts of the region. As a sign of the times, the species is probably easiest to observe beside roads, scavenging at the corpses of animal road kills.

JAY *Garrulus glandarius* LENGTH 33–35cm

A colourful and distinctive bird, although its wary nature ensures that its attractive plumage is seldom viewed to best effect and the raucous calls are heard more often than the bird itself is seen. Often the only feature that is noticed is the white rump, emphasised by the black tail, and seen as the bird flies away. Each Jay buries thousands of acorns every autumn as a food supply for the rest of the year. The sexes are similar. **ADULT** and **JUVENILE** have mainly pinkish-buff body plumage, except for a white rump, undertail and lower belly. The wings are marked with a black and white pattern and by a chequerboard patch of blue, black and white. Note also the black 'moustache', the streaked pale forecrown and the pale eye. **VOICE** – utters a loud and harsh scream. HABITAT AND STATUS The Jay is essentially a woodland bird whose precise distribution is linked to the occurrence of mature oak trees. Acorns (both freshly ripened as well as stored) are an important part of the diet throughout year but, during the summer months, the species is more of an opportunistic omnivore, taking invertebrates as well as the eggs and young of other birds. There are probably more than 150,000 pairs of Jays in the region. For the most part the birds are rather sedentary, but if the acorn crop fails then widespread dispersal takes place and influxes from mainland Europe may also occur. OBSERVATION TIPS For most of the year, Jays are difficult to observe well, given their rather shy nature and the fact that they are still persecuted in many parts. The species is often easiest to see in October, when birds are busy searching for acorns and burying them in caches, often some distance from their tree of origin.

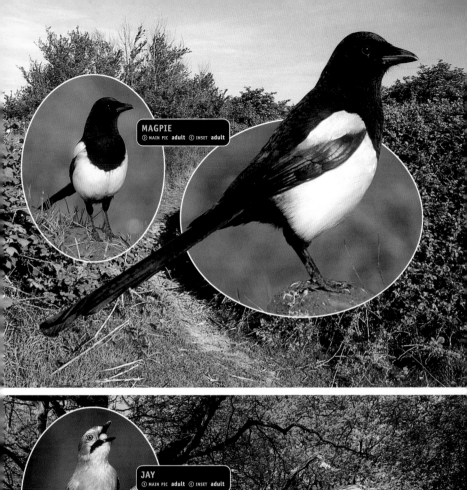

MAGPIE
MAIN PIC adult · INSET adult

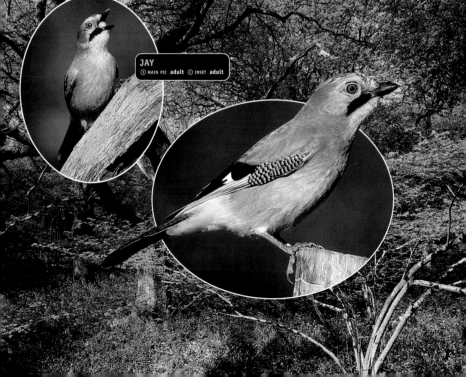

JAY
MAIN PIC adult · INSET adult

JACKDAW *Corvus monedula* LENGTH 31–34cm

The most widespread and familiar small corvid. The Jackdaw is an engaging and opportunistic feeder, quick to exploit any new food source. It walks with a characteristic swagger and is aerobatic in flight. Outside the breeding season, it forms flocks. The sexes are similar. **ADULT** has mainly smoky-grey plumage that is darkest on the wings and crown; at close range, note the pale blue-grey eye and the grey nape. **JUVENILE** is similar, although the plumage often reveals a brownish tinge and the eye is darker and duller. **VOICE –** utters a characteristic *chack* call. HABITAT AND STATUS The Jackdaw is a widespread and common resident in the region. It seems equally at home on farmland, on sea cliffs and in towns and villages. Apart from the availability nearby of areas of short vegetation for feeding, the common factor is the presence of holes and cavities for nesting: caves, rock crevices, old buildings and even chimneys are frequently used. Several hundreds of thousands of pairs of Jackdaws breed in the region. Outside the breeding season, influxes of birds from mainland Europe boost the numbers and more than a million birds are probably present during the winter months. OBSERVATION TIPS You should have little difficulty finding and identifying Jackdaws in the region, whatever the time of year. The species is probably most impressive when seen in aerobatic flocks on sea cliffs in the west of the region. In some urban areas where food scraps are in plentiful supply, Jackdaws have become remarkably bold and inquisitive.

juvenile

RAVEN *Corvus corax* LENGTH 55–65cm

An impressive bird, and the largest passerine in the region. The Raven is appreciably larger than a Carrion Crow or Rook, and it is easily recognised on the ground by its massive bill and the shaggy throat, which appears most ruffled when the bird is calling. Being relatively wary of people, it is most often seen in flight; a distant bird bears a passing resemblance to a Buzzard, but it can be recognised by the long, thick neck and the wedge-shaped tail. Ravens are incredibly aerobatic, tumbling and rolling in mid-air; the species is often seen in pairs. The sexes are similar. **ADULT** and **JUVENILE** have mainly black plumage, but in good light an oily or metallic sheen is discernible. **VOICE –** utters a loud and deep *cronk* call. HABITAT AND STATUS There is a distinct westerly bias to the Raven's current distribution in the region, which, in part, reflects a history of persecution of the species in Britain. However, the relatively sanitised nature of farmland in the lowland eastern half of the region is also significant: carrion, which forms the basis of this scavenging species' diet, is in short supply here. Today, Ravens are resident in areas of rolling, wooded countryside, desolate upland areas, and rugged and windswept coasts. Several thousand pairs are present in the region as a whole. OBSERVATION TIPS The Raven is relatively easy to find if you visit suitably remote and rugged districts within the species' westerly range in the region. Most stretches of sea cliff from Cornwall to the west coast of Scotland, and in the west of Ireland, have resident pairs and the birds usually announce their presence with loud, resonant calls. The flight silhouette is distinctive and diagnostic.

!CONFUSION SPECIES!

CARRION CROW
Page 238

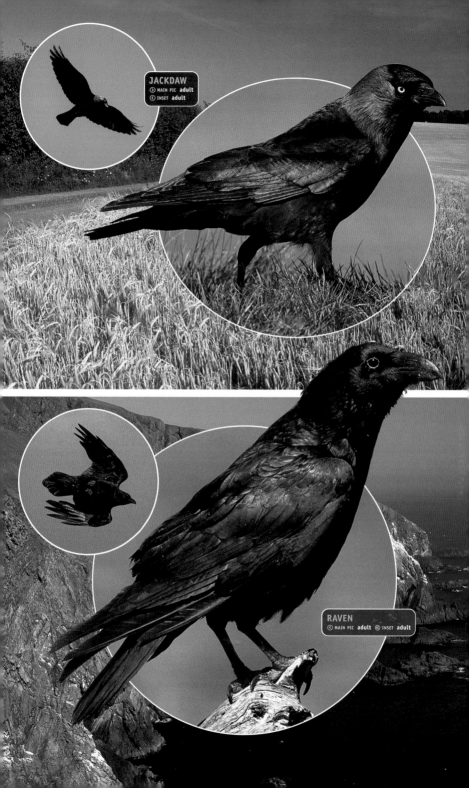

JACKDAW
MAIN PIC **adult**
INSET **adult**

RAVEN
MAIN PIC **adult** INSET **adult**

CARRION CROW *Corvus corone corone* LENGTH 45–50cm

The archetypal member of the crow family. Confusingly, the species *Corvus corone* is represented in our region by two, geographically separate subspecies with entirely distinct plumages. Carrion and Hooded Crows are, however, structurally identical and are not considered to be separate species because, where the two races overlap, they interbreed and produce fertile offspring. The behaviour of both subspecies is similar and typically they are extremely wary birds, and justifiably so since they are widely persecuted. Carrion Crows are opportunistic feeders, taking both carrion and live prey; they will also scavenge quite happily at rubbish tips and in car parks. Typically, the Carrion Crow it is far less gregarious than either the Rook or Jackdaw, and it is typically encountered

!CONFUSION SPECIES!

JUVENILE ROOK
Page 240

singly or in pairs, rather than in flocks. The sexes are similar. **ADULT** and **JUVENILE** have all-black, glossy plumage and a stout bill. **VOICE** – utters a harsh, slightly slurred *creeaa-creeaa-creeaa* call. HABITAT AND STATUS The Carrion Crow is found throughout England and Wales but in Scotland it is largely confined to the south and east of an imaginary line drawn roughly from the Firth of Clyde to the Dornoch Firth. It is replaced to the north and west by the Hooded Crow and a zone of hybridisation between the two subspecies occurs along, and either side of, the Scottish transition line. The Carrion Crow has an extremely limited presence in Ireland, where it is confined to the north-east coast, and it is also found on the Isle of Man. Both Carrion and Hooded Crows occur in a wide variety of habitats, from farmland and seashores to moorland and relatively urban locations. The nest is usually constructed in a tree and even an isolated specimen will suffice. Several hundred thousand pairs of both Carrion and Hooded Crows occur in the region as a whole. OBSERVATION TIPS You should have little difficulty seeing a Carrion Crow but there is potential for confusing one with a juvenile Rook, which lacks the adult's bare, whitish skin at the base of the bill; although the bill is longer in a Rook than in a Carrion Crow this is not always apparent in the field.

HOODED CROW *Corvus corone cornix* LENGTH 43–50cm

The northern and western counterpart, in our region, of the Carrion Crow, to which it is very closely related. It is an arch opportunist and scavenger but it will also take live prey, including the eggs and young of birds. Typically the nest is constructed in a tree. The sexes are similar. **ADULT** and **JUVENILE** have mainly grubby grey body plumage with black wings and tail; the head is black and the black throat and centre of the upper breast form a bib. The bill is stout and dark and the legs are black. **VOICE** – utters a harsh, slightly slurred *creeaa-creeaa-creeaa* call, essentially identical to that of a Carrion Crow. HABITAT AND STATUS The Hooded Crow occurs only very occasionally in England and Wales and its true stronghold in Scotland lies north and west of an imaginary line drawn roughly from the Firth of Clyde to the Dornoch Firth. It also occurs throughout Ireland and on the Isle of Man, where it either predominates or replaces entirely the Carrion Crow. Like its cousin, the Hooded Crow can be found in a wide range of habitats, from moorland and mountains to marshes and agricultural land. During the winter months, birds are frequently seen scavenging on the shoreline. Within the Hooded Crow's well-defined range in our region, several hundred thousand birds are probably present. OBSERVATION TIPS You should have little difficulty finding a Hooded Crow, so long as you visit its regional strongholds; do not expect to encounter this subspecies outside its relatively well-defined range. The Hooded Crow presents few identification problems.

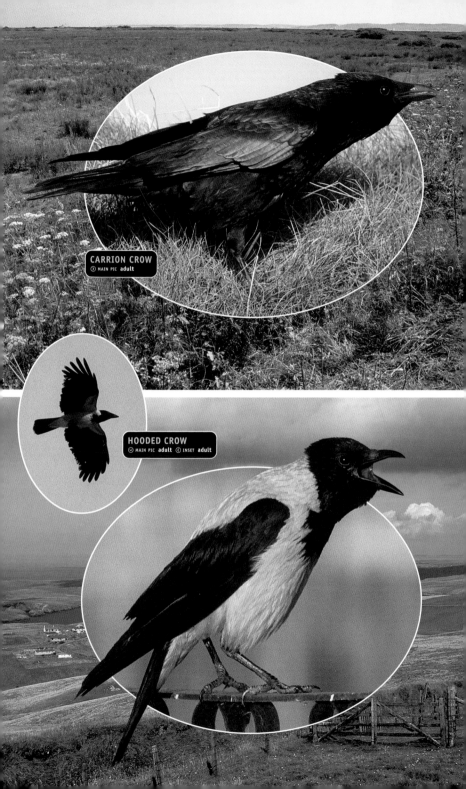

CARRION CROW
⊕ MAIN PIC **adult**

HOODED CROW
⊙ MAIN PIC **adult** ⊙ INSET **adult**

CHOUGH *Pyrrhocorax pyrrhocorax* LENGTH 38–40cm

An all-dark, Jackdaw-sized corvid. The Chough is easily recognised by its long, down-curved, red bill, which is used to probe the ground for invertebrates. Outside the breeding season, the species forms flocks and in flight it can be recognised by its superb aerobatic skills, by its broad, 'fingered' wingtips and by its frequently uttered calls. The sexes are similar. **ADULT** has glossy, black plumage. The legs are reddish-pink and the downcurved bill is bright red. **JUVENILE** is similar, but the leg colour is duller and the bill is dull yellow. **VOICE** – utters a distinctive *chyah* call; typically, this is accompanied by the caller

!CONFUSION SPECIES!

JACKDAW
Page 236

flexing and flicking its wings in a seemingly agitated manner. HABITAT AND STATUS The Chough is a scarce resident in the region, with an extremely restricted habitat preference. In Britain and Ireland it is associated almost exclusively with the coast, favouring sea cliffs with short turf for feeding and caves and cavities for nesting. It is found around the south and west coasts of Ireland, in west Wales, on the Isle of Man and on a few Hebridean islands, notably Islay. Several hundred pairs probably breed in the region as a whole. The species has also recently recolonised one of its former haunts, Cornwall. OBSERVATION TIPS Choughs are probably easiest to observe outside the breeding season, when they gather in sizeable and typically noisy flocks; sometimes birds will feed on beach strandlines. You are unlikely to come across the species outside its rather restricted range and away from coastal grassland. Listen out for its distinctive call.

ROOK *Corvus frugilegus* LENGTH 45–48cm

A familiar farmland bird. The Rook is often seen in large flocks feeding in fields or gathering at colonial tree-nest sites, which are noisy and active from early March to May. It is an omnivore, but the bulk of its diet comprises invertebrates, notably earthworms and leatherjackets, and seeds and roots, which

!CONFUSION SPECIES!

JUVENILE may
be confused with
CARRION CROW
Page 238

it probes from the ground. The sexes are similar. **ADULT** has all-black plumage that reveals a reddish-purple iridescence at certain angles. The bill is long, narrow and rather pointed; note also the bare patch of whitish skin at the base. **JUVENILE** is similar but the patch of bare white skin at the bill base is absent. **VOICE** – utters a grating *craah-craah-craah* call. HABITAT AND STATUS The Rook is associated mainly with areas of farmland. Flocks forage in grassland and ploughed fields, and the species breeds colonially, building large twig nests in clumps of tall trees. During the winter months, these sites, and other isolated copses and woodlands, are used for communal roosting. Around a million pairs probably breed in the region as a whole, and Rooks are generally common everywhere except in upland districts and in the north and west of Scotland. During the winter months, the population is boosted by influxes of birds from mainland Europe. OBSERVATION TIPS Rooks are generally easy to find throughout the year in lowland Britain and Ireland. The species is most memorable (and noisy) at the start of the breeding season in early March, when nests are being repaired and courtship is under way.

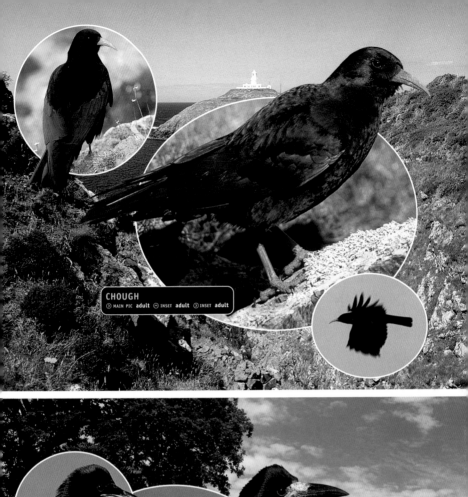

CHOUGH
> MAIN PIC **adult** > INSET **adult** > INSET **adult**

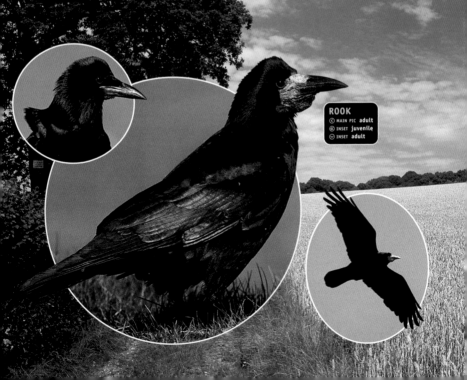

ROOK
< MAIN PIC **adult**
< INSET **juvenile**
< INSET **adult**

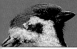

HOUSE SPARROW *Passer domesticus* LENGTH 14–15cm

A familiar species, in part because of its affinity for human habitation. The House Sparrow frequently dust-bathes and small groups are often encountered sitting on roofs, uttering familiar sparrow chirps. Where it is fed in urban parks, it can become remarkably tame, sometimes even taking food from the hand. The sexes are dissimilar. **ADULT MALE** has a grey crown, cheeks and rump. The nape, sides of the crown, back and wings are chestnut-brown, the under-parts are pale grey, and the throat and breast are black. The bill is dark and the legs are reddish. In winter, the chestnut colour is less intense and the bill is paler. **ADULT FEMALE** has mainly brown upperparts, including the crown; the back is streaked with buff. The underparts are pale grey, and note the pale buff supercilium behind the eye. **JUVENILE** is similar to an adult female but the plumage pattern is less distinct. **VOICE** – utters a range of chirping calls. HABITAT AND STATUS The House Sparrow is widespread in Britain and Ireland, although scarce or absent from many upland and northern districts. The species' predilection for nesting in roof spaces and holes in walls, and for taking advantage of food supplies in the vicinity of houses and farms, means that its precise occurrence tends to be clus-tered around villages, towns and farm buildings. Consequently, there are large tracts of land from which the House Sparrow is missing, although in the absence of suitable man-made nest sites it will build a large and untidy nest in a bush. The species has declined markedly in the last few decades, perhaps by as much as 50 per cent, but there are still several million pairs in the region. OBSERVATION TIPS You should have no difficulty finding or identifying House Sparrows, no matter where you live in the region. The species is probably easiest to see well in urban parks where people feed the birds.

TREE SPARROW *Passer montanus* LENGTH 13–14cm

A distinctive and well-marked bird. The Tree Sparrow is the more rural counterpart of the House Sparrow, although within its restricted and shrinking range it some-times occurs alongside that species, especially in the vicinity of untidy farms. Out-side the breeding season, the Tree Sparrow forms flocks and sometimes feeds alongside buntings and finches in fields. The sexes are similar. **ADULT** has a chestnut cap and a striking black patch on the otherwise whitish cheeks and side of the head; note also the black bib. The underparts are otherwise grey-ish-white, and the back and wings are streaked brown; note the white wing-bars. **JUVENILE** is similar, but the facial markings are duller, darker and less dis-tinct. **VOICE** – utters House Sparrow-like chirps but also a sharp *tik-tik* in flight.

HABITAT AND STATUS The Tree Sparrow is occasional-ly found on the outskirts of villages but is more commonly associated with untidy arable farms, taking advantage of frequent grain spills. It usually favours lowland areas and is absent from, or scarce, in the west of England and Wales, and in northern and upland districts elsewhere. Typically, the species nests in tree-holes, although it has benefited from the provision of nest boxes. The Tree Sparrow population has suffered a catastrophic decline (more than 90 per cent) in recent decades and the species has disappeared from many of its former haunts. Changes in farming practices, notably the autumn planting of cereal crops (and the consequent lack of winter stubble fields) and the virtual absence of 'weed' seeds in many areas (thanks to the use of increasingly 'efficient' herbicides) are behind its demise. There are proba-bly around 100,000 pairs in the region. OBSERVATION TIPS Nowadays, you should consider yourself lucky if you come across a winter flock of Tree Sparrows, so scarce has the species become. The strong-hold appears to be the East Midlands and parts of East Anglia, but who knows how long this will remain the case? If you live in a potentially suitable rural area within the Tree Sparrow's current range, you could try putting out nest boxes to encourage the species. However, it is a social bird and so you will need to place several boxes in the vicinity of one another.

adult

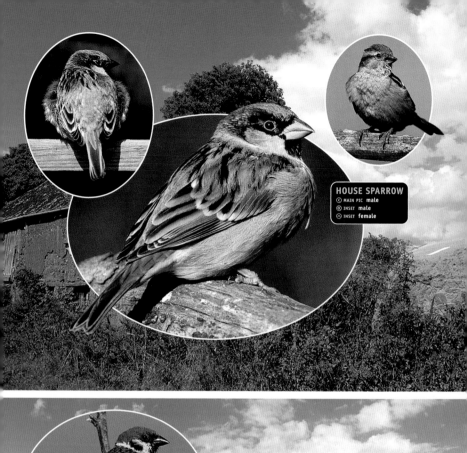

HOUSE SPARROW
◐ MAIN PIC **male**
◑ INSET **male**
◒ INSET **female**

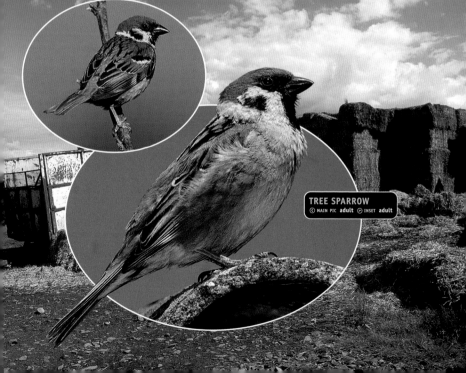

TREE SPARROW
◐ MAIN PIC **adult** ◑ INSET **adult**

CHAFFINCH *Fringilla coelebs* LENGTH 15cm

One of the commonest and most widespread birds in Britain and Ireland. The Chaffinch's song is a familiar sound in the spring. Outside the breeding season, it forms flocks and its diet switches from one that includes a significant proportion of insects to an almost strictly seed-eating regime. The sexes are dissimilar. **ADULT MALE** has reddish-pink, or perhaps pinkish-orange, on the face and underparts, a blue crown and nape, and a chestnut back. Note also the dark wings and whitish wingbars, and the white undertail and vent. The white outer tail feathers are easiest to see in flight. The colours are brightest in spring and early summer. **ADULT FEMALE** and **JUVENILE** have mainly buffish-brown plumage that is palest on the face and underparts; note the pale wingbars (the pattern is similar to that seen on the male) on the otherwise rather dark wings. **VOICE** – utters a distinct *pink, pink* call. The song comprises a descending trill with a characteristic final flourish. HABITAT AND STATUS The Chaffinch can be found in the region throughout the year. Resident birds are associated with a wide variety of habitats, including gardens, parks and woodlands of almost all kinds. Several million pairs probably nest here, making it one of our most numerous species. Outside the breeding season, influxes of birds from northern mainland Europe probably more than double the population during the winter months; flocks of these immigrants can be seen foraging for seeds on the ground in open woodland and in fields. OBSERVATION TIPS You should have little difficulty finding Chaffinches almost anywhere in the region and at all times of the year. Once you are familiar with the species' distinctive song and call, you will notice its presence in all sorts of seemingly unlikely habitats.

BRAMBLING *Fringilla montifringilla* LENGTH 14–15cm

A well-marked and distinctive finch. The Brambling is a northerly cousin of the Chaffinch and during its winter stay with us it often associates with that species. At all times, it can be recognised in flight by its white rump; the absence of white outer tail feathers helps distinguish it from the Chaffinch. The sexes are dissimilar. **SUMMER ADULT MALE** (this plumage is sometimes acquired before departure in early spring) has an orange throat, breast and lesser wing coverts; the underparts are otherwise white, although there are discrete dark spots on the flanks. The head and back are blackish. The wings are dark, but note the pale feather margins and the striking whitish-orange wingbars. The bill is black. **WINTER ADULT MALE** (males in the region are most likely to be encountered in this plumage) is similar, but the black elements of the plumage (on the head and back) are obscured by pale buff and grey-buff fringes. The bill is yellow with a dark tip. **ADULT FEMALE** has similar plumage patterns to a winter male on the wings, breast and underparts, although the colours are less intense. Pale fringes obscure the dark feathers on the back, and the head is pale grey-brown with dark lines on the sides of the crown and nape. The bill is yellow with a dark tip. **JUVENILES** are similar to winter adults of their respective sexes, although the colours are less intense. **VOICE** – calls include a harsh *eeerrp*. The song, which is seldom heard in the region, comprises a series of buzzing notes. HABITAT AND STATUS Although very occasionally a pair of Bramblings attempts to breed here, the true status of the species in the region is that of a rather common winter visitor. Numbers vary from year to year, but typically there might be several hundred thousand birds present in the winter months. Bramblings forage for seeds on the ground and are usually associated with winter woodlands; the seeds of beech (beechmast) are a particular favourite of the species. OBSERVATION TIPS Good numbers of Bramblings usually begin to arrive in the region in October. During the first few weeks after their arrival they can turn up in a wide variety of wooded habitats, but by midwinter most have formed flocks and become concentrated in areas of mature beech woodland. This habitat is therefore where you should concentrate your attentions when looking for the species. When foraging on the ground among leaf litter, Bramblings can be surprisingly unobtrusive, so let their distinctive calls alert you to their presence. During the winter it is also worth checking through Chaffinch flocks, because you stand a chance of picking out the occasional Brambling amongst them.

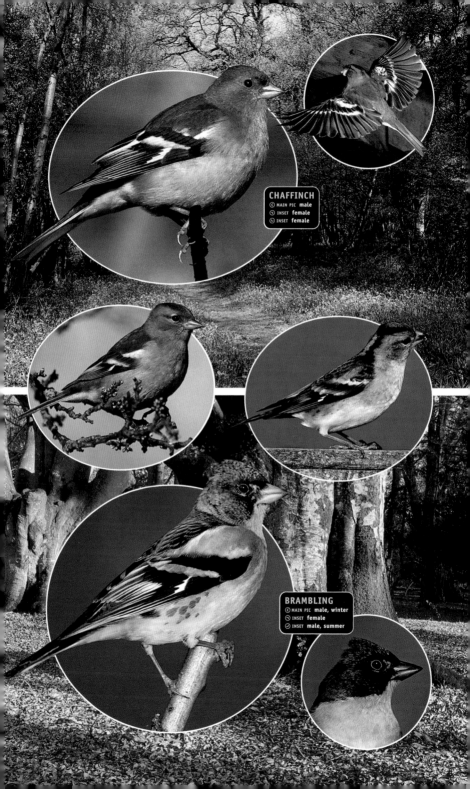

CHAFFINCH
- MAIN PIC **male**
- INSET **female**
- INSET **female**

BRAMBLING
- MAIN PIC **male, winter**
- INSET **female**
- INSET **male, summer**

GOLDFINCH *Carduelis carduelis* LENGTH 13–14cm

One of our most colourful birds. The charming Goldfinch is a favourite among bird-watchers, not least because it is often surprisingly tolerant of a close approach. Birds form flocks outside the breeding season and the sound of their tinkling flight calls is a true delight. In flight, the combination of yellow wingbars and a white rump is unique and diagnostic. The sexes are similar. **ADULT** has a striking black and white pattern on the head, with a colourful red face. The back is buffish-brown and the underparts are mainly whitish but suffused with pale buff on the flanks and sides of the breast. The wings are black with a yellow wingbar and white tips to the flight feathers; there are also white tips to the black tail feathers. The bill is relatively long, narrow, conical and pale pinkish-buff. **JUVENILE** has mainly pale buffish-white plumage, streaked brown on the flanks and back, and to a lesser degree on the head. Like the adult, the wings are black with a yellow wingbar. **VOICE** – utters a tinkling, trisyllabic call. The song is twittering and rapid, containing call-like elements. HABITAT AND STATUS The Goldfinch is widespread and can be found in the region throughout the year. During the breeding season, it is associated with areas of scrub, deciduous woodland and mature gardens, and several hundred thousand pairs nest here. Outside the breeding season, it forms flocks that are typically associated with wayside ground and field margins where seed-producing plants such as thistles and teasels are numerous. Most of our Goldfinches move south in autumn and the majority spend the winter in mainland Europe. A return movement north begins in February and March, and at such times Goldfinches are often so desperate for food that they will visit gardens in search of seeds. OBSERVATION TIPS Within their range, Goldfinches are usually easy to find at most times of the year in the region, although they are least numerous in midwinter. If you want to watch the species with minimal effort and at close range, grow some teasels in your garden and stake up the dried stems and seed-laden heads in an open position; you would be most unlucky not to have regular visitations. Increasingly, people are reporting Goldfinches collecting seed from bird tables in winter; some have even mastered the art of feeding on hanging peanut feeders.

HAWFINCH *Coccothraustes coccothraustes* LENGTH 17–18cm

An impressive and distinctive bird, and a giant among finches. The Hawfinch can be recognised at all times by it relatively massive, conical bill, which is used to crack the hard-cased seeds of trees such as hornbeam and cherry. A relatively large head and thick neck match the proportions of the bill. In flight, the rather short tail contributes to the species' characteristic front-heavy silhouette. The sexes are separable with care. **ADULT MALE** has mainly pinkish-buff plumage with grey on the neck and a brown back. Note the broad whitish wingbar, the blue-black flight feathers and the broad white tip to the tail. The bill is dark grey in summer but buffish-brown in winter. **ADULT FEMALE** is similar, but the colours are muted and an additional pale panel on the wings is sometimes discernible. **JUVENILE** is similar to an adult female, but the plumage colours are even duller and the patterns less distinct. **VOICE** – utters a sharp, almost Robin-like *tsic* call. The song is quiet and subdued, and is seldom heard. HABITAT AND STATUS The Hawfinch is associated mainly with mature, deciduous woodland, although it will certainly visit orchards and large gardens in rural areas if suitable seed-bearing trees are present. Several thousand pairs probably breed in the region as a whole. Outside the breeding season, it forms small, usually single-species, flocks. OBSERVATION TIPS Given the fact that the Hawfinch is not unduly rare in the region, it remains one of the trickiest species to observe. So count yourself lucky if you do see one, and even more so if you are able to watch the species on a regular basis. Hawfinches are unobtrusive birds and, despite their size, they can be difficult to find among tangled branches and foliage. Try to learn the distinctive call, as this will give you a head start. Birds can sometimes be located by the sound they make when they crack hard seeds with their bills. Hawfinches are easiest to discover during the winter months when the leaves have fallen from the trees. Try to find a large and mature hornbeam near you – hanging bunches of seeds will be visible for much of the winter – and pay regular visits to look for feeding birds.

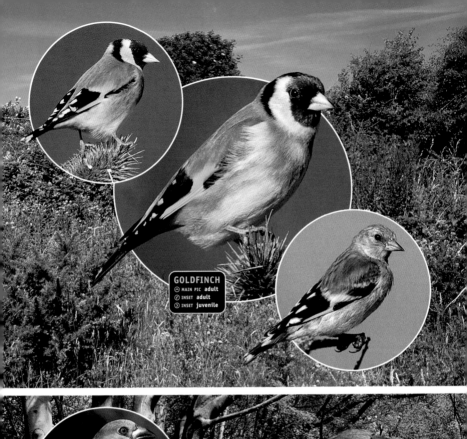

GOLDFINCH
- MAIN PIC **adult**
- INSET **adult**
- INSET **juvenile**

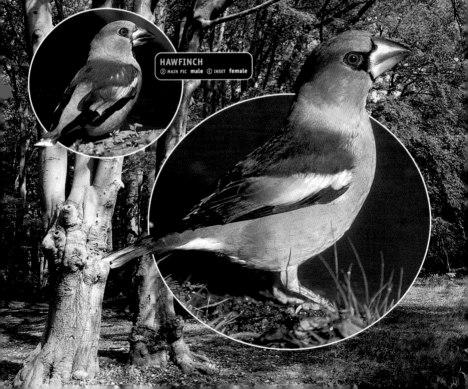

HAWFINCH
- MAIN PIC **male**
- INSET **female**

LINNET *Carduelis cannabina* LENGTH 13–14cm

A familiar little finch. The Linnet is a delightful bird of wayside habitats. In summer, the male is colourful and distinctive, but in other plumages the species is rather nondescript. Outside the breeding season, Linnets form flocks that often associate with other finch species, as well as buntings. All birds have a grey bill at all times, but otherwise the sexes are dissimilar. **SUMMER ADULT MALE** has a grey head with a rosy-pink patch on the forecrown, and a chestnut back. The otherwise pale underparts are flushed rosy-pink on the breast. Note the whitish patch on the wings, the pale sides to the relatively long, forked tail, and the streaked throat. **WINTER ADULT MALE** is similar, but the rosy-pink elements of the plumage are dull and brownish or absent, obscured by pale feather tips. **ADULT FEMALE** has a brown back, a grey-brown head and pale underparts that are streaked and spotted, and are flushed grey-buff on the breast. Note the whitish patch on the wings. **JUVENILE** is similar to an adult female but with duller colours and more extensive streaking. **VOICE** – utters a distinctive *tetter-tett* call. The male's twittering, warbling song is usually delivered from a prominent perch. HABITAT AND STATUS The Linnet is a year-round resident in the region. It is common and widespread in most parts, although it is scarce in upland districts and absent from much of north and northwest Scotland. Several hundred thousand pairs probably breed in the region as a whole but, like other bird species that rely on farmland 'weed' seeds for much of their winter diet, the Linnet has declined markedly in recent years. During the breeding season, it is associated with areas of scrub and hedgerows on farmland, and with mature gorse patches on heaths and near the coast. At other times, the species forms loose flocks that feed on weedy wayside ground and in ploughed and stubble fields. OBSERVATION TIPS Linnets are most obvious in spring, when males often sit conspicuously on sprays of gorse and other prominent perches. At other times, the species can be rather unobtrusive, especially when feeding on the ground. Every few minutes, flocks tend to take to the wing, often returning within a few seconds to a patch of ground just a short distance away. Their distinctive calls give a clue to their identity.

TWITE *Carduelis flavirostris* LENGTH 13–14cm

A rather dumpy-bodied little finch. In many ways, the Twite is the northern and upland counterpart of the Linnet. At a glance, the two species are rather similar, at least during the winter months, when you are most likely to encounter them side by side. The bill is grey in spring and summer but yellow in autumn and winter. The unstreaked throat is another useful identification feature. The sexes are rather similar. **SUMMER ADULT MALE** has brown upperparts with heavy dark streaking; note the pinkish rump (not always easy to discern in autumn) and the white margins to the flight and tail feathers. The pale underparts are heavily streaked, especially on the breast and flanks; the throat is unstreaked and, together with the face generally, appears rather buffish-brown. **WINTER ADULT MALE** is similar but it has subdued markings and the head and breast in particular appear warm buffish-brown. **ADULT FEMALE** and **JUVENILE** are similar to a winter male although the rump is brown, not pink. **VOICE** – utters a characteristic, sharp *tveeht* call. The song comprises a series of trilling and rattling notes. HABITAT AND STATUS During the breeding season, the Twite is restricted to upland and northern districts, favouring heather moorland and coastal and island locations where traditional crofting-type agriculture is still employed. Several tens of thousands of pairs probably breed within the species' restricted range. Outside the breeding season, it is associated mainly with coastal sites; saltmarshes and coastal fields are important. The Twite's range in winter extends to southeast England, and influxes from northern mainland Europe boost its numbers. OBSERVATION TIPS The Twite is usually easy to see if you visit suitable habitats in northern Scotland, the northern isles and the Pennines in spring and early summer. Outside the breeding season, the best chances of observation come from visiting coastal habitats in East Anglia; there are usually reliable flocks present on many saltmarsh areas along the north Norfolk coast.

!CONFUSION SPECIES!

MEALY REDPOLL
Page 250

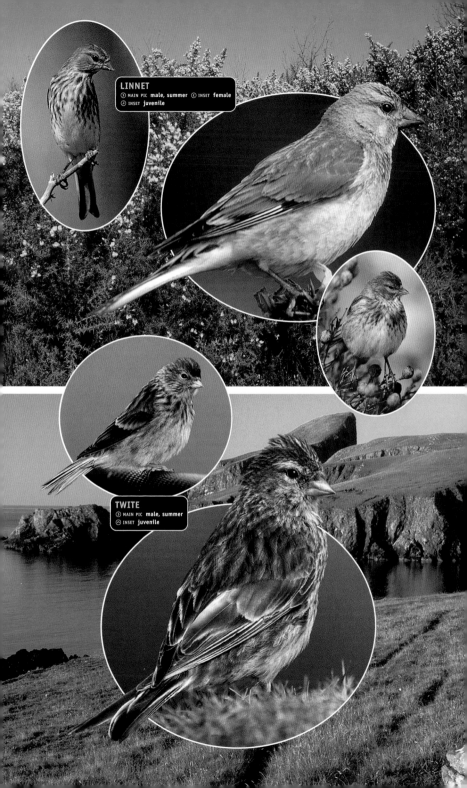

LINNET
- MAIN PIC **male, summer** · INSET **female**
- INSET **juvenile**

TWITE
- MAIN PIC **male, summer**
- INSET **juvenile**

LESSER REDPOLL *Carduelis cabaret* LENGTH 12–14cm

A well-marked little finch. Outside the breeding season, the Lesser Redpoll forms restless flocks, which feed acrobatically in the treetops, sometimes in the company of Siskins. The bill is yellow and conical. The sexes are rather similar. **ADULT MALE** has heavily streaked grey-brown upperparts that are darkest on the back.

!CONFUSION SPECIES!

LINNET
Page 248

The underparts are pale but heavily streaked. Note the red forecrown, black bib and lores, the white wingbar and the pale, streaked rump; there is usually a pinkish-red flush to the breast. **ADULT FEMALE** and **JUVENILE** are similar to an adult male but they lack the pinkish flush to the breast. The **MEALY REDPOLL** *C. flammea* is appreciably paler in all plumages than the Lesser Redpoll; adult males sometimes show a red flush to the breast. **VOICE** – utters a rattling *chek-chek-chek* call in flight. The song comprises a series of wheezing and rattling notes. HABITAT AND STATUS Confusingly, redpoll classification has changed in recent years. Formerly, both the Mealy Redpoll and the bird now referred to as the Lesser Redpoll were treated as races of the Common Redpoll complex; now, they are considered to be separate species. The Lesser Redpoll occurs in the region throughout the year. At all times it is associated with woodland. During the breeding season it favours areas of birch, and more than 100,000 pairs probably nest here. At other times of year, it occurs in both birch and alder woodlands, feeding on their seeds. Many of the birds that breed in the region migrate south in autumn, but influxes from mainland Europe ensure the species is still widespread and generally common. Mealy Redpolls are exclusively winter visitors to the region from northern mainland Europe, mainly to eastern districts of England and Scotland. OBSERVATION TIPS Redpolls (of both species) are easiest to find during the winter months, when the birds are in flocks and the leaves will have fallen from the trees.

SERIN *Serinus serinus* LENGTH 11–12cm

A diminutive and colourful finch. The Serin's relatively large head and small, stubby bill are useful identification clues in all plumages. The sexes are dissimilar. **ADULT MALE** is flushed with bright yellow on the head, back and breast. The back is heavily streaked and the underparts are otherwise whitish with bold streak-

!CONFUSION SPECIES!

SISKIN
Page 252

ing on the flanks. Note also the two pale wingbars, forked tail and pale yellowish rump. **ADULT FEMALE** is similar, but the yellow elements of the plumage are much less intense, except perhaps on the rump and throat. **JUVENILE** is similar to an adult female but the yellow elements of the plumage are buffish-brown. **VOICE** – utters a distinctive buzzing call. The song is an extremely rapid series of buzzing, jingling notes. HABITAT AND STATUS The Serin does occasionally breed in southern England but its mainland status is essentially that of a rare visitor. Most records (30 or 40 in a good year) occur at migration times; it breeds on a regular basis in the Channel Islands. In spring, singing Serins usually favour areas of mature conifers. In autumn, the species is usually discovered among flocks of ground-feeding finches. OBSERVATION TIPS For the best chances of finding a mainland singing Serin, visit coastal districts of Devon and Dorset in April and May; for more guaranteed sightings, visit Jersey.

BULLFINCH *Pyrrhula pyrrhula* LENGTH 16–17cm

An unobtrusive finch that is often encountered in pairs. The Bullfinch's soft call is heard more frequently than the bird itself is seen. The bill is stubby and dark. All birds reveal a white rump as they fly away. The sexes are separable with care. **ADULT MALE** has a rosy-pink face, breast and belly. The back and nape are blue-grey and the cap and tail are black. Note the white wingbar on the otherwise black wings. **ADULT FEMALE** is similar but the rosy-pink elements of the plumage are dull buffish-pink. **JUVENILE** is similar to an adult female but the head is uniformly buffish-brown. **VOICE** – utters a distinctive piping call, sometimes delivered in duet by a pair. The quiet song comprises slow, fluty notes. HABITAT AND STATUS The Bullfinch is resident in the region and is found in woodlands, hedgerows and mature gardens. Several hundred thousand pairs probably nest in the region but it is secretive and hard to survey accurately. OBSERVATION TIPS Once you are familiar with the Bullfinch's soft call, you will detect its presence in a wide range of wooded habitats.

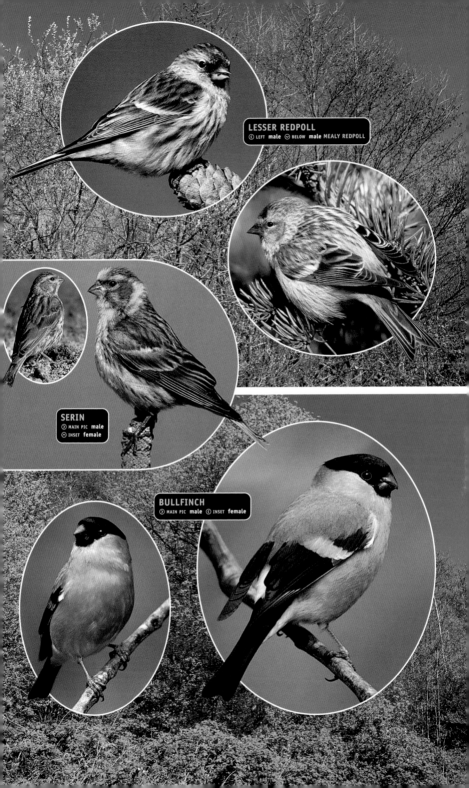

LESSER REDPOLL
ⓛ LEFT **male** ⊖ BELOW **male** MEALY REDPOLL

SERIN
⊙ MAIN PIC **male**
ⓛ INSET **female**

BULLFINCH
⊙ MAIN PIC **male** ⓛ INSET **female**

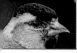

SISKIN *Carduelis spinus* LENGTH 11–12cm

A charming and well-marked little finch. The Siskin can be recognised in all plumages by the broad yellowish bar on the otherwise dark wings, the yellow rump, and the yellow sides to the otherwise dark tail; these features are most obvious in flight. Outside the breeding season, it forms flocks, which feed acrobatically on tree seeds using the narrow, conical bill. The sexes are separable with care. **ADULT MALE** has striking yellowish-green upperparts, with streaking on the back, and a black cap and bib. The breast is flushed yellow-green, but the underparts are otherwise whitish with bold streaking on the flanks. Note the dark wings and yellow wingbars. **ADULT FEMALE** is similar but lacks the intensity of yellow colour; the head is rather uniform, and lacks the male's black cap and bib. **JUVENILE** has mainly streaked grey-brown plumage that is palest on the head and underparts; the wing and tail patterns are similar to those of adult birds. **VOICE** – utters whistling or twittering, disyllabic calls. The song comprises a series of twittering, almost warbling, phrases. HABITAT AND STATUS During the breeding season, the Siskin is associated mainly with conifer woodlands. Although widespread in the region, occasionally even nesting in mature gardens in southern England, it is common as a breeding species only in Scotland and parts of Wales; several hundred thousand pairs probably breed here. During the winter months, the species is more widespread, and certainly more common, in the south, due in part to influxes of birds from mainland Europe. At such times, it favours mainly alder and birch woodlands. OBSERVATION TIPS The Siskin is probably easiest to find during the winter months, when it searches for seeds in the outer branches of leafless alder and birch trees. Numbers vary from year to year, however, as does their precise occurrence within the region as a whole. Feeding flocks tend to be rather nomadic, so you will have to search for a while to find one; they are, however, typically rather vocal. In late winter in particular, when tree seeds have become depleted, Siskins sometimes visit the garden feeders of fortunate observers.

GREENFINCH *Carduelis chloris* LENGTH 14–15cm

A distinctive finch and a familiar garden resident in many parts of the region. The Greenfinch has a relatively large, pinkish and conical bill. In all plumages, the yellowish patch on the wings – seen as a yellow bar on the closed wing – and the yellow sides to the base of the tail are useful identification clues. The sexes are dissimilar. **ADULT MALE** appears overall mainly yellowish-green, darkest on the back and with grey areas on the face, sides of the neck and on the wings. The intensity of the colour on the body increases throughout the winter months as pale feather fringes are worn away. **ADULT FEMALE** is similar, but the colours are much duller and faint streaking can often be discerned on the back. **JUVENILE** recalls an adult female, but both the back and pale underparts are obviously streaked. **VOICE** – utters a sharp *jrrrup* call in flight. The song either comprises well-spaced wheezy *weeeish* phrases or a series of rapid, trilling whistles; the latter is sometimes delivered in flight, on deliberately slow wingbeats. HABITAT AND STATUS During the breeding season, the Greenfinch is associated with parks, gardens and hedgerows, particularly where the supply of seeds is sufficient to provide a source of food during the winter months. The species is widespread and reasonably common, with several hundred thousand pairs being present here. During the winter months, many northern and upland districts are abandoned and the Greenfinch is then more numerous in lowland districts in the south; influxes from mainland Europe boost the numbers in the region as a whole. In the past, flocks would have been widespread on arable farms, but the disappearance of winter stubble fields and the prevalent use of herbicides means that the species' occurrence in the countryside at large is increasingly localised. OBSERVATION TIPS The Greenfinch often nests in gardens – sometimes using thick conifer hedges – so listen out for the male's breezy, call-like song in spring. The species also frequently visits garden bird-feeders, often dominating and attempting to exclude smaller species.

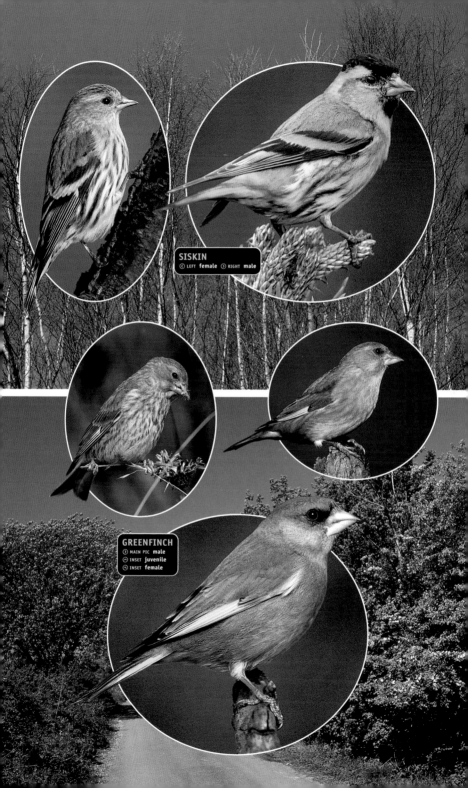

SISKIN
LEFT **female** RIGHT **male**

GREENFINCH
MAIN PIC **male**
INSET **juvenile**
INSET **female**

COMMON CROSSBILL *Loxia curvirostra* LENGTH 15–17cm

An extraordinary and distinctive finch. The Common Crossbill has evolved crossed-tip mandibles that are the perfect tool for extracting seeds from conifer cones, particularly those of larch and spruce species. It forms single-species flocks outside the breeding season; nesting takes place early in the year, often in February or March. The sexes are dissimilar. **ADULT MALE** has mainly red plumage but with brownish wings. **ADULT FEMALE** has mainly greenish plumage but with brownish wings. **IMMATURE BIRDS** are similar to adults of their respective sexes but the plumage colours are duller. **JUVENILE** is grey-brown and heavily streaked. **VOICE** – utters a sharp *kip-kip-kip* flight call. **HABITAT AND DISTRIBUTION** The Common Crossbill is associated with mature conifer woodland with plenty of trees of cone-bearing age. Several tens of thousands of pairs are probably present in the region at most times, but numbers vary considerably from season to season. Being almost entirely dependent on conifer seeds, Common Crossbills often have to wander extensively and nomadically if food in a given area is depleted. Large-scale irruptions of mainland European birds occur in years when the cone crop fails there, with many thousands reaching Britain and Ireland. **OBSERVATION TIPS** Common Crossbills often feed high in the treetops and so can be surprisingly difficult to spot. Listen for their distinctive calls and for the sound of falling cones. Birds visit the ground regularly to drink at woodland pools.

SCOTTISH CROSSBILL *Loxia scotica* LENGTH 15–17cm

Superficially very similar to the Common Crossbill, so extreme caution and care are needed to separate the two species. The Scottish Crossbill has evolved a more robust and stout bill than that of its cousin, an adaptation to the specialised habit of extracting seeds from the cones of mature native Scots Pines. The sexes are dissimilar. **ADULT MALE** has mainly red plumage but with brownish wings. **ADULT FEMALE** has mainly greenish plumage but with brownish wings. **IMMATURE BIRDS** are similar to adults of their respective sexes but the plumage colours are duller. **JUVENILE** is grey-brown and heavily streaked. **Voice** – utters a sharp *kip-kip-kip* flight call, similar to, but slightly deeper than, that of the Common Crossbill. **HABITAT AND STATUS** The Scottish Crossbill is the only bird species that is endemic to Britain. It is restricted to relict areas of native Scots Pine forest in Scotland plus mature Scots Pine plantations in its restricted Highland range. Its population probably numbers no more than a few thousand birds. **OBSERVATION TIPS** Just because you have seen a crossbill in Scotland does not necessarily mean that you have seen a Scottish Crossbill. You will have to visit a Caledonian pine forest in the Highlands – Abernethy and Rothiemurchus forests are well-known spots – to find one. If you want to do more than 'tick' the species, based on geographical range and the tree species in which it is feeding, pay close attention to the size and shape of the bill.

COMMON ROSEFINCH *Carpodacus erythrinus* LENGTH 14–15cm

A robust little finch with a proportionately stout bill. Adult males are colourful and distinctive, but most Common Rosefinches (sometimes referred to as Scarlet Rosefinches) seen in the region are in rather sombre and nondescript plumage. The sexes are dissimilar. **ADULT MALE** has a red head, breast and rump. The underparts are whitish, and the back, tail and wings are brown; note the two pale wingbars. **ADULT FEMALE** and **FIRST-SUMMER MALE** have mainly brown, streaked plumage, but note the two pale wingbars and the pale underparts. **JUVENILE** is similar to an adult female but the plumage has a more buffish tone overall. **VOICE** – utters a Greenfinch-like *tchu-ee* call. The song is a whistling *weed-ya, weed-ya, viu*. **HABITAT AND STATUS** The Common Rosefinch is a regular passage migrant and 100 or so birds are recorded in a good year. Recently, however, it has made tentative steps towards colonisation as a breeding species, and a few pairs nest in most years. The Common Rosefinch is found in a wide range of wooded and scrub habitats; migrants are usually found in coastal scrub. **OBSERVATION TIPS** Identifying a female Common Rosefinch can be a bit of a challenge. Look for the proportionately large, dark bill and the presence of two pale wingbars. The species is most likely to turn up on the south and east coasts of England, on the east coast of Scotland and on the northern Scottish isles in late spring and early autumn following southeasterly winds.

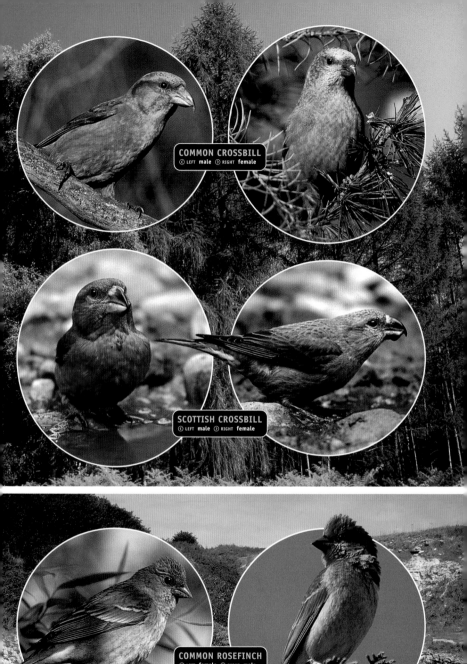

COMMON CROSSBILL
‹ LEFT **male** › RIGHT **female**

SCOTTISH CROSSBILL
‹ LEFT **male** › RIGHT **female**

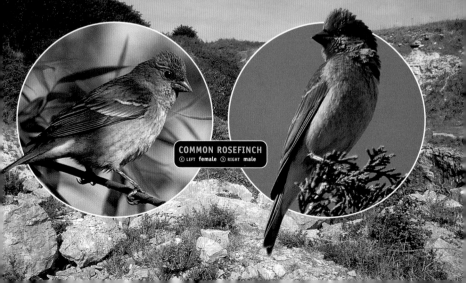

COMMON ROSEFINCH
‹ LEFT **female** › RIGHT **male**

YELLOWHAMMER *Emberiza citrinella* LENGTH 15–17cm

A colourful bunting. The Yellowhammer is known as much for the male's easily recognised song as for its attractive appearance. Outside the breeding season, it forms flocks and feeds in fields and on open ground, sometimes in the company of other buntings and finches. The sexes are dissimilar. **SUMMER ADULT MALE** has a mainly bright yellow head and underparts, and a reddish-brown back and wings. Note the faint dark lines on the head, a chestnut flush to the breast and streaking on the flanks; the rump is reddish-brown and the bill is greyish. **WINTER ADULT MALE** is similar, but the yellow elements of the plumage are subdued or absent, and dark streaking on the head and underparts is more extensive. **ADULT FEMALE** has a streaked greenish-grey head and breast, streaked pale yellow underparts and a brown back; note the reddish-brown rump. **JUVENILE** is similar to an adult female but with more distinct streaking. **VOICE** – utters a rasping call. The song is often rendered as '*a little bit of bread and no cheese*'. HABITAT AND STATUS The Yellowhammer is a widespread resident in the region, absent from, or least common in, some northern and upland districts; the population numbers more than a million birds in the region as a whole. It thrives best in countryside where there is a mosaic of open grassland, or farmland fields, with scattered patches of scrub and extensive, mature hedgerows. During the winter months, flocks feed in stubble fields (where these are still part of the agricultural landscape), at grain spills or on short grassland. OBSERVATION TIPS Once you are able to recognise the Yellowhammer's distinctive song, you will have no difficulty finding the species in the spring and early summer in areas of lowland countryside throughout much of the region. Outside the breeding season, look for flocks feeding around the margins of arable farms.

CIRL BUNTING *Emberiza cirlus* LENGTH 16–17cm

A well-marked bunting. The Cirl Bunting is superficially similar to the Yellowhammer but it is readily separable at all times. The male is particularly distinctive during the summer months and all birds reveal an olive-grey rump (that of a Yellowhammer is reddish-brown at all times). Outside the breeding season, it typically forms small, single-species flocks. The sexes are dissimilar. **ADULT MALE** has a distinctive head pattern comprising a black throat and eyestripe, separated and defined by yellow. The breast, nape and crown are greenish-grey and the underparts are yellow, flushed and streaked chestnut on the flanks; the back is reddish-brown. The colours are less distinct and grubbier in winter than in summer. **ADULT FEMALE** has dark and yellowish stripes on the head, a streaked greenish-grey crown, nape and breast, and streaked yellowish underparts. The back is reddish-brown. **JUVENILE** is similar to an adult female but the yellow elements of the plumage are extremely pale. **VOICE** – utters a sharp *tziip* call. The song is a rather tuneless rattle, reminiscent of that of a Lesser Whitethroat. HABITAT AND STATUS The Cirl Bunting was once fairly widespread in southern England, but today it is effectively restricted to coastal districts of south Devon; occasionally it is found at sunny sites inland and the species also occurs on Jersey. The population in the region as a whole numbers just a few hundred pairs. Cirl Buntings favour areas of low-intensity farmland with a mosaic of mature hedgerows and scrub patches. The species is generally rather sedentary. OBSERVATION TIPS If you want to see a Cirl Bunting you will have to walk the South Devon Coastal Path or, failing that, visit Jersey. The species is easiest to discover in the spring, when males are singing their distinctive songs. Please note, however, that the species is scarce and protected, so avoid causing any disturbance and watch from a safe distance. In the winter, small single-species flocks can sometimes be found feeding in weedy stubble fields within their range.

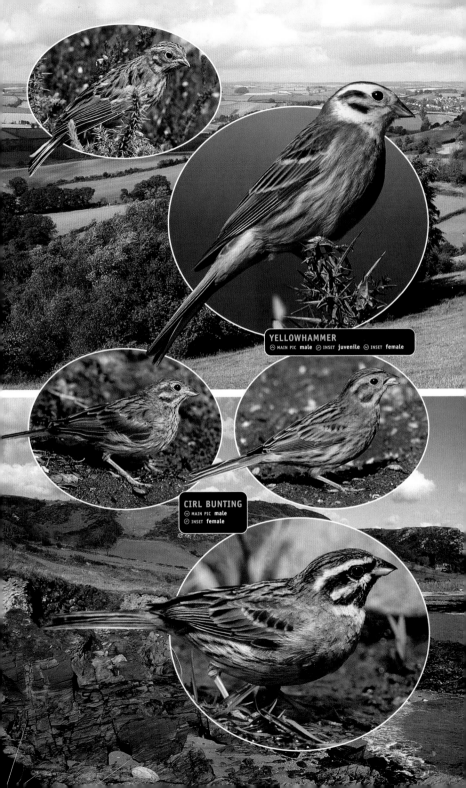

YELLOWHAMMER
⊘ MAIN PIC **male** ⊘ INSET **juvenile** ⊘ INSET **female**

CIRL BUNTING
⊘ MAIN PIC **male**
⊘ INSET **female**

REED BUNTING *Emberiza schoeniclus* LENGTH 14–15cm

A well-marked bunting. The Reed Bunting is a familiar bird of wetland margins. Out-side the breeding season it forms flocks, sometimes in the company of other ground-feeding buntings and finches. The sexes are dissimilar. **SUMMER ADULT MALE** is unmistakable, with a black head, throat and bib, and a white collar and sub-moustachial stripe. The underparts are otherwise whitish with faint streaking, the back is dark and the wings have reddish-brown feather mar-gins. **ALL OTHER PLUMAGES** have heads adorned with dark brown and buff-ish-brown stripes, and a strikingly pale sub-moustachial stripe. The back is marked with dark brown and buff stripes, there are reddish-brown margins to the wing feathers, and the pale underparts are streaked on the flanks and breast. Males show a suggestion of the head pattern seen in summer, notably dark spotting on the throat and bib. **VOICE** – utters a thin *seeu* call. The song is simple, chinking and repetitive. HABITAT AND STATUS The Reed Bunting is typically associated with areas of scrub on the margins of wetland; clumps of bushes around lake margins and reedbed fringes are ideal for the species. However, it also occurs on farmland, par-ticularly in Rape fields. Several hundred thousand birds are present during the breeding season, and British and Irish birds are typically year-round residents. Outside the breeding season, the population is boost-ed by influxes from northern mainland Europe. OBSERVATION TIPS Reed Buntings are most conspicuous in the breeding season, when males sing their distinctive songs from prominent perches. At other times of year, the species is rather unobtrusive; small flocks may be found feeding in weedy and arable fields.

ORTOLAN BUNTING *Emberiza hortulana* LENGTH 15–16cm

A subtly colourful and distinctive bunting. The Ortolan Bunting is usually seen in first-winter plumage in the region, when there is an outside risk of confusing it with other immature buntings. However, all birds have a diagnostic combination of a pale yellow eye-ring, a pink bill, and a yellow throat and sub-moustachial stripe. The sexes are dissimilar. **SUMMER ADULT MALE** (seldom seen in the region) has a mainly greenish-grey head, neck and breast, but shows all the features detailed above. The underparts are orange-brown and the upperparts are brown and streaked. **IN ALL OTHER PLUMAGES** note the streaked pale orange-brown underparts and streaked brown back; the streaked greyish head, neck and breast show the diagnostic features detailed above. **VOICE** – calls include a thin *tsee* and a tongue-clicking *tche*. HABITAT AND STATUS The Ortolan Bunting is a regular passage migrant through the region; 50 or more might be recorded in a good year, mostly in autumn and along the south and east coasts of England. Migrants favour areas of short grassland for feeding and frequent-ly turn up in stubble fields. OBSERVATION TIPS The Ortolan Bunting is usually unobtrusive and typically rather wary. Consequently, it is always a challenge to find one.

CORN BUNTING *Miliaria calandra* LENGTH 16–18cm

Although it is rather nondescript, the Corn Bunting does have a distinctive song. It characteristically dangles its legs when flying short distances. Outside the breed-ing season, it forms flocks, often associating with other ground-feeding passer-ines. The sexes are similar. **ADULT** and **JUVENILE** appear rather plump-bodied. The upperparts are brown and streaked, while the underparts are whitish, streaked on the breast and flanks, and flushed with buff, especially on the breast. The bill is stout and pinkish-buff. **VOICE** – utters a *tsit* call. The song has been likened to jangling keys. HABITAT AND STATUS The resident Corn Bunting gained its common name from its association with cereal fields. Today it has all but disappeared from large tracts of farmland where formerly it was widespread. Its decline is associated with changes in agricultural practices. Today, it is locally common only in parts of central England. The Corn Bunting's current population is probably of the order of a few tens of thousands of pairs; formerly it would have been num-bered in the hundreds of thousands. OBSERVATION TIPS As recently as a few decades ago, advice on where to look for Corn Buntings would have been straightforward: visit almost any area of arable farmland in lowland England. Nowadays, although it is still widespread in the same habitats, it is absent from many seemingly suitable locations.

!CONFUSION SPECIES!

SKYLARK
Page 176

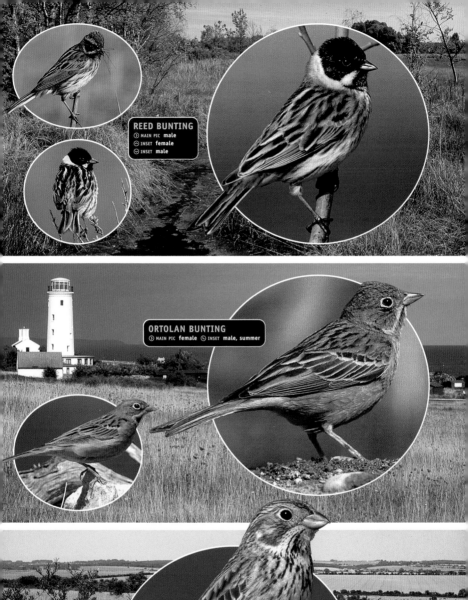

REED BUNTING
- MAIN PIC **male**
- INSET **female**
- INSET **male**

ORTOLAN BUNTING
- MAIN PIC **female** • INSET **male, summer**

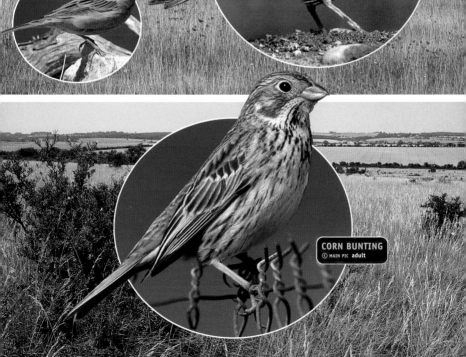

CORN BUNTING
- MAIN PIC **adult**

SNOW BUNTING *Plectrophenax nivalis* LENGTH 16–17cm

A plump-bodied bunting. The Snow Bunting's attractive appearance and typically confiding nature ensure that it is a favourite among birdwatchers. The plumage varies considerably between the sexes and throughout the year, but all birds show a considerable amount of white on the inner wing, and on the rump and tail; these features are particularly striking in flight. The sexes are dissimilar. **SUMMER ADULT MALE** has mainly white plumage with a blackish back and black and white on the wings. Note that some individuals have variable amounts of orange-buff on the white elements of the plumage. All birds have a black bill and legs. **SUMMER ADULT FEMALE** is superficially rather similar, but the back is brownish and variable amounts of streaked brown and buff can be seen on the head, neck and sides of the breast. **WINTER ADULTS** and **FIRST-WINTER BIRDS** have mainly white underparts and buffish-orange upperparts. Adult males are whitest on the wings, face and underparts. The bill is yellowish and the legs are black in all birds. **VOICE** – utters a tinkling call in flight. The song is twittering but the tone is clearly that of a bunting. HABITAT AND STATUS Perhaps as many as 100 pairs of Snow Buntings breed in the region, mainly in the Highlands of Scotland, where they are found around rocky outcrops on desolate mountain slopes and plateaux. However, the species is better known as a regular winter visitor, and more than 10,000 individuals are probably present in most seasons. Outside the breeding season, it occurs in mainly coastal districts and is commonest on the east coast, from Kent to the Shetland Islands. Saltmarshes, short-turf coastal grassland and the stabilised dune margins of sandy beaches are ideal Snow Bunting habitats, but in Scotland in particular it is also found inland, often in seemingly bleak upland terrain. OBSERVATION TIPS Snow Buntings are easiest to spot outside the breeding season, when groups can be found in suitable habitats on many stretches of the Scottish and English east coasts. Typically, they occur in small flocks. However, because of their creeping habits and relative indifference to people, the birds can be surprisingly easy to overlook until almost trodden upon. Small groups also gather in the vicinity of ski lifts and associated car parks in the Scottish Highlands in winter.

LAPLAND BUNTING *Calcarius lapponicus* LENGTH 14–16cm

A well-marked bunting. The Lapland Bunting is striking in summer plumage, but outside the breeding season (when most records of the species occur in the region) its appearance is more subtle. As a winter visitor, it forms small flocks and often associates with other ground-feeding passerines. Typically, it is rather nervous and wary. The sexes are dissimilar. **SUMMER ADULT MALE** (seldom seen in the region) is unmistakable, the black face and throat defined by a striking white line (a continuation of the supercilium); the crown is black and the nape is chestnut. The underparts are otherwise white and the back is streaked brown and black. The bill is yellow. **SUMMER ADULT FEMALE** (seldom seen in the region) has a pale suggestion of the male's striking head pattern; the underparts are white with streaks on the flanks and the back is streaked brown. **WINTER ADULTS** and **JUVENILE** have a reddish-brown face with a dark line defining the ear coverts; the crown is dark and a pale median stripe is sometimes discernible. The back is streaked brown, and note the reddish-brown wing panel defined by two whitish wingbars. The underparts are whitish and streaked on the flanks; juveniles are also streaked on the breast, while adults show a hint of a black bib. **VOICE** – utters a distinctive rattling call in flight, sometimes also a whistling *tchu*. HABITAT AND STATUS The Lapland Bunting is essentially a winter visitor to the region from breeding grounds in Scandinavia and eastwards into Russia. Small flocks are found in coastal fields and saltmarshes, mainly on the east coast of England, and several hundred may be present in a good year. The species is also a passage migrant through the region, seen mainly in autumn, and most coastal migration hotspots record small parties in most years. Just occasionally, a male is discovered in spring on potentially suitable breeding territory (tundra-like moorland) in Scotland, giving rise to speculation about the species nesting here. OBSERVATION TIPS To stand a chance of seeing a Lapland Bunting, you will need to visit the east coast of England during the winter months. If you find a mixed feeding flock of finches, buntings and larks, it will be worth scrutinising every bird. Count yourself lucky if you get close views of this species, because typically it is rather shy and inclined to fly away at the slightest disturbance. Lone birds sometimes turn up in autumn outside their usual wintering range and these individuals are usually more confiding.

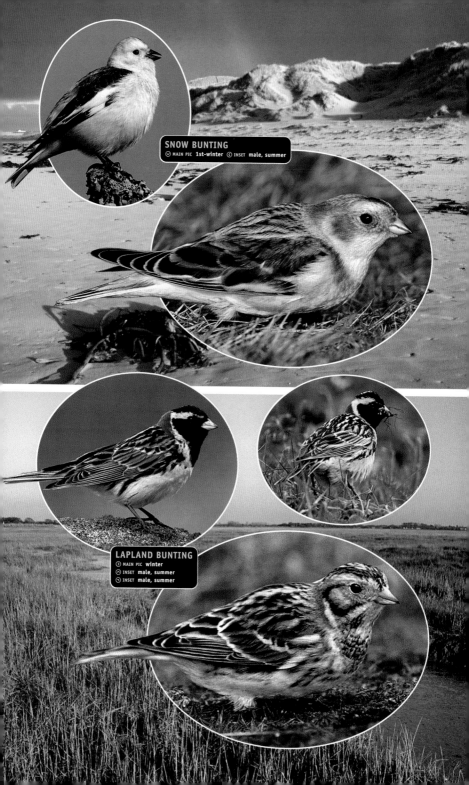

SNOW BUNTING
⊙ MAIN PIC **1st-winter** ⊙ INSET **male, summer**

LAPLAND BUNTING
⊙ MAIN PIC **winter**
⊙ INSET **male, summer**
⊙ INSET **male, summer**

WILSON'S STORM-PETREL *Oceanites oceanicus* LENGTH 16–18cm

A tiny seabird that is superficially very similar to a Storm-petrel (p.32). **IN ALL PLUMAGES**, Wilson's Storm-petrel looks mainly dark at a distance, but with a striking white rump. At close range, note the square-ended tail, the relatively long legs (when outstretched, the toes project beyond the tail) and the pale panel on the upperwing coverts. It glides on outstretched, flat wings and also flutters low over the water, pattering the surface with its dangling feet. Wilson's Storm-petrel breeds in the southern hemisphere. Outside the breeding season, it visits the north Atlantic, and the seas off southwest Britain and Ireland probably represent its northerly limit. The species is only rarely seen from land. However, it is encountered regularly, but in small numbers, on summer pelagic trips from the Scilly Isles and Cornwall, and (beyond our region) from ferries crossing the Bay of Biscay.

SOOTY SHEARWATER *Puffinus griseus* WINGSPAN 95–105cm

A medium-sized shearwater with relatively long wings. **IN ALL PLUMAGES**, the Sooty Shearwater appears all dark at a distance, but at close range, and in good light, note the sooty-brown plumage and silvery-white underwing coverts. It banks and glides effortlessly, low over the sea. The Sooty Shearwater breeds in the southern hemisphere. Outside the breeding season, it visits the north Atlantic, passing through our seas in late summer and early autumn. In season, it can be seen from ferries and pelagic trips, and also from headlands, especially off the west and southwest coasts of Britain and Ireland during periods of strong onshore winds. Several hundred birds might be recorded in the region in a good year; many more must go unnoticed. Confusion species: Mediterranean Shearwater (p.34).

SQUACCO HERON *Ardeola ralloides* LENGTH 45–47cm

A compact and stocky bird. **SUMMER ADULT** looks mainly buffish-brown, with streaking on the crown and trailing plumes on the nape; the underparts are white. The dagger-like bill is bluish-yellow with a dark tip. **IMMATURE** and **NON-BREEDING PLUMAGE ADULT** look similar to summer adult, although the head and neck are more heavily streaked and the head plumes are absent. In flight, all birds are transformed by the pure white wings. The Squacco Heron is associated with well-vegetated wetlands. It breeds in southern Europe and winters in Africa. A handful are recorded in our region each year, the majority in spring. Confusion species: Little Egret (p.42).

NIGHT HERON *Nycticorax nycticorax* LENGTH 60–65cm

A stocky bird with a hunchbacked appearance at rest and a proportionately large head. The Night Heron typically roosts during the day and feeds actively only at night. **ADULT** has a black bill, crown and back, with grey wings and a pale face and underparts; the eyes are large and red, and the legs are yellowish. **JUVENILE** has mainly brown plumage, heavily adorned with white spots. The species is associated with wetland habitats and usually roosts in waterside trees or bushes. In flight, the wings look broad and rounded. The Night Heron breeds in central and southern mainland Europe, and winters in Africa. It is a scarce but regular visit to our region, with perhaps 10 or 20 recorded here in a good year.

LITTLE BITTERN *Ixobrychus minutus* LENGTH 35–38cm

A tiny heron, and the smallest of its kind in the region. **ADULT MALE** has a greyish face, a black cap, back and flight feathers, and orange-buff underparts. In flight, a wing panel that grades from orange-buff to greyish-white is revealed. **ADULT FEMALE** is similar, but the plumage is overall browner, the back is streaked and the patterns and markings are subdued. **JUVENILE** is similar to an adult female, but the plumage is even more brown and streaked, and its appearance recalls that of a miniature Bittern. The Little Bittern is associated with wetland habitats; extensive reedbeds are favoured but vagrants sometimes turn up elsewhere. It breeds in southern and central mainland Europe and winters in Africa. The species has bred in Britain on occasions, but most records here relate to solitary birds that turn up in spring.

PURPLE HERON *Ardea purpurea* LENGTH 80–90cm

An elegant and slender wetland bird. The Purple Heron is superficially similar to the Grey Heron but it is readily separable on close inspection. **ADULT** looks mainly greyish-purple. The head and neck are orange-buff and a black stripe runs the length of the neck on both sides. Note also the long head plumes and long, streaked breast feathers. In flight, the wings look broad and rounded; the upperwing is purplish-brown with darker flight feathers, while the underwing is grey with a maroon leading edge. **JUVENILE** is similar but the plumage is more uniformly brown. In flight, all birds hold the neck in a snake-like curve; the hind toe is cocked upwards (usually held flat with the Grey Heron). The Purple Heron is associated with wetland habitats, typically large reedbeds, where it can be difficult to observe. It breeds in mainland Europe and winters in Africa. Some 20 or so individuals might be observed in our region in a good year, mainly in spring and early summer. Confusion species: Grey Heron (p.42)

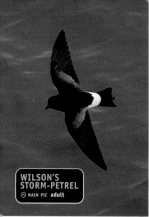

WILSON'S STORM-PETREL
⌃ MAIN PIC **adult**

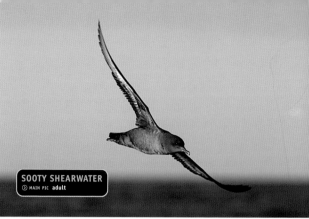

SOOTY SHEARWATER
⟩ MAIN PIC **adult**

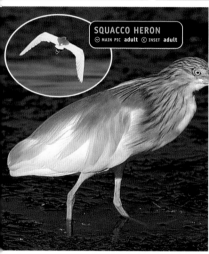

SQUACCO HERON
⌄ MAIN PIC **adult** ⟨ INSET **adult**

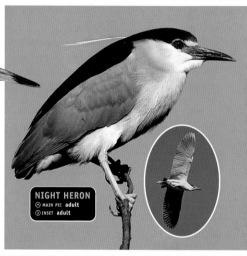

NIGHT HERON
⌃ MAIN PIC **adult**
⟩ INSET **adult**

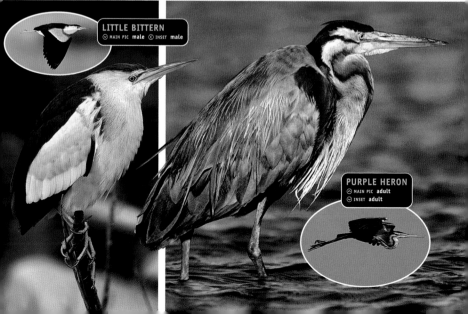

LITTLE BITTERN
⌄ MAIN PIC **male** ⟨ INSET **male**

PURPLE HERON
⌃ MAIN PIC **adult**
⌄ INSET **adult**

GLOSSY IBIS *Plegadis falcinellus* LENGTH 55–65cm

An elegant wetland bird with the proportions of a heron but the bill shape of a Curlew. **ADULT** can seem black in silhouette, but in good light it looks deep maroon with a metallic sheen on the wings and back. In summer, note the white line from the base of the bill and around the eye; in winter, this is absent and the plumage also appears overall duller, with pale streaks on the head and neck. **JUVENILE** is similar to a winter adult but the plumage colours are even duller. In flight, all birds hold the neck and legs outstretched. The Glossy Ibis breeds around the Mediterranean and most birds winter in Africa. A handful of individuals are recorded in our region each year, some staying in the same general area for months on end.

CATTLE EGRET *Bubulcus ibis* LENGTH 48–52cm

A stocky, pure white heron. Compared to a Little Egret (p.42), and **IN ALL PLUMAGES**, the Cattle Egret's bill is yellow and much shorter; the legs are also shorter and are greenish-brown in colour. Note, too, the 'bulging throat' appearance and the rather steep forehead. In breeding plumage (seldom seen in our region), adult birds acquire a buffish tinge to the crown and back. In flight, all birds have broad, rounded wings and the neck is held hunched up. The Cattle Egret favours drier habitats than many of its relatives and it is often associated with grazing animals; it catches insects and other prey disturbed by their passage. The species is resident in southwest Europe and occurs in our region as a vagrant. Half a dozen birds might be recorded here in a good year; typically they stay put for a few days – sometimes weeks – allowing observation by good numbers of birdwatchers.

GREATER FLAMINGO *Phoenicopterus ruber* LENGTH 125–145cm

An unmistakable long-legged, long-necked wetland bird. **ADULT** has pinkish plumage, which can look almost white in poor light. The pink, banana-shaped bill has a black tip and the legs are uniformly reddish-pink. In flight, the wings reveal black flight feathers and reddish-pink coverts; the neck and legs are held outstretched. **JUVENILE** has similarly unmistakable proportions, but the plumage is grey-brown and the legs and bill are dull. The Greater Flamingo is very locally common around the Mediterranean. The species wanders during the winter months and records in our region (a handful are seen in most years) could conceivably relate to genuinely wild individuals. However, it is also kept in captivity and most records are probably escapees. Beware the possibility of confusion with the **CHILEAN FLAMINGO** (*P. chilensis*), which occasionally also escapes from captivity. It is superficially similar, but note the dark legs and striking red 'knees'.

RED-BREASTED GOOSE *Branta ruficollis* LENGTH 55–60cm

A well-marked and unmistakable goose with a proportionately short bill and thick neck. **ADULT** has deep red on the cheeks and the neck, and a complex and diagnostic pattern of black and white elsewhere on the body. **JUVENILE** has a similar pattern of markings but the red elements of the plumage are duller. The Red-breasted Goose breeds in Siberia and winters mainly on the Black Sea coast of Romania and Bulgaria. A handful of individuals are recorded in our region each year, and typically these birds arrive with flocks of either White-fronted, Brent or Barnacle Geese, remaining in their company throughout the winter months. Regular locations for the species, in recent years, include Slimbridge in Gloucestershire, the north Norfolk coast and Islay.

LESSER WHITE-FRONTED GOOSE *Anser erythropus* LENGTH 55–65cm

Superficially similar to the White-fronted Goose (p.48). **ADULT** has a relatively small bill, a white blaze on the forehead that extends above the eye, and a diagnostic yellow orbital ring around the eye. **JUVENILE** lacks white on the forehead and hence it is very similar to a juvenile White-front; note, however, the presence of a dull, but diagnostic, yellow orbital ring. The Lesser White-fronted Goose breeds eastwards from northern Scandinavia and winters in southeast Europe. A handful of individuals are recorded in our region in a good year, invariably with wintering White-fronted Geese; they usually remain until the flocks depart in early spring. Slimbridge in Gloucestershire has the lion's share of records.

SNOW GOOSE *Anser caerulescens* LENGTH 65–75cm

A striking, medium-sized goose. **ADULT** white-phase bird is almost unmistakable, having mainly pure white plumage except for the black outer flight feathers; the latter are conspicuous only in flight. The bill and legs are pink. Beware of confusion with white 'farmyard' geese, domesticated forms of the Greylag (p.48). The Snow Goose also occurs as a darker form: so-called 'blue phase' birds have a white head and upper neck, but otherwise mainly grey-brown plumage. **JUVENILE** has grubby white plumage. The Snow Goose is widely kept in captivity and most records relate to free-flying escapees. However, a few genuinely wild vagrants of this North American species are thought to occur here each winter, typically being found among flocks of Greenland White-fronted Geese.

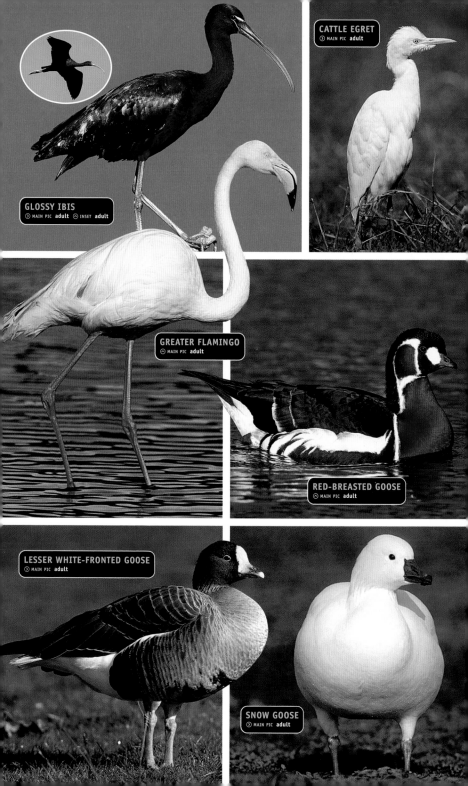

GLOSSY IBIS
⏵ MAIN PIC **adult** ⏵ INSET **adult**

CATTLE EGRET
⏵ MAIN PIC **adult**

GREATER FLAMINGO
⏵ MAIN PIC **adult**

RED-BREASTED GOOSE
⏵ MAIN PIC **adult**

LESSER WHITE-FRONTED GOOSE
⏵ MAIN PIC **adult**

SNOW GOOSE
⏵ MAIN PIC **adult**

RUDDY SHELDUCK *Tadorna ferruginea* LENGTH 61–67cm

A distinctive, goose-sized duck with similar proportions to a Shelduck. The **ADULT** Ruddy Shelduck (the most likely plumage to be encountered) has an orange-brown body with a clear demarcation from the paler buff head and upper neck; in the summer, the male has a narrow black collar separating these two body colours. Standing birds show black wingtips, but in flight the wings look black and white. The Ruddy Shelduck occurs in southeast Europe. It wanders during the winter months and some records in our region (there might be a dozen or more in a good year) could relate to genuinely wild birds. However, the species is also kept in captivity and free-flying escapees confuse the situation.

AMERICAN WIGEON *Anas americana* LENGTH 48–55cm

A medium-sized duck, and the North American counterpart of the Wigeon (p.54). Adult males are distinctive, but identification of other plumages is a challenge. The American Wigeon's white axillaries ('armpits') are useful at all times (they are grey in Wigeon). **ADULT MALE** has a striking head pattern with a green stripe stretching back from the eye, a creamy-white forehead and crown, and a speckled grey face. The body plumage is otherwise mainly pinkish-buff and there are bold black and white markings at the rear. In flight, note the striking white patch on the upper surface of the inner wing. **ALL OTHER PLUMAGES** (including eclipse males) are similar to their Wigeon counterparts. However, the head appears greyer, with a dark patch through the eye, and the body is rather pinkish-orange. American Wigeon are usually found in Wigeon flocks in autumn and winter, and there are a handful of records each year.

GREEN-WINGED TEAL *Anas (crecca) carolinensis* LENGTH 34–38cm

A small, dainty duck, and the North American counterpart of the Teal (p.58). **ADULT MALE** has a striking and diagnostic vertical white stripe on the breast; the adult male Teal's horizontal white body stripe is absent. The head has a Teal-like pattern of green and chestnut, although the yellow lines that separate the colours on a Teal are missing. The body is adorned with fine grey and white vermiculations, and the stern shows a striking yellowish patch, defined by black. In flight, note the green speculum and white wingbar. **ALL OTHER PLUMAGES** are inseparable in the field from their Teal counterparts. The Green-winged Teal is invariably discovered among flocks of Teal in autumn and winter, on the coast or on freshwater marshes; 15 or so might be recorded in a good year. If the feeding is good, individuals tend to stay put for a few weeks.

BLUE-WINGED TEAL *Anas discors* LENGTH 37–40cm

A small and distinctive North American duck. **ADULT MALE** has a bluish head with a striking and diagnostic white crescent. The body is buffish-brown, marbled with darker spots, and a white patch can be seen on the otherwise black stern. **ADULT FEMALE** and **JUVENILE** are mainly marbled brown and are similar to their Teal counterparts. However, the plumage is greyer; note the pale spot at the base of the bill and the absence of a pale patch at the side of the base of the tail (seen in Teal). In flight, all birds reveal an extensive and diagnostic blue panel across much of the upper surface of the inner wing. Ten or so individuals might be recorded in a good year, mainly in autumn and winter. Blue-winged Teals favour freshwater wetlands and occur in similar habitats to those frequented by migrant Garganeys in spring and summer.

RING-NECKED DUCK *Aythya collaris* LENGTH 38–45cm

A striking diving duck, and the North American counterpart of the Tufted Duck (p.62). All birds have a peaked hindcrown (rounded in Tufted Duck) and a tricoloured bill, the black tip and grey base being separated by a white band. **ADULT MALE** has a light grey belly and flanks, the leading edge of which is pale and appears as a vertical white line in swimming birds. The plumage is otherwise mainly black, although note the pale grey underwings and flight feathers seen in flying birds. **ADULT FEMALE** has a greyish head with a white patch at the base of the bill, and a white 'spectacle' around the eye. The body plumage is brown, palest on the flanks, the leading margin of which appears as a vertical whitish line in swimming birds. A dozen or so vagrants are usually found in our region in a good year; typically, they turn up in winter on lakes and reservoirs in the company of Tufted Ducks.

SURF SCOTER *Melanitta perspicillata* LENGTH 45–55cm

A hardy North American seaduck. **ADULT MALE** has mainly black plumage, but note the striking white patches on the nape and forecrown. The bill is orange-yellow with a white basal patch in which there is a black spot; at close range the whitish eye can sometimes be discerned. **ADULT FEMALE** has mainly dark grey-brown plumage with a white patch at the base of the bill, and one below the eye. In flight, all birds show uniformly dark wings. A handful of Surf Scoters are found in our region in most years, usually in late autumn or winter and among mixed flocks of Common and Velvet Scoters on the sea (p.70).

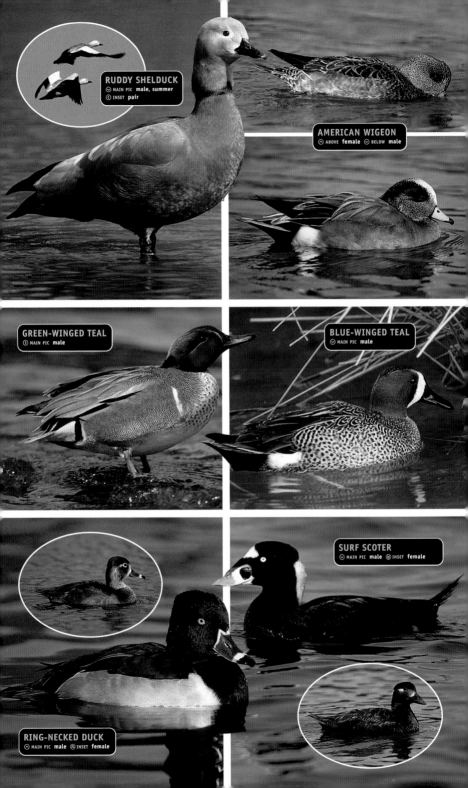

RUDDY SHELDUCK
⌄ MAIN PIC **male, summer**
⌃ INSET **pair**

AMERICAN WIGEON
⌄ ABOVE **female** ⌄ BELOW **male**

GREEN-WINGED TEAL
⌐ MAIN PIC **male**

BLUE-WINGED TEAL
⌄ MAIN PIC **male**

SURF SCOTER
⌄ MAIN PIC **male** ⌄ INSET **female**

RING-NECKED DUCK
⌄ MAIN PIC **male** ⌄ INSET **female**

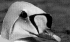

KING EIDER *Somateria spectabilis* LENGTH 55–62cm
A distinctive seaduck. **ADULT MALE** is spectacular, the rather outsized-looking blue head bearing a red bill and a large orange basal knob. The breast is pinkish-orange and the rest of the body is mainly black, with a white patch on the side of the stern and a horizontal white line on the flanks. Raised, sail-like scapulars can be discerned at close range. **ADULT FEMALE** has warm brown, marbled plumage. Confusion is possible with a female Eider, but note the smaller bill and rounded forecrown (in silhouette, an Eider's head and bill shape is more evenly triangular). The King Eider is an Arctic species and vagrants to our region are discovered mainly in winter. Look for it among Eider flocks, off the coasts of north and east Scotland. Confusion species: Eider (p.68).

BLACK KITE *Milvus migrans* WINGSPAN 145–155cm
A medium-sized raptor that is most easily confused with a Red Kite or a female Marsh Harrier (both p.78). **ALL BIRDS** have mainly brown plumage that is palest on the head. In flight, note the forked tail, although this can appear straight-ended when broadly fanned. Note also the pale panel on the outer flight feathers of the otherwise rather dark wings. At very close range, the yellow base to the bill and the yellow legs can sometimes be discerned. The Black Kite breeds in mainland Europe and winters in Africa. Vagrants to our region usually turn up in spring and autumn, and perhaps 10 or so might be recorded in a good year. However, most individuals seldom linger in one location for very long and so usually they are seen by just a handful of lucky observers. This is a tricky species to catch up with in our region.

RED-FOOTED FALCON *Falco vespertinus* WINGSPAN 65–75cm
An elegant and rather small falcon. **ADULT MALE** has mainly dark grey plumage with pale primaries, and a red vent and thighs; at close range, the red feet and red skin around the eye are discernible. **IMMATURE MALE** is similar, but with paler underparts and a pale face and throat. **ADULT FEMALE** has an orange-buff crown and underparts, a barred grey back, white cheeks and throat, and a dark mask through the eye. In flight, it could be mistaken for a Hobby (p.90). However, the Red-footed Falcon frequently hovers in a Kestrel-like fashion, and often sits on telegraph wires and fenceposts (habits seldom observed in the Hobby). It breeds in eastern Europe and winters in Africa. The species' spring migration has an easterly bias and hence most records in our region (10 or 20 in a good year) are at this time of year.

COLLARED PRATINCOLE *Glareola pratincola* WINGSPAN 60–70cm
An atypical wader that is unmistakable, both on the ground and in flight. **ADULT** has mainly dark sandy-brown upperparts and a pale belly. However, note the yellow throat, defined by a black border. The bill is red at the base with a hooked black tip. **JUVENILE** is similar, but the back appears scaly, the bill is uniformly dark and the pattern on the throat is subdued. The Collared Pratincole sometimes feeds on the ground, but typically it catches insects in flight, when, with its long wings and forked tail, it recalls a tern or an outsized Swallow. It is supremely aerobatic on the wing. Three or four might be recorded in a good year, mostly in spring and early summer. Look for this species around the margins of coastal freshwater and brackish pools.

AMERICAN GOLDEN PLOVER *Pluvialis dominica* LENGTH 24–26cm
The North American counterpart of the Golden Plover (p.112), compared to which note the grey (not white) 'armpits' (axillary feathers) and the proportionately longer legs of all birds. Most records (seven or eight in a good year) relate to juvenile birds, seen in autumn. **JUVENILE** has mainly greyish upperparts, spangled with golden spots, and barred grey-buff underparts. Compared to a juvenile Golden Plover, note the overall greyer appearance, and the darkish cap and pale supercilium. **SUMMER ADULT** (seen very occasionally in our region) has more extensive black on the underparts (particularly males), but they are best identified by the underwing colour. Look for this species in coastal grassland and wetlands, in the west of the region.

BROAD-BILLED SANDPIPER *Limicola falcinellus* LENGTH 15–17cm
A dainty little wader that is slightly smaller than, but superficially similar to, a Dunlin (p.114). The legs are relatively short and yellowish, although both features are not obvious in birds that are wading in muddy water. The bill shape is the most reliable clue to identity: it is rather long and straight, but with a distinct downward kink at the tip. **SPRING ADULT** has mainly brown upperparts and whitish underparts. Pale feather margins on the back sometimes align to form stripes, and note the split pale supercilium on the otherwise dark crown. **JUVENILE** is similar, but with cleaner-looking, more distinct markings on the head and back. The Broad-billed Sandpiper breeds in northern Scandinavia and winters in Africa and Asia. A handful of birds might be recorded in our region in a good year, most turning up in spring on coastal mudflats and pools.

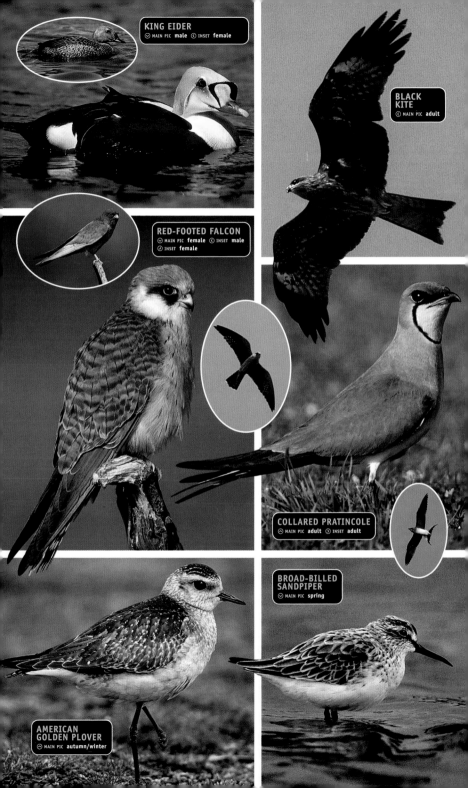

KING EIDER
⊙ MAIN PIC **male** ⊙ INSET **female**

BLACK KITE
⊙ MAIN PIC **adult**

RED-FOOTED FALCON
⊙ MAIN PIC **female** ⊙ INSET **male**
⊙ INSET **female**

COLLARED PRATINCOLE
⊙ MAIN PIC **adult** ⊙ INSET **adult**

BROAD-BILLED SANDPIPER
⊙ MAIN PIC **spring**

AMERICAN GOLDEN PLOVER
⊙ MAIN PIC **autumn/winter**

MARSH SANDPIPER Tringa stagnatilis LENGTH 22–25cm

An elegant wader with long, yellowish legs and a thin, needle-like bill. **SUMMER ADULT** has mainly grey-brown upperparts that are spangled with blackish spots; the underparts are white and streaked on the neck, breast and flanks. **NON-BREEDING ADULT** has mainly grey upperparts and clean white underparts. **JUVENILE** recalls a summer adult but the back appears rather scaly. The Marsh Sandpiper breeds in central Asia and winters in Africa and southern Asia. Half a dozen or so are recorded in our region in most years, mainly in spring and early summer. Look for the species on freshwater pools. Confusion species: Green Sandpiper (p.128).

WHITE-RUMPED SANDPIPER Calidris fuscicollis LENGTH 16–18cm

A small North American wader. Superficially, it resembles a Dunlin (p.114), but it reveals a white rump in flight. In all birds, the wings project well beyond the tail at rest (the wings are roughly the same length as the tail in a resting Dunlin). Note also the rather short, slightly downcurved bill, which has a dull orange base to the lower mandible, and the striking, whitish supercilium. Most records occur in autumn, when **MOULTING ADULT BIRDS** have whitish underparts with streaking on the breast and flanks, and greyish-brown upperparts, the back studded with black and brown feathers. **JUVENILE** is similar but cleaner looking, the pale margins to the back feathers creating a scaly appearance. A dozen or so individuals might be recorded in a good year.

LESSER YELLOWLEGS Tringa flavipes LENGTH 23–25cm

An elegant wader that recalls an outsized Wood Sandpiper (p.128) but with extremely long, bright yellow legs. Vagrants to the region are seen typically in **JUVENILE** or **FIRST-WINTER PLUMAGE**, with a brown back and wings, spangled with black and whitish spots, mainly white underparts and the pale head, neck and breast streaked with buffish-brown. The Lesser Yellowlegs is a North American species and there might be eight or so records in a good year. The species usually turns up in autumn or early winter, typically after prolonged periods of westerly gales. It favours the margins of lakes and reservoirs, and freshwater marshes, around which it wades in a stately fashion.

SEMIPALMATED SANDPIPER Calidris pusilla LENGTH 13–15cm

A tiny North American wader. Most records occur in autumn and relate to **JUVENILES**. These are most easily confused with a juvenile Little Stint (p.116), compared to which note the thicker-tipped bill and the duller, more uniform upperparts (although the feathers have pale margins, they do not align to form the striking white lines seen on a Little Stint's back). Partly webbed toes are a diagnostic feature but hard to discern in the field. The Semipalmated Sandpiper typically turns up in southern Ireland and southwest England after westerly gales in autumn. Look for it on drying freshwater margins and on beaches; a handful of individuals might be recorded in a good year.

BAIRD'S SANDPIPER Calidris bairdii LENGTH 14–17cm

A stint-sized vagrant wader from North America, with long wings (they project well beyond the tail in standing birds) and a relatively long bill. Most records (a handful in a good year) occur in autumn and relate to **JUVENILES**. These show a uniformly scaly pattern on the back and wings, created by pale feather margins. The head, neck and breast are buff, and the underparts are otherwise white and unmarked. The Baird's Sandpiper typically feeds on areas of short grassland, but occasionally it is discovered on beaches. Confusion species: Little Stint (p.116).

BUFF-BREASTED SANDPIPER Tryngites subruficollis LENGTH 18–20cm

A delightful little wader from North America that could be confused with a juvenile Ruff (p.126). Most records occur in autumn and are **JUVENILES**, which appear pale buffish-brown overall. The back feathers are rather dark greyish, but pale margins create a scaly appearance. The pale buffish head and whitish eye-ring serve to emphasise the rather large, dark eye. The bill is relatively short and dark, and the legs are yellowish. Buff-breasted Sandpipers are typically discovered on areas of short grassland. Some 20 or 30 individuals might be recorded in a good year, most in the western half of the region.

PECTORAL SANDPIPER Calidris melanotos LENGTH 19–22cm

A compact and rather deep-bodied wader. It recalls a Dunlin (p.114), but note that at all times it has yellow legs. Most records occur in autumn and relate to **JUVENILES**, which have grey, brown and black feathers on the back, all with pale margins; these align to form striking white stripes. The face, neck and breast are streaked, but there is a clear pectoral demarcation from the clean white underparts. The Pectoral Sandpiper is the most frequently recorded North American wader in our region – 50 or 60 might be discovered in a good year. Look for it beside freshwater pools and marshes.

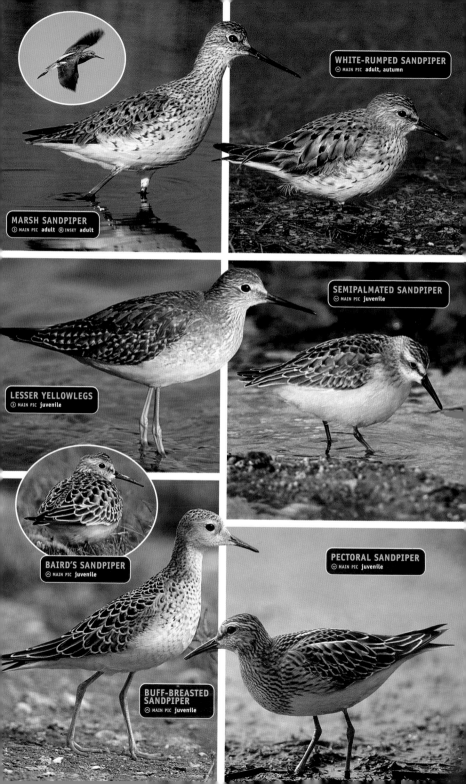

MARSH SANDPIPER
⊙ MAIN PIC **adult** ⊛ INSET **adult**

WHITE-RUMPED SANDPIPER
⊙ MAIN PIC **adult, autumn**

LESSER YELLOWLEGS
⊙ MAIN PIC **juvenile**

SEMIPALMATED SANDPIPER
⊙ MAIN PIC **juvenile**

BAIRD'S SANDPIPER
⊙ MAIN PIC **juvenile**

**BUFF-BREASTED
SANDPIPER**
⊙ MAIN PIC **juvenile**

PECTORAL SANDPIPER
⊙ MAIN PIC **juvenile**

LONG-BILLED DOWITCHER *Limnodromus scolopaceus* LENGTH 28–30cm

A North American wader that recalls a Snipe (p.130). Note the very long bill, the broad and pale super-cilium, and the yellowish legs. **JUVENILE** has an orange-buff suffusion with rufous-edged dark feathers on the back. **FIRST-WINTER BIRD** is greyish overall and palest on the belly. **SUMMER ADULT** has godwit-like colours, the head, neck and underparts flushed with reddish-orange. The Long-billed Dowitcher favours coastal pools and it feeds in the manner of a slow sewing machine. Half a dozen individuals might be recorded in a good year, mostly in autumn and early winter.

GREAT SNIPE *Gallinago media* LENGTH 26–30cm

Superficially very similar to a Snipe (p.130). Compared to that species, and **IN ALL PLUMAGES**, note the proportionately shorter bill, three striking white wingbars and more extensively barred underparts. When taking off, the outer tail feathers are revealed as being largely white. Great Snipe usually favour drier habitats than Snipe; Stinging Nettle-covered wetland margins are ideal for migrants. The species breeds in eastern Europe and winters in Africa. Most records in our region (four or five in a good year) occur in autumn and in the northern isles. However, the species surely must be overlooked elsewhere.

WILSON'S PHALAROPE *Phalaropus tricolor* LENGTH 22–24cm

A North American wader with a longer, more needle-like bill than other phalaropes (p.132) and yellow legs. Most records in the region (a dozen or so in a good year) occur in autumn and relate to birds moulting from **JUVENILE TO FIRST-WINTER PLUMAGE**, where the back is mainly grey but variably adorned with brown feathers. The plumage is otherwise mainly white, although the crown and nape are grey, and a grey line extends down the side of the neck. **SUMMER ADULT** (sometimes seen here) has red and yellow on the neck with a dark band down the side of the neck. The plumage is otherwise greyish above and white below, females being brighter than males. Wilson's Phalaropes usually turn up on coastal pools.

WHISKERED TERN *Chlidonias hybridus* LENGTH 24–27cm

Recalls a miniature Common Tern (p.148) with a proportionately shorter, much less-forked tail. **SUMMER ADULT** has a black crown and nape and a white throat; the plumage is otherwise smoky-grey, darkest on the breast and belly. The bill and legs are dark red. **NON-BREEDING ADULT** is mainly white with pale grey upperwings and blackish speckling on the hindcrown. **JUVENILE** is similar to a winter adult but it shows an orange-brown mantle and grey flight feathers. The Whiskered Tern breeds in southern Europe and winters mainly in Africa. Vagrants to our region (half a dozen in a good year) usually turn up at migration times, hawking insects over fresh water.

WHITE-WINGED BLACK TERN *Chlidonias leucopterus* LENGTH 20–24cm

In breeding plumage, could only be confused with a Black Tern (p.150). **SUMMER ADULT** has a black head, neck and body, pale grey upperwings that are palest on the leading edge, and underwings with black coverts and pale grey flight feathers. The rump, stern and tail are pure white, while the bill is dark and the legs are red. Adults begin to moult black elements of the plumage by July, and **NON-BREEDING ADULT** is grey above and white below; however, note the whitish collar and rump, streaking on the hindcrown and the dark spot on the ear coverts. **JUVENILE** is similar to a winter adult, but note the blackish mantle, hood and nape, and the contrasting white rump and sides to the neck. The White-winged Black Tern breeds in eastern Europe and winters in Africa. Vagrants to our region (a dozen or so in a good year) usually turn up at migration times, hawking insects over fresh water.

CASPIAN TERN *Sterna caspia* LENGTH 50–55cm

A huge and unmistakable tern. At all times, the massive, blood-red bill is diagnostic. **SUMMER ADULT** has a black crown, a white face, neck and underparts, and a grey back and upperwings; the outer primaries are blackish when seen from below in flight. **NON-BREEDING ADULT** is similar, but the dark crown is incomplete and particularly pale on the forecrown. The Caspian Tern has a powerful and direct flight. It breeds locally in mainland Europe and winters in Africa; most records in our region (seven or eight in a good year) occur in spring and early summer. Vagrants favour freshwater sites.

GULL-BILLED TERN *Sterna nilotica* LENGTH 35–40cm

Recalls a Sandwich Tern (p.150), but note the broader wings, the thicker, all-dark bill and the stockier body. The flight is direct and gull-like. **SUMMER ADULT** (the plumage in which it is usually seen in the region) has a black crown and a white face and underparts; the upperparts are grey except for the dark primary tips, which create a dark trailing edge to the outer wing. The Gull-billed Tern has scattered breeding colonies in mainland Europe and it winters in Africa. Just a handful of records occur each year, mostly in spring and early summer, and usually on coastal marshes.

LONG-BILLED DOWITCHER
> MAIN PIC juvenile

GREAT SNIPE
> MAIN PIC adult > INSET adult

WILSON'S PHALAROPE
< MAIN PIC moulting juvenile

WHISKERED TERN
< MAIN PIC adult

WHITE-WINGED BLACK TERN
> MAIN PIC summer

CASPIAN TERN
> MAIN PIC summer > INSET summer

GULL-BILLED TERN
> MAIN PIC summer

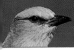
RING-BILLED GULL *Larus delawarensis* LENGTH 42–48cm

A medium-sized gull from North America that, in some ways, is intermediate in character between Herring (p.136) and Common Gulls (p.142). **ADULT** mainly grey back and upperwings, but otherwise the plumage is white. Note the yellowish legs and eyes, and the yellow bill with a black sub-terminal band; the outer primaries are black with small white spots. In winter, the colours are duller and the head and neck are streaked. **IMMATURE BIRDS** are confusingly similar to their Common Gull counterparts, but the back is paler grey and note the proportionately larger head and stouter bill. Some 50 or 60 Ring-billed Gulls might be recorded in the region in a good year. The species could turn up at almost any site where medium-sized and large gulls congregate, although coastal locations in Cornwall, south Wales and Ireland are particularly good. Some individuals are long-staying.

IVORY GULL *Pagophila eburnea* LENGTH 41–45cm

An elegant and distinctive high Arctic gull. **ADULT** has pure white plumage and black legs. The rounded head, dark eye and dainty bill create an almost dove-like appearance. At close range, note the bluish base and yellow tip to the bill. **JUVENILE** is similar, but the face is grubby-looking and the wings are adorned with neat black spots. The Ivory Gull is typically discovered in the dead of winter and records from our region (a couple in a good year) have a northerly bias. The species often feeds on beached seal and porpoise carcasses in our region. Confusion species: Iceland Gull, 3rd-winter (p.140).

ROSS'S GULL *Rhodostethia rosea* LENGTH 30–32cm

A small but relatively long-winged gull from Arctic waters. All birds have a dainty, dark bill and short, reddish legs. **ADULT** has a wedge-shaped white tail, a very pale back and upperwings, and grey underwings; a broad white trailing edge can be seen in flight, both from above and below. The plumage is otherwise white but, in spring, it acquires a black neck ring and a pink flush to the underparts. In winter, note the dark smudge around the eye; a hint of the neck collar can often be discerned. **FIRST-WINTER BIRD** recalls a first-winter Little Gull with a black 'W' line on the upperwings. However, note the pure white trailing edge to the wing and the relatively long, wedge-shaped tail. A couple of Ross's Gulls are usually recorded each year, mostly in winter or early spring, and in the company of Black-headed Gulls (p.134).

ROLLER *Coracias garrulus* LENGTH 30–32cm

A colourful and unmistakable bird of crow-like proportions and size, with a powerful, hook-tipped bill. **ADULT** has a blue head, neck and underparts, palest on the forehead and with a narrow dark patch through the eye. The back is chestnut and the rump, tail and parts of the wing are bluish-purple. In flight, the wings look striking, the dark flight feathers contrasting with the paler blue coverts; note also the dark tips to the otherwise pale blue outer tail feathers. **JUVENILE** has similar markings but the colours are much duller. The Roller breeds in southern Europe and winters in Africa, and most records in our region (four or five in a good year) occur around migration times. Vagrants are usually found in dry, open habitats such as heaths, and – fortunately for observers – they typically perch out in the open.

ALPINE SWIFT *Apus melba* WINGSPAN 52–58cm

Appreciably larger than a Swift (p.166) and with diagnostic markings on the underparts. Compared to its common and familiar cousin, and **IN ALL PLUMAGES**, the wings are broader-based and the body is more bulky. Seen from below, note the white throat, which is separated from the white belly by a dark collar; the underparts are otherwise dark. The upperparts, which are seldom observed (birds are usually seen flying overhead), are uniformly sooty-brown. The Alpine Swift has a crescent-shaped outline when gliding; in active flight, the wingbeats are slower than those of a Swift. The species breeds in southern Europe and winters in Africa. A dozen or so are recorded in our region in a good year, mainly in spring and early summer. Given the roaming nature of the species, it is hardly surprising that most individuals are seen by just a handful of observers. However, occasionally a vagrant will stay in the same general area for a few days and adopt a moderately predictable pattern of behaviour.

RED-RUMPED SWALLOW *Hirundo daurica* LENGTH 15–18cm

An attractive cousin to the Swallow (p.174), from which it is readily distinguished at all times by its pale (sometimes reddish) rump. **ADULT** has mainly blue-black upperparts, except for the buffish-orange nape and cheeks, and the pale rump. The underparts, including the underwing, are mainly pale and streaked. The tail and tail coverts are black with a neat cut-off: it looks like the bird has been dipped, tail first, into a pot of black paint. **JUVENILE** is similar, but the pale elements of the plumage (particularly the rump) are almost white and the tail streamers are rather short. The Red-rumped Swallow breeds in southern Europe and winters in Africa. Most records in our region (15 to 20 in a good year) occur at migration times, and vagrants are usually seen in the company of Swallows, catching insects on the wing.

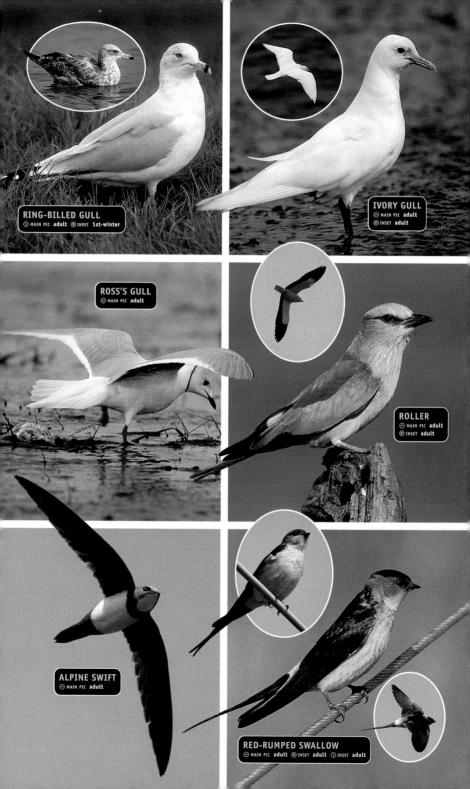

RING-BILLED GULL
▷ MAIN PIC **adult** ◉ INSET **1st-winter**

IVORY GULL
⊙ MAIN PIC **adult**
◉ INSET **adult**

ROSS'S GULL
⊙ MAIN PIC **adult**

ROLLER
⊙ MAIN PIC **adult**
⊙ INSET **adult**

ALPINE SWIFT
⊙ MAIN PIC **adult**

RED-RUMPED SWALLOW
⊙ MAIN PIC **adult** ◉ INSET **adult** ▷ INSET **adult**

RICHARD'S PIPIT *Anthus richardi* LENGTH 17–19cm

Appreciably larger than a Meadow Pipit (p.180), with a much longer tail and legs. **IN ALL BIRDS**, the upperparts are brown and streaked, recalling a Skylark; the hindclaw is particularly long. The flanks and streaked breast are flushed with buff but the underparts are otherwise whitish. Note also the stout bill and pale supercilium. **JUVENILE** in early autumn has whitish fringes to the wing coverts that form two pale wingbars. Flight call is a loud, House Sparrow-like *pschreep*. Richard's Pipit is a vagrant from Asia with mostly autumn records. Typically, birds occur in long grass, usually in coastal locations.

OLIVE-BACKED PIPIT *Anthus hodgsoni* LENGTH 14–16cm

As well marked as a Tree Pipit (p.180) but separable from that species, and from the Meadow Pipit, with care. **IN ALL PLUMAGES**, the upperparts are olive-brown and only faintly streaked. The whitish underparts are flushed warm buff and heavily streaked on the breast and flanks. The head has a bold, pale supercilium, which is buff in front of the eye but whitish behind, and defined above by a narrow black border; a white and black patch can also be seen on the ear coverts. The tail is often pumped up and down as the bird walks, and the call is a thin *tseep*. The Olive-backed Pipit is a vagrant from Asia and most records (four or five in a good year) occur in autumn. Look for it feeding in areas of short grassland.

TAWNY PIPIT *Anthus campestris* LENGTH 16–18cm

A large and rather plain pipit. **ADULT** (the most likely plumage to be encountered in the region) has uniform, and only faintly streaked, sandy-brown upperparts and whitish underparts with only a few streaks on the side of the breast. Note the striking pale supercilium, the dark eye-stripe and loral stripe, and the dark centres and pale margins to feathers on the median wing coverts. **JUVENILE** has more contrasting feather markings overall; note the dark streaking on the back and the dark spotting on the breast. Calls include a sharp *tseelp*. The Tawny Pipit breeds in mainland Europe and winters in Africa. Most records (a handful in a good year) occur at migration times in areas of coastal short grassland.

RED-THROATED PIPIT *Anthus cervinus* LENGTH 14–15cm

A distinctive pipit, particularly **ADULTS**, whose face, neck and breast are variably suffused with reddish-orange. This colour is most intense in spring and summer, and males are more striking than females. Note also the bold white and dark stripes on the back, and the clean white underparts with distinct streaking on the flanks. **FIRST-WINTER BIRD** lacks any reddish colour and has more streaking on the underparts. Flight call is a thin, high-pitched *pssee*. The Red-throated Pipit breeds from northern Scandinavia eastwards and winters mainly in Africa. Most records in our region (a dozen or so in a good year) are at migration times. Look for the species in damp grassland and on freshwater margins.

CITRINE WAGTAIL *Motacilla citreola* LENGTH 15–17cm

A well-marked wagtail. **SUMMER ADULT MALE** is unmistakable, with a deep lemon-yellow head, neck and underparts. The back is grey, and note the black collar and the two striking white wingbars. **ADULT FEMALE** is similar, but the yellow colour is less intense and the grey colour on the back continues onto the nape and crown; note also the greyish ear coverts. **FIRST-WINTER BIRD** has essentially grey upperparts and whitish underparts, including the undertail coverts. Note the two striking white wingbars and the complete white border to the ear coverts. Flight call is a thin *sree*. The Citrine Wagtail is a vagrant from Asia. A handful of individuals are recorded in a good year, mostly at migration times and near fresh water. Confusion species: Yellow Wagtail (p.184) and Pied Wagtail (juv) (p.186).

EASTERN STONECHAT *Saxicola (torquata) maura* LENGTH 11–13cm

Considered by some authorities to be the eastern race of our Stonechat (p.196); others treat it as a separate species. In all plumages, it has a pale and unmarked rump. **ADULT MALE** is similar to a male Stonechat but with almost white underparts; note the white rump and extensive white band on the side of the neck. **IN ALL OTHER PLUMAGES**, birds are much paler than their Stonechat counterparts, particularly so on the underparts and supercilium. The Eastern Stonechat is a vagrant from Asia, and a dozen or so are recorded in a good year, mostly in autumn and from coastal migration hotspots.

SUBALPINE WARBLER *Sylvia cantillans* LENGTH 12–13cm

A secretive bird, reminiscent of a Dartford Warbler (p.208) in size, shape and habits. **ADULT MALE** has blue-grey upperparts, except for the brownish wings. The throat and breast are reddish, but note the striking white 'moustache'; the belly is white and note also the red orbital ring. **ADULT FEMALE** and **JUVENILE** have much duller colours than the male, although a hint of a pale 'moustache' can usually be discerned. Utters a sharp *tchett* alarm call. The Subalpine Warbler breeds in southern Europe and winters in Africa; vagrants (a dozen or so in a good year) occur mainly at migration times, typically in coastal scrub.

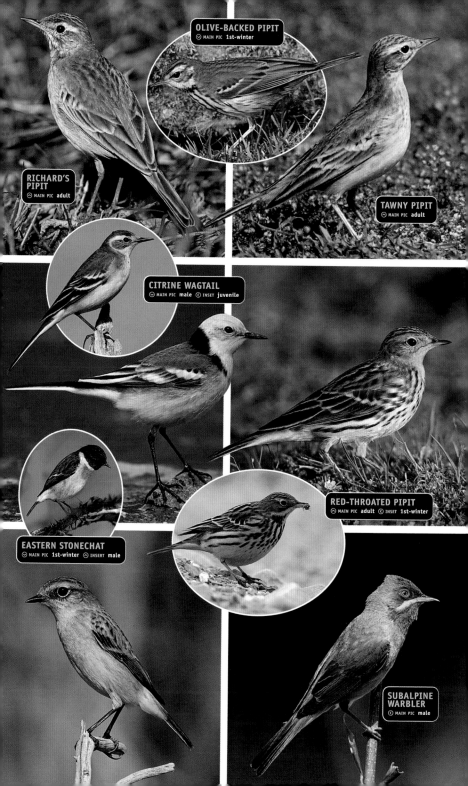

OLIVE-BACKED PIPIT
⌄ MAIN PIC **1st-winter**

RICHARD'S PIPIT
⌄ MAIN PIC **adult**

TAWNY PIPIT
⌄ MAIN PIC **adult**

CITRINE WAGTAIL
⌄ MAIN PIC **male** ⌄ INSET **juvenile**

RED-THROATED PIPIT
⌃ MAIN PIC **adult** ⌃ INSET **1st-winter**

EASTERN STONECHAT
⌄ MAIN PIC **1st-winter** ⌃ INSERT **male**

SUBALPINE WARBLER
⌄ MAIN PIC **male**

GREAT REED WARBLER *Acrocephalus arundinaceus* LENGTH 17–20cm

Similar to a Reed Warbler (p.206) but appreciably larger, and with a relatively longer and stouter bill. **IN ALL PLUMAGES**, the upperparts are sandy-brown, darkest on the crown and most rufous on the rump. The underparts are pale buff with a rufous wash to the flanks. Note also the pale supercilium. The Great Reed Warbler breeds in mainland Europe and winters in Africa. Vagrants are found mainly at migration times, and there might be half a dozen records in a good year. Given the generally inaccessible nature of its reedbed habitat, this would be a difficult bird to detect were it not for the fact that males that appear in spring typically sing; although similar to that of a Reed Warbler, the song is slower and much louder, with a croaking, almost frog-like quality.

BONELLI'S WARBLER *Phylloscopus bonelli* LENGTH 11–12cm

A delicate little warbler, reminiscent of a Chiffchaff or Willow Warbler (p.212). Some authorities recognise two species, Eastern (*P. orientalis*) and Western (*P. bonelli*) Bonelli's warblers, while others classify them as two races, *P. b. orientalis* and *P. b. bonelli* respectively. The latter is the more distinctive of the two (species or races) and the one that is most likely to be encountered in our region. **ADULT WESTERN BIRDS** have a pale, greyish head, grey-green upperparts and clean, whitish underparts; note the yellowish rump and the yellow patch on the wings. **JUVENILE WESTERN** and **ADULT EASTERN BIRDS** have duller and darker colours. The call is a disyllabic *hu-eet*. The Bonelli's Warbler breeds in southern Europe and winters in Africa. Vagrants to our region are typically found at migration times and in coastal woodland and scrub; there might be half a dozen records in a good year.

PALLAS'S WARBLER *Phylloscopus proregulus* LENGTH 9–10cm

A tiny and energetic warbler that recalls a Firecrest (p.216) or Yellow-browed Warbler (p.216) in terms of its size and behaviour. This Asian species is invariably recorded in late autumn (the middle of October is a classic time) and sightings relate to birds in **FIRST-WINTER PLUMAGE**. The upperparts are mainly olive-green, while the underparts are whitish. Note, however, the striking head pattern, comprising a dark eye-stripe, a bright yellowish supercilium and a pale median stripe on the otherwise dark olive crown. Two pale wingbars are clearly visible, but the pale rump can be harder to discern. The Pallas's Warbler is usually found in coastal woodland and scrub. Some 50 or 60 individuals might be discovered in a particularly good year, and the Scilly Isles and East Anglian coast are hotspots for the species.

DUSKY WARBLER *Phylloscopus fuscatus* LENGTH 11–12cm

Recalls a rather sombre-looking Chiffchaff or Willow Warbler (p.212), but is distinguished by subtly different plumage details and by its call. In **FIRST-AUTUMN BIRDS** (the most likely plumage to be encountered in the region), the upperparts are dusky grey-brown, while the underparts are a pale but grubby-looking buff colour. Note the dark eye-stripe and the long, pale supercilium, which is buffish behind the eye but whitish in front. The bill is rather thin and the legs are pale reddish-brown. The call is a sharp, Lesser Whitethroat-like *tchek*. The Dusky Warbler is a vagrant to our region from Asia, and most records (there might be half a dozen in a good year) occur in autumn, in coastal woodland and scrub. However, the species has also spent the winter here (in southern England) on a couple of occasions in recent years, favouring scrub patches in the vicinity of wetland areas.

RADDE'S WARBLER *Phylloscopus schwarzi* LENGTH 12–13cm

A comparatively bulky and plump-bodied *Phylloscopus* warbler. **FIRST-AUTUMN BIRDS** (the only plumage likely to be encountered in the region) are rather dingy-looking (not unlike a Dusky Warbler), but subtle plumage and structural differences allow certain identification if the bird is seen well. The upperparts are dark olive-brown, while the underparts are yellowish-buff, palest on the throat. Note the dark eye-stripe and the long, pale supercilium, which is buffish in front of the eye but whitish behind. The bill is noticeably short and stout, and the legs are pale pinkish-buff. The call is a soft *chip*. This species is a vagrant from Asia, and most records (half a dozen in a good year) occur in late autumn, at coastal migration hotspots such as the Scilly Isles and East Anglia. Look for the species in low scrub and rank vegetation.

LESSER GREY SHRIKE *Lanius minor* LENGTH 19–21cm

An elegant and well-marked shrike. **ADULT** has mainly grey upperparts, white underparts and black wings and tail. Compared to a Great Grey Shrike (p.230), note the smaller size, the relatively longer primaries and shorter tail, and the black patch through the eye that extends onto the forehead; in addition, there is more white on the wings and a rosy flush to the underparts can sometimes be discerned. **JUVENILE** is similar, but the black eye patch does not extend onto the forehead; the back and crown appear scaly and faintly barred. The Lesser Grey Shrike breeds in southern and eastern Europe and winters in Africa. Vagrants (half a dozen in a good year) occur mainly at migration times.

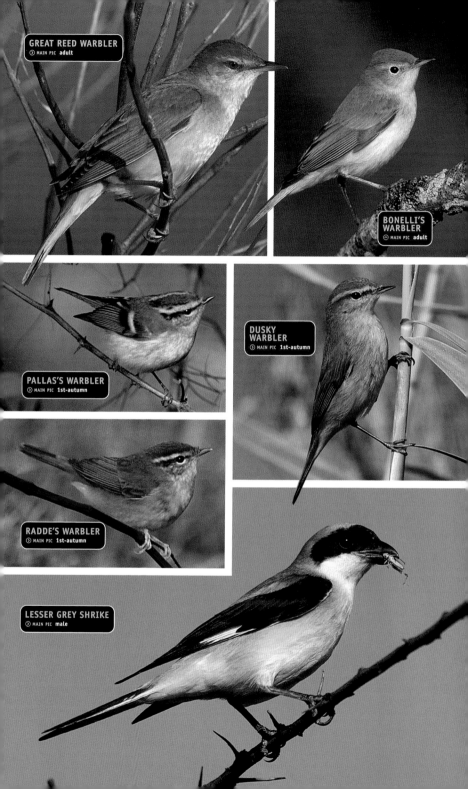

GREAT REED WARBLER
⊘ MAIN PIC **adult**

BONELLI'S WARBLER
⊘ MAIN PIC **adult**

PALLAS'S WARBLER
⊘ MAIN PIC **1st-autumn**

DUSKY WARBLER
⊘ MAIN PIC **1st-autumn**

RADDE'S WARBLER
⊘ MAIN PIC **1st-autumn**

LESSER GREY SHRIKE
⊘ MAIN PIC **male**

PARROT CROSSBILL *Loxia pytyopsittacus* LENGTH 16–18cm

Confusingly similar to a Crossbill, or Scottish Crossbill (both p.254), come to that, and separable from those species only with great care. As with its cousins, **ADULT MALES** have mainly dull red plumage while that of **ADULT FEMALES** is yellowish-green; **IMMATURES** have duller colours than adults of their respective sexes, while **JUVENILES** are brownish and streaked. All Parrot Crossbills have deep and powerful-looking bills, the mandibles of which overlap at the tip, but not to the extent seen in most crossbills; the head and neck also look proportionately large. In terms of habits and behaviour, it is similar to other crossbill species. The Parrot Crossbill's status is an irruptive visitor from Scandinavia. It is recorded in small numbers in most years but, occasionally, after a failure of the cone crop in mainland Europe, large numbers arrive, mainly in autumn. After such arrivals, it sometimes lingers here and breeds.

ARCTIC REDPOLL *Carduelis hornemanni* LENGTH 12–14cm

A charming little finch that superficially resembles a Mealy Redpoll (p.250). All birds look overall extremely pale, particularly so on the underparts, which are almost unmarked; the rump is diagnostically almost white and unstreaked. **ADULT** has mainly pale grey-brown and streaked upperparts and whitish underparts. Note the small black bib, red forecrown and white wingbar on the dark wings. **FIRST-WINTER BIRD** is similar but with a warmer buff wash to the head, breast and back. The Arctic Redpoll's winter range usually extends no further south than Scandinavia. Records in our region have a northerly bias and most individuals (10 or so in a good year) are discovered in late autumn or winter.

RUSTIC BUNTING *Emberiza rustica* LENGTH 14–15cm

An attractive and distinctive bunting, most records of which (a handful in a good year) occur in autumn and relate to **JUVENILE** or **FIRST-WINTER BIRDS**. Their clean, whitish underparts, adorned with reddish-brown streaks on the breast and flanks, are useful in identification, as is the unmarked reddish-brown rump. Note also the pinkish bill, the pale supercilium and the pale spot towards the rear of the dark-margined ear coverts. Two whitish wingbars add to the distinctive appearance. **SUMMER ADULT** (seen only very occasionally in our region) is unmistakable, with black and white markings on the head, and with its reddish neck, breast and streaks on the flanks offset by pure white underparts; males are brighter than females. The Rustic Bunting breeds from Scandinavia eastwards and winters in Asia. Look for it in coastal fields and areas of short grassland. Confusion species: Reed Bunting (p.258)

LITTLE BUNTING *Emberiza pusilla* LENGTH 12–14cm

A small, well-marked bunting that could perhaps be confused with an immature or female Reed Bunting (p.258). However, a few plumage details allow certain identification on close inspection. In **FIRST-AUTUMN BIRDS** (the most likely plumage to be encountered in the region), the back is brown and streaked, the brown wings have two pale wingbars, and the underparts are mainly whitish with streaking on the breast and flanks. The head pattern is diagnostic: note the reddish-brown face and throat, the pale reddish-brown median stripe to the dark crown, and the narrow black border to the rear part of the ear coverts; the pale eye-ring is rather striking and a pale spot towards the rear of the ear coverts can sometimes be discerned. The Little Bunting is a vagrant from Asia, and 20 or 30 individuals might be discovered in a good year. It is usually found in late autumn, but individuals do occasionally spend the winter here, usually among flocks of other bunting species.

YELLOW-BREASTED BUNTING *Emberiza aureola* LENGTH 14–16cm

A distinctive bunting. **ADULT** (particularly the male) is almost unmistakable, with reddish-brown upperparts, a white shoulder patch, a black face and breast band, and otherwise mainly yellow underparts. However, most records in our region (half a dozen in a good year) relate to **IMMATURE BIRDS** seen in autumn. These are vaguely Yellowhammer-like (p.256), but note the two white wingbars, the yellowish flush to the underparts and the relatively strong head pattern comprising a pale supercilium and dark margins to the ear coverts and sides of the pale crown. The bill is pinkish in all birds. The Yellow-breasted Bunting breeds eastwards from eastern Scandinavia and winters in southeast Asia. Look for it in coastal grassland.

BLACK-HEADED BUNTING *Emberiza melanocephala* LENGTH 15–17cm

A striking and colourful bunting. A significant proportion of the records in our region (half a dozen in a good year) relate to **ADULT MALES** seen in late spring. Such birds are almost unmistakable, having a black hood and bright yellow underparts and neck. The back is chestnut, while the wings are dark with white feather margins; spring males often attract attention with their chinking songs. **ADULT FEMALE** has much duller colours; the head is greyish, not black, but note the clean, unstreaked yellowish underparts. All birds have a grey bill. The Black-headed Bunting is a vagrant to our region from its summer range in eastern Europe; most are found in areas of scrub near the coast.

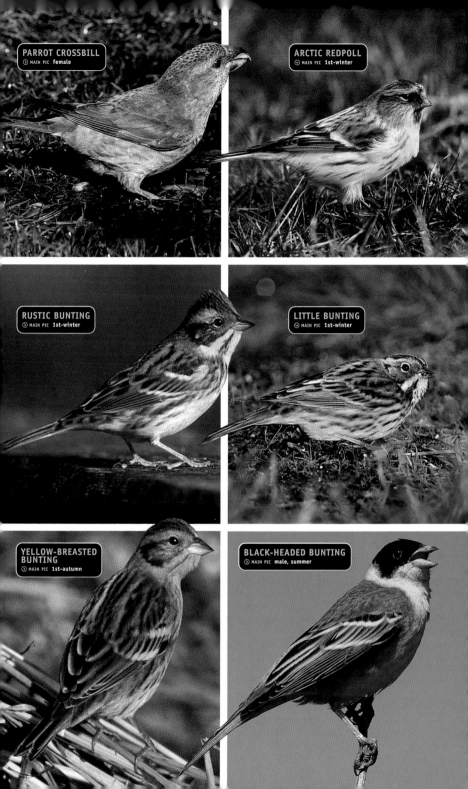

PARROT CROSSBILL
> MAIN PIC **female**

ARCTIC REDPOLL
> MAIN PIC **1st-winter**

RUSTIC BUNTING
> MAIN PIC **1st-winter**

LITTLE BUNTING
> MAIN PIC **1st-winter**

YELLOW-BREASTED BUNTING
> MAIN PIC **1st-autumn**

BLACK-HEADED BUNTING
> MAIN PIC **male, summer**

FURTHER READING

Birding World. Ornithological magazine (12 issues per year).

British Birds. Ornithological magazine (12 issues per year).

Brown, A., and Grice, P. (2004). *Birds in England*. Christopher Helm.

Campbell, B., and Lack, E. (ed.) (1985). *A Dictionary of Birds*. Poyser.

Delin, H., and Svensson, L. (1988). *Photographic Guide to the Birds of Britain and Europe*. Hamlyn.

Lack, P. (1986). *The Atlas of Wintering Birds in Britain and Ireland*. Poyser.

Wingfield Gibbons, D., Reid, J.B., and Chapman, R.A. (1993). *The New Atlas of Breeding Birds in Britain and Ireland: 1988–1991*. Poyser.

Mullarney, K., Svensson, L., Zetterstrom, D., and Grant, P.J. (1999). *Collins Bird Guide*. HarperCollins.

Sterry, P. (1997). *Collins Complete British Wildlife Photoguide*. HarperCollins.

Wernham, C., Toms, M., Marchant, J., Clark, J., Siriwardnea, G., and Baillie, S. (eds) (2002). *The Migration Atlas*. Christopher Helm.

USEFUL ADDRESSES

British Trust for Ornithology
BTO
The Nunnery
Thetford
Norfolk IP24 2PU
www.bto.org

Royal Society for the Protection of Birds
The Lodge
Sandy
Bedfordshire SG19 2DL
www.rspb.org

The Wildlife Trusts
The Kiln
Waterside
Mather Road
Newark
Nottinghamshire NG24 1WT
www.wildlifetrusts.org

All the background landscape photographs were taken by the author and Andrew Cleave, with the exception of the picture behind the Dunnock. All other photographs were taken by the author with the exception of the following:

Nature Photographers Ltd:
Andrewartha, T 117 (M inset); Blackburn, Frank 91 (T & T lower inset), 207 (T), 255 (TL); Bolton, Mark 27 (B inset), 33 (T inset), 35 (B & Med Shearwater flying), 149 (B), 275 (BR); Carlson, Kevin 79 (BR), 185 (T female), 205 (BR), 217 (BR); Carver, Colin 31 (T), 91 (B), 157 (B), 173 (BR), 179 (B), 181 (B), 197 (TL female), 199 (BL & BR), 207 (BL), 213 (BL & BR), 227 (TR), 259 (TR), 261 (BL male); Chandler, RJ 109 (T flying), 147 (T inset); Chapman, Bob 152 (B); Clark, Hugh 53 (T inset), 66 (T), 85 (B), 99 (M), 165 (BL), 167 (TL inset), 171 (TR inset), 172 (T, M & B), 175 (TR inset), 185 (B flying), 187 (T inset), 190 (BL), 229 (TL inset & B inset), 245 (T flying), 255 (TR); Cleave, Andrew 31 (M inset), 36 (M), 38 (B), 133 (B summer), 139 (B), 141 (T), 155 (B inset), 275 (TR inset), 275 (TR); Craig-Cooper, Peter 273 (BL); du feu, Geoff 40 (M), 49 (B flying), 54 (TL); Fisher, RH 111 (T inset); Gore, Michael 169 (T inset), 211 (T), 229 (TL); Green, Phil 123 (T winter), 153 (TR flying), 155 (B), 233 (T juv), 249 (TR); Hancock, James 107 (TL inset); Hill, Michael 39 (T inset), 53 (M inset), 183 (T), 277 (TR); Hughes, Barry 79 (M), 115 (T winter), 181 (TR), 185 (B); Janes, Ernie 23 (B), 24, 77 (B), 93 (TL inset), 95 (T right inset), 123 (B), 158 (T), 191 (T background), 251 (TL); Knights, C 44 (BR); Miles, Hugh 97 (B inset), 146 (B); Newman, Owen 89 (TR); Newman, Philip 51 (B inset), 77 (TR), 80 (B male & female), 81 (M & B), 83 (T), 88 (TR), 89 (BL & BR), 95 (T, & B inset male), 97 (T & T inset), 112 (T), 117 (B summer), 177 (T), 189 (B), 197 (TL), 211 (M), 257 (TR), 259 (T female); Osborn, David 37 (B & B flying), 68 (T male), 69 (T & T inset), 75 (T inset), 133 (T summer standing), 165 (T); Paton, WS 87 (T), 93 (TL), 163 (BL inset); Reynolds, JF 119 (T winter); Roberts, Peter 143 (B adult flying), 145 (B adult flying); Russell, J 201 (B juv); Smith, Don 27 (T flying), 68 (T flying), 163 (T flying pale breasted & BR flying); Smith, RT 173 (BL); Thompson, EK 27 (M), 44 (ML), 67 (T), 163 (T & BR); Tidman, Roger 31 (B inset), 33 (B inset), 35 (B flying & Great Shearwater flying), 44 (TR), 47 (B inset), 54 (TR), 56 (T), 58 (T), 64 (B), 77 (TL), 79 (T), 80 (T male & female), 81 (TL), 87 (T flying ×2, B & B adult flying), 88 (TL), 89 (TL), 93 (TR), 105 (B inset), 109 (B female), 111 (B flying), 112 (B), 113 (T winter & B winter), 119 (T flying), 121 (B), 123 (B winter & flying), 127 (T flying), 131 (T), 137 (B juv), 145 (B & B juv), 151 (M ×3, & B inset), 153 (TL), 155 (TR 'bridled' & winter swimming), 161 (T), 163 (BL), 177 (T flying), 195 (TL), 201 (TL), 207 (BR), 209 (T), 211 (B inset), 213 (ML), 215 (T), 217 (BL), 227 (TL), 231 (B juv), 237 (B), 247 (T juv, BL & BR), 251 (M ×2), 255 (BL), 257 (T female & B female), 259 (MR), 263 (TL), 275 (ML), 279 (TR), 281 (TL); Washington, D 149 (M); Whalley, Patrick 16 (T), 173 (MR), 225 (B); Wolmuth & Muller 85 (T inset).

Other Sources:
Andersen, Janus 47 (T inset), 76 (TR), 77 (B inset), 83 (B ×2). Cade, Martin 219 (B inset). Ekström, Göran 53 (B flying), 70 (T & B), 74 (T), 94 (BR), 99 (T flying), 143 (B juv), 215 (B), 279 (upper ML). Loseby, Tim 255 (BR), 271 (lower ML), 277 (centre T), 279 (lower ML), 281 (TR & BL). **Natural Image:** Lane, Mike, 205 (BL). Stephenson, Brent 263 (TR).
Windrush Photos: Altstedt, Göran 35 (Great Shearwater); Brooks, Richard 58 (B); Coster, Bill 61 (T flying & B flying), 64 (T); Desmette, Frederic 161 (B), 255 (ML & MR); Doherty, Paul 85 (T), 127 (B flying); Ennis, Tom 141 (B), 271 (BL); Morris, Arthur 74 (B), 89 (B inset), 267 (BR), 273 (TL); Peltomaki, Jari 72 (B); Tipling, David 45 (B inset), 67 (T inset), 94 (TR), 99 (M inset & B ×2), 139 (T 1st-w), 147 (B inset), 155 (TL winter & TL flying), 217 (TR), 281 (ML); Young, Steve 75 (B).

Abbreviations: T (top), M (middle) and B (bottom), sometimes with L (left) and R (right), refer to the main pictures on a page.